The Zero Fallacy

and Other Essays in Neoclassical Philosophy

The Zero Fallacy

and Other Essays in Neoclassical Philosophy

Charles Hartshorne

**Edited with an Introduction
by Mohammad Valady**

OPEN COURT
Chicago and La Salle, Illinois

Open Court Publishing Company is a division of Carus Publishing Company.

First printing 1997

Printed and bound in the United States of America.

Library of Congress Cataloging-in-Publication Data

Hartshorne, Charles, 1897–
 The zero fallacy and other essays in neoclassical philosophy /
 Charles Hartshorne ; edited with an introduction by Mohammad Valady.
 p. cm.
 Collection of essays, some of which were previously published,
 reprinted with minor revisions.
 Includes bibliographical references and index.
 ISBN 0-8126-9323-X (cloth : alk. paper). — ISBN 0-8126-9324-8
 (pbk. : alk. paper)
 1. Philosophy. I. Valady, Mohammad, 1957– . II. Title.
 B945.H351 1997
 191—dc21
 97-112
 CIP

SELECTED QUOTATIONS FROM CHARLES HARTSHORNE

With pragmatists and existentialists (and including Whitehead) I grant that it is trifling with philosophical problems to accept as valid questions and answers that have no conceivable bearing on how we propose to live. A philosophy must in some significant way express values relevant to life's choices. For this reason alone, though there are many others, classical determinism is to be rejected.

IO, p. 373

The absolute principle is creativity, not order; it is freedom, not necessity. . . . Not God, not the devil, and not some particularly wicked individual or social system is the ultimate source of suffering and conflict in the world. Rather it is the chance intersections of lines of creative activities that bring creatures into conflict, frustration, suffering. . . . Life is risk taking or nothing.

DL, p. 208

A merely creaturely or a merely divine process or reality explains nothing. The former has no principle of order, no directive to enable freedom to produce anything but meaningless chaos. The latter has no content; it is an empty power—to do what?

OO, p. 82

Life is full of choices between good things. . . . This conflict of positive values is at the root of both contingency and tragedy in existence.

CS, p. 311

Either God really does love all beings, that is, is related to them by a sympathetic union surpassing any human sympathy, or religion seems a vast fraud. . . . The future of theology depends, I suggest, above all upon the answer to this question: can technically precise terms be found which express the supremacy of God, among social beings, without contradicting his (her, its) social character?

DR, pp. 25–26

Either complete understanding is impossible, or an all-understanding being is eternally actual. Thus not all ideals can be reduced to the Deweyan formula: potential human achievements. It cannot be the goal of human endeavor to attain complete sympathy and appreciation of others, because such

attainment would contradict the condition of human life as such. But it is a very deep aspiration of men and women to be able to feel that they are now completely understood, not necessarily, indeed not possibly, by other human beings, but by someone.

BH, p. 47

The Ultimate loyalty is not to any human person, including oneself. Perhaps it is not even to the totality of mankind, still less to a nation, class, or party, but rather to that cosmic something or someone relation to which, or relation to whom, must ultimately embrace all *our values, and which or who is above our narrow prejudices, and stands for the truly common or universal good of all creatures. Without an aim beyond self, and even beyond any merely human good, life on this temporary planet seems as absurd as Sartre says it is.*

CS, p. 316

If anything important is known, I should think it is the appropriateness of love, or the transcendence of mere selfishness, as the ideal of action.

LP, p. 130

To be is to be contributory and to enjoy the contribution of others. *

[S]uccessful or true metaphysics expresses no illusion but a necessary or a priori truth, not in particular about "the world," but about reality as such, about any and all possibilities or conceivabilities for worlds or thinkable states of affairs. The belief in this necessary truth does not satisfy any particular wish, nor does it counter any particular fear, but rather it expresses common factors relevant to all possible wishes and all possible remedies for fear, against no matter what.

WM, pp. 63–64

A theistic philosophy must take 'create' or 'creator' as a universal category, rather than as applicable to God alone. It must distinguish supreme creativity from lesser forms and attribute some degree of creativity to all actuality. It must make of creativity a 'transcendental', the very essence of reality as self-surpassing process.

NT, p. 26

*Charles Hartshorne, "Man in Nature," in Irwin Lieb, ed., *Experience, Existence, and the Good: Essays in Honor of Paul Weiss* (Carbondale, Ill.: Southern Illinois University Press, 1961), p. 93.

I am deeply convinced that classical metaphysics mistranslated the essential religious issue by misdefining 'God'. It confused the divine fullness with an abstraction called 'the absolute' or the 'unmoved mover', or 'most real being'. None of these, I am persuaded, is genuinely worshipful. . . . I agree with one main conviction of current philosophizing, that people have been so eager to answer questions that they have failed to give proper heed to the way words are being used, and perhaps misused, in formulating these questions.

CS, p. 38

Psychicalism, I hold, is implicit in theism. If supreme reality is supreme mind or experience, lesser form of reality can only be lesser form of mind or experience. . . . The very concept of mere matter as a form of reality has no place in a theistic metaphysics (really, in any metaphysics).

CS, p. 143

The logic of ultimate contrasts is for me the logic of metaphysics. However, the truth that metaphysical concepts symmetrically require each other implies an asymmetrical consequence, which is that instantiations of only one of a polar pair include instantiations of the other. If there are both an abstract and a concrete entity, the former is real only in the latter, not vice versa. *

God may be wholly immutable, independent, and absolute in whatever senses it is good to be so, and uniquely mutable, dependent, and relative in whatever sense capacity to change, dependence, or relativity (as in sensitive sympathy) is an excellence. This is my doctrine of dual transcendence.

WM, p. 133

My basic conclusion from "Anselm's principle" is not that we certainly know the divine existence but that we can know, with reasonable certainty, that the only intelligible alternative to the divine existence is the divine impossibility, the incoherence of the idea itself. . . . The question of meaning is the entire question. In other words, the idea of divine existence is irreducibly metaphysical, transempirical. **

Those who want to go on being themselves forever and yet pass on to additional experiences after death are either asking for unbearable monotony,

*Lewis Hahn, ed., *The Philosophy of Charles Hartshorne* (LaSalle, Ill.: Open Court, 1991), p. 675.
**Ibid., p. 596.

endless reiteration of the same personality traits, or they are asking for a unique prerogative of God, ability to achieve self-identity through no matter how great and diverse changes and novelties. Unconsciously they either want to be bored to death, so to speak, or to be God.

OO, p. 35

Belief is a gift, a blessing, or an achievement, not a duty one can simply demand that all should perform. What may be a duty is that one should not "bar the path of inquiry" (Peirce), including inquiry into the pros as well as the cons of the metaphysical belief that is theism and into the relative merits of various formulations, new as well as old, of this belief.

CA, p. 283

What we need is to make a renewed attempt to worship the objective God, not our forefathers' doctrines about him.

DR, p. 148

CONTENTS

PREFACE

The idea of this book arose, according to my memory, exactly as Dr. Valady says it did. Our luncheon meetings were also his idea, and I recall no hesitation in agreeing. Long ago I learned that friendship is not a matter of being of the same country, or same native language, or same religion. It depends on the kind of family or small group one has grown up in, the particular school one has been taught by, the genes the two persons happen to have come by in the lottery of conception, and finally on the uses the two people and those around them have made of their bits of creative freedom moment by moment. I recall how in India the face and manner of the man chosen to meet us at a hotel in Varanesi told us almost instantaneously that we would be friends— and we were. Similar things happened in Taiwan, New Zealand, Australia, Germany, Japan. My wife and I made friends in nearly every country we visited, and they were numerous.

I deeply appreciate the generous effort Dr. Valady has made to produce this introduction to what I call neoclassical metaphysics, and its applications to several kinds of empirical topics. I have no criticism of his introduction or of his many questions in "Points of View: A Brisk Dialogue"; they seem to me invariably pertinent and models of clarity.

One criticism I make of my former self: this is that I now regret having for so long followed the routine practice of using the male gender in referring to deity, also in taking *man* as the name of the species. I became profeminist more than seven decades ago but began showing this linguistically less than two decades ago. I have tried to purify some of the offending passages.

Chapter 4, and the brief inclusion of section C in chapter 8, are my additions to his choice among my unpublished essays. Otherwise the book is as he planned it. Dr. Valady's term of editor for himself is modest indeed since without him nothing at all like this book would have existed. Others have understood my thought, but who else would, for so many years, have focused so sharply and adroitly on the task of enabling the philosophically concerned world to understand it by reading this single not very large book? In the history of philosophy I know of no other case of a young trained philosopher (trained in two cultures and expert in another, Sartre and French philosophy) so generously and brilliantly aiding an elderly one. In chapter 1, he formulates seventy some questions or critical comments on my thought, averaging about four lines of his own words per comment, sometimes with briefer quotations from my writings, and leaving me enough space for my seventy

replies. Not once did his formulations seem irrelevant, unintelligent, or unfair to me or anyone else. These facts seem to me, after my long experience with the difficulties of communication in philosophy, almost miraculous.

One more comment. The expressions of admiration in his foreword for me as a person and as a philosopher and scholar were new to me; in our oral discussions he never paid compliments. There was no need. The way his face lighted up each time we met, like the Hindu's smile in Varanesi, was quite enough. There are some people who know who they are and with whom they can be friends.

CHARLES HARTSHORNE

ABBREVIATIONS OF WORKS BY CHARLES HARTSHORNE

AD	=	*Anselm's Discovery*
AW	=	*Aquinas to Whitehead*
BH	=	*Beyond Humanism*
BS	=	*Born to Sing*
CA	=	*Creativity in American Philosophy*
CS	=	*Creative Synthesis and Philosophic Method*
DL	=	*The Darkness and the Light*
DR	=	*The Divine Relativity*
IO	=	*Insights and Oversights of Great Thinkers*
LP	=	*The Logic of Perfection*
MV	=	*Man's Vision of God*
NT	=	*A Natural Theology of Our Time*
OO	=	*Omnipotence and Other Theological Mistakes*
PP	=	*The Philosophy and Psychology of Sensation*
PS	=	*Philosophers Speak of God*
RS	=	*Reality as Social Process*
SC	=	*The Social Conception of the Universe*
WM	=	*Wisdom as Moderation*
WP	=	*Whitehead's Philosophy*
WV	=	*Whitehead's View of Reality*

EDITOR'S INTRODUCTION

> *On religion in particular the time appears to me to have come, when it is the duty of all who being qualified in point of knowledge, have on mature consideration satisfied themselves that the current opinions are not only false but hurtful, to make their dissent known; at least, if they are among those whose station or reputation gives their opinion a chance of being attended to.*
>
> J. S. Mill

In his career, which has spanned more than seven decades, Charles Hartshorne—the eminent living process philosopher—has made significant contributions to speculative philosophy, particularly to philosophical theology. The essays which comprise the present work are an indication of his vast learning and wide range of theoretical and empirical interests. With the exception of seven essays, "Points of View: A Brisk Dialogue," "Why Classical Theism Has Been Believed by So Many for So Long," "The Zero Fallacy in Philosophy: Accentuate the Positive," "Dreaming about Dreams: An Epistemological Inquiry," "The Kinds and Levels of Aesthetic Value," "Democracy and Religion," and "The True Physicalism" (section C of chapter 8), the remainder of the essays contained in this collection have previously been published. With the exception of chapter 6 ("What Metaphysics Is"), which is a shorter version of the original article, the remainder of the previously published articles included in this volume are reprinted with minor (largely stylistic) revisions made by Charles Hartshorne and the editor. As a selection of Hartshorne's sizable corpus,[1] this collection presents his reflections on several subjects, most notably the history of philosophy, philosophical psychology, philosophy of science, epistemology, ethics, aesthetics, literature, ornithology, and, above all, theology and metaphysics. My hope is that this collection can offer further insight into Hartshorne's philosophy for those already conversant with his ideas, as well as an accessible

1. For a comprehensive bibliography of Charles Hartshorne's writings up through 1990, see Lewis Hahn, ed., *The Philosophy of Charles Hartshorne* (LaSalle, Ill.: Open Court, 1991), pp. 735–66.

introduction for those who may not have studied Hartshorne's often intricate writings.

I

I first met Charles Hartshorne in the fall of 1985 at the University of Texas at Austin and enjoyed many conversations with him over lunch. We conversed about many philosophical topics, in addition to domestic and international issues that interested us both. It did not take me long to realize that some kind of documentation of my conversations with Hartshorne was in order. Having kept a list of the topics we had discussed, and to better enable Hartshorne to express his views, I decided to provide him with a set of questions (formulated based on my knowledge of his published works, which I had now studied extensively, as well as his remarks in person to me) to which he could reply at his leisure. Hartshorne graciously accepted my proposal; "Points of View: A Brisk Dialogue," in this volume, is the outcome of that project.

Four characteristics of Hartshorne's, namely, his admirable willingness to share his enormous learning with anyone, his amazing ability (given his advanced age) to sustain discussions of a highly speculative nature, his willingness to acknowledge ignorance, and his unpretentious manner, strike anyone who is acquainted with him. The first, third, and fourth traits just stated render Hartshorne a very special person and a unique intellectual. As for the second trait indicated, many would assume that a person of Hartshorne's age would scarcely be able to argue so rigorously or write so sensibly. The magnitude of Hartshorne's corpus is indeed enviable; but what is rare is his productivity as a scholar in his advanced age: since his eighty-fifth birthday he has published five books, has responded extensively to his critics in four separate volumes (which could easily comprise a good-sized book), and has published more than sixty essays and reviews. Approaching his centenarian mark, he is still an indefatigable scholar, laboring daily to expand his sizable corpus. And, what is more, he is still able to come up with new insights and clearer formulations of his lifelong theological and metaphysical beliefs. The untiring and ever-searching mind of Hartshorne is the best evidence that aging does not necessarily put an end to, or even diminish, the genius of a person.

If asked to summarize my appraisal of Hartshorne as a thinker in a sentence, I would say that perhaps more than any other American philosopher in the last seven decades, he has attempted to identify and subvert the philosophical biases shared by many people (including many a philosopher). In other words, the defining characteristic of Hartshorne's career has been his determination to liberate philosophers as well as laypersons from many long-standing ideas (prejudices) whose harm, he contends, has not been sufficiently appreciated.

(1) One prejudice that particularly permeated classical theism, and which Hartshorne has time and again criticized, is the prejudice in favor of one pole of ultimate contrasts. This prejudice accounts for classical theologians' seemingly one-sided views on God as utterly absolute, necessary, infinite, actual, and eternal, that is, a being devoid of relativity, contingency, finitude, and potentiality. In contrast to this conception of God, which actually amounted to an idolatry of empty abstractions (*OO*, p. 44), Hartshorne has defended what he has termed the doctrine of "dual transcendence," namely, a doctrine which defines God as *both* necessary and contingent, absolute and relative, and infinite and finite in *supremely unique and excellent ways:* In His/Her necessary, absolute, and infinite aspects God is unsurpassable even by himself/herself, but in His/Her contingent, relative, and finite aspects God is self-surpassed but not surpassable by others.

More than any other contemporary theologian, Hartshorne has underscored *divine relativity.* Contra classical theologians, God is the *uniquely, cosmically social being,* and as such relates to *all* creatures which are themselves through and through social. For Hartshorne, "to be and to enter into social relations are . . . inseparable."[2] All creatures exhibit relatedness or sociality understood as "appeal of life for life, of experience for experience."[3] God relates to the lowest level of being (singular or actual entities) *not* as supreme self-creativity to a created "stuff" bereft of self-creativity (experience, feeling) but to *self-creative* entities that enjoy some degree (however slight) of feeling (experience): "The effect must in some way express the nature of its cause. How can an infinitely creative being produce an *absolutely* noncreative being? That which is absolutely devoid of what God supremely possesses—what can it be but the zero of actual existence" (*CS*, p. 11).

(2) Hartshorne repeatedly criticizes the bias, due to "the perennial appeal of simplicity" (*IO*, p. 164), in favor of symmetry in metaphysics.[4] Many philosophers, he argues, fail to realize that "nonsymmetrical concepts are logically primary, and symmetrical concepts derivative" (*CS*, p. 226), which accounts for many metaphysical oversights: "I incline to believe that logicians will eventually . . . accept the theory of asymmetrical creativity as ultimate. But this acceptance, when and if it comes, will be a vast intellectual revolution whose consequences can only in part be foreseen" (*LP*, p. 185). The primacy of asymmetry (directional relations), for instance, is illustrated in knowledge. Knowing is a one-way dependence of the subject upon the object. The subject is intrinsically relative to the object: "It is knowing which

2. Charles Hartshorne, "Theological Values in Current Metaphysics," *The Journal of Religion* 26, no. 3 (July 1946): 162.
3. Charles Hartshorne, "A New Philosophic Conception of the Universe," *Hibbert Journal* 44, no. 1 (Oct. 1945): 17.
4. Lewis Hahn, ed., *The Philosophy of Charles Hartshorne*, p. 675.

relates itself to the known, not *vice versa*. Our knowing Plato relates us to Plato, not Plato to us. It is we, not Plato, who thereby acquires a relative property" (*CS*, p. 224).[5]

(3) Since, for Hartshorne, "every major mistake about God involves a mistake about human nature" (*OO*, p. 104; cf. *LP*, pp. 138–39), the classical idea of divine causal power could not but give rise to an erroneous anthropology which denied causal power to humans, let alone other creatures. And belief in freedom of *all* creatures, not merely human freedom, is for Hartshorne the acid test of any sound philosophical system: "God cannot choose a single creaturely act in its concreteness, for the simple reason that it would not then be a creaturely act" (*CS*, p. 138).[6] Unqualified determinism is a "metaphysical blunder" not required by either science or common sense (*CS*, p. 214): "the only world that makes sense religiously is one whose details are all, through and through, matters of chance" (*WM*, p. 86); "The details of what happens in the world are *unintended, even by God*" (*DL*, p. 96, emphasis is Hartshorne's). "I charge philosophers as a class," writes Hartshorne, "with having through the centuries been largely blind to several metaphysical truths, the recognition of which long ago might have saved us from our present danger; philosophers did not really and unambiguously believe in freedom of individuals; and they failed to think out the consequences of admitting the negative aspects of chance and risk inherent in that freedom."[7]

The so-called "problem of evil" is one consequence of failure to believe in creaturely freedom. Having interpreted the divine eminent power as monopoly on decision making, philosophers have then wondered how God in His/Her eminent goodness could allow evil to exist in the world. According to Hartshorne, once philosophers realize that God does not enjoy omnipotence as traditionally defined, they would be able to recognize that the "problem of evil" is but a pseudoproblem. Evil is an *inevitable* reality of this world (or any other world created by God) in that "evil springs from creaturely freedom, and without such freedom there would be no world at all."[8] Through the laws of nature the eminent power "guarantees a predominance of chances of good

5. Cf. Charles Hartshorne, "Categories, Transcendentals, and Creative Experiencing," *The Monist* 66, no. 3 (July, 1983): 319–35.

6. Cf. Charles Hartshorne, "A Metaphysics of Universal Freedom," in G. F. McLean and Hugo Meynell, eds., *The Nature of Metaphysical Knowledge* (Lanham, N.Y.; London: University Press of America, International Society for Metaphysics, 1988), pp. 69–75; and Charles Hartshorne, "Panpsychism: Mind as Sole Reality," *Ultimate Reality and Meaning* 1, no. 2 (1978): 115–29.

7. Lewis Hahn, ed., *The Philosophy of Charles Hartshorne*, p. 729.

8. Charles Hartshorne, "A New Look at the Problem of Evil," in Frederick C. Dommeyer, ed., *Current Philosophical Issues: Essays in Honor of Curt John Ducasse* (Springfield, Ill.: Charles Thomas Publisher, 1966), pp. 207–8.

over those of evil" in the world (*DL*, p. 208). God does not decree (nor can God foresee or prevent) any *particular* evil (cf. *DL*, p. 385). Particular evils stem from creaturely free decisions and their unavoidable conflict: "With a multiplicity of creative agents, some risk of conflict and suffering is inevitable. The source of evil is precisely this multiplicity. But it is equally the source of good. Risk and opportunity go together, not because God chooses to have it so, but because opportunity without risk is meaningless or contradictory" (*CS*, p. 238).

(4) Hartshorne has spent the most effort among contemporary theologians to subvert the classical theological concepts of omnipotence, omniscience, and perfection. "No worse falsehood was ever perpetrated than the traditional concept of omnipotence. It is a piece of unconscious blasphemy, condemning God to a dead world, probably not distinguishable from no world at all" (*OO*, p. 18).[9] To attribute omnipotence (as defined by classical theologians) to God is to attribute a *tyrant* conception of power to God who as such is rendered unworshipful. Moreover, "Our idea of decision, or of freedom, has to come from our own experience of deciding; and if we have no power of this kind how can we even form the idea of it in conceiving God as possessing a monopoly of the power?" (*IO*, p. 367). Divine power does not consist in deciding the creature's each and every decision or act: "Not a single act of a single creature has been or could have been simply decided by divine action" (*CS*, p. 239). In other words, God is 'all-powerful' not in the sense that there are no other free, decision-making agents capable of exercising power besides God in the world: "What then is adequacy of cosmic power? It is power to do for the cosmos (the field of divine social relationships) all desirable things that could be done and need be done by one universal or cosmic agent. Adequacy is *not* power to do for the cosmos things that could be done by nonuniversal agents. There are such things, and they are the free acts of localized beings, such as man" (*DR*, p. 134). God's supreme power, then, ensures an optimal order (via the laws of nature) in a world that consists of innumerable agents enjoying some degree of power:

> Then the cosmic order consists, not in a determination of all events just as they occur, but in the setting of limits to the self-determination inherent in each event. Order is thus the limit imposed upon chaos. It is not the alternative to or

9. Cf. *WM*, pp. 53–54: "I consider this idea of a single all-determining power to be as devoid of philosophical as it is of scientific merit. Theology should have nothing to do with it. For it means that the only real freedom is divine, that even man is like a puppet in the hands of God. If the puppet praises God, this is merely God praising God. If the puppet disobeys God, this is God disobeying God. We may well leave such nonsense to those of our ancestors who managed to come to terms with it." In *OO*, Hartshorne even goes so far as stating that "the word [omnipotence] has been so fearfully misdefined, and has so catastrophically misled so many thinkers, that I incline to say that the word itself had better be dropped" (p. 26).

the absence of chaos but its qualification as limited or partial, rather than absolute or pure, chaos. . . . God's power cannot be exercised upon nonentity or upon the powerless but only upon lesser powers. 'Being is power' (Plato); if there are beings besides God, there are powers other than the divine. If God is supremely free, then men also are free in some measure and even in relation to God. God cannot absolutely determine what his creatures do; for then they would not exist as creatures, and he would not exist as ruler of creatures or as actual creator. (*PS*, p. 436; cf. *NT*, p. 120)

According to Hartshorne, divine omniscience does not imply that God infallibly knows all truths about the future in the same sense that He/She does about the past. Rather, there is growth in God's knowledge, in the sense that as new actualities are produced, God comes to know those actualities. To assert that God's ideal (infallible) knowledge covers *both* past and future actualities is to destroy the contrast between past and future as well as the contrast between actual and potential (*WM*, p. 28): "As the Socinians said, once for all, future events, events that have not yet happened, are not there to be known, and the claim to know them could only be false. *God does not already or eternally know what we do tomorrow, for, until we decide, there are no such entities as our tomorrow's decisions*" (*OO*, pp. 38–39, emphasis is Hartshorne's).

Hartshorne is equally against the traditional idea of divine perfection which implied that God could not be excelled in any fashion whatsoever, inasmuch as for any being (including God) to change indicated a weakness or imperfection in that being. But, for Hartshorne, a being unchangeable/unsurpassable in *every* respect whatsoever is not conceivable. God is unsurpassable both by others and by Himself/Herself only in His/Her abstract attributes, e.g., goodness and wisdom. But God is self-surpassing in His/Her aesthetic appreciation of the world, for "*An absolute maximum of beauty is a meaningless idea.* . . . Either God lacks any aesthetic sense and then we surpass God in that respect, or there is no upper limit to the divine enjoyment of the beauty of the world" (*OO*, p. 10, emphasis is Hartshorne's). Hartshorne rejects "purely one-way relation between creator and creature," (*SC*, p. 63), that is, a relation where the latter contributes nothing to the life of the former.[10] Rather, creatures are "humble cocreators with God and for God."[11] God is dependent on creatures in that the latter contribute to His/Her aesthetic self-surpassing: "[o]ur decisions decide something for God, enrich the divine life, give God actual value that was *previously* unactual. . . . And this for me is the point of

10. Lewis Hahn, ed., *The Philosophy of Charles Hartshorne,* p. 672: "My sharpest objection to classical theism is its making God the giver of everything and recipient of nothing."
11. Charles Hartshorne, "Scientific and Religious Aspects of Bioethics," in E. E. Shelp, ed., *Theology and Bioethics* (Dordrecht, Boston, Lancaster, Tokyo: D. Reidel Publishing Company, 1985), p. 30.

religion, that we contribute to God's consequent reality."[12] The Hartshornian deity, in short, is a deity that "can be endlessly enriched aesthetically" (*CS*, p. 310). One has no way of deciding or knowing what God's aesthetic appreciation of one's aesthetic experience of Mozart will be; but it is nevertheless the case that God will become aesthetically enriched via one's unique appreciation of Mozart.

(5) Many philosophers and nonphilosophers have been overfascinated with "dichotomous thinking" or "false simplicities."[13] Witness the popularity of both radical monism and radical pluralism (*WM*, p. 6). Sound metaphysics, according to Hartshorne, is not possible unless we practice "the principle of moderation," i.e., that truth lies somewhere between doctrinal extremes (*WM*, pp. 1–13). In Hartshorne's view, both unqualified determinism and indeterminism are extreme doctrines which misrepresent the world. The former doctrine denies the reality of independence/disorder while the latter commits the equally erroneous mistake of denying dependence/order. The moderate view (*relative* determinism or indeterminism) acknowledges the reality of both causality (dependence/order) and freedom (independence/disorder). All events are caused; but to say so does not imply that an event is strictly deducible from its antecedent cause(s): "Each event is a determinate, but not antecedently determined or predictable, act of concretion, endowed with its proportional spontaneity or possibility of partial self-determination" (*LP*, p. 183); "A free act is the resolution of an uncertainty inherent in the totality of the influences to which the act is subject. The conditions decide what can be done and cannot; but what is done is always more determinate than merely what can be done" (*LP*, p. 231).

(6) Hartshorne has repeatedly questioned the validity of what is known as the self-interest theory of human motivation (see chapter 12 in this volume). The theory basically states that altruistic human behavior is ultimately motivated by the promise of future rewards for one's own self. That is, altruism can be explained in terms of self-interest. According to Hartshorne, the self-interest theory presupposes a strict identity between the self-now and the self-future. Hartshorne questions the soundness of this presupposition and holds that both personal identity and nonidentity between persons are partial (*OO*, chap. 4). My interest in my future self, strictly speaking, is interest in "another self": "In the last analysis all relation is other-relation" (*DL*, p. 7).[14] In a word, self-interest presupposes altruism. What mankind needs to avoid is

12. John B. Cobb and Franklin I. Gamwell, eds., *Existence and Actuality: Conversations with Charles Hartshorne* (Chicago: University of Chicago Press, 1984), p. 75.

13. Lewis Hahn, ed., *The Philosophy of Charles Hartshorne*, pp. 685, 723.

14. Cf. Charles Hartshorne, "Science as the Search for the Hidden Beauty of the World," in Deane W. Curtin, ed., *The Aesthetic Dimension of Science* (New York: Philosophical Library, 1980), p. 101. See also *BH*, pp. 155–56; *CA*, pp. 225, 231; and *LP*, p. 17.

the 'mental cramp' of strict self-identity (*DL,* p. 6): "By de-absolutizing self-identity, one opens the way to an ethically valuable de-absolutizing of non-identity of self with others" (*LP,* p. 18). What Hartshorne has attempted, then, is to show that "self-interest has no privileged metaphysical basis whatever" (*CS,* p. 191; cf. *OO,* p. 124), and that what really "needs to be enlightened is not *self*-interest, but simply interest in, concern for, those selves with which we have to do and which we can influence or help—as the scriptures have it, ourselves and our neighbors" (*WM,* p. 19).[15]

(7) Hartshorne has argued against the idea of "a mere spectator God" who is not affected by creaturely joy or suffering (*CS,* p. 263). Classical theologians, according to Hartshorne, in their zealous drive to purify deity of all popular anthropomorphic attributes actually conceived of deity as a being that *feels nothing.* What this also denied was the idea of receptivity, dependence, passivity, and relatedness in God (*WM,* p. 92): "A strong prejudice governed both philosophy and theology for two thousand years. This was the supposition that, to conceive the highest being, we must maximize in conception the aspect of giving, but minimize that of receiving, maximize activity but minimize passivity, maximize unity but minimize variety, maximize permanence but minimize achievement of the new."[16] But God is "the most irresistible of influences precisely because he is himself *the most open to influence*" (*DR,* xvii, emphasis added).[17] Divine dependence is "sympathetic dependence," that is, "an omniscient sympathy, which depends upon and is exactly colored by every nuance of joy or sorrow everywhere in the world" (*DR,* p. 48).

God, Hartshorne agrees with Whitehead, is "the fellow sufferer who understands," a being who because of His/Her adequate prehensions feels the feelings of *all* creatures. There is tragedy in God in the sense that God, as a being who is related to all and influenced by all, feels creaturely sufferings (*CS,* p. 241): "To say, 'God suffers' is to speak analogically; to say, God has all suffering as intrinsic to his own reality, is to speak literally."[18] To love God

15. Cf. Charles Hartshorne, "Ethics and the Process of Living," in Jorge J. E. Gracia, ed., *Philosophical Essays in Honor of Risieri Frondizi* (Rio Piedras, Puerto Rico: Editorial Universitaria, 1980), pp. 191–202; and "A Dual Theory of Theological Analogy," in W. Creighton Peden and Larry E. Axel, eds., *God, Values, and Empiricism: Issues in Philosophical Theology* (Macon, Ga.: Mercer University Press, 1989), pp. 88–89.

16. Charles Hartshorne, "Theological Values in Current Metaphysics," *The Journal of Religion* 26, no. 3 (July 1946): 163.

17. Cf. *CA,* p. 112: "since to prehend something is to be influenced or conditioned by it, not only is God open to influence ... but also God is the most universally open to influence of all beings."

18. Charles Hartshorne, "The Idea of God—Literal Or Analogical?" *The Christian Scholar* 9, no. 4 (June 1956): 135.

not only requires that one loves others, but also, and equally important, that one loves oneself. Hartshorne avers (see chapter 12 in this volume) that one has an obligation to promote one's own happiness; this obligation, in the last analysis, is due to the fact that "our avoidance of suffering for ourselves spares God the tragic participation in that suffering which his unlimited sympathy would involve, should the suffering occur" (*RS*, p. 194).

II

Hartshorne may at times appear as excessively polemical as those whom he criticizes, but that is perhaps unavoidable when one realizes that Hartshorne had to disturb the dogmatic slumber of not a few theologians and philosophers. Or one may get the impression that Hartshorne has exaggerated the significance of certain contemporary philosophers, particularly Peirce, Whitehead, Popper, and Bergson, or certain religious traditions such as Buddhism and Socinianism. The fact is that as Hartshorne finds sparks of God in all things, he also finds sparks of intelligibility and truth in many schools of thought. He does not hesitate to embrace ideas originated in various authors and traditions, but his relationship vis à vis the very authors or traditions that he admires is undoubtedly one of *critical dialogue.* As his replies to my questions in "Points of View: A Brisk Dialogue" (chapter 1 of this volume) reveal, his philosophical heroes (e.g., Peirce) are not revered uncritically, for Hartshorne is *no one's* uncritical disciple;[19] his philosophy has its own distinct identity, which is to say that it is *not* reducible to any *single* philosophical or theological tradition. Accordingly, he is correct when he claims that "my thinking is my own" (*CA, xiii*).[20]

Hartshorne scholars have mostly, and not altogether unjustifiably, underscored his affinities with and differences from philosophers such as Whitehead, Peirce, and James, while insufficient attention, in my view, has been paid to commonalities between Hartshorne and non-American philosophers such as Bergson, Berdyaev, and Popper. In *The Philosophy of Charles Hartshorne,* for example, surprisingly no essay is devoted to a study of Hartshorne's philosophy vis à vis the philosophies of Bergson, Berdyaev, and Popper, despite the fact that Hartshorne acknowledges many commonalities

19. Hartshorne has observed that his "primary aim has always been to arrive at *truth* through Whitehead, or to make truth accessible to others through him, more than to ascertain or communicate the truth about Whitehead." See his *Whitehead's Philosophy: Selected Essays, 1935–1970* (Lincoln, Neb.: University of Nebraska Press, 1972), p. 3, emphasis added. Cf. Lewis Ford, "Hartshorne's Interpretation of Whitehead," in Lewis E. Hahn, ed., *The Philosophy of Charles Hartshorne,* p. 313.

20. Cf. Andrew J. Reck, "Hartshorne's Place in the History of Philosophy," *Tulane Studies in Philosophy* 34 (1986): 18; and John B. Cobb, "The Philosophy of Charles Hartshorne," *Process Studies* 21, no. 2 (summer 1992): 78.

with these philosophers.[21] Hartshorne, for example, has on several occasions described Karl Popper as the pre-eminent philosopher of our time, some of whose seminal ideas he has incorporated into his own philosophy: "The best claim among the living to philosophical greatness that I see is Sir Karl Popper's. He has shed a flood of light on many subjects. He was the first to make sharply the most useful distinction between empirical or contingent and metaphysical or necessary truths: that the former would be contradicted by *some conceivable observations* whereas the latter are compatible with *any conceivable observations*. I make a few revisions in this but am largely in agreement with it and regard it as epoch making" (*DL,* p. 382).[22]

"I am systematically non-extremist," said Hartshorne in a conference held in his honor in 1981.[23] He sincerely attempts to remain faithful to the maxim that wisdom consists in moderation, but does he always succeed? Here I contend that as much as Hartshorne has advocated nonextremism in philosophy, his belief in the centrality of theism and his apparent equation of philosophy with theology would perhaps strike many as extreme: "Philosophy as a non-empirical study has no other subject-matter [but God]" (*LP,* p. 132); "The theistic question . . . is not one more question, even the most important one. It is . . . the sole question" (*LP,* p. 131); "the whole content of metaphysics must be contained in the theory of deity" (*CS,* p. 39). But though one may not share Hartshorne's apparent reduction of philosophy to theology, his neoclassical theology provides a more viable conception of the deity, and is surely less repugnant to the atheists than classical theology. In classical theology with its highly problematic concepts of omnipotence, omniscience, and perfection, as Hartshorne rightly points out, "God is exalted by degrading the creatures" (*WM,* p. 26). His own theology, it can be said, is an attempt to restore dignity both to God and the creatures, where the latter are not mere puppets, and the former is no longer portrayed as an unfeeling, monopolistic, and therefore *unworshipful* being.

To be sure, not a few contemporary students of philosophy may not be as convinced as Hartshorne that theism, "fully thought out . . . is the most coherent of all explicit world views" (*LP,* p. 126). But I contend that if and only if one is to believe in a deity, then Hartshorne's deity, to whose *actuality*

21. Charles Hartshorne, "Bergson's Aesthetic Creationism Compared to Whitehead," in Andrew Papanicolaou and Pete Gunter, *Bergson and Modern Thought: Towards a Unified Science* (New York: Harwood Academic Publishers, 1987), pp. 369–82. See also Charles Hartshorne, "Charles Hartshorne on Metaphilosophy, Person and Immortality, and Other Issues," *Process Studies* 19, no. 4 (winter 1990): 256–77.

22. Cf. Hartshorne's remarks on Popper in "Points of View: A Brisk Dialogue," chapter 1 of this volume, and *IO,* pp. 306, 373.

23. John B. Cobb and Franklin I. Gamwell, *Existence and Actuality: Conversations with Charles Hartshorne,* p. 69.

all creatures contribute,[24] is one of the more viable ones. "A future age,"
writes James P. Devlin, "may well inherit, chiefly from him [i.e., Hartshorne],
a conception of deity that does not make a fool of every believer."[25] But the
coherence of his neoclassical conception of deity aside,[26] consider the ethical
implications of the following statements by Hartshorne and the difference
that their wholehearted acceptance *could* make in our lives: "Cruelty to other
creatures, or to oneself, means contributing to vicarious divine suffering"
(*OO*, p. 28); "Hurt me and you hurt God" (*WM*, p. 23);[27] "The ultimate ideal
of knowledge and action remains this: to deal with the world as the body of a
God of love" (*BH*, p. 315). If humans truly believed that by harming any sen-
tient being they would indeed harm God, and if they sincerely viewed the
cosmos as the divine body, what positive change(s) could not this bring about

24. Divine actuality vs. divine existence is a pivotal distinction in Hartshorne's
neoclassical theism (cf. *NT*, pp. 123–24). All actuality, including divine actuality, is
contingent; but divine existence, unlike creaturely existence, is necessary (cf. *CS*, pp.
150–51). According to Hartshorne, even Anselm (1033–1109), who rightly argued that
necessary existence is deducible from the very definition (essence) of God, failed to
realize that *not* everything in God is necessary (cf. *IO*, pp. 93–103): "Anselm's argu-
ment can be rescued from what I call the 'Findlay paradox' only if it be conceded that
while the bare necessary truth that divinity exists is exceedingly abstract (and only for
this reason can it be necessary), the full truth about God is concrete and contingent.
An essence exists if and only if it is actualized or concretized *somehow*, in some con-
crete form; but just *how*, in what concrete form is what I call the 'actuality' of exis-
tence. . . . The latter, the how of concrete realization, *never* follows from essence,
even when, as in the divine case, the bare existence, the 'somehow' realized, does fol-
low" (*WM*, p. 80).
25. James P. Devlin, "Hartshorne's Metaphysical Asymmetry," in Lewis Hahn,
ed., *The Philosophy of Charles Hartshorne*, p. 275.
26. Hartshorne is not oblivious to a serious challenge posed to his neoclassical
theism by relativity physics, namely (to quote Hartshorne himself) "how God as pre-
hending, caring for, sensitive to, the creatures is to be conceived, given the current
non-Newtonian idea of physical relativity, according to which there is apparently no
unique cosmic present or unambiguous simultaneity." See Lewis Hahn, ed., *The Phi-
losophy of Charles Hartshorne*, p. 616; see also p. 642. Cf. *NT*, pp. 93–94; *CS*, pp.
291–92; and John B. Cobb and Franklin I. Gramwell, eds., *Existence and Actuality:
Conversations with Charles Hartshorne*, p. 75. The aforementioned challenge, as
Donald W. Viney argues, raises a further question: "If physics and metaphysics are, as
Hartshorne maintains, autonomous disciplines, why is there an apparent conflict
between relativity theory and neoclassical theism? . . . The very idea that a theory in
physics could either pose a threat to, or vindicate, Hartshorne's theism suggests that
there is a more intimate relationship between metaphysical and the empirical science
than Hartshorne is willing to allow." See Donald W. Viney, *Charles Hartshorne
and the Existence of God* (Albany, N.Y.: State University of New York Press, 1985),
p. 137.
27. Cf. Charles Hartshorne, "Tragic and Sublime Aspects of Christian Love,"
Journal of Liberal Religion 8, no. 1: 36–44.

in their everyday decisions with regard to their fellow beings, other animals, and the entire ecosystem?[28]

Hartshorne has at times been accused of irreverence toward the medieval tradition and the Bible. That he does not think very highly of Thomas Aquinas or the Book of Revelation, for example, is common knowledge: "the Book of Revelation has no place in the Bible—it's a mess. It's rotten. It's not Christian at all, and it's not good for anything."[29] "We theists," Hartshorne has said, "can scarcely doubt that the primary theoretical enemy is in our own ranks" (*LP*, p. 129; cf. *IO*, p. 242). Or as he says in conversation, speaking of medieval theologians and religious fundamentalists, "With friends like these, God does not need enemies!" What Hartshorne has done in his theology, then, is to put limits on divine omnipotence and omniscience in order to make room for creaturely freedom. However, he has no illusions about human nature. According to Hartshorne, atheists and humanists are alike in that they unduly exalt the human animal. His portrayal of humanity is indeed nonextremist. While Hartshorne emphasizes the constructive dimension of man, he never fails to underscore his capacity to do harm on a large scale: "The plain truth is that man is now by far his own worst enemy, or even his only serious enemy" (*LP*, pp. 299–300); "Man is a destructive creature indeed, compared with whom all other animals are gentle and harmless" (*LP*, p. 13); "Not non-human nature is ethically horrible—human nature is" (*DL*, p. 152).

The destructive capacities and moral shortcomings of humans are again and again underlined in Hartshorne's more recent works. Here a comparison between Hartshorne and the Karl Popper of "A History of Our Time: An Optimist's View" would be helpful. Popper states that, unlike Bertrand Russell and others who believe that "our intellectual development has outrun our moral development," that is, that "we are clever, perhaps too clever, but we are also wicked; and this mixture of cleverness and wickedness lies at the root of our troubles," he would contend that "We are good, perhaps a little too good, but we are also a little stupid; and it is this mixture of goodness and stupidity which lies at the root of our troubles." "The main troubles of our

28. Cf. William L. Reese, "The 'Trouble' With Pantheism—and the Divine Event," in Lewis Hahn, ed., *The Philosophy of Charles Hartshorne,* p. 195. See also H. Tristram Engelhardt, Jr., "Natural Theology and Bioethics," in Lewis Hahn, ed., *The Philosophy of Charles Hartshorne,* p. 164: "Since Hartshorne's arguments regarding divine relativity and sympathy lead us to conclude that the Deity depends on us and suffers and experiences with us, choices made in terms of what is morally right or wrong in the sense of violating rights or fulfilling obligations to other finite entities can be supplemented when they would otherwise be inconclusive. The character of one's life singly and with others can also be judged in terms of its contribution to the life of God."

29. Charles Hartshorne, "Charles Hartshorne on Metaphilosophy, Person and Immortality, and Other Issues," p. 276.

time," Popper goes on to say, "are not due to our moral wickedness, but, on the contrary, due to our often misguided moral enthusiasm" which makes us prone to be manipulated by demagogues.[30] Now, Hartshorne does not deny that contemporary humans at times suffer from "misguided moral enthusiasm," but he would concur with Russell that not a few humans' moral development patently lags behind their enormous intellectual-material achievements.

"We need an ethics," Hartshorne writes, "that takes our crowded, pollution-and-annihilation-threatened world realistically" (WM, p. 49). Uncaring as many individuals are about the ills of their society, they are even more insensitive toward the predicaments of other nations and peoples. The fundamental cause of this egocentricity is "the extreme individualism of Western metaphysics" (WM, p. 46; cf. LP, p. 15). Hartshorne goes on to say: "Egocentricity is an illusion pervading our lives, but we know that it is an illusion" (OO, p. 124). However, influenced for so long as many Westerners have been by the self-interest theory of motivation—and given the ethos of selfishness that permeates many Western societies—one wonders whether they could really be aware of their egocentricity, let alone realize its illusory nature. Hartshorne calls for taking "our ethical responsibilities toward less powerful people seriously" (LP, p. 320), for curbing "our appetite for luxuries," and, above all, for an ethics of companionship and love, i.e., a fundamental revision of our attitudes toward nature and other humans.

Aware though Hartshorne is of "something deeply tragic in the world" (LP, p. 13), unlike Schopenhauer, he believes that "life in general is basically happy. . . . [S]uffering is secondary and satisfaction primary in the lives of creatures" (WM, p. 56). Time and again, Hartshorne states that life is not absurd.[31] That life is not absurd, is not because our contribution to human posterity will ensure our social immortality or because our present existence is a bridge to an everlasting life in heaven.[32] The doctrine of heaven and hell, Hartshorne often repeats, is "a colossal error and one of the most dangerous that ever occurred to the human mind" (LP, p. 254), hence his unpopularity among religious fundamentalists. The nontheistic conception

30. See Karl Popper, Conjectures and Refutations (London: Routledge and Kegan Paul, 1963), pp. 365–66.

31. Cf. Lewis Hahn, ed., The Philosophy of Charles Hartshorne, p. 688: "the declaration of totally hopeless despair cannot express life and is an existential contradiction of thought with the thinker's very life." See also IO, pp. 335–36.

32. Cf. LP, p. 254: "And there will be no such thing as our feeling (with a feeling we lacked while on earth) pain or sorrow as punishment for misdeeds, or bliss as reward for good ones. The time and place to look for the rewards of virtue is now and here. If you cannot on earth find good in being good and ill in being or doing ill, then I doubt whether you will find it in any heaven or hell." See also NT, pp. 107–11.

of social immortality, though not as problematic as the doctrine of heaven and hell, is also ruled out as a cogent answer to the question of meaning in life (Cf. *NT,* p. 57). The sole satisfactory doctrine, therefore, is Whitehead's doctrine of "objective immortality of the past," i.e., that one's experiences are imperishable in "the consequent nature of God": "In short, our adequate immortality can only be God's omniscience of us. He to whom all hearts are open remains evermore open to any heart that ever has been apparent to him."[33] Life's aim, thus, is to enrich life and contribute beauty to further life, ultimately and all-inclusively to divine life, which alone can enjoy the total beauty of the entire creation. Hence, the Hartshornian categorical imperative might be: Realize (or facilitate the realization of) those values which you would want to see as part of the inclusive value (i.e., God). "I hold that if we could not influence God," he notes, "our existence would be simply vain."[34]

As arguably one of the most prominent metaphysicians of the last seven decades, Hartshorne has argued for the *necessity* and *vitality* of metaphysics. Acknowledging that "Ours is a somewhat antimetaphysical culture" (*CA,* p. 256), he still contends that "even if it [i.e., the renunciation of metaphysics] is culturally viable I fail to see that it represents our best or most intelligent option" (*CA,* p. 255). He ardently avers that metaphysics as a body of *necessary* truths that "no experience can contradict . . . , but . . . that any experience must illustrate" (*LP,* p. 285) is unavoidable. "Why should we give up," asks Hartshorne, "all efforts to satisfy such *natural curiosity* as that about the eternal or necessary aspects of reality, in contrast and reaction to which the contingent and emergent aspects *alone* have their full sense and definition?" (*CA,* p. 255, emphasis added). So much bad classical metaphysics, according to Hartshorne, is responsible for the antimetaphysical attitude of certain contemporary scholars (e.g., Morris Lazerowitz), as so much bad theology has led many intelligent women and men to adhere to atheism. The failure of classical metaphysics was not caused by the fact that it was metaphysics, but rather because classical metaphysics suffered from several handicaps and biases (e.g., bias against contingency and becoming) which ruled out the construction of any viable system of necessary truths. Besides emphasizing that metaphysics has a proper task, Hartshorne underscores two further points: (1) that metaphysics is essentially theistic, or as he puts it, "Metaphysics without God outdoes Hamlet without Hamlet" (*WM,* p. 66); and (2) that

33. Charles Hartshorne, "Time, Death, and Eternal Life," *The Journal of Religion* 32, no. 2 (April 1952): 101. Cf. Lewis Hahn, ed., *The Philosophy of Charles Hartshorne,* p. 662; and *WM,* pp. 61–62.

34. Charles Hartshorne, "Marcel on God and Causality," in Paul A. Schlipp and Lewis E. Hahn, eds., *The Philosophy of Gabriel Marcel* (LaSalle, Ill.: Open Court, 1984), p. 360.

metaphysics's task involves assisting humanity in its attempt to avoid annihilation in the contemporary world. "Probably the most important function of metaphysics . . . is to help in whatever way it can to enlighten and encourage man in his agonizing political and religious predicaments" (*CS*, p. 55). Hartshorne is reiterating the same conviction when, discussing Richard Rorty's 'mirrorless philosophy', he writes:

> My ethics, which has a metaphysical aspect, tells me that, despite these awful dangers [of contemporary warfare], we are obliged to do the best we can with a situation one would not have chosen to be in, but which has been brought about by freedom, the source of both good and evil. There seems no way in which giving up the metaphysical quest would lessen the dangers and some possibility that pursuing the quest would increase our powers to avoid them. (*CA*, p. 263)

To be able to offer an evaluation of the *totality* of the history of philosophy requires a learning of unusual magnitude; small wonder that few philosophers have been able to accomplish such a daunting task. In many of his writings, Hartshorne has undertaken an interpretation of the history of philosophy that both reveals his substantial learning in the philosophical tradition and a not-too-common approach to the ideas of the past and contemporary thinkers. Hartshorne contends: (1) the historian of philosophy should not be exclusively concerned with those philosophies (or philosophers) that have enjoyed immense influence. The fact of influence is not necessarily proof of soundness: "What is important is *why* [an idea] was held, and whether the supposed reason stands up in the light of our knowledge today" (*IO*, p. 5); (2) past histories of philosophy have not been sufficiently analytic, i.e., we have been offered accounts of philosophical *systems* and told to choose between them: "Each philosophy has been presented en bloc, as though it were a biological organism, with all prominent elements interdependent and equally important" (*IO*, p. 3; cf. *DL*, p. 391). What we need, rather, is a history of philosophical *problems* and the "doctrinal possibilities" concerning each problem. The history of philosophy should be conceived as "a treasure house of *suggestions* for possible views and possible arguments" (*IO*, p. 8); (3) "What we need is a more *philosophical* history of philosophy than we have now." The historian of philosophy should have a "touchstone," "a clue as to where the truth might lie" (*IO*, p. 7). That is, the historian of philosophy should not merely *describe* what has been thought, we also need to know "what the historian thinks about what has been thought" (*IO*, p. 3).

Hartshorne has been quite outspoken in his critical appraisal of many philosophers and philosophical traditions in at least two books and many articles. One, of course, may not always agree with his assertions regarding the alleged oversights of certain philosophers (e.g., Kant, Hegel, or Aristotle), but one cannot deny that his assertions provoke much thought, exhibit his uncommon historical erudition, and make it abundantly clear as to where exactly he stands on many cardinal philosophical issues.

In addition to proposing a different approach to the history of philoso-
phy, Hartshorne declines to view this history as one of progressive decline. In
particular, he rejects Heidegger's narration of the history of philosophy back-
ward, that is, Heidegger's contention that after the pre-Socratics the history of
philosophy has been essentially a history of failure, i.e., forgetfulness of
Being. "The history of philosophy," Hartshorne argues, "should be viewed as
exhibiting progress but also regression" (*IO*, p. xv). And if the antispeculative
thinkers of our era cannot observe progress in philosophy, it is primarily due
to their ignorance of the ideas of the major representatives of Anglo-Ameri-
can thought in this century, notably James, Whitehead, and Peirce. What the
history of philosophy provides *is not* just "a family romance involving, e.g.,
Father Parmenides, honest old Uncle Kant, and bad brother Derrida."[35] Con-
tra deconstructionism (Rorty, Derrida) philosophy *is not* merely "a kind of
writing."[36] For Hartshorne, philosophy is about a reality outside of the text,
and "in some respects at least we come closer to the truth than our forerun-
ners and at least mitigate the distortions, exaggerations, one-sidednesses, of
the traditional array of doctrines. . . . Every great philosopher sees some
aspect of reality more clearly than those before him have done, though he
may make his own mistakes as well" (*IO*, p. xvi).

III

"What is the use of studying philosophy," Wittgenstein once wrote, "if all it
does for you is to enable you to talk with some plausibility about some
abstruse questions of logic, etc., and if it does not improve your thinking
about the important questions of everyday life."[37] Similarly, Hartshorne has
charged writers like Rorty with being "overconcerned about problems invent-
ed by philosophers and too little concerned about problems of human beings"
(*CA*, p. 257).[38] The problems of death, tragedy, and evil aside, humans have
also been preoccupied with issues such as justice, utopia, democracy, racism,

35. Richard Rorty, "Philosophy as a Kind of Writing: An Essay On Derrida,"
New Literary History 10, no. 1: 143.

36. Even in deconstructionism, Hartshorne finds a glimpse of truth: "the decon-
structionists are partly right in holding that we cannot discern a clear and genuine dis-
tinction (yet also a correlation) between language and what language is about: the
world that we experience. Deconstructionists themselves admit that the language they
use in talking about language must itself be deconstructed, or is itself open to the same
caveat. Hence what they claim is not the whole truth, even about language." See Lewis
Hahn, ed., *The Philosophy of Charles Hartshorne*, p. 714.

37. Ludwig Wittgenstein in a letter to Norman Malcolm, quoted in N. Malcolm,
Ludwig Wittgenstein: A Memoir (London: Oxford University Press, 1958), p. 39.

38. Cf. Charles Hartshorne, "Rorty's Pragmatism and Farewell to the Age of
Faith and Enlightenment," in Herman Saatkamp, ed., *Rorty and Pragmatism*
(Nashville and London: Vanderbilt University Press, 1995), pp. 16–28.

etc. Particularly in his later works, Hartshorne has been concerned with the aforementioned issues.[39] He is no expert on political philosophy and has even explicitly stated that "If it were not a civic duty, I would scarcely try to judge political issues. Most metaphysical puzzles seem to me easy by comparison" (*DL*, p. 15). Throughout his career, Hartshorne has always been torn between the so-called socialist planning and capitalist free enterprise (*DL*, p. 168). The former, he has argued, places "excessive limitations upon chance-spontaneity of the many, and . . . seems to ask both too much and too little of human love."[40] The latter, on the other hand, is vitiated by at least two "metaphysical deficiencies," inasmuch as "it toys with the idea of an invisible hand which always and infallibly brings beneficent results out of individual motivation and . . . with the idea that human beings should resign themselves to being, outside of family relations, simply selfish and calculating, rather than beings whose core is love or social solidarity."[41] In short, "Blanket socialistic or anti-socialistic dogmas are pseudo absolutes." What we badly need is a system of *moderate* planning where "the ultimate factors of chance and love [are] in correct mutual adjustment."[42] The fall of socialism in Eastern Europe and the Soviet Union, Hartshorne would argue, confirms his view that utopia is an impossible dream, a dream based on the bias that "life could be completely non-tragic, harmless but beautiful, devoid of conflict but full of vitality."[43]

Hartshorne is frequently annoyed by what he regards as the maxim of American culture, that is, that the bigger something is the better it is, and by the vast economic inequality notable in many countries, including the U.S. As far as the latter problem is concerned, its solution definitely does not consist in will-to-luxury for all. Hartshorne speaks favorably of Martin L. Weitzman's idea of "share economy" or Mortimer Adler's "universal capitalism" as alternatives to the current economic system (*WM*, pp. 36–37). The reform of contemporary society in many of its aspects is immensely vital for the future of mankind: "without reform not only do we not move closer to heaven but we do move closer to hell" (*WM*, p. 152). This reform, among other things, must include: (1) a change in our naive view of science as that which necessarily enlarges mankind's power to do good, overlooking the fact that science can equally increase mankind's power to do evil to an unprecedented degree;

39. For a discussion of Hartshorne's political philosophy, see Randall C. Morris, *Process Philosophy and Political Ideology* (Albany, N.Y.: State University of New York Press, 1991).

40. Charles Hartshorne, "Chance, Love, Incompatibility," *The Philosophical Review* 58, no. 5 (Sept. 1949): 449.

41. Ibid, p. 448.

42. Ibid, p. 449.

43. Charles Hartshorne, "Philosophy After 50 Years," in Peter A. Bertocci, ed., *Mid-Twentieth Century American Philosophy: Personal Statements* (New York: Humanities Press, 1974), p. 151.

(2) besides measures to curb population growth, decrease harm to the ecosystem, and to end the arms race, we need to adopt policies which would narrow the gap "between those with subhuman status and near zero participation in wealth and power and those with vast extravagances and wielding immense power" (*WM,* p. 37);[44] (3) we need to strive for an education which promotes the virtue of charity both in its economic and intellectual aspects, because voluntary renunciation of wealth is a must if inequality (between classes and nations) is to be reduced at all: "Today we simply have to take our ethical responsibilities toward less powerful peoples seriously, for local affairs now immediately become world affairs" (*LP,* p. 320); and (4) we must forego the self-serving belief that we are God's "chosen" race or that we enjoy the only infallible book about the deity: "We are not Gods, and the belief that we *know* a book that will tell us exactly how God sees our problems is an arrogant claim. . . . Religious belief is a privilege; it should not be used as a weapon to coerce others with" (*WM,* pp. 135–36).

Unlike philosophers such as Sartre, Russell, and Adler, Hartshorne has not attempted to widely popularize his views, nor has he given heed to what is regarded as "fashionable" in philosophy. In other words, in our basically positivistic age, where more than a few intellectuals are disillusioned with metaphysics and theology, Hartshorne has striven to promote the "unfashionable," i.e., metaphysics and theology.[45] Early in his youth, Hartshorne had decided "to trust reason to the end" (*LP,* p. viii), no matter how unpopular and iconoclastic the outcome might be. Of course, a genuine thinker cannot be oblivious of the current issues and solutions in his intellectual environment; but, as J. S. Mill aptly put it, "No one can be a great thinker who does not recognize that as a thinker it is his first duty to follow his intellect to whatever conclusions it may lead;"[46] or, to quote Karl Popper, "A seeker for truth must dare to be wise—he must dare to be a revolutionary in the field of thought."[47] Holding minority positions on philosophical issues does not trouble Hartshorne much.[48] "In philosophy," he notes in his book of recollection, "I simply am an elitist. I do not expect the majority to be right on technical

44. Cf. Santiago Sia, ed., *Charles Hartshorne's Concept of God* (Dordrecht, Boston, London: Kluwer Academic Publishers, 1990), pp. 246, 253.

45. Cf. John B. Cobb, "Hartshorne's Importance for Theology," in Lewis Hahn, ed., *The Philosophy of Charles Hartshorne,* p. 185.

46. J. S. Mill, *On Liberty,* edited by Currin V. Shields (New York: The Bobbs-Merrill Company, 1958), p. 41.

47. Karl R. Popper, "How I See Philosophy," in S. G. Shanker, ed., *Philosophy in Britain Today* (Albany, N.Y.: State University of New York Press, 1986), p. 203.

48. Hartshorne's refutation of both materialism and dualism in favor of psychicalism, i.e., that the basic units of reality (singular actualities or active singulars) are not devoid of psychical qualities, i.e., feeling or experience (*WM,* pp. 10–13, 20–22; *BH,* pp. 165–93; *OO,* pp. 51–63; see also chap. 8, section A of this volume) and his defense of "the nonempirical status of belief in God" (*DL,* p. 363), that is, that "the

issues; nor on religious issues, unless in a very broad and vague sense" (*DL,* pp. 362–63).

However, it is one thing to believe that the majority does not always adhere to sound philosophical ideas—and Hartshorne is undoubtedly right in this regard—but it is quite another not to attempt to reach a wider readership on whom a writer like Hartshorne's iconoclastic views could perhaps have a notably positive impact. To be sure, Hartshorne's *Omnipotence and Other Theological Mistakes* (1984) marks a sincere attempt on his part to present his alternative, neoclassical theism to a wider readership, but he himself acknowledges that it would take many more such works to seriously challenge the deleterious influence of classical theism. "No truth is more absolute," Hartshorne has remarked, "than this: you cannot have *all possible* good things. This truth even applies to God" (*DL,* p. 368). We then should appreciate what Hartshorne has accomplished in defense of metaphysics and theology in academic and religious circles, and hope that his ever-growing disciples will spread his views among the ordinary men and women who may benefit from his theological, metaphysical, ethical, and political ideas.

existence of God is either logically impossible or logically necessary" (*DL,* pp. 361–62), are just two positions that clearly set him apart form a good many contemporary philosophers and theologians. On Hartshorne's position that the theistic question is an *a priori* one, see also John B. Cobb and Franklin Gamwell, *Existence and Actuality,* p. 41: "I repeat once more: the puzzle about God is not, granting that we know very well what we mean by God, does what we mean describe anything real? No, the puzzle, the mystery is, do we clearly know what we mean? . . . If we can know that, we need not worry about God's existence. For this will be already included in what we will know." Hartshorne is well known for his defense of the Ontological Argument for the existence of God (see *AD, LP,* chap. 2, and *IO,* chap. 8); but it is not the case that Hartshorne considers this argument *by itself* as sufficient grounds for belief in God (Cf. *CS,* p. 257). Quite the contrary; he has written: "If I were asked, 'Why do you believe in God?' I would not reply, 'Because of the ontological argument.' Rather, I would say that it is because of a group of arguments that mutually support one another so that their combined strength is not, as Kant would have it, like that of a chain which is as weak as its weakest link, but like that of a cable whose strength sums the strength of its several fibers." (See Charles Hartshorne, foreword to George L. Goodwin, *The Ontological Argument of Charles Hartshorne* [Missoula, Mont.: Scholar's Press, 1978], p. xi.) Contending that the theistic question is an *a priori* one (*CS,* p. 258), Hartshorne has argued that *all* arguments for the existence of God are a priori (cf. *NT,* pp. 52–56). For Hartshorne's six theistic a priori proofs, see *CS,* pp. 275–97. Nor is it the case that the Ontological Argument is for Hartshorne the most important and compelling of all theistic proofs: "[The Ontological Argument] is not by itself the chief, or even one of the chief, reasons for theistic belief. My two primary reasons for belief are the arguments: (1) without God we cannot understand how cosmic order as such is possible; and (2) without God as recipient and objective immortalizer of our achievements, 'all existence is a passing whiff of insignificance', considering our mortality and other basic aspects of animal life." See Lewis Hahn, ed., *The Philosophy of Charles Hartshorne,* p. 665.

It is to Hartshorne's credit that he can foster thoughtfulness and crea-
tivity in others who may not share many of his philosophical convictions. He
advocates respect for fellow humans irrespective of their belief or disbelief in
God,[49] let alone their disbelief in the Hartshornian conception of the deity—it
is this uncommon characteristic of Hartshorne's that evokes profuse admira-
tion in others toward himself: "The time of his greatest influence may still lie
ahead."[50]

49. Cf. Santiago Sia, ed., *Charles Hartshorne's Concept of God,* p. 244.
50. John B. Cobb, Jr., "Hartshorne's Importance for Theology," in Lewis E.
Hahn, ed., *The Philosophy of Charles Hartshorne,* p. 185.

1

POINTS OF VIEW: A BRISK DIALOGUE

MV: With the statement, "We need a fresh approach to the history of ideas," you conclude your "Twelve Elements of My Philosophy."[1] When you wrote *Insights and Oversights of Great Thinkers,*[2] it seems you had this statement in mind. Isn't there perhaps a danger in your way of reading the history of ideas, namely a biased reading of one's predecessors, akin to what Husserl on occasion does in his *The Crisis of European Sciences and Transcendental Phenomenology*?

H: There surely is that danger. I agree about Husserl. But note, my bias is sufficiently different from that of other historians so that my mistakes or exaggerations are unlikely to go unnoted. The small deference I show to Hegel, for example, has already been strongly attacked by George Lucas, John Smith, and others. I am rather proud of the fact, though, that my treatment of Aristotle and Plato has in each case been given strong support by a specialist. Yet I am no scholar in Greek.

MV: That you prefer Plato to Aristotle, whom you hold partly responsible for two millennia of bad metaphysics, is rather obvious. Could it be that the Plato you admire is the product of your own neoclassical/process reading of his works?

H: On some issues I am an Aristotelian. He founded a sound logic of modality, allowing for genuine contingency and genuine necessity, and relating both to time and eternity, largely correctly. His big mistake was in taking

1. Charles Hartshorne, "Twelve Elements of My Philosophy," *The Southwestern Journal of Philosophy* 5, no. 1:7–15.

2. Charles Hartshorne, *Insights and Oversights of Great Thinkers* (Albany, N.Y.: State University of New York Press, 1983).

God to be *purely* necessary and immutable. Also he took the stars to be eternal except for circular locomotion, and seemed to take species to be eternal. Here he was misled by the failure to distinguish between an absence of observation and an observed absence. We may not observe a qualitative change in the sun or in animal species; but this only proves there are no changes rapid or great enough to be detected by our means and in our short intellectual history. Also, he fell into the trap Plato fell into in book 2 of the *Republic* when he argued that the perfect cannot change since it already has all possible good qualities. In assuming that potential values could be exhaustively actualized, one fails to face the truth that positive values are sometimes mutually exclusive. Later, Plato attributes becoming to perfect being and "self-change" to soul as such. He did not get it all clearly together; but his theism is much closer to mine than Aristotle's. Of that I feel quite convinced, and with support from Cornford and Burnet.

Part of the trouble is the formula "absolute beauty." No one has ever given a rendition of this pseudoconception that withstands careful analysis. Absoluteness goes with abstractness; concreteness is in principle dependent and relative. And concrete beauty includes all beauty, by what Whitehead well calls the Aristotelian Principle! The beauty of mathematics is in the experiences of mathematicians, or of God.

MV: You acknowledge Aristotle's genius and metaphysical acumen, particularly his theory of objective temporal modality. However, you also emphasize his at times negative influence on his successors. Peirce, one of your philosophical heroes, did his best to transcend Aristotle, but he did not go as far as you wish he had gone. What Aristotelian concept or principle do you consider most harmful to a genuine metaphysics, and why?

H: Aristotle dropped Plato's analogy of cosmic soul for deity, along with Plato's definition of soul as self-moved; this almost ruined theology for two thousand years. The Neo-Platonists were all too Aristotelian, partly under the Stoics' and also Philo's influence. Aristotle exaggerated the separateness of substances from one another, and had an absurd confidence in the capacity of sense perception to tell us directly what visible things really are. Here Epicurus was far superior. Here too Aristotle misled multitudes. His physics was feeble, as Peirce admits. Instead of Plato's *caring,* and in eminent ways *changing,* deity one had a supernatural but totally uncaring thinking—of what? Just that very thinking itself. How could this be the God of the book of Job, caring about us and all the animals, or of the New Testament, with its all-loving God of Jesus and Paul?

MV: You have criticized the medieval Judeo-Christian-Islamic philosophy (theology) perhaps more than any other living philosopher. For example, you have asserted that "Medieval philosophy made rather little progress on questions about mind and matter, or on questions about the scope and precise meaning of causation" (*IO,* p. 80), not to mention that you consider as

"intellectual nightmares" the medieval notions of predestination, omnipotence, etc. Like a few of your American predecessors, you acknowledge the superiority of medieval Asia over medieval Europe concerning philosophical and theological matters. What valuable insights could a Western student of philosophy learn from the cultures of Asia?

H: Western thought was mostly excessively individualistic, compared to Hinduism, Buddhism, and Chinese or Japanese thought. It exaggerated personal or substantial identity within a substance (or person) and nonidentity among substances. It was also materialistic or dualistic. In Asia various forms of idealism occurred before the first idealism in the West (Leibniz). However, Leibniz was clearer in his transcendence of the concept of mere matter, irreducibly different from mind or the physical. Materialism and dualism are alike in claiming to have a positive meaning for matter as contrasted to mind. Extension will not do, for simply nonspatial mind is a nonidea. It would have to be nowhere or in a point. There are no *positive* properties for matter that can be shown not to apply to mind in some form. It is also helpful to find that many of the basic mistakes of Western thought occurred also, sometimes much earlier, in Asia. For instance the exaggerated esteem for symmetry. F. H. Bradley rejects relations, whether mutually constitutive or internal to terms, or mutually external, failing to consider relations constitutive of one term and nonconstitutive of the other or others. A similar oversight occurred long before in Nagarjuna the great Buddhist. And the Hua Jen tradition of Fa Tsang in China of the sixth or seventh century, and later in Japanese Zen, failed similarly to consider the nonsymmetrical cases. Russell took the opposite side with the same neglect of the one-way form. Peirce and Whitehead avoided this mistake in practice, but did not state the general principle involved.

MV: You, on the one hand, acknowledge that "Descartes did make a new beginning" in philosophy (*IO,* p. 111); on the other hand, it is obvious that you do not adhere to his dualism and his solution of the mind-body problem. In fact you have written: "By denying feeling or thought to the other animals, Descartes did a number of important things. . . . He made animal experimentation no ethical problem. He made our self-flattering superiority absolute, by definition. He made it seem particularly easy to deny freedom, even of the most minimal sort, to animals other than the human and thus open all nonhuman nature to the reign of strict causal laws" (*IO,* p. 114). What is your estimation of Descartes's contribution to philosophy? Has his influence been positive overall?

H: Descartes's affirmation of *human* causal or metaphysical freedom is the most definite and illuminating of any of the great philosophers after Epicurus and before Crusius, Kant's contemporary. And no national tradition equals the French in its support of this. The British tradition is far inferior in its emphasis on metaphysical freedom, as distinct from political freedom. And Descartes stimulated natural science and mathematics.

MV: On a number of occasions you have said that Leibniz, although wrong on several issues, enjoyed an unprecedented degree of clarity in his work; the only Leibnizian thesis that you (with certain qualifications) accept is his psychical atomism. Do you really believe that the "future of the philosophy of nature, as well as of natural theology lies . . . in a reformed Leibnizianism?" (*IO*, p. 133). Is it not true that an adequately reformed Leibnizianism would hardly resemble what we know of Leibniz's ideas?

H: Because of Leibniz's mathematical clarity it is not hard to transform his lucid mistakes into lucid truths. For example, his possible worlds are *exactly* the wrong way to conceive possibility. Whitehead's cosmic epochs and universal creativity save him from sharing in this error. Peirce had still another view of cosmic evolution which was probably a blind alley. Here he failed I think. Similarly exact and wrong was Leibniz's view of absolute individual identity through change.

MV: Whenever we have discussed Hume's philosophy, you have expressed dissatisfaction with his belief in the symmetrical separability of distinguishables. You have also remarked: "Hume was the great and remarkably pure example of an ostensibly radical empiricism and extreme pluralism, a position combining two of the great oversimplifications or false extremes that philosophy always has to reckon with. It remains relevant as a view to be carefully avoided" (*IO*, p. 149). Do you find any idea in Hume, besides his refusal to view altruism as derivative from self-interest, which is metaphysically sound?

H: Hume is valuable for his radical critique of causal determinism if taken as metaphysically valid, and his critique of substantial or personal identity taken as similarly absolute and valid a priori. But he fails to find any metaphysical truths about causation or individuality, and pretends to find empirical evidence of strict determinism.

Hume's splendid *Dialogues on Natural Religion* are valuable as showing what happens if deterministic scientism and the pseudo-idea of omnipotence (as often construed) are combined. Kant said Hume freed him from his dogmatic slumber, but Kant did not move beyond Hume in the aspects just mentioned. In one respect, however, thanks to his Cleanthes, Hume showed a more flexible response to the medieval heritage than Kant. He did give a voice to the entirely pertinent charge that identifying God with the immutable absolute is, taken literally, a virtual giving up of theism as a religious doctrine. Also, it was Kant and not Hume who held we must (along with Dante) look beyond or behind human careers between birth and death for some supernatural union of happiness and virtue in ourselves, instead of, like the ancient Jews, worshipping God while expecting no other results in ourselves than we can experience in this life.

MV: "To be is to be for God." You have made this remark on a number of occasions (e.g., *CA,* p. 249). It sounds Berkeleyan, though you do not buy his version of *esse est percipi.* What is your assessment of his idealism?

H: Berkeley related ideas to human mind and divine mind, but he had no real principle for relating mind to mind, whether human or divine. Concrete instances of mind, not mere ideas, are contributors to the divine life by the Whiteheadian principle of prehension. This is no mere having of ideas, but feeling of others' feelings *as theirs.* Ideas, abstractions, are real only in concrete experiences or at least sentient actual entities. God is the supreme experiencer. Nature is, as in Leibniz, a vast hierarchy of sentient actualities, but the final singularities are what Leibniz calls "states" of monads, and the monads, as enduring through successive experiences, are sequential societies of actual entities (experiences). God too is socially ordered, this being the most difficult aspect of the theory.

MV: Your critique of Kantian philosophy is as severe as your critique of medieval theology. You have said that Kant's "work produced one of the maddest speculative outbursts of all" (*CA,* p. 7). One aspect of Kant's philosophy that you appear to have some sympathy for is his ethics, though even here you find him a victim of grave exaggerations. I am not sure that Kant was a much worse philosopher than Leibniz. Could not the following remark of yours about Kant also apply to Leibniz?: "I wonder if philosophers are not as likely to be misled as helped by taking Kant more than mildly seriously as a guide to philosophic truth" (*IO,* p. 175).

H: Some have, I do hold, been misled in this way. But note that Kant is more recent and is thought to have disposed of Leibniz as of Hume. On the contrary, I think in some ways both Hume and Leibniz are more worthwhile now than Kant because they are more readable and clear and it takes much less time to learn their main points.

MV: Not unlike Kant, you believe that metaphysics is natural to humanity, and you also distinguish "bad metaphysics" from a genuine metaphysics which you contend is both possible and desirable. Consider your own words on the function of metaphysics: "Metaphysics gives us no fact, ordinary or superior, but it gives us the key to fact, on both levels, the clue or ideal by which factual experience is to be interpreted" (*LP,* p. 297). Could you elaborate on how your ideas on the function and nature of metaphysics differ from those of Kant's?

H: I agree with Kant that experience does not simply exhibit just what is there as it is; also that in applying highly abstract categories it is the temporal structure of experience that must be our guide. I also agree that the idea of God has a regulative function of putting the most general ideas in mutual relationship.

I have, however, never agreed with the idea of an appearance which absolutely conceals what it is that appears. The spatiotemporal array of phenomena cannot be the way something utterly nonspatial and nontemporal appears to us. Nor can the self that we experience in memory be something utterly nontemporal and only in its timeless noumenal form free. I say also, as Crusius did then, that there can be no absolutely sufficient "reason" for the succession of experiences that each of us enjoys. Nor are we mistaken in supposing that our own selves are "here" and other selves "there." Space is how we have neighbors, "which are those with whom we intimately react" (Peirce).

Kant's idea of God is essentially medieval and monopolar. He never dreamt of dual transcendence. The Kantian *summum bonum* is human persons ideally good and ideally happy. I say it is the dually transcendent Encompassing deity, ideally good and wise but not in an absolute sense ideally happy, for the alleged concept of absolute happiness, or of absolute beauty, is a nonidea. Concrete aesthetic value admits of no absolute maximum. Here Plato, in his *Republic,* was mistaken, and Leibniz repeated the mistake. The inclusive aesthetic value must be concrete, only the abstract can be wholly absolute, independent, immutable, infinite, and so on. Aristotle's Unmoved Mover is also a nonidea, incurably abstract and lifeless. With Rabbi Heschel I say that God is "the most [and best] moved mover." The bracketed words are mine but I imagine Heschel would have accepted them. God is the unrivaled cause, but also the unrivaled effect, the source and result of all there is: the so-called secondary causes, the creatures, are genuine causes, each with its own freedom. God enjoys and suffers the outcomes, does not unilaterally decide or determine them, and there is no final outcome. Becoming is everlasting as well as beginningless. Any beginning or ending is a matter of our or some other "cosmic epoch," as Whitehead has it.

The final value of our lives, between birth and death, is their internal beauty, their happiness, and that of others we influence, as adequately enjoyed by God, not by human individuals in some heavenly realm. In this way "our fleeting days acquire abiding significance" (Jewish saying).

With Popper I regard Kant as belonging with Newtonian science, and insofar as he does, not of major importance for us in a very different scientific, theological, and metaphysical cultural state than the one Kant knew. His essay on peace, however, is still relevant.

MV: "Darwin was even more right than he knew" (*CA,* p. 130). "Darwinism fits theism better than traditional biology ever could" (Ibid., p. 138). You speak rather affirmatively of Darwin's critique of classical theism. What is your overall view of his work?

H: The theistic teleology Darwin rejected was a form of theological determinism which made God responsible for monstrosities, human wicked acts of every kind, and assigned no unambiguous freedom to the creatures.

By denying piecemeal contingency it denied freedom and made the attribution of freedom even to deity problematic at best.

Darwin's chance variations were, he thought, not really chance. On the contrary, chance is pervasive, as physics now affirms. It always was implicit in freedom, as Epicurus, Aristotle, and I think Plato, saw.

Charles Kingsley, in the lifetime of Darwin, accepted evolution as meaning that God "makes the creatures make themselves." God inspires them to make contingent decisions that conform to certain general directives that enable the results to constitute a viable world with enough order and predictability so that the *risks* of freedom are justified by the *opportunities* freedom makes possible. The conjunction of free decisions involves an element of genuinely chance results, intended by no one, God or creature. X decides A, Y decides B, what happens so far as both are successful, AB, is decided by no one. Add God as Z, and you have ABC. There will still be chance, but a viable world order. Without God multiple freedom means no intelligible limit to chaotic disharmony, frustration, lack of positive achievement. The Laws of Nature cannot be strictly deterministic, but must allow for aspects of chance; as not strictly deterministic (and as now envisaged they are not so) they do set limits to the risks of conflict. Without freedom, no reality and no truth; with freedom, risks as well as opportunities. The problem of evil is not to explain particular goods or evils, harmonies or discord. Any absolute *why* for these would contradict freedom. The problem is to explain how the opportunities justify the risks. Without at least statistical kinds of order, what prevents the conflicts, disharmonies, from prevailing? Mere creaturely freedom does not explain concrete order as such. "Adaptation" cannot be to mere chaos. Darwinism assumes a basic physicochemical order that it does not explain. With Whitehead, Peirce, and many others I can see only divine freedom's deciding cosmic laws as solution for this problem. Freedom, both divine and nondivine, there must be. God *could not want not* to have a world. Nor should we wish this had been possible. It could not be possible.

In a letter, Darwin hints at some such solution, but his inclination toward determinism, as in many modern thinkers, was too strong. He could not really believe in chance, hence not in freedom. Therefore not in divine freedom.

MV: It is obvious that you see some value in the ideas of early American philosophers, e.g., J. Edwards and Emerson. But the former you describe as "a giant intellect, but an intellect in prison" (*CA,* p. 14) and the latter as one who "had everything but a sane metaphysics" (Ibid., p. 48). What exactly do you find valuable in pioneer American philosophers, particularly the Transcendentalists? In other words, in what way(s), if any, are they relevant to contemporary philosophy?

H: The "prison" was Calvinism: Hell and the false "Omnipotence" which contradicts human freedom. As Frankena said, Edwards was as good a philosopher as was possible, with those limitations. He embodied much of the

beauty of holiness, and was eloquent about the beauty of nature and of human and divine love. Emerson had some of the best of Edwards, but dropped Hell and soared above American provincialism and British snobbery alike; he saw the ugliness of slavery and was perhaps freer from male chauvinism than anyone in the world of his time. In poetry and prose he was a master of language. "Things are in the saddle and ride mankind." How relevant to our time! He understood Hinduism like a Hindu.

MV: In what way(s) is your pragmatism (see *CA*, p. 210) different from those of certain American philosophers (e.g., William James)?

H: James's holistic empiricism gets him into trouble, he fails to see that the proper method for learning contingent truths cannot be the same as the method for learning necessary truths, and that 'contingent' has application only if 'necessary' also has. He took Peirce's pragmaticist definition of *meaning* as also giving in general the definition of *truth,* whereas only with necessary truths can utility alone be the criterion of truth. If a contingent statement had happened to be untrue (as, by definition of *contingent,* it could have been) it would not have been useful on the whole to believe it. In contrast, a necessary statement can be false only by being absurd. Only by thinking without sufficient care can we take such impossible statements as true, whether true contingently or necessarily. Hume's extreme pluralism *could not* be true, and neither could Parmenides' sheer monism. Similarly, we can all see that no animal could live as though there were no order in the succession of events; but equally no animal could live as though what happens next is settled in advance by what has already happened. It has to *decide* some part of the new happening. The absolute opposite of strict determinism is obviously unbelievable; but careful consideration convinced Epicurus, also Plato and Aristotle, though not the Stoics, that absolute determinism is also unbelievable. To see *that* is not nearly so easy. But it can be, and it was, seen. The time seems near when almost everybody may be able to see it.

In India absolute monism seems more nearly believable; in the West, absolute pluralism. But they are both absurd. Most Indians and most Westerners believe something between these extremes.

MV: In your evaluation of Santayana's philosophical works, you write: "I think Santayana is in metaphysics a rationalist, and the better for that, but unfortunately he is one who has failed to find rational solutions for the metaphysical or *a priori* problems" (*CA,* p. 124). What particular views of Santayana do you regard as indefensible?

H: Santayana is a fine poet and writer of splendid prose. He wrote a novel. Like Bertrand Russell, he is more than merely a philosopher, and less than a very great one. This Spanish-born American was a complex man. Student and then teacher at Harvard, he deliberately gave up teaching for a purely writing career. The bulk of his life was spent in Europe, especially Italy. He was a complete bachelor, so far as known. Among his many limitations as

philosopher he missed the merits and saw almost exclusively the faults of the idealistic tradition. Like some of the idealists themselves, he overlooked the ontological importance of memory and perception as key examples of how effects can relate themselves to their own causal conditions. We perceive what *has* happened and yet *is* influencing our present experiencing, as is obvious when what we see is light years away. Memory and perception have the same basic causal and temporal structure, but whereas the former gives us our own past experiences, the latter gives us what has just happened in our bodies and, less directly, outside our bodies. For all Santayana can show, his "matter" is an empty word apart entirely from "spirit" or mind, taken in its most general meaning (as in Leibniz or Whitehead) as at least sentience, feeling. In all nondivine memory and perception what is given is only *more or less, mostly less, distinctly* given. Indeed divine mind has by definition the only form of intuitive possession of its objects that is fully adequate to these objects. For Santayana our memories and perceptions have independent, genuinely given, objects only in the latters' essences, not in their actual existence. *Purely* by "animal faith" we believe in the actuality of the objects. For me, such entirely nonpossessive perception and mere faith are alike myths in the bad sense. There are no such things. Indistinctness with mistaken interpretation of the indistinctly given is not the same as *total* nonpossession with *mere* faith. Here are two false negative absolutes. They are not the only ones in this philosophy. We indistinctly have the actual past and, for reasons that are not hopelessly mysterious, we supplement this inadequate possession by hazardous elaborations. We have been learning how to do this since birth or even longer.

MV: Dewey, you remark, "is chiefly a philosopher of middle-sized ideas, not of the largest or most strictly universal ones. He is not quite a philosopher's philosopher" (*CA*, p. 101). You also note that Dewey "lacked . . . a sense of tragedy," an appreciation "of basic evils and the dangers of human existence" (*CA*, p. 92). This estimation, to be sure, will be considered as rather unfair by those who do not regard Dewey as one who "concerning the highly theoretical issues of philosophy . . . [merely] used the discoveries of others rather than making any of his own" (*CA*, p. 98). If Dewey were as unoriginal as you tend to portray him, why does he enjoy the fame that he does?

H: He is a fine exponent of "natural piety" and a great philosopher of politics and of education. His essay on "Time and Individuality" makes him one of the important exponents of the new metaphysics of becoming and relativity, rather than of being and absoluteness. Simply as philosopher I put him above Santayana.

Dewey started out as Hegelian, which did not help him to appreciate the beauty of exact thinking. How could it? He then tried Leibniz (who as mathematician knew the beauty in question) but did not acquire much of Leibniz's famous clarity. Dewey's strength, like that of Mead, was in his contributions

to psychology, sociology, and political philosophy. His influence on American education may, I incline to think, have been one cause of our population's weakness in exact science (mathematics pure and applied), from which we suffer today. Dewey was, however, greatly superior to some of his disciples. For instance he saw the importance of causal freedom, as Sydney Hook did not.

MV: You speak of Peirce's "overindulgence in the admiration of continuity" (*CA,* p. 84), of his failure "to clearly transcend the Aristotelian pattern of reality" (Ibid., p. 85), and of his "somewhat vague and wavering theology" (Ibid., p. 90). You also find his theory of categories in need of a not insignificant revision. However, you consider him as one of the most original thinkers of the last one hundred years. Is it fair to say you perhaps exaggerate Peirce's significance, whereas you downplay a philosopher like Dewey's originality?

H: I may do the latter but hardly the former. Peirce's pragmatism, tychism, theory of categories, and theory of time as objective modality, were immense steps forward. He was the Leibniz of his time, knowing all the hard sciences of that time, including mathematics and symbolic logic. He also was the best of the Aristotelians of his time, while appreciating Epicurus and Plato (the latter as the one who knew "what philosophy is" or should be). My emendation of his categories and of his partly mistaken synechism, I hold, make Peirce more coherent. And he lacked the stimulus of quantum physics to break his dogmatic slumber derived from his father. Whitehead helped here.

MV: Your admiration for Whitehead is well known and some would perhaps say exaggerated. "To me it is really obvious," you write, "that as metaphysician Whitehead has in this century had no superior, and I question if there has been even a close competitor" (*CA,* p. 103). What concepts in Whitehead, besides his concept of prehension which you consider as "one of the most original, central, [and] lucid proposals ever offered in metaphysics" (Ibid., p. 109), renders him the most prominent metaphysician of this century, as you claim?

H: The idea of "actual entity" as concrete unit event and of sequentially ("personally") ordered series of actual entities as the primary (noncorpuscular) type of individuals. Also the clarity about the dual transcendence (my terms) of God as finite *and* infinite, complex and simple, concrete and abstract, actual and potential.

When, after eight years of college and university training, from the beginning (at least partly) in philosophy, I simultaneously encountered Whitehead and began to edit the writings of Peirce, I found that each of these two had in himself almost the range of concerns and most of the ideas collectively covered by the dozen or more of my previous philosophical favorites, and had these ideas in sharper focus and with valuable additions. This was

particularly true of Whitehead, who came a generation later than Peirce and had the benefit of Plancke's and Einstein's discoveries, as Peirce did not. If these two philosophers were not geniuses, then I have no idea who is.

MV: In the introduction to *Insights and Oversights of Great Thinkers,* you pose a helpful question: "We should ask about a philosopher of the past—or present: What questions has he put deliberately and carefully, mindful of the possible answers and arguments, and what questions has he ignored, or formulated and answered hastily?" (*IO*, p. 8). Now, given your considerable familiarity with the philosophies of Peirce and Whitehead, what questions did they fail to raise, or hastily answer?

H: Peirce defines Firstness as independence of all else, Secondness as dependence on one other thing, and Thirdness as dependence on two other things. But these are clearly special cases of dependence or independence. And nothing, unless the abstract divine essence of deity, or of world (what is not God) simply as such can be independent of all else. Also, in emphasizing the continuity of conceivable *possibilities* he should have seen that it is precisely their discreteness that distinguishes actualities. He never even put the question here. Half a space is a smaller space, but half an animal is not a smaller animal, nor is half an atom a smaller atom. This applies to experiences, taken temporally. We have a small number of them per second.

Whitehead, after Planck, saw the temporal discreteness of actualities, but failed to see the *nondiscreteness* of conceivables, eternal objects. Where there is definite plurality there are definite singulars (Leibniz), and by Whitehead's geometry, there is no instantaneous or punctiform actuality. Universals are continua, with no definite plurality. Whitehead's eternal objects are "Platonic" in the bad sense. To this charge he replied, "Perhaps I have missed something."

MV: What are the most significant differences between your philosophy and that of Paul Weiss? How do you evaluate his contributions to speculative philosophy?

H: I like Paul's *The God We Seek: A Phenomenology of Religion* better than the *Modes of Being* and its successors. I think he repeats some old mistakes: (1) retaining a dualism of mind and matter, failing to see the importance of the Aristotelian or Ontological Principle that abstracts are in concretes, not vice versa; (2) exaggerating the absoluteness of identity through change in substances or persons. Weiss's founding of his journal on, and society for, metaphysics, also his co-editing of Peirce, were great contributions.

MV: In your essay on Nietzsche (*IO*, pp. 234–45), you somewhat sympathize with his critique of popular Christianity and certain notions in traditional metaphysics. However, you do not regard Nietzsche as a philosopher who questioned, let alone liberated himself from, a few dogmas of the very tradition which he attacked: "Nietzsche's longing for a surrogate for deity expresses itself [as he expounds the doctrine of eternal recurrence] in a

display of rhetorical resourcefulness and less than logically cogent reasoning that quite balances traditional theology in these characteristics. In challenging a great tradition, he chooses, in my opinion, to exempt from critical examination some of the worst features of that tradition" (*IO*, p. 241). What value, if any, do you assign to Nietzsche's iconoclastic work? Should he be taken seriously by anyone who is genuinely interested in metaphysics?

H: He did say that being is only an abstraction from becoming and in this anticipates Process Philosophy. In some ways he anticipated Dewey's rejection of the theological orthodoxies. Unfortunately he retained determinism, said nasty things about women, and seemed at times to praise militarism. On these points Dewey is a far better guide.

MV: You had the opportunity to attend Husserl's lectures and be exposed to his phenomenology. Based on your written remarks and our conversations on Husserl, you do not seem to assign much significance to his philosophical outlook. In fact, you have argued that "Husserl takes as ultimate certain presuppositions of ordinary practical common sense as to the terms in which physical entities are to be analyzed" (*IO*, p. 271). What basic insight of Husserl's do you find compatible with your neoclassical metaphysics?

H: I take him to have rejected determinism, but not any too clearly. He of course rejected materialism, but seems to open the door to a kind of dualism that is also in Berkeley, that between subjects and mere ideas or noemata. The vast hierarchy of living and, for all we can ever know, sentient forms that make up nature he sets aside because we cannot distinctly intuit its feelings or even, in the microcases, its behavior. He wants absolute "evidence," all natural science put aside, to make phenomenology a strictly independent study. I regard this as naive. If we do not know chimpanzees have feelings, how do we know that other people do? Where do physicists or psychologists draw the line between minded and mindless matter? I think nothing like it can be drawn.

Of course a rock does not feel, and neither, I think, does a tree. But the ever-active atoms or molecules of the one or cells of the other may do so. What could tell us they do not? To this question I have long been awaiting an answer. Husserl was right about the superiority of the concept of mind as explanatory principle. As Peirce put it, mind is "the sole self-intelligible thing" and "the fountain of all existence." But Husserl's understanding of mind was mediocre, and lacking in generality. And he makes impossible demands on knowledge by acquaintance.

Husserl sometimes calls very short-range memory *retention* and sometimes calls it *memory*. I think it is the most direct and philosophically instructive form of memory and an immediate intuition (Whitehead's "prehension"). We feel or experience how we have just been feeling or experiencing. It is the real "introspection." Husserl thinks memory gives us the past and perception

the absolute present. I follow Whitehead here in thinking that present experience does not have itself as a given, it simply *is* itself. What it has as given is the past, whether one's own past, and then we call it memory, or the past of other things, and then we call it perception. The other things include processes in our own cells, especially nerve or brain cells. True we could not be without these, nor could we be without a reasonable range of temperatures in our vicinity.

Husserl also claims we can distinguish absolutely between sensation and feeling. I hold, with Berkeley, Goethe, and some psychologists, that this contention is mistaken. Pains and physical pleasures are sensations and feelings in one, and sweet tastes and odors are plainly pleasurelike and some others are painlike. Similarly with sounds and colors. In the last case the truth is hardest to see, but I am not alone in claiming to see it.

What Husserl did for me was to challenge me to think further about these topics, from a perspective that contrasted with the one in which I had dealt with them in my dissertation. I went on to Heidegger and his quite different perspective; later to Peirce and Whitehead, who have their own phenomenology, Peirce explicitly so. In my judgment Europe needed Husserl far more than America did. Luckily for me, training in psychology was required by the Harvard philosophy department. Here I had an advantage over Whitehead, but his insights on points relevant to Husserl and Heidegger fitted, and helped me to extend, mine.

MV: Levinas contends that "a man who undertakes to philosophize in the twentieth century cannot not have gone through Heidegger's philosophy, even to escape it."[3] Do you agree with Levinas's contention? Which twentieth-century philosopher is unavoidable if one is seriously interested in philosophizing?

H: I saw a lot of Heidegger early in my career. I'm not sure that I learned much I could not have had without him. Peirce, Bergson, James, Whitehead, Popper taught me more. Even Dewey perhaps did. Also C. I. Lewis, Burnet, Cornford, and Shorey on Greek philosophy may have taught me more; or Wolfson on Philo, the Church Fathers, and Spinoza. Heidegger was a penetrating critic of Husserl, but what he criticizes in him I disbelieved anyway on my own, so far as I can see. And what I can find in his *Dasein* theory I also find in others. Much of what he rejects as metaphysics I rejected before encountering him.

MV: One odd thing about your *Insights and Oversights of Great Thinkers* is that you do not devote a critical essay to the philosophy of Bergson. It is quite obvious that you think highly of some of his insights, e.g., his notions of memory, time, and creativity. What, in your opinion, were his insights and oversights?

3. Ibid., p. 42.

H: It is indeed odd, my always dealing with Bergson in a "by the way" manner. I could and should have met him in 1923, but foolishly did not. Bergson's reputation strikes me as somewhat misleading. His early books got immense attention but to my mind were not his best. His extreme theory of metaphysics as intuitive and "without symbols" or concepts led him to use symbols and concepts carelessly, as when he said that mental states cannot have definite multiplicity (since they "interpenetrate") and failed to distinguish between earlier and later states and simultaneous aspects of each state. The aspects may interpenetrate (a symmetrical relation) but if earlier and later states also do, then we have the denial of time's arrow and the contrast between the actual and definite past and the potential-probable partly indefinite or open future. Lovejoy pointed out this inconsistency and so did Russell and Santayana.

Bergson is also noted for his attempt to explain evolution by a vague *élan vital.* For me the most correct part of his book on evolution is his argument against the supposed truism, "There might have been nothing at all." I find convincing his analysis of the, in principle, relative significance of 'nothing', meaning nothing to the purpose in hand. This is logic, not mere intuition.

In *The Two Sources of Ethics and Religion,* Bergson answers the question, Why do all the branches of the human species exhibit some form of religion? If anyone else has ever given as good an answer to this question I do not know his name. He shows three reasons why an animal as reflective and knowledgeable as we are faces difficulties not, so far as we can see, encountered by members of other species, difficulties that are not answered or disposed of by science but are dealt with by religion. Scientific progress intensifies the need for religion rather than doing away with it. We still all die, and there is no way to know that our species will survive forever. Also we still are all subject to frustrations, chance obstacles, and evils. Lions and tigers do not much frighten us, but plenty of other forms of danger abound, many of them results of technological applications of science. Above all, the old issue between selfishness and generosity, hate and love, personal advantage and the interests of others, remains acute. It is still true that "the poor ye have always with you." Equality of opportunity is still a dream, scarcely a reality.

Bergson's theory of the mystical element in religion seems to me profound. His essay on dreams is unrivaled apart from psychiatric aspects that I take to be complementary rather than contradictory of his main contentions on the subject.

I value the simple statement, "duration (becoming) is reality itself." Before quantum theory, Bergson saw that Newtonian physics, taken literally, was an absurdity, with its notion of strict mechanical necessities and wholly insentient, inwardly inert, lumps of matter. Peirce saw this before Bergson,

but neither of them saw that unqualifiedly continuous becoming was an equally artificial notion. Peirce's extreme synechism, continuity-ism, prevented him, as it did Bergson, from anticipating quantum theory in principle. I hold the mistake was metaphysical and logical, not merely a matter of empirical ignorance.

Another surprising weakness in Bergson's philosophy of religion is his failure to take seriously enough his own idea that freedom (however minimal in many cases) is everywhere in nature and that this means that (Whitehead) "disorder is as real as order," and that the actual goods and bads of life are pervasively subject to chance happenings that no one, human or divine, intended or determined—not in advance, much less eternally or timelessly. Thus he fails to deal directly and cogently with the problem of evil. He even in one passage denied the reality of disorder. Peirce knew better than that.

MV: Based on our conversations and your essays on Sartre and Merleau-Ponty (*IO,* pp. 332–63), I have the impression that you favor the latter insofar as you find anything valuable in French phenomenology. Your view seems to be that Merleau-Ponty's philosophy is closer to that of Whitehead's than Sartre's Cartesianism. Which aspect(s) of Merleau-Ponty's philosophy do you consider cogent and which aspect(s) is (are) indefensible?

H: Merleau-Ponty, like me, but unlike Whitehead, philosophized partly on the basis of some detailed knowledge of psychology. His authorities in this subject were continental, not Anglo-American. His theory of knowledge was psychophysiological. So, with less detailed knowledge, was Whitehead's. Merleau-Ponty arrived at an almost mystical idea of the centrality of "the flesh" in cognition. We, like the other animals, have the rest of the world through our bodies. Spinoza had already said this. Kant and Hegel seem to me not to have genuinely accepted the point or to have begun to really explore its significance. Spinoza's mind-body theory was warped by an artificial theory of strict two-aspect parallelism. Also he excluded freedom in the proper sense. I do not recall Merleau-Ponty on freedom, but assume that, like Husserl and Heidegger, he avoided unqualified determinism and a mere correspondence between mind and body. What is missing in Merleau-Ponty is the realization that Plato's "second God," the "World Soul" with the Cosmos its body, enables theology to complete the picture for the Encompassing Reality. My Platonism, which I began to work out more that sixty-five years ago, obviously demands that I generalize the centrality of the mind-body relation so that it really is as basic as Merleau-Ponty says it is. Even particles have an extreme form of the duality in that atoms, for example, have particles as bodily members, and particles have their environments formed by other forms of active singularity, without which they could not exist or act. Combining this with Whitehead's generalization of social relationships in the form of "feeling of feeling," we get rid, once and for all, of the problem of

solipsism, whether of the individual experiencer or prehender, or of its momentary actual instance or actual entity. Both in memory and in perception, a unit of experiencing always and in principle feels feelings other than, and neither created nor altered by, its own feelings.

To extend this to deity requires the definite rejection of the merely non-dual definition of God as infinite, immutable, independent, or absolute in every aspect. This is to be done not by going to the opposite extreme of a wholly relative, finite, mutable, or dependent deity. It also requires giving up any unqualified identification of God (as in Whitehead) with a single actual entity, devoid of anything comparable to memory of a real past and a real, partly open future. Of course Merleau-Ponty probably did not dream of such a theological change.

I met and shook hands with Merleau-Ponty once; my impression? A thoughtful, serious person, with no, to me, visible sense of humor. I was prejudiced against him by having been told, just before, that he quarreled with his adult daughter so that she felt it necessary to live elsewhere. Of course I was, and am, in no good position to judge the significance of this information. But nothing in his appearance seemed to conflict with it. I recall nothing that he said, which I think was not much. (At that time I was little-known internationally). I am pleased by Merleau-Ponty's rejection of anthropocentrism in his "Man is not the absolute." I add, of course, that neither is God, in the traditional unqualified sense of absoluteness. Not that this tradition overstates the divine excellence, but that it deprives what it calls "God" of concreteness, and destroys its religious or practical relevance. We do not rightly praise God by employing abstract symbols with either contradictory or else hopelessly ambiguous connotations. The "negative theology" was always partly positive, and it was anybody's guess which of the incompatibles should be sacrificed. Both dependence or relativity and independence or absoluteness have good as well as bad forms; God must have uniquely good forms of both, in different aspects of the divine life.

MV: As you have evaluated Russell's philosophy, he was a victim of fatal oversights. What, if any, redeeming quality do you find in his philosophical outlook?

H: Russell finally accepted the analysis of substantial identity into a sequential group of events in which the causal order allows for aspects of chance and therefore freedom, creativity. He gave up determinism. He also rejected pure empiricism, holding that inquiry presupposes some indemonstrable principles of causal order. Yet he never gave up his Humean idea that what is distinguishable is logically separable, and he failed to distinguish between one-way separability and two-way or symmetrical separability. How a logician could fail to make this distinction at this point I find fantastic. My ancestors lived without and before me, and even granted that, I might never have come to be; but that I could have come to be without them is

mere words, supported by nothing we know about anything at all, so far as I can see.

Russell held, rightly I think, that structures and relations logically could not exist without qualities; he also said, rightly again, that the only qualities we definitely experience are those that arise within our animal bodies and cannot safely be attributed to inanimate parts of nature. What qualities there are apart from animals, Russell thought, we simply know nothing about. My view is that we can know there are qualities of feeling which *we* cannot feel, but that God, by definition, could and does feel.

MV: In your essay on Wittgenstein, and in other remarks on his philosophy and influence scattered throughout your later works, you rightly distinguish his work from those of some of his followers. For example, you find a few of Wittgenstein's insights in *Zettel* compatible with your neoclassical metaphysics (*IO,* pp. 293–96). I recall you saying that Wittgenstein and Nietzsche's familiarity with the history of philosophy was not that extensive. However, you have said the same thing about Whitehead (*IO,* p. 7). Why do you think Whitehead, and not Wittgenstein, emerges as one of the greatest philosophical figures of this century?

H: 1) I find much more definite and apt references to great philosophers of the past in Whitehead than in Wittgenstein. 2) Whitehead (like Peirce) was able to deal with the exact sciences of his time from the inside, and was an important contributor to mathematics, logic, and physics. Whitehead is one of the greatest constructive philosophers; Wittgenstein is a skeptical metaphilosopher, like Carneades for instance. Doubtless we need both types.

MV: In *Culture and Value* Wittgenstein writes: "I may find scientific questions interesting, but they never really grip me. . . . Only *conceptual* and *aesthetic* questions do that. At bottom I am indifferent to the solution of scientific problems; but not the other sort."[4] How, if in any way, would you correct Wittgenstein's view?

H: Your quotation illustrates my point. I, and philosophers I most admire, have never been indifferent to the solution of scientific problems, and some of them gripped me from the outset, some in experimental psychology and some in ethology or the study of animal behavior as a key to animal psychology. Peirce was profoundly gripped by problems of evolution, of chemistry, and of psychology. He was one of the most versatile interpreters of empirical science that has been seen during the last dozen decades or more, say, since 1860. Whitehead is like Peirce, except that he was an armchair, not a laboratory thinker, not an experimenter. Here Peirce was superior.

4. Ludwig Wittgenstein, *Culture and Value,* trans. Peter Winch (Chicago: University of Chicago Press, 1984), p. 79e.

MV: On several occasions you have mentioned to me that "Karl Popper is the greatest living philosopher." However, in your essay "Karl Popper on Whitehead" (*IO,* pp. 306–22), you mainly show how he has misunderstood and underestimated Whitehead's work. It would be helpful if you could explain why you "prefer him to any living philosopher" (*IO,* p. 306). Which seminal idea(s) of Popper's do you find most compatible with your own philosophy, and with which idea(s) of his do you most disagree?

H: 1) It is partly what Popper does *not* say that I value. He accepts neither a merely positivistic (or phenomenalistic) view of our knowledge, nor an unqualified determinism. A realist, he is not a naive realist. Kant's absolute dichotomy of phenomena and inaccessible noumena is set aside by him, and so is the notion that we can simply, correctly, and certainly capture the essences of things. He holds that we must accept a less extreme doctrine than either of these.

2) Popper avoids both extreme trust and extreme distrust in metaphysics, and, better even than Peirce, defines the difference between empirical knowledge, say physics and metaphysics, thus: in the former, observation can falsify a generalization, but not in the latter. His realistic postulate is that while we do not simply know the essences of nature's constituents, by doing our best to falsify hypotheses about them we can move toward better and better approximations to what is really there. In any case, what we are trying to know is not simply our own future, or possible, experiences, but independent realities, and increasing success in this is to be hoped for.

3) I value Popper's doctrine that falsification is done by observation not of purely negative but always of *positive* facts. My example: we observe not the nonflatness of the earth but its approximate sphericity. This accords with Bergson's denial of mere nothingness as a possible fact.

4) Popper is a *mind-matter dualist;* since 1918, when I became twenty-one, I've been a *"mind only"* monist. The phrase is Buddhist, but I got it from C. S. Peirce, who called himself a Buddhisto-Christian. Whitehead was close to this, as were the mature Bergson and William James.

MV: Although you have not written extensively on Marxism, you have, for example, in *Beyond Humanism,* not altogether ignored it either. Reading the little that you have written concerning Marxism, however, one gets the impression that you account for the relative popularity of Marxism (at least in some circles) in terms of the failure of non-Marxists, or better yet, anti-Marxists, to offer viable solutions concerning fundamental speculative problems in philosophy. Is there any Marxist insight (particularly concerning social matters) that is sound enough to be embraced by non-Marxist philosophers? What basic Marxist thesis do you consider the most socially harmful and metaphysically unsound?

H: The pretension that they will abolish the class structure when they get world control, though meanwhile they are indeed an extreme case of

imperialistic injustice and unfair treatment of their own population outside the party. Also their pretension to have solved the religious problem and the mind-matter problem. They are correct that quantitative differences imply qualitative ones. Huge populations change the quality of life, as they are finding with ecological deteriorations.

The communistic version of Marxism seems to be waning in power as its economic failures become manifest. But then some of our failures are also apparent. We all need to learn. No country is in a position to feel wholly proud of its record in its treatment of its own citizens, and members of the species in general. Swelling populations, in spite of genocides, press hard indeed on available resources, hunger is still a bitter reality in much of the world. And everywhere environments are deteriorating. Excessive luxuries need conscientious scrutiny. We Americans have scarcely begun to face realities in this respect.

MV: A few of your remarks from the lecture given at the Fourth Annual Conference in Philosophy (Feb. 1971) at the University of Georgia, would strike some Americans as unpatriotic, if not "pro-socialist." For example, you speak of the necessity to "transcend patriotism and learn to acquire a double loyalty: to country and to mankind on this planet." "We need," you go on to say, "a vastly more diffused ownership of industrial wealth, not state socialism but still in a broad sense socialism."[5] Can you elaborate on your economic ideals? Have you ever attempted to develop a theory of justice?

H: I roomed for nine months with an economist at Harvard. He was a son of an economist, and an intelligent partisan of free enterprise. He ended up in government service and did not become famous. But he and some of his friends stimulated me to think about economic problems. At Chicago for twenty-seven years I saw a lot of the famous free-enterprise economists there, especially Henry Simons, Frank Knight, Paul Douglas, and several others. I had a Marxist friend in Chicago, in fact two, husband and wife, but they were not in a university. There was at the University of Chicago one socialist, but he went to Poland and was lost to this country.

I also came to know a German socialist in Berlin, a truly idealistic fellow. For some years my bible in economics was the pamphlet by Henry Simonds, *A Positive Program for Laisser Faire.* His scheme was to allow private businesses so long as they really competed, but to turn to social

5. Charles Hartshorne, "The Environmental Results of Technology," presented at the University of Georgia, February 18–20, 1971, for the Fourth Annual Conference in Philosophy: Philosophy and the Environmental Crisis. Published in William T. Blackstone, ed., *Philosophy and Environmental Crisis* (Athens: University of Georgia Press, 1974), pp. 69–78.

ownership or cooperatives for all natural monopolies, including railroads, for example. He would also limit the size of corporations and enforce antitrust laws. Alas he died prematurely, and apparently deliberately so.

I do not like our present situation, with the very rich getting richer and the poor poorer. Our measure of the quality of life is far too much in terms of wealth, far too little in truly aesthetic terms. The New Testament text, "How hardly shall a rich man enter into the kingdom of heaven" is taken much too little to heart. One of the ways in which I feel fortunate is that I have never been dismally poor and never filthy rich. Nor did I ever take any important step to become more rich.

The book *The Share Economy,* by Morris Weizman of Harvard, makes sense to me. It advocates our doing more as Japan does with its bonus system. If the company prospers, an annual bonus, if it does not, no bonus. But not a reduction of jobs. The system takes away security of amount of income, but at present what we have is, either no diminution of income or no income at all (when the job disappears). That surely is among the worst kind of insecurity.

I had a socialist friend in Chicago whose wife said to me once, when we were talking about income tax problems: "Think of the luxury of having an income." I often enjoy recalling this wise sentence.

A saying of Simons was, "socialism is all right as a description of heaven." Russia still has plenty of class inequality. What they seem to have is a million rich and fifty, or a hundred, million poor or something like that. However, some of their poverty is no worse, possibly not as bad, as our worst.

MV: In your essay on Merleau-Ponty, you speak highly of his "meditations on Marxism" and his remark to the effect that "In the democracies the violence is in everyday life" (*IO,* p. 362). Do you not think that, by and large, continental philosophers have been more perceptive in their reflections on democracy and capitalism than their American counterparts?

H: On the whole, I incline to say, yes. Partly to blame is our individualistic pioneering background, with no great tradition of anti-individualism such as Buddhism (with its radical relativizing of self-identity) to bring this individualism in check—in spite of Emerson's Brahmanism and Royce's great doctrine of community. But we should also remember Royce's radical eternalism and his virtual denial of genuine contingency, hence of libertarian freedom. Reaction against his errors tended to neutralize his influence. Also, the optimism of our New World sense of immense continental resources, seeming to make affluence for all a possibility, plus Spencer's notion of inevitable progress, combined with "Social Darwinism," has tended to obscure the profound issues of rich and poor and the age-old problem of a just distribution of benefits accruing from technological progress.

Another factor is the harsh dilemma in our traditional Christianity between torture in Hell or bliss in Heaven after death, which somewhat distracted attention from the real issues of misery and happiness in this life

between birth and death. That one should love the other *"as oneself"* and God "with *all* one's being" was verbally granted, but with less depth of commitment than Buddhists exhibited in their doctrines. Unbelievers, attacking theism as such, rather than its perverse forms, did not go to the essential points either.

Finally, fascination with technical, esoteric problems of logic and metaphysics makes it easy enough to set aside questions about our contingent, human social problems, provided we have been favored by the social framework, as I indeed have been.

MV: In your work, particularly in your later essays, one encounters an unmistakable emphasis on contrast and conflict as inevitable facts of life. At the same time, you ardently advocate cooperation and brotherhood of all mankind, regardless of their creed, national origin, or sex. Does not your realism in a way render your noble ideals somewhat problematic?

H: Contrast and conflict are aesthetic requirements, but so are harmony and common purposes. Multiple freedom guarantees there will be some contrast and conflict; without sound ideals there could be only hopeless, meaningless discord and mutual frustration.

Also, as Kant foresaw, military conflicts tend to get more costly and threatening to impoverished societies. What he did not foresee is that they could destroy the higher forms of life on this planet. Environmental problems show a similar tendency to become more and more deadly unless high ideals help us to mitigate our greed and indulgence in emotions of hostility, or careless indifference to the present and probable future needs of our species. We ought to be realistic about some now quite obvious, but traditionally little noticed, forms of danger. General awareness of these dangers is growing.

MV: "All the utopians unwittingly imagine an absence of creativity."[6] I agree with you that radical utopianism is not the best philosophy of social change; but is it not the case that some form of utopianism can have a positive function, namely to encourage vital reforms?

H: Yes, I agree. We have to imagine how social arrangements could be improved. We know they *will* change, and if we do not take care they may change for the worse. My answer to those who try to eliminate any hope of progress from generation to generation is similar; we cannot have simply the same values as earlier generations, for all things change, except extremely abstract aspects of reality, so that, unless we have some new values we will be inferior rather than merely equal to our ancestors. As a great German historian said, "Each age is immediate to God." Whatever he meant by this, it has a good meaning for me. Our job is not to make a greater contribution to

6. Charles Hartshorne, "Philosophy After Fifty Years," in *Mid-Twentieth Century American Philosophy: Personal Statements,* ed. Peter A. Bartocci (New York: Humanities Press, 1974), p. 151.

the divine life, but to make the best contribution we can. It must be different; our forms of beauty cannot be merely more examples of precisely the same.

MV: "The remedy," you correctly point out, "is not heaven, but better social arrangements and better conduct on all our parts."[7] Don't you think that you tend to be overoptimistic about the possibility of "voluntary austerity" in this society? How many philosophers, let alone ordinary persons, do you know who support your noble idea?

H: "Ordinary persons" are perhaps as likely as philosophers to exhibit remarkable unselfishness, nobility, heroism. In emergencies this often becomes apparent. Women at least as well as men are to be counted in this.

Saintliness will always be rare, I suppose, but what is needed is a relative but considerable shift from emphasis on some values to emphasis on some other—and, for our partly new global problems, more critical—values, including new disvalues. The general awareness of environmental dangers, nuclear war dangers, population problems, extremes of wealth and poverty, is increasing. The "glorious doctrine of greed" that Peirce objected to has never been reasonably compatible with the religious beliefs our citizens have mostly professed. Buddhism puts average Christians to shame, in my opinion, in this respect. "Love your neighbor as yourself" was taken more literally by Buddhists than by average Christians. The late Rabbi Nolan was a Jewish example of really meaning what one says religiously. He was also an example of what it is like to believe that nature is divinely ruled (yet pervasively free) and that the people who really try to learn what nature is like are scientists. Who else?

MV: You believe that "most men throughout recorded history have rationalized the subordination of women."[8] And, "Male ideals seem less and less able to protect us from catastrophe" (*WM,* p. 35). Are there such things as purely female ideals, and if so, which one(s) must be adopted in order to "protect us from catastrophe"?

H: I've not thought much about *purely* feminine ideals and am rather suspicious of them. Purely masculine ideals would, however, be worse, and I fear we have come too close to them in the past. Men have thought far too much in terms of power to coerce and far too little in terms of creative love. The history of war is a fearful thing to contemplate and recent technology has made it more fearful still. War itself seems more and more to be the chief enemy. General MacArthur himself seemed to have seen this after Hiroshima: "This is our last chance," he declared. Kant tried hard to solve the war problem, but Hegel seems regressive in this (and not only in this). Nor do I see

7. Ibid., p. 147.

8. Charles Hartshorne, "The Nature of Philosophy," *Philosophy in Context* 4, (1975): 14.

Nietzsche as much better. The late Richard McKeon thought peace was *the* philosophical problem of our time. I am not prepared to refute this contention.

What we need are *human* ideals, ideals fitting our unique status as the speaking animals. Linguistic potentialities are innate in both sexes and all races. Variations in it are vastly more individual than sexual or racial.

MV: In philosophers like Sartre and Levinas one encounters seemingly extreme conceptions of responsibility toward others. Consider the following remark by Levinas: "the intersubjective relation is a non-symmetrical relation. I am responsible for the Other without waiting for reciprocity, were I to die for it."[9] Do you find this congenial to your notion of responsibility? What are the limits of our responsibility toward others?

H: I agree that our responsibility for others is not limited to the possibility of reciprocity on their part toward us. We exist to create value, in ourselves and others. But there are many others and I do not see that any single other is more important than I am just because the other is other. And one does have a primary responsibility for oneself since no one else can as constantly and intimately know me as I can or influence me as I can. So I'm not sure what point Levinas is making.

MV: "I am influenced by my neighbors and predecessors, but not by remote contemporaries or successors."[10] How true is this contention of yours? Are we not influenced or moved by what we learn about the tragedy that happens to our remote contemporaries? Do we not at times alter our decisions because we worry about their negative consequences for our remote successors? Isn't this a form of being influenced by posterity?

H: I do not recall what I had in mind when I wrote that sentence. Probably it was merely relativity physics as I, with Whitehead, interpret it. We are influenced by our *idea* of posterity, but not by individuals who may come to be after we die. *Future individuals* names an intensive not an extensive class. While "they" are still future, they are not individuals in any strict sense. This would be the fallacy of "possible worlds." As Peirce insisted, future entities are real, while still future, *only as generalities,* not as definite particulars. Before you and I were, "we" were not even definite possibilities. This would be a superstitious reification of abstractions. If possibilities had all the qualities of actualities, actualizing them would accomplish nothing. Actualization has its value precisely from this qualitative distinction between possibilities and actualities. (Pro-life fanatics deliberately obscure the importance of the vast difference between possibilities of persons in the full value

9. Emmanuel Levinas, *Ethics and Infinity: Conversations with Philippe Nemo,* trans. Richard A. Cohen (Pittsburgh: Duquesne University Press, 1985), p. 98.

10. Charles Hartshorne, "Love and Dual Transcendence," *Union Seminary Quarterly Review* 30, nos. 2–4 (winter–summer 1975): 96.

sense and the psychological reality of such persons, thinking like persons, acting like persons.)

Remote contemporaries may, though only to a fantastically slight extent, influence us as individuals (according not to relativity but to quantum physics), but it is essentially only as ideas that truly remote contemporaries (light years away) can do much to us. In the cosmos at large, China is not remote from us. We can telephone there and have dialogues with individuals. A Chinese student living in my house did so last year.

MV: "I am not a metaethicist," you have said on one occasion, "though a few basic ethical principles are important for my whole philosophy."[11] What are those principles?

H: They follow, for me, from the old *Deus est caritas,* God is love, provided one understands love as basically sympathy. For that is how we love ourselves. We care about our own past and potential future feelings. God's love is not mere unfeeling doing good. God is the one "to Whom all hearts are open." God does not merely conceptualize our feelings, God *feels* them but *as ours.* The duality of the Whiteheadian "feeling of feeling" is not merely rhetorical, it is essential, the very point. No one quite said it before Whitehead. It fitted, precisely enough, what I believed, but I did not say it until he did. Does this mean that God suffers in our suffering? Whitehead says so: "God is the fellow sufferer who understands." (Berdyaev also affirms divine suffering.) *We* suffer without, in any full sense, understanding. To us all hearts are not open, not even our own hearts. My Episcopal minister father had similar ideas.

Kant thought that with his categorical imperative he had captured the essence of the golden rule of love. It did not occur to him that his definition of deity as *ens realissimum* was incompatible with it. And so his *summum bonum* was not the *divine* unity of ideal goodness with happiness but human achievement of this union, yet not in earthly living but in some noumenal sense. He partly missed the point. For him practical reason was, in a sense, enlightened self-interest, except for the qualification that we do not know the truth of our hope of immortality and theistic belief but only accept them to make sense out of our ethics. I say that our mortality should teach us that, as Peirce neatly put it, our aims must transcend our own future advantage.

Loving God "with all one's being" means just what it says. Kant loved God as necessary to his and our achievement of the *summum bonum.* I say also that we can "know" that God is real *if* we can know that belief in God is required to make sense out of our ethics. And we have other reasons additional to the ethical one, and just as cogent, for believing in God. Whether all can be made to so believe is another question, but so is it whether all can be made Kantians in ethics.

11. Ibid., p. 146.

Kant's essay *Perpetual Peace* seems to me a noble effort that we should not forget. He at least tried to do something about this dreadful problem. What did Hegel do? Or Nietzsche? Royce did make an effort, doubtless partly inspired by Kant. What have the Marxists done?

MV: Bernard Loomer believed that process thought could learn from Marxism, existentialism, and psychoanalysis.[12] What, in your view, could process philosophers learn from these continental schools? What, in particular, do you find enlightening in psychoanalysis?

H: One can learn from almost anyone, or any tradition. Existentialism is a doctrine of human freedom, but neglects to generalize this into a transcendental applicable to God and the humblest active singulars in nature. Psychoanalysts, especially Sullivan and some other American practitioners, have made wonderfully clear how important are the experiences infants have of their parents, *above all their mothers.* If the mother is not loved, then life is felt as hateful, and the individual is prepared for going through life motivated far too much by fear or hatred. Freud partly missed the point because of his male chauvinism. Both parents are important but the primacy of motherhood is so obvious that it is wonderful anyone could fail to see it. Elie Sagan is my authority here, but I think H. S. Sullivan saw the truth too, as did a psychiatrist of Emory University whose name I forget.

MV: Loomer also contended that "what this [process] outlook needs to develop is a total social philosophy, in its economic, political, social, and educational dimensions."[13] If we accept his view, what would process social philosophy be like? Would it be a new form of individualism?

H: Not the individualism distorted by the attempt to absolutize individual identity. Although G. H. Palmer, chairman of the philosophy department at Harvard when James, Royce, etc., were there, was not a great thinker, he did coin a phrase, the "conjunct self," which seems helpful. The reference is not to a special kind of self. Any self is conjunct with others, and this includes divine selfhood. What is needed is not enlightened self-interest but enlightened interest in selves generally, including oneself, of course. How could I love selfhood in others if I did not at all love it in myself?

The Latin American "theology of liberation" may be important here, but my knowledge of it is sketchy. Some others who take process philosophy seriously, including Schubert Ogden and W. L. Reese, have done better at this. Mary Markofski is another.

From Marxism we can learn how quantity is "transformed into quality." Doubling the population of an area does not leave the kind of lives the individuals have unaltered. Nor does making some people vastly richer, while

12. Bernard M. Loomer, "Process Theology: Origins, Strength, Weaknesses," *Process Studies* 16, no. 4 (1987): 253.

13. Ibid.

others are poorer, leave members of either group with all their previous qualities. The change from town to city does not mean simply more of the same. Fetuses are not simply smaller children and children simply smaller adults. To call all these stages of human existence *persons* obscures one of the greatest qualitative contrasts in the known universe, as "pro-life" people (note the utter vagueness of 'life') fanatically refuse to recognize.

Cruel deprivations and hideous inequalities of opportunity did characterize the industrial revolution as Marx saw, but alas they are also found in every communist society so far achieved. We rightly prize our freedoms and our rule of law, but we are still far from winning the "war against poverty," overcoming our racism, and dealing adequately with the nuclear dangers (and other destruction and pollution) in either their military or their civilian aspects. There are faults and blame "to go around." I am somewhat haunted by Nietzsche's phrase, "human, all-too human." Individual and national modesty are virtues we could all do well to cultivate around the world. Compared to the grandeur of the cosmos we are all pygmies. To say that "size is not the point" is to miss the point. A single elephant is not only bigger, it is far better, than a single worm or ant. It may not be better than we are, but the huge *brain* in the elephant and its splendid matriarchal behavior should teach us something. "The glory, jest, and riddle" of the world, our species is also the greatest nuisance and threat in that world, so far as known to us. The size of the universe gives room for a large number of planets, including many inhabitable ones.

Instead of "bigger and better" as goal, we need to consider the possibility of substituting "better, and perhaps not bigger, or perhaps a good deal smaller." To deal well with this issue will not be easy, since our traditions suited the early phases of the human expansion over the planet. Expanding over our solar system, or galaxy, differs so hugely quantitatively that differences in quality and degrees of possibility are quite certainly very great. We had better take seriously our vast isolation in the cosmos. As a physicist has said, in this context, "how conceited can we get" with our talk about the conquest of space? Our primary job is life on this planet.

MV: George Pixley (*Process Studies* 4, no. 3) has stated that "Whitehead's philosophical investigations of culture and civilization, if not counterrevolutionary, are open to appropriation for counterrevolutionary purposes." In response (in the same issue), Clark Williamson underscored the similarities between Whitehead and Marxism and rejected the view that Whitehead's "thought contains counterrevolutionary tendencies." What is your reaction to both sides of this debate?

H: Whitehead was strongly and understandingly in favor of women's rights to political suffrage, for which he argued publicly. In principle he was in favor of persuasion rather than coercion. Freedom as self-determination was for him a universal principle of reality, and human freedom was of course

the highest level of freedom, so far as we know life on this planet, and apart from deity as the supreme level. Whitehead admitted that he had been fortunate in life and probably took a too favorable view of economic and political arrangements as they were in his time. I may be open to the same charge. I have always been tempted by the socialist ideal, though never by Lenin and his crowd, and certainly not by Nazism.

Whitehead did defend Chamberlain's concessions to Hitler, on the grounds that a million young men would have died otherwise. As it was, many millions died. The Englishman's view of the price of stopping Nazism was far too low. Any chance to do it cheaply had passed. I do, however, recall once when I mentioned Hitler to him and it was as though a shadow had been cast over his face as he replied, "I'm afraid mankind is going into a decline." I'm not sure *when* this was.

MV: "What is lacking in much recent British thought," you write, "is even mild curiosity about ontological questions" (*IO*, p. 303). This criticism, one may argue, is perhaps equally applicable to many American philosophers who are hardly sympathetic toward British philosophy. What are your main criticisms of American philosophers nowadays?

H: Perhaps I've been too busy doing my own thing to make much relevant criticism. Unlike England this country is too vast, and we have too much freedom, for any one school of thought to dominate at all completely. Anything fairly well done can get a hearing. I think that Quine, admirable writer and gentleman that he is, is taken even more seriously than he quite deserves. He is deliberately self-limited in what he tries to do, leaving too many central issues dangling. His attempt to do away with the idea of ontological necessity, his holistic contingentism, which I cannot see that he himself really believes, makes him in my view inferior to Carnap or Popper. Also he does little with the history of philosophy, although in this respect he is like Carnap. As he himself says, his central interest is in mathematics. From that stronghold he makes sallies into philosophy. His intellectual agility (and wit) is admirable. But the primary issues are not much illuminated. On some questions, he is "on the side of the angels," for instance in rejecting the notion that altruistic behavior has to be justified in terms of enlightened self-interest (in *Quiddities*).

For understandable reasons, ours has been the age of specialization in philosophy. Some do ethics (or metaethics), some aesthetics, some are scholars in a single philosopher, or a portion of the history of philosophy. The general population is left remarkably unphilosophical, it seems to me.

Wilfred Sellars and Richard Rorty (my student once for a year) ably represent the trend toward reducing philosophy either to a minor game played by philosophers or to a vague "pragmatic" scheme for preparing people to do without truth other than that given us by science. Or is it (Rorty) that we must do without truth and content ourselves with the present state of discussion?

With Tarski and Popper I hold it to be obvious, or reasonably beyond doubt, that there is truth by correspondence in some genuine sense (or senses). The precise sense (or senses) is the reasonable issue. Both Sellars and Rorty exhibit a materialistic, mechanistic, and atheistic bias, and to those with this bias they may give some satisfaction. In view of the mistakes by theologians and scientists and because of the dangers of fanatically held religious beliefs, I can to some extent understand this.

MV: Reading your remarks on your own contribution to philosophy, one on occasion gets the impression that you regard your work merely as a revision of Peirce's and Whitehead's systems, which basically amounts to emphasizing what they failed to adequately emphasize, e.g., the asymmetry of the subject-object relation. How exactly do you regard your philosophy vis à vis the philosophies of Peirce and Whitehead?

H: I have made explicit the *general principles* which these men largely conformed to but did not quite state about the *ultimate contrasts,* as I call them, such as necessary/contingent, absolute/relative, symmetrical/one-way, infinite/finite, object-subject. I have arrived at several schemes genuinely new and, I have no doubt, valuable for metaphysics. One is the idea of doctrinal matrices, *exhaustive divisions* of the optional answers to metaphysical questions. Related to these is a pattern for revising *arguments for theism.* Instead of the old format of allegedly self-evident premises entailing the divine existence, a limited number of statements, theistic or nontheistic, are arranged in sets to constitute quadrilemmas or quatrilemmas, such that the statements in a set *logically could not* all be false and *only one could* be true. What these schemes do is to make explicit the cost of not asserting the form of theism or atheism that one favors, and also the cost of the other options. To assert any one is to deny all the others. To reject any one is to face a choice among the others—or admit you do not know. Something more than formal logic is unavoidable in dealing with this, as with any basic, philosophical issue. But formal logic does play a role, if we are rational.

MV: One recurrent idea in your philosophy is that "we intuit God" and thereby are influenced by Him/Her (*AW,* p. 41). Or take your claim: "So far from finding any severe paradox in the idea of direct experience of deity, or the unsurpassable, the paradox is, in my view, to suppose that such a reality could be known or truly affirmed only on the basis of indirect evidence. The Unsurpassable must be unsurpassably pervasive, that is to say, ubiquitous. It must be where everything is."[14] In what sense of the term do we intuit God, and how is your view different from that of mystics?

14. Charles Hartshorne, "Mysticism and Rationalistic Metaphysics," *The Monist* 59, no. 4 (Oct. 1976): 463.

H: I hold that what mystics do consciously others do unconsciously. To experience is not necessarily to know *what* one experiences. Only divine experience has this fully conscious character.

My first philosophy teacher, Rufus Jones of Haverford, was a scholar in mysticism who held that the difference between mystics and ordinary people was a matter of degree. My metaphysics implies that this is true. If anyone experiences God we all do, but not all of us do so consciously. In many ways it is evident that there is much in experience we are not normally aware of, and cannot ever be fully aware of. Such full awareness of one's experience is possible only for God. Argumentation for theism has to be indirect, but if it is successful what it shows is that it is impossible for anyone not to prehend God. Most nondivine prehensions are feelings, not conceptual cognitions, and in most cases (with other animals rather generally, I suppose) could not be cognized. It is one aspect of our unique position as the talking animals that for us it is an open possibility, but one not inevitably actualized.

MV: In your essay "Mysticism and Rationalistic Metaphysics"[15] you contend that "The challenge of mysticism needs to be taken seriously." What, if anything, can mystical thought contribute to Western rationalism?

H: I like Whitehead's remark, "Philosophy is mystical, not in its method, but in its conclusions." In the end we know that we can never "see" God, or anything else, as God sees God or other realities. As previously stated, I like in Rufus Jones, the great Quaker writer, his contention that mystics differ only relatively from ordinary people. Talk about absolute differences tends to be careless (apart from strict logical type differences), and we are all members of one species. Moreover, from the concept of prehension which I owe to Whitehead, and definitions that I find appropriate of the distinction between God and all else, I find it deducible that in whatever sense anyone experiences or prehends God, and indeed if 'God' has denotion at all, all subjects must prehend God. Mystics are those who can be highly conscious of what must be there in everyone's experience.

One more thing. In medieval Christian, Islamic, and Jewish mysticism are found statements which to some extent provide what the orthodox systems failed to make room for. For instance the entire independence of God from the creatures is by some mystics definitely negated. Indeed it is left unclear whether the writer did not go to the opposite extreme, and assert the entire dependence of God upon the actual creatures, as did Spinoza. Rationality and mystical experience may both contribute to wisdom.

MV: In an interview which took place in 1981, Jacques Derrida remarked: "It is as impossible to say what philosophy *is not* as it is to say

15. Ibid., p. 469.

what it *is*."[16] What, according to you, is the function of philosophy? Do you agree with Popper that philosophy's task is to critically examine humans' "dubious and often pernicious views of uncritical common sense"?[17]

H: I like perhaps better Creighton's view that philosophy is criticism of categories, where category means a very general conception, such as actual or possible; contingent or necessary; subject or object; singular or plural; mind or body.

The word philosophy is used loosely. I think one can say what metaphysics is not, if one accepts as I do Popper's demarcation test, "If any *genuinely conceivable experience could* falsify a statement it is not a metaphysical truth." Empirical statements, those not metaphysical, would be falsified by some conceivable experiences. Both empirical and metaphysical statements can be supported or confirmed, but not strictly proved or verified, by experiences. I largely agree with Popper's theory of knowledge. Philosophy is more than metaphysics; it has to mediate between metaphysics and the competing religions and many divisions of science and the common sense of the community. It must try to justify itself as the critical consideration of the basic contrasts, including facts and values, actualities and possibilities, objects and subjects, particulars and universals.

MV: "I predict," you have written, "that the natural science of the future will make ever increasing use of certain principles that have been emerging in modern metaphysics during the last several centuries."[18] Which principles of this emerging metaphysics that you, no doubt, favor will be embraced by science in the future? Will any of your own principles be among them?

H: Science is coming closer to ridding us of the false ideal of absolute order and necessity embodied in Stoicism, Spinozism, Leibnizian sufficient reason, strict Kantian causality—with freedom dismissed to the inaccessible noumenal realm, and Hegelian or Marxian dialectic—in which some alleged but ambiguous, slippery superlogic manipulates the agents in history. The door has been opened for a philosophy of freedom, with causality the way in which acts of freedom influence subsequent acts without fully predetermining them.

We face also the task of overcoming the problem now of how to overcome two mistakes about mind and matter: dualism and materialism. Apart from dualism, *either* in principle physics is the ultimate science *or* a generalized comparative psychology is. Neither physics nor psychology has offi-

16. Richard Kearney, *Dialogues with Contemporary Continental Thinkers* (Manchester: Manchester University Press, 1984), p. 114.

17. Karl R. Popper, "How I See Philosophy," in S. G. Shanker, ed., *Philosophy in Britain Today* (Albany: State University of New York Press, 1986), p. 204.

18. Ibid., p. 15.

cially declared on this issue. A simple conjunction of "mind and matter" is a counsel of despair. I hold that a universal psychicalism is the only long-run solution. It will be Leibniz, but with some qualifications upon sufficient reason, with windows between the monads or active singulars, and a relativizing and pluralizing of the self-identity of individuals through change, also a relativizing of their nonidentity with one another. "We are members of one another" (in another translation, "members of the body of Christ"), as the Apostle Paul said; also the final unit-reality or monad is not I or you but I now or you now. In all this I am Whiteheadian. But Peirce and Bergson anticipated important aspects and were part-causes in my arriving at the view.

MV: One perhaps puzzling aspect of your philosophy is your "idealism." For you, objects do not depend on our particular experiences of them; rather, you believe in the asymmetrical dependence of subjects on their objects. Thus, epistemologically speaking, you are not an idealist but a realist. However, you contend that "Epistemological realism is entirely compatible with metaphysical idealism."[19] What, exactly, does your "metaphysical idealism" entail, and is "idealistic" indeed an appropriate label for your type of metaphysics?

H: I deal with this especially in "The Synthesis of Idealism and Realism," *Theoria* 15 (1949); also in "What was True in Idealism," *Philos* 43 (1946). The key is fourfold: (1) subject-object relations are subject-subject relations so far as objects are active singulars and concrete, otherwise the objects are abstractions from or collections of such subjects; (2) actual objects are temporally prior to and hence independent of subjects to which they are given; (3) subjects (Leibniz) are enormously varied and in the vast majority of kinds more or less radically different from human persons, varying from feelings of electrons, say, at the lower end of the hierarchy, to God at the upper end; (4) fully concrete and particular subjects are not persons and the like, but single experiences (Whitehead's actual entities). My psychicalism and Whitehead's "reformed subjectivism" are virtually the same, so far as I can see. The subject-object relation is prehension. No one else ever clearly had this idea previously. Tibetan Buddhism seems to have come fairly close, Berkeley and Hegel not at all. Ewing's definitions of idealism include one that clearly fits my use of the word.

MV: You take the question of meaning seriously (*CS,* chap. 2). Like Popper, you acknowledge the importance of language in the formation of consciousness. Yet analytic and linguistic philosophers (particularly most of Wittgenstein's followers) have not received high marks from you or Popper.

19. John B. Cobb and Franklin Gamwell, eds., *Existence and Actuality: Conversations with Charles Hartshorne* (Chicago: University of Chicago Press, 1984), p. 13. Cf. *CS,* p. 168.

What, according to you, are the merits and shortcomings of analytic and linguistic philosophies?

H: In not making explicit how much I have in common with the linguistic analysts I have missed a chance. I share their view that philosophical technical terms have to be explicated in ordinary or (Ryle) "standard" language. Thus I substitute "independent" for "absolute" as a term for the divine supremacy, and then show that the former word also has ordinary uses that are helpful theologically. I then go on to insist that both dependence and independence must apply to God equally literally and without contradiction. I similarly reject the word "perfect" as a technical term for divineness, and distinguish two meanings, both of which are needed theologically, i.e., absolute perfection and relative perfection. My quarrel with the partisans of ordinary language is the biased way in which they proceed. They quarrel with the idea that God 'loves' creatures on the ground that divine power, allegedly absolute, fails to result in the world as one would expect if the motive were love. But they allow 'power' to pass unchallenged as a technical term from which deductions may be made. The Book of Job challenges our ability to know what we mean by the divine power to create or rule the world. Omnipotence is the smoking gun here, much more than "love."

MV: You have charged rival philosophical theories (e.g., linguistic analysis and classical theism) with being anthropomorphic and anthropocentric. However, you admit that your own philosophy is not altogether free from anthropomorphism (*WM*, p. 120). What makes your anthropomorphism more cogent than those of your rivals?

H: Peirce is my authority, though Whitehead is similar, for distinguishing between legitimate anthropomorphism and not legitimate. Peirce said all our thinking has to be "zoomorphic." What we know best is ourselves as thinking animals. We get to the rest by analogy. Physicists do it too, as he held and I hold. The question is how well we do justice to the two sides of an analogy, the likeness and the difference involved. We and other animals have bodies, does God? No, said Aristotle and Aquinas; yes, said Plato. But he views the divine body as vastly different from ours, and not merely in degree. Our body is a fragment of the Cosmos, God's is the Cosmos. I add, God is "unborn and undying" (in Buddha's phrase); we are born and die. We can be diseased; can the Cosmos? The sixteen possible views about applying ultimate contrasts or polarities to God bring out the difference between God and the creatures.

MV: You are arguably the most metaphysical theologian of this century. It is your belief that knowledge of the history of metaphysics is a necessary condition for sound philosophy. Is it also the case that one must be competent in the history of metaphysics in order to produce a sound theology?

H: Ideally, yes, but human limitations set limits. Niebuhr was a good scholar in the history of theology, but Tillich perhaps was more competent in

the history of metaphysics. Yet I take Niebuhr to have been the greater theologian. (This was partly a matter of character.)

One of my maxims is, if you don't know a subject relevant to your work, try to read or talk to someone who does know it. My father read, or in a seminary listened to, some good scholars. He was also a friend of several such scholars. In some respects he was a sound theologian. I am not anything like a physicist, but I know what some of the good physicists think about physics in its metaphysical aspects. Also what some good biologists think or have thought about metaphysical problems of their subject.

MV: A cursory review of your work would show that your intellectual interests are much broader than those of many (even well-known) contemporary philosophers. Can one pursue philosophy or theology without knowing a good deal of natural sciences?

H: Not to know any science at all is to be uneducated—on this I agree with T. H. Huxley. But how much one needs to know varies. One must at least pay some respectful attention to scientists who have a gift for, and make the effort to engage in, writing or speaking to the educated public. I was once (for twenty-five years) the sole professional philosopher in a club of scientists at the University of Chicago. This was a great stroke of good luck. Once in the men's room at the Faculty Club a club-member who knew something of my theological interest asked me, "Hartshorne, are you still working on God?" Before I could even begin to focus on the question, the voice of Hutchins came from behind me, "He ought to let God work on him." What better answer to the question could there have been?

The great philosophers have been more than merely that. Aristotle was a great biologist and *the* logician of the ancient world. Descartes was a great mathematician and a physicist; Leibniz spanned, with his creativity, many sciences of his time. Peirce did this in psychology, physics, mathematics, formal logic . . . I could go on. On a humbler level, my ornithological essays and book were taken seriously by experts in their fields and some of the ideas in them are, after more than thirty years, still cited. If I discuss metaphysics and its distinction from empirical science, I have been a practitioner of both. *Born to Sing* deals with a host of observational facts, some of them my observations. My first book, on sensation, also appeals to hosts of observations, and some psychologists judged, or now judge, it ahead of its time. The basic ideas of these two books have yet to be refuted. I will have to be evaluated under more than one heading, perhaps as many as four—sensory psychology, biomusicology (science of animal music), metaphysics, philosophical theology. There is also phenomenology, in which my views synthesize ideas of Husserl, Heidegger, Bergson, Peirce, Whitehead, and Dewey.

MV: One unique feature of your work is the degree to which you have tried to defend the possibility and necessity of a reformed (neoclassical) metaphysics. Besides, you have defended the legitimacy of "intruding the

theistic aspect into the definition of metaphysics" (*CS,* p. 40). In fact, one quotable statement of yours is, "A Godless metaphysics is a dull affair" (*IO,* p. 334). This, some might say, is more a theistic bias than a self-evident thesis. Are Godless sciences and aesthetics, too, dull affairs?

H: These are astute questions. It is my *empirical* observation that godless metaphysical systems have been found dull. Hume turned to history writing, Russell to all sorts of concerns.

Egyptian and Greek deities were found exciting, but who can now believe in them? Sellars (father and son) had/have a godless metaphysics, but how many scientists bother with it, or how many politicians or statesmen? Buddhism is the strongest case of a seemingly godless but interesting metaphysics. But Buddhism is only ambiguously rationalistic. Also, according to the Buddhist scholar Suzuki, it is only ambiguously atheistic. I try to be a rational theist.

MV: "It is the logical questions [about fundamental metaphysical concepts] that we need to put" (*CA,* p. 207). How important is logic in your metaphysical outlook?

H: Most of my teachers (especially C. I. Lewis and H. M. Sheffer) were logicians, so were Plato (by standards of his time) and certainly Aristotle. Also Leibniz, Peirce, Whitehead. I learned from Carnap as colleague, too, and from Popper. Metaphysics is inquiry into the logic of the most general conceptions. Because of their generality they have mutual requirements from one another. On that abstract level, truth is by coherence.

I have tried to use logic to make it possible to exhaust the possible definite answers to metaphysical questions. Finally, in the case of theism, it has turned out that there are sixteen mutually exclusive and collectively exhaustive ways to apply polarities such as finite-infinite, relative-absolute, subject-object, God and what is not God (the world). This had not been done before, but so far as I can see, until it was done nobody could rationally know what the theistic question was. To select among sixteen possible theories as though they were only two or three, or five or six, when they are sixteen, is not to know what one is doing.

MV: It is well known that you reject claims like "there is no progress in philosophy" or "metaphysics is nonprogressive." By what criteria do you decide that there has been progress in philosophy?

H: The progress is chiefly exemplified by the great creative thinkers. The advance is not unqualified; there are regressions, too. Plato's duality between the Demiurge and the World Soul was lost in Aristotle and badly distorted in the Neo-Platonists, but was finally refound on a higher level of insight in the movement from Socinus and some others in Europe through Fechner, Pfleiderer, Lequier, Varisco, Whitehead, W. P. Montague, Hocking, myself, and now a fair number of others. Also some in Asia.

The test is, does the philosopher know what, by his assertions, he or she is implicitly denying? Does the thinker know *what else can be thought* on the subject in hand? Whitehead, in rejecting classical determinism, knew very well what he was rejecting; in accepting quantum theory he knew well the classical view of continuous change that Max Planck had found not to fit the facts. Not a single ancient Greek had even a notion of the possibility of a cell theory of animal and plant organisms. Logically, they could have thought up such a theory, but they did not.

Aristotle, in his theory of an organism as simply a single form or soul in a single mass of matter, was implicitly denying not only what Democritus had asserted about atoms but also what logically some later successor could assert about cells. In many other of his theories he similarly reasoned from ignorance as though it were knowledge. The aim of philosophy is to argue from genuine knowledge, not from blind guesses as though they were bits of knowledge.

MV: Certain continental thinkers and their American disciples have questioned the philosophy/literature dichotomy traditionally held by those who attribute to philosophy a privileged access to reality. In your view, is literature able to fulfill the task usually assigned to philosophy, namely, to satisfy humankind's metaphysical curiosity?

H: Literature as a form of art aims at the creation of valuable forms of experience. Beauty and related values—prettiness, sublimity, comedy, soul-stirring tragedy—are its aims, more than literal truth. Still, much truth can be conveyed in this way. Much of this will consist of empirical truths about the contingent human species of animal, not metaphysical truths about God or all cosmic epochs. However, in Wordsworth's poetry I find deep truths about nature not yet to be encountered so definitely in treatises on physics, biology, or astronomy. Here Whitehead and I agree closely. The great novelists knew more about the possibilities of human life than most of us would be able to get from simply meeting actual people, reading newspapers, historians, or perhaps psychologists. And the novelists give us this information along with the aesthetic values mentioned above. We are not just learning about life, we may be intensely living, as we read them.

MV: Nietzsche once wrote that "Compared with music all communication by words is shameless."[20] You, too, have praised the superiority of art (particularly music) over other modes of communication, including metaphysics.[21] Do artists enjoy a privileged access to God?

20. Frederick Nietzsche, *Will To Power,* trans. Walter Kaufmann and R. J. Hollingdale (New York: Vintage Books, 1968), p. 428.

21. John B. Cobb and Franklin Gamwell, *Existence and Actuality,* p. 77.

H: Nietzsche and Schopenhauer say some profound things about music. Rufus Jones said that some Quakers were "stupid" to exclude music from their religious meetings. Of course music can scarcely define the idea of God, but it can convey affective states suitable to express what it is like to worship God. It can convey the sense of the sublime, or of dedication, or of tragedy, or of deep mystery. Balinese percussion music to me seems to impart such a sense with its slow sounds from deep kettledrums, contrasting with the rapid tinkling sounds from the small percussion instruments.

MV: In your philosophy, you have tried to do justice to both a priori and empirical elements in knowledge and valuation. Which one of the following philosophers does more justice to the aforementioned elements, Whitehead, Peirce, or Popper?

H: Probably Whitehead, but all three are good; and Popper gave the best definition of the empirical-metaphysical 'demarcation', which is indeed a priori. Peirce's tychism is the key to time's arrow, the indeterminate but to-be-determined future, in contrast to the determined or actual past. His three categories, with some clarifications, and Whitehead's prehensive actual entities mutually clarify and partly support each other. Peirce's uncritical, pre-quantum ontologizing of continuity has to be curtailed as I think he could have been convinced had he obtained mental alertness for a few decades longer.

MV: A metaphysical statement, you agree with Popper, is unfalsifiable experientially; but you go on to add that "It does not follow that it is in any absolute sense 'unverifiable'."[22] In what significant sense is a metaphysical statement verifiable?

H: Since metaphysics is the study of concreteness as such, any case of concreteness is an illustration of metaphysical truth. Any momentary experience, intuited or prehended in immediately succeeding experience, is an example. There is a phenomenological aspect of metaphysics. Before and better than Husserl, Peirce dealt with this in his "Phaneroscopy." Later, he used Husserl's term also. Whitehead's "Metaphysics is a descriptive science" points to the same idea. As Popper has it, metaphysical truth is "confirmable," weakly verifiable or supportable, by observation. What observation alone cannot give is necessity. Many statements are observationally true but are also contingent, and might have been false.

Mathematical statements can be necessarily true; but the necessity is conditional or hypothetical. Metaphysics seeks *existential* necessities, what must be in every conceivable cosmic epoch.

MV: You criticize Stephen Pepper's predilection for metaphorical classification of philosophical systems (*CA,* pp. 205–10), yet your own meta-

22. Charles Hartshorne, "Present Prospects For Metaphysics," *The Monist* 47, no.2 (winter 1963): 207.

physical reflections are not devoid of metaphors. What metaphors can a meta-physician legitimately use in his/her system? Or is it perhaps preferable (if it is possible) to avoid them altogether?

H: Whitehead's "Philosophy is the criticism of analogies" (and he also uses "metaphor" in this context) implies that one cannot do without them. "Philosophy of organism," "cell theory of reality"—"Eros" as standing for God, "prehension" for the intuition of already actualized entities, show how much he relies on this linguistic resource. But none of Pepper's four basic metaphors, as he uses them, quite fits what Whitehead does. What fits best is contextualism, *provided* one does precisely what Pepper *refused* to do, gener-alize the *social* context so that all enduring, changing individuals become societies, and God is the cosmic and supreme social agent—except that here Whitehead falls into a traditional oversimplification of treating God as a sin-gle actual entity rather than a sequential society.

The structure of dependence and independence, or internal and external relations, and the subject-object structure, also mind-body, carefully general-ized, are the crucial keys. The new concept of prehension is the great break-through, plus the idea of quantized, rather than continuous becoming. It is the ultimate contrasts, or polar contraries, and their logic that count, rather than the analogies Pepper emphasizes.

MV: You contend that "science has made it easier and easier to see, what metaphysically was always accessible to sufficient resolute inquiry, that the absolutizing of law and regularity is self-defeating."[23] How about the con-tributions of metaphysics to science?

H: Metaphysics tries to distinguish hypotheses that could be true from those that could not be. Only among the former could the truths about the present cosmic epoch be found. My factual study of bird behavior was greatly helped by Whitehead's metaphysical principle that all actuality seeks beauty, aesthetic satisfaction.

Ancient atomism derived logically from the Parmenidean thesis that being is immutable and positive. However, the atomists affirmed that nonbe-ing must also be, and cleverly identified nonbeing with the void, empty space. So the atoms had size and shape but could only change by altering location in the void. The metaphysics was partly wrong, but so was that of Parmenides; and the two together began the long search for the golden medium between excessive monism and excessive pluralism, also between an excessive empha-sis on space (and a false view of time and change) to a proper understanding of space-time, or better, of time-space.

Democritus, followed by the Stoics, asserted that "necessity" is the uni-versal principle, thus denying freedom, in the causal sense in which past conditions determine only what could happen next, not what does happen, so

23. Ibid., p. 202.

that the present actuality can be self-determined rather than the uniquely pre-programmed result of the past. Epicurus defended the reality of freedom. Physics has come to agree with him, or at the very least to give up the claim to refute him.

MV: Not very long ago, you noted that "by my criteria [George Herbert] Mead was not a metaphysician. It follows that he was a great philosopher only in the sense in which philosophy is not identical with metaphysics" (*CA*, p. 143). It seems that for you, philosophers, unless they are metaphysicians or sympathetic towards metaphysics, are only men of "middle-sized ideas." Is this impression correct?

H: I incline to think that. Dewey tried to finesse the issue, but his Hegelian background and his lack of mathematical sense limited him. He wrote on Leibniz but failed, as Hegel did, to learn much from him. He did contribute to political philosophy, as Mead did to sociology. His aesthetics was rather good. He tried to help in philosophy of religion, but ignored Peirce and Montague (in his own Columbia University, i.e., in Barnard [women's] College), and was unable to appropriate much from Whitehead because of his behavioristic and antitheistic bias. This was partly because Whitehead himself was too little behavioristic.

MV: You once wrote, "a view like Rorty's . . . is like a *quarter-truth* mistaking itself for a *whole* truth, while denying that there is *any* truth!"[24] This is not exactly a compliment and shows that you have little sympathy for philosophers like Rorty's way of philosophizing, or as some might say, undoing philosophy. What is your overall view of a Rortyean attempt to deconstruct "epistemologically centered philosophy" and construct a "philosophy without mirrors"?

H: To me the unqualified denial that experience mirrors reality to any extent or in any way is downright silly. The opposite extreme, that human experience completely, perfectly mirrors reality is also silly. The truth has to lie between these extremes. Rorty admits that scientists and theologians tend to look for some degree and kind of mirroring, and that some kind of idealism or psychicalism is the only likely result. But, he asks, "Who now believes in idealism?" I find this argument unimpressive.

Considering the deep contrast between physics and psychology, as at present, and the contrasts between rival religions, or any religion and science, I fail entirely to see how humanity can do without philosophers to mediate between these forms of human life. Debates about abortion, or about evolution versus creation science, so-called, show what happens when a population lacks the philosophical culture to deal rationally with such absurd claims as that a fetus lacks nothing of what makes mature human persons important,

24. Robert Kane and Stephen H. Phillips, *Hartshorne, Process Philosophy, and Theology* (Albany, N.Y.: State University of New York Press, 1989), p. 182.

compared even to whales or gorillas. Or that religion should worship a book written, translated, interpreted by people as the very voice of God.

MV: It is your view that traditional theism suffered from an "all too negative theology" and an "all too negative anthropology" (*LP*, p. 147). What we need, therefore, is a new (less negative) anthropology, otherwise "God becomes inconceivable" (*LP*, p. 143). But neither is a viable anthropology possible without a "clear knowledge about God" (*LP*, p. 144). Excluding process theology, what other theological traditions have made viable contributions to a sound theology?

H: Among Roman Catholic theologians various approaches to a positive theology have been made. I have been invited to speak at various Catholic institutions, even a Trappist Monastery (I had a conflict of engagements unluckily) where I was assured I would have a cordial welcome. I did have such a welcome at Marquette University for an Aquinas lecture. Rabbi Bemporad, a disciple of Rabbi Heschel, and I find our views very compatible. Many Unitarian-Universalists find my work helpful. I was invited to teach for a semester at Leuven in Belgium. One branch of Hinduism, the Bengali School of Sri Jiva Goswami anticipated process theology in some important respects by a century or two. Some trends in German theology are partly in the new line. Among Methodists, John Cobb and Schubert Ogden are influential writers whose views are more or less based on Whitehead's or my philosophies.

Rabbi Heschel has said what some Christians ought to have said long before, and what I think my Episcopal father would have liked: "God is the most moved mover." By adding two words, these six words virtually cover the subject to perfection: "God is the most *and best* moved mover." Surely, of the ancient Greeks, Plato came closest to this. It precisely corrects Aristotle just where he was most definitely wrong; but where he was followed all too definitely by nearly two millennia of writers in the three principal schools of Western theology.

MV: Perhaps more than any contemporary theologian and philosopher, you have defended the idea of freedom: "the denial of freedom ruins theology" (*OO,* p. 71). I have the impression that once an author inclines towards strict determinism his/her philosophy no longer appeals to you. Is this accurate? Was there any period in your life when you opted for strict determinism? If so, what caused your conversion to a philosophy of freedom?

H: Many contemporary theologians—Cobb, Ogden, and others—are not deterministic. My father's theology was not, though he perhaps limited freedom to God and humanity. I once accepted psychological determinism for a brief time, while watching a drama in which a character is made to seem completely determined by certain drives. But I soon saw that strict determinism is an overstatement of anything such evidence could establish. I read Spinoza with care but never agreed with his necessitarianism; and I also never

accepted Leibniz's idea of "spiritual automaton," much as I like some aspects of Leibniz's thought.

Even Santayana finally gave up determinism, although he never adequately appreciated the value of this move for the philosophy of religion and for ethics. I suspect it was Peirce who influenced him in giving up his earlier mechanism. Except for J. Edwards at the outset and for R. W. Sellars and his son Wilfrid, American thought has been largely libertarian in metaphysics as well as in politics. French thought has been like ours. British and German thought, especially the former, has not, but with and since Schelling, the Germans, and lately even the British, have changed for the better.

MV: Not many living prominent philosophers enjoy your familiarity with several traditions in philosophy: Eastern and Western (continental as well as Anglo-American) philosophies. What have you learned from Asian philosophical traditions which you could not equally learn from Western philosophies?

H: I have partly answered this in responding to a previous question. Loving others as oneself makes sense only if Buddhism and Whitehead are correct in rejecting the absoluteness of personal identity through change. Buddhism had a metaphysics of altruism, Christianity did not. This is tragic. "We are members of one another," was in the New Testament but was not taken seriously. We are partly identical with others and not wholly identical with ourselves through change. Those who quarrel with this are really falling into a verbal trap. They think the denial of absolute identity is the same as the assertion of absolute nonidentity. In that case nothing makes sense. False absolutes always snarl the twine. We sympathize, "identify," with our own past and potential future experiences, we also do this with the past and future experiences of others. The analogy is genuine and goes deep. Most psychologists, I suspect, would see the point here. Absolute egos are not known entities, apart from God. Moreover, the Aristotelian-Thomistic doctrine of a wholly or merely absolute divine ego, many of us have come to see, is nonsense.

Not only Buddhism, Vedantism also conflicts with the notion of a multiplicity of absolute egos. Indeed I wonder what Oriental religion fits that notion. Possibly Jainism, with its personal immortality and denial of deity? Some Westerners I could name have agreed.

MV: In the early 1960s you complained of "the dearth of careful criticism of my writings" (*LP*, p. ix). Has this situation changed? Have you lately encountered fair and constructive criticism from scholars?

H: That was over twenty-five years ago. Yes, I've had a reasonable amount of good criticism. I have no longer any complaint about that. My joint fascination with Peirce and Whitehead complicated by my exposure to Husserl and Heidegger in Europe, made me to some extent a late bloomer. I had a lot to digest. Luckily, in spite of the slowness with which my views

were taken into account, of all the philosophers who have ever lived a long life, I may well be the one who has had by far the greatest opportunity to profit from critical evaluations while still able to react energetically to these appraisals. This present work is one of five question and answer or critically evaluative books, the others much longer than this one. I feel deeply indebted to you for the remarkable way in which you planned and executed your part of this undertaking. It is unique in combining brevity in questions and answers with limiting the questioner to one person, who, however, takes great care to select only relevant questions.

MV: Your conceptions of evil, divine omnipotence and perfection, or personal immortality, for example, are nonconventional and contrary to what many have believed for at least two millennia. Also, you emphatically reject strict determinism and dualism, and contend that metaphysics is essentially theistic. In other words, you have not tried to be popular. Is this the reason why your philosophy has not been given the attention that it well deserves?

H: These are only some of the reasons why I did not feel that I had to be preoccupied with what "everybody" was saying. But my work has never been *badly* neglected. *Beyond Humanism,* over fifty years ago, sold nine hundred copies immediately to a Book of the Month Club. Even my first book got some cordial reviews. Also in a sense I make human beings less guilty than some theories do, since the evils that occur are always brought about partly by the chance intersections of the multiplicity of free decisions (by nonhuman as well as human creatures) that are always involved. No one, human or divine, is solely responsible for concrete actual occurrences. Growing up in a secure family of eight persons, with each of whom I was popular enough, I did not develop the desperate sense some have of the need for out-of-family support. With parents, both of whom felt at ease with a main-line religion, and also, in my father's case especially, with science as it then was, especially biology and its evolutionary perspective, my first great intellectual challenge was to decide how far I could agree with the parental religious position, once Matthew Arnold had made me aware of its openness to incisive criticism. I had to solve *this* problem, no matter what others' problems might be. No very high percentage of philosophers in this century can have grown up in a family much like ours. Some intellectuals have had to fight a crudely antiscientific form of religion, which looked to the Bible for information concerning the facts of nature. Father thought *that* a silly idea. So did my *maternal* grandfather. The continental, not the Anglican, Protestants substituted Bibliolatry for idolatrous churchism. Some have had to reconsider a crudely antireligious family inheritance. Many, I suspect, were in effect taught either that obtuseness to science was a religious demand, or that obtuseness to the (perhaps legitimate) claims of religion was a scientific demand.

MV: Your view is that the essential theistic issue is not so much whether God exists, but whether we clearly know what we mean by the term

'God'. Do you consider this correction as one of your major contributions to theology in this century? For which theological insight would you like to be remembered?

H: My "Anselmian Principle" (that the God of the high religions *either* could not exist and is an incoherent or hopelessly indefinite idea *or* could not fail to exist), i.e., that to know that the God idea makes sense and to know that God exists are inseparable. Carnap held that the idea lacks possible "cognitive meaning" and to this extent he was logically closer to my position than to that of many theists. I would like to be remembered for this *and* for my analysis of the sixteen logically possible ways of thinking about God and my defense of one of the sixteen (*NC.cn*—see chap. 5) as alone making coherent sense. Also for my defense of Plato's analogy of God as Soul whose body is the entire Cosmos. The sixteen-fold division has no precedent in the literature outside of my writings. It took fifty years and help from Joseph Pickle of Colorado College to get it right a couple of years ago.

MV: In retrospect, how would you evaluate your own philosophical career? Are there things that you wish you had done differently? Do you notice mistakes which you prefer you had avoided?

H: I deal with the question of my mistakes in my book of recollections, *The Darkness and The Light*. I might have written fewer articles and more well-planned books. I might have developed my grasp of mathematics and formal logic further. I rather wish I had written a book on aesthetics. James Devlin has some notebooks of mine from my aesthetic teaching and thinks of writing a book on the subject from my point of view. I hope he does. On the whole I think I have been lucky to do as well as I have. Weiss and I had a somewhat similar simultaneous exposure to Peirce and Whitehead. I cannot think he learned as much from either, but certainly not nearly as much from Whitehead.

I would like to close by recording my gratitude to researching medical science and practicing medical art that have made it possible for me, at the age of ninety-nine, to be not only still alive but still able to be excited by ideas and to do something to express this excitement. Repeatedly through my long life, that science and that art have been required to make this now possible.

2

DO BIRDS ENJOY SINGING? (AN ORNITHO-PHILOSOPHICAL DISCOURSE)

WHY do more people study birds than any other class of nonhuman animals? There are at least a dozen reasons for this popularity, such good reasons that one almost wonders how the other animals can attract any enthusiasts at all! That birds sing more and better than other nonhuman creatures—though some insects, amphibians, howling wolves and coyotes, gibbon apes, and humpbacked whales, can be said to sing—is but one of these reasons. It is, however, the one that, more than any other, led me to become a keen birder over sixty [now eighty] years ago.

Being a philosopher during most of those years, I have not been content to identify species and keep a life list; I soon ceased to bother with the latter. What I have wanted to do was to discover new *truths* about song, to probe deeper into the mystery of *subhuman music*. This interest was intensified when I was (about 1929) asked to teach aesthetics at the University of Chicago. I knew that three musically trained people (Cheney, Matthews, Saunders) had studied songs of Eastern North American birds and had found that, as patterns of sound, they are definitely musical. The composer Dvořák (among several others) was of this opinion. What is the meaning of this prehuman development of musical skill? Are the musical qualities of song important to birds, or only to human listeners? Do "good" singers differ from "poor" ones in any way other than this, that we human beings prefer them? Is the difference biologically significant?

To answer these questions on a basis of solid evidence took many years. It required going to school (at the age of fifty-five) with students of animal behavior, partly by making two summer visits at the University of Michigan

Biological Station where Dr. Sewall Pettingill was the excellent ornithologist. But mostly I read books and professional journals and observed birds in many places (in over forty states and about thirty countries).

The essential question was, Do birds have a primitive but still genuine musical sense, remotely analogous to our human pleasure in sound patterns? One sign of pleasure in patterns of sound is the tendency to imitate them. That there is a good deal of this in bird life we know, since it has been established that in many species, hearing adults of the species sing helps the young to learn the proper songs. Another sign of musical feeling is the tendency to make sounds of some complexity, and not just occasionally and under strong and immediate environmental stress, as in alarm cries, but persistently and for long periods. Birds do this. As Kierkegaard the philosopher-novelist put it, not only do birds "sing at their business but" (to judge from their behavior) "their business it is to sing." In the nightless arctic summer, a bird has been known to sing more than twenty out of the twenty-four hours. The creatures must be deriving some satisfaction from this activity.

Soon after E. Howard's *Territory in Bird Life* came out in 1920 I read this book and accepted its main thesis, that song is primarily a means of advertising territorial claims. Aldous Huxley takes this to refute the idea that birds sing from pleasure or love. "Keep out, damn you," or something like that, is, he suggests, the meaning of the singing. But this is at least as anthropomorphic as the older idea that song expresses love or pleasure. For one thing, song is addressed not only to rival males who might trespass but also to possible or actual mates. In the typical cases a male adopts a territory and begins to sing abundantly—until a mate joins him, whereupon the singing is greatly diminished. So "come here and join me" is almost as much the meaning as "keep out." Cries of alarm or anger are different; they have a more nearly single meaning, focused on an immediate situation. They are simpler than songs. When danger is past, or the annoying behavior has ceased, the cries stop. But singing may go on for hours with neither rival nor mate present. Is the bird thinking all the time, "I must warn rivals, should there be any," or "I must attract or please a mate"? Birds are not thinkers. They do not know the territorial theory. They must act chiefly from feeling rather than thought. A musical creature is one that enjoys making musical sounds; with human music there is also intelligent purpose, but with birds feeling must be the primary factor. The behavior of birds in singing fits the hypothesis that for them singing is a self-reinforcing activity, something they like doing. Young birds play at singing as kittens play at fighting. Both activities must be enjoyed, and both are beautiful to observe. The analogy between animal play and human art is a familiar one.

If birds have a musical sense they must enjoy even their rivals' singing. The facts fit the idea that they do enjoy it—provided the rival is not too close. Rivals often engage in "countersinging," each pausing while the other sings,

and then responding. There is a tendency to repeat the other's song, if it is in one's own repertoire, or to take it into the repertoire if it is not, especially if the singer is still young. Countersinging does not lead to boundary fights unless another singer is trespassing, as shown by the song coming from the wrong spot. There is reason to think birds positively like being surrounded with singing rivals, each staying on his own territory but easily audible from neighboring territories.

Highly imitative singing, as with mockingbirds, lyrebirds, and many others in the world, suggests that some species have a more catholic taste in sounds than most, and listen with interest to the songs of a variety of species. That most species have narrowly limited taste is what we should expect, on the assumption that their musical sense is naive, primitive. But even human musicians have their narrownesses. Haydn said Mozart was the greatest of all, but neither one made or makes the other superfluous.

If birds are musical, why do some of them sing so monotonously, repeating the same little song, as many species do, hundreds or thousands of times a day, day after day? During my first summer at the Michigan station I put this question and during the second summer I found the answer. Monotony in the aesthetic sense implies memory: the same song is the same only for an animal that is still aware of the previous utterance. The lower animals have vivid memory for only a few seconds. This is the reason parrots utter such short sentences (rarely even five seconds) and the definite patterns in bird song are short, the majority well under four seconds. The longest one I know is fifteen seconds, and this is very unusual. There are some longer patterns but they are not very definite; e.g., a trill, how many seconds it goes on, may vary. When a bird sings continuously for longer periods it is stringing together patterns, the sequence not forming a pattern that the bird could reproduce except by accident. If a bird has but a single pattern it usually pauses for a number of seconds, the pauses being far longer than the pattern, before repeating it. Thus the singer avoids monotony. Practically all "true songbirds" (*oscines*) that sing repetitiously pause in this manner. The really monotonous singers, such as the whippoorwill, are not songbirds, that is, they lack well-developed muscles for sound control. They are also not known to imitate. So the facts suggest that the evolution of the ability to sing goes with an evolution of musical sense, including the sensitivity to monotony.

Two questions remain. How objective are the criteria for singing skill, or for "good" or "highly developed" song? And what special biological significance, if any, does a high degree of singing skill have? If by objective is meant something our knowledge of which is absolute, entirely free from subjective elements, then there may not be any. But a great deal of science is less than absolute in this sense. There are cases where argument might go on perhaps forever as to whether two groups of birds belong to a single species. Relatively objective criteria for singing skill I take to be: (1) loudness,

(2) scope or complexity, (3) continuity (shortness of pauses between patterns), (4) musical tones rather than noisy or slurred sounds, (5) musical coherence or *gestalt* closure in the same sense as in human music except for the brevity of the patterns, and finally (6) imitative power. I assign numbers from 1 to 9 under each of the six heads and add the numbers for a total score, or overall measure of singing skill. Species scoring 42 or above I classify as "Superior." In the world there seem to be nearly two hundred of these, nine in England and about twice as many in the forty-eight contiguous states of our vastly larger country.

How subjective is the list I have given in my *Born to Sing* of 190-odd superior singers? It agrees fairly well with traditional lists of superior singers in the various countries, as estimated by specialists in song, including A. A. Saunders in this country and Alexander and Nicholson in England. It also fits biological facts well. (a) All (or nearly all) superior songsters are true songbirds, physically well equipped for sound control. (b) If we divide families of songbirds into (1) those with traits or habits tending to make singing biologically important and (2) those without these traits or habits, we find that the superior singers belong overwhelmingly to the first group. The traits or habits include above all territoriality and inconspicuousness—the less a nongregarious bird can be seen the more it must be heard. Thus a high degree of singing skill correlates well with biological need for song. (c) How *much* a bird sings in a yearly cycle correlates strongly with its rating as superior, middling, or little developed in its singing, as shown in the total scores. Quantity of singing is computed from the length of the song season, continuity and persistence of singing, night singing, singing out of season. In fact quantity, computed in this way, correlates well with quality, with degree of singing skill. Thus the mockingbird sings annually probably more than any other species in its area, and its chief rivals in this respect are also superior: the two meadowlarks, wood thrush, Bachman's sparrow, song sparrow, lark sparrow, Carolina wren, Bewick's wren, cardinal. In the Sierra Nevada Mountains the hermit thrush, the solitaire, and the fox sparrow (nearly superior) outsing other species in quantity as well as in quality. There are species of birds that fly little and poorly (slowly, with effort, and crude control of direction), others that fly much and well (fast and with delicate control); so with song. Singing skill like other skills, increases with need, and is more abundantly used.

How one views the world depends a good deal on how one views those parts of it one knows best. I know people and birds best. I see in both the same basic principles and these principles are aesthetic. No animal likes repetition, unrelieved by pauses, beyond a certain point; all animals are stimulated by novelty, but disturbed if it is too great. "Unity in variety," the old formula for beauty, is the key to much of life. It is sad to think of parents who worry about teaching their children morals (often neglecting to set an example by

their own actions) yet have scarcely a notion of the prior necessity to help them find life interesting and enjoyable. Desperately bored or unhappy children are not good candidates for moral instruction, especially by those who bore or painfully annoy them. How many married people are too little aware that life together must be sufficiently varied and adventurous, but also sufficiently foreseeable (hence the need for fidelity), if the bond is to be lasting or happy. Life is an aesthetic problem first, last, and always; it is a moral problem only part of the time. An infant has no morality, but it can be bored, and it can be unhappy.

We live in a culture which tends to oscillate between moral ideals and economic goals, leaving genuinely aesthetic ideals neglected. To have a fancy car, motor boat, or snowmobile, but mediocre conversations about them, is that a very good life? For most years of my adult life I have owned no car, but I feel I had a good life those years. This was good luck as well as good management. I had and could learn from parents who were too genuinely wise and kind to be oppressive. They cared about and exemplified morals, but they knew life should be interesting and happy, and that neither morality nor economics suffice for that.

In my view aesthetic principles go deepest. In my religion, to "serve God" is to make one's contribution to the beauty of the world as spectacle for God's enjoyment. Birds interest us because of the way they show their interest in their affairs. As one birder put it, a towhee is "infinitely dedicated to towheeism!" But all animals have also some interest in other kinds of animals. We are the most catholic in our ability to enjoy other forms of life. Deity is the eminent level of this ability. God is the supreme (primordial, everlasting, cosmic) form of life-interested-in-other-life. And as we prefer to observe interested and happy animals, rather than bored or unhappy ones, so God prefers interested and happy creatures to those that are bored or miserable.

Alas, people have often been prevented from taking this view by a terrible mistake of theologians. Long ago (in what are well called the Dark Ages) theology fell into a conceptual trap, the name of which is "omnipotence." This is the pseudo-idea of one Decision-maker whose decisions settle everything. Result, the so-called problem of evil. It is really the problem of bad theology. If God decides everything, why does God not decide that we should all be happy? There is no good answer to a question so poorly phrased. If God decides everything, what do we decide? And if nothing, then how does the word "decide" have a human meaning?

According to what is called "process theology," every creature every moment decides something that God does *not* decide for it. Living is deciding, and each creature must do its own deciding, its own living. Scientific determinism, now fortunately qualified even in physics, had the effect of seeming to support bad theology, since both conceived past (or eternal)

reality as leaving nothing truly unsettled for us in the present to decide. But life is a process of turning a partly open future into a definite past. The interest of life depends on this process.

Every good artist mixes the foreseeable and the unforeseeable in due proportions. Theology and science will eventually find their way to validate this idea for the cosmos. For several centuries both have been moving in this direction. Darwin's denial of old-fashioned teleology, for example, was, as I have argued elsewhere, implicitly (though Darwin was only partly aware of this) a quarrel with precisely what was wrong in theology, its denial of creaturely freedom. Theologians attributed so much decision making to providence that none was left for real creatures, each living its own life and making its own contribution to the worldly future. A creature can only be a lesser creator. A world must be more than God playing with his (or her) own fancies. It has taken theology more than a century (since Darwin's chief book) even to begin to correct its mistake in this matter.

So the study of bird song is for me a window into reality. A bird with a repertoire of songs has to decide which one to sing next. It is not God's business to make such decisions. Probably people will always disagree somewhat about such profound topics. But I am sure that life cannot be understood in merely mechanical, merely economic, or merely moral terms, and that aesthetic values are more universal than any others.

Is it not clear that the energy crisis, which bids fair to deepen, must in time force us to look for values less dependent on energy than our traditional standard of living? Besides, using sun and wind more, we could heat and air condition less and still be happier than we are. For happiness does not chiefly depend on the exact temperatures in our houses. It depends on imaginative and wise living, on many arts, including conversation and friendship as arts. Wasteful cars cost more than good books, but contribute less to life's value. Our squandering of resources, unique in the world's history, is thoughtless and childish. (Some of us thought so before the energy crisis.) Our design for living needs radical revision. This is a task so immense and challenging that it is sad indeed to see a large fraction of the young, and the not so young, seeking to escape from boredom through drugs or alcohol. There are more constructive and safer ways to make that escape. If the birds on their level of awareness can avoid monotony, we should be able to do it on ours.

Have I overemphasized the aesthetic aspect? Has not science taught us to abstract from values in analyzing what goes on in nature? Science has taught us to abstract from *irrelevant* values—those personal to the investigator, peculiar to our species, or rashly imputed to God—but science is, I believe, the search for the real values, those which actually move creatures. Darwinism assumes that animals try to escape danger, get food, (and, especially if female) care for young. They certainly act as if these objectives were valuable to them. Animals perceive, display what in us is called curiosity;

they act as if observing the world, responding to its endless variety, were for them enjoyable. Why should science forbid us to admit these apparent truths about animals? The point is not to deny that animals have values, preferences, enjoyments, but to find out what these are. It was a scientific error to suppose that song was not functional, or was functional only in relation to a mate—for there is the territorial function. But a bird is not as conscious as we are of the ultimate biological functions of its actions. An activity as persistent, and as devoid of immediate external stimulus or relevance as singing, must have some psychological basis other than the dual functions of mating and territorial defense. A primitive musical sense fits the requirements. Species with a great need for song will have more of this sense than those with slight need. To act in the right way for individual and species survival the animal must feel in the right way. By danger it must be caused to fear, by an empty stomach to desire food, by a mate to desire copulation. By a need for sustained, distinctive sound production—and music is more distinctive than mere noise—an animal must be caused (by mutations, variations, and natural selection) to have a liking, as well as organs, for such production, in other words, a musical sense.

One thing more. Who could count the scientists, especially the most creative ones, who have told us that, in the words of one of them, "In the arts, as in the sciences, the quest is after the same elusive quality: beauty"? Or again, "beauty is that to which every human mind responds at its deepest and most profound." (The astronomer Chandrasekhar in the University of Chicago Magazine, summer 1975.) One could quote to the same effect Heisenberg, Poincaré, Kepler, Aristotle . . . there is no end to the creative minds who have tried to tell us this. Somehow our culture has not quite absorbed the message. Scientific truth is one of the ways in which beauty is made apparent to humanity. Our eyes see the beauty of ocean waves, but the beauty of air waves, waves of radiant energy, probability waves of quantum physics, these forms of beauty can only be enjoyed through the eyes of thought guided by observation and experiment. How much of this vision is made apparent to our children in schools or homes? I fear not a great deal, the reason being that the teachers and parents have mostly not acquired it themselves. And the reason for that? Well, we must stop somewhere. The deepest principle of value, the aesthetic, is the one we must learn to understand. Only so can economic and ethical questions be put in the right perspective. Only so can the harshness of our culture, as shown in the reliance upon violence as preferred antidote to boredom, be mitigated.

Ethical value, goodness, is partly a form of beauty, and genuine goodness is a source of beauty, fostering its production. "Good" people who make life ugly for self and others are suspect. The meaning of life is that it is, or can and should be, interesting and beautiful, that is, intense and prevailingly harmonious. The art of life is action favorable to this end. Life must have

pattern, but the patterns should have some openness toward the future. Life is a perpetual creation of novelty, but ideally of novelty within judicious limits. That we seek to predict is a truism for science; the neglected truth is that we also want the future to be partly unexpected. Who wishes to predict the next joke a good friend may make?

To return to birds: the more complex a bird's repertoire, the more highly developed the singing, the greater the unpredictability of the next phrase or song. Yet there will be an overall unity of style, and so, aesthetic value. It is all to the good that science is establishing limitations upon predictability. Nor is this a defeat for science, whose functions are twofold: to predict the predictable and explain the limitations on prediction. Only the latter, the undecided aspect, gives scope for decision making. "Science is prediction *and* control"—but the two aspects are not the same. Only where the first ends is anything left for (future) control. And that remainder is where the action is.

So we can learn wisdom from the birds![1]

1. For book-length discussion of the themes of this essay, see my *Born to Sing: An Interpretation and World Survey of Bird Song* (Indiana University Press, 1973; reissued in 1992).

3

SOME THEOLOGICAL MISTAKES AND THEIR EFFECTS ON MODERN LITERATURE

WHAT I mean by theological mistakes will emerge in this essay and is more extensively discussed in my book *Omnipotence and Other Theological Mistakes* (1984). Theological mistakes are not easily distinguished from mistakes by philosophers. Most philosophers have indulged in theologizing or in criticisms of theology; and the important theologians have mostly been philosophers as well. By literature I mean poems and novels or other works of fiction.

A poet or novelist deals mostly with more concrete topics than a philosopher. Theology, so far as it deals simply with the question of the existence and essential nature of deity, is on the same abstract level as philosophy, or as that part of philosophy called metaphysics. Poets and fiction writers, so far as they or their characters have religious concerns, or concerns with a metaphysical aspect, often express or imply philosophical beliefs. Such beliefs as expressed in literature are what I wish to discuss.

Since we are dealing with abstract aspects of otherwise largely concrete writings, let us look briefly at the human condition in its concreteness. An animal species, unique on this planet in its great symbolizing power, has spread over the surface of the planet as has no other species. More and more, the use of this symbolic power for scientific inquiry and technological applications of resulting discoveries is changing our environments and our ways of thinking about ourselves and our universe. Yet prescientific ways of thinking are also widely influential. Philosophy and theology are the mediators between science and religious beliefs, meaning by such beliefs those implicit in our fundamental goals or ideals. To ignore philosophical issues is to risk basing one's life on notions that were once, perhaps, the best that leading

minds could do and by which they may have lived well, but which are by no means so appropriate now.

There are basic reasons why philosophers and, therefore, theologians are likely to make mistakes. First, to be an animal, even though a human animal, means the following: An animal feels itself at the center of the cosmos, or at least it feels its group at the center. If not egocentric it is group-centric. We all incline to be either of the *me* or the *us* generation. Perhaps it is better if it is us rather than me; still, group conceit issuing in will to group dominance can be our deadliest danger. It also inclines us to underestimate the nonhuman creatures. Second, an animal feels itself subject to momentum coming from the past and threatened by dangers looming in the future. With the highest animals the anticipated future may be far ahead and include the individual's own eventual death.

Several philosophical questions arise from the foregoing. One of these is, How far does the momentum coming from the past determine what happens? This is the problem of causality and freedom. Long ago a few thinkers declared that conditions in the past strictly determine what happens now. In that sense there is, for such thinkers, no freedom. What we say we decide was in fact decided, or at least determined, settled, long ago. That we could not have done otherwise will obtain, whatever we do. Some philosophers claim that this still leaves us all the freedom we need, or at any rate all we can have. So far as we do what we wish or will to do, without interference by others or control by habits that we would like to overcome, we are free. Freedom is simply voluntariness. This is the deterministic view of freedom. It is a definite abstract theory, and an extreme one. Like all extremes it has an opposite, which is that, whatever has already happened, anything conceivable could happen next. No animal can live by that notion. Nevertheless, to some minds in love with simplicity, it seems that we must choose between a pragmatically hopeless notion of chaos—"anything may happen, regardless of what has already occurred"—and the opposite extreme—"what has already occurred entirely predetermines what happens next or is now done."

In strict logic there is no need to limit the options for belief to the two extremes just stated. Yet early modern science, like some ancient Greek science and the Stoic philosophers, adopted the deterministic extreme. Some modern theologians and many modern philosophers, with medieval precedents, applied the scheme even to human behavior. Spinoza and Jonathan Edwards are classical cases, but Hume and Kant also fell into the trap of seeing nothing between determinism and sheer chaos.

I say that the adoption of determinism, however it may for some centuries have helped science, was for philosophy and religion a definite mistake, a lapse from rational method. That one extreme, "the past has no influence on the present," is obviously untenable does nothing to justify adopting the opposite extreme, "the past settles everything." Yet where in the literature

of the subject was any other and more valid argument given for unqualified determinism? Some transparent special pleading is all that I at least find.

It is time to consider a literary example of determinism. I take the following from one of the great satirists of all time, Thomas Love Peacock.[1] In *Headlong Hall,* Mr. Escot has saved Mr. Cranium, the phrenologist, from drowning. Some time later Squire Headlong tries to settle a dispute between Escot and Cranium by asking the latter,

> "Who fished you out of the water?"
> "What is that to the purpose?" asks Mr. Cranium. "The whole process of the action was mechanical and necessary. The application of the poker necessitated the ignition of the powder: the ignition necessitated the explosion: the explosion necessitated my sudden fright, which necessitated my sudden jump, which, from a necessity equally powerful, was in a curvilinear ascent: the descent, being in a corresponding curve ... I was, by the necessity of gravitation, attracted, first, through the ivy, and secondly through the hazel, and thirdly through the ash, into the water beneath. The motive or impulse thus adhibited in the person of a drowning man, was as powerful on his [Escot's] material compages as the force of gravitation on mine; and he could no more help jumping into the water than I could help falling into it."
> "All perfectly true," said Squire Headlong, "and, on the same principle, you make no distinction between the man who knocks you down and him who picks you up."
> "I make this distinction," said Mr. Cranium, "that I avoid the former as a machine containing a peculiar catabillitive quality, which I have found to be not consentaneous to my mode of pleasurable existence; but I attach no moral merit or demerit to either of them ... seeing that they are equally creatures of necessity.... I no more blame or praise a man for what is called vice or virtue, than I tax a tuft of hemlock with malevolence or discover great philanthropy in a field of potatoes...."
> "Yet you destroy the hemlock," said Squire Headlong, "and cultivate the potato...."
> "I do," said Mr. Cranium, "because I know that ... the potato will tend to preserve ... my animal republic; and that the hemlock ... would necessitate a great derangement ... of my corporeal mechanism."
> "Very well," said the Squire, "then you are necessitated to like Mr. Escot better than Mr. Panscope?"
> "That is a nonsequitur," said Mr. Cranium.
> "Then this is a sequitur," said the Squire: "Your daughter and Mr. Escot are necessitated to like one another; and unless you feel necessitated to adhibit your consent, they will feel necessitated to dispense with it."
> Mr. Cranium fell into a profound reverie. ...

The foregoing passage will be criticized by "soft determinists," who do employ ethical terms. Mr. Cranium is what is now called a "hard determinist."

1. *The Pleasures of Peacock* (New York: Farrar, 1941), pp. 52–54. The stilted pompous language of this quotation is Peacock making fun of the way determinists talked.

I hold that both are making essentially the same mistake about causality, the truth being that determinism makes neither ethical nor unethical sense. It tells us nothing upon which we can act. Absolute predictability, given absolute knowledge of the past, is irrelevant to our problems since only God could have absolute knowledge. And many theologians now think that divine knowledge of the past would still leave the future open for God since God knows that creatures have freedom. As Lequier said, God "waits to see" what creatures do. Karl Popper, perhaps the greatest living philosopher of science, suggests that God, supposing the divine existence, would find a world with open future vastly more interesting than one whose future was already settled.[2]

The contention of soft determinists that the doctrine does no harm to our ethical conceptions or our essential values is not in agreement with the way many great poets and fiction writers have viewed the matter. I do not think these writers have been as stupid as soft determinism implies. I have in mind Thomas Hardy, Robinson Jeffers, Robert Frost, Ambrose Bierce, and Mark Twain. All of these, with the possible exception of Frost, were determinists. (If Frost was not, he did not say so.) Not one of these writers, in my opinion, gave us a livable philosophy of life. Yet all wrote wonderful literature. I incline to include also in this list Wallace Stevens, who, in one passage, seems to imply determinism. He gives us neither a religion nor (here I agree with an essay whose author I have forgotten) a viable substitute for a religion. The case of Hardy is well known. His determinism leads him to a distorted view of life and a satirical metaphor of God as President of the Immortals who mismanages the world.

That Jeffers was definitely committed to determinism is as clear as genius could make it. In "Meditation on Saviors," we read: "The mountain ahead of the world is not forming but fixed." Whatever happens is subject to "the iron consistency."[3] And Jeffers is one of the few great recent poets with a clearly religious belief. The poem "Triad" ends with: "God, who is very beautiful, but hardly a friend of humanity." In "Self-criticism" we find: "If only you could sing / That God is love." And the reply is: "I can tell lies in prose." So the God of Jeffers does not love us; neither, it seems, does Jeffers. His misanthropy is grandiose. Of course, one cannot consistently live such a doctrine. It is clear that determinism is a chief source of this grim theology. In "At The Birth of an Age," The Hanged God declares, "I torture myself to discover myself." In "Meditation on Saviors," we read: "He brays humanity / to bring the savior." Life—including divine life, Jeffers tells us—without con-

2. P. A. Schilpp, ed., *The Philosophy of Karl Popper* (La Salle, Ill.: Open Court, 1974), The Library of Living Philosophers Series 14, p. 103.
3. *The Selected Poems of Robinson Jeffers* (New York: Random House, 1927), pp. 202, 249, 601, 559, 176.

flict and suffering is impossible, or would be hopelessly lacking in intensity. Since there is no freedom in the proper sense of creaturely determination of what is left undetermined by deity, it must be divine will that selects our sufferings and our joys. God is the supreme sadist—but also masochist, for our sufferings become elements in the intensity of the divine life.

It seems that even a child (but not some theologians and philosophers) could see the alternative: God does not, and logically could not, simply determine what creatures do. To be is to act, to determine what otherwise is not fully determinate. If we exist, and not God alone, then we and not God decide some aspects of our lives.

I have found only one poet who makes it sun-clear that he believes in human as well as divine freedom. This is Sidney Lanier. To the idea that if he writes a poem praising God it is really God who determines the content of the poem, he replies, "It is not true, it is not true," and insists that he, "and not another, God nor man," makes the poem. See *Individuality,* a philosophical title indeed.[4] The poem also raises the question, If an inanimate object, say a cloud sending rain and lightning, does harm, is the object to be blamed for the damage? He replies in the negative, saying of his cloud, "There is no thee." The cloud is not an individual, an active being. What clouds do, he seems to think, is really divine action, the reasons for which we cannot penetrate.

How close yet how far from the open secret! The poem's title suggests that we must suppose *either* that the nonhuman, inanimate world does not consist of individuals (what then?) *or* that, since a cloud is not an individual, it must be a group, an assemblage of individuals, perhaps atoms or molecules. If individuals are free, then atoms or molecules have some freedom. (Epicurus and Lucretius thought so long ago, but did not convince the world.) Even God, then, does not fully determine what they or their assemblages bring about. Moreover, if human beings and other animals are individuals acting individually (how else?), then the conjunction of human behavior with the lightning or rain is partly a matter of chance intersections of free creaturely volitions, not of divine volitions alone.

Lanier leaves his problem in the middle, but he makes the right start. To be as an individual is to act individually, not fully determined by anything else, divine or otherwise. What one must do is generalize this for creatures as such, so far as they are individuals rather than mere collectives. To work this into an impressive cosmology has never been possible until quite recently. Statistical laws of gases first, then quantum theory, have shown that the religious alternative to absolute order need not be absolute chaos, but may be freedom, individual creativity, sufficiently influenced by a divine vision of cosmic order to make what happens partially predictable, but not wholly so

4. *Selected Poems of Sidney Lanier* (New York: Scribner's, 1947), pp. 10–14.

even for God. A group of philosophers, Charles Peirce, Henri Bergson, William James, A. N. Whitehead, Karl Popper, and others in Germany, France, and Italy, have worked on such a philosophy, and many physicists now believe that determinism had best be given up or qualified so that freedom in the radical sense is not excluded.

Frost seemed to think that the problem of religion was how to reconcile mercy and justice in an idea of God. But he seemed also to think that God could only be conceived as determining the details of events in the world. At least, he never takes up the question of how divine action leaves any genuine scope for creaturely decision or determination. If justice means appropriate rewarding and punishing, how is this to be brought about? Either the creatures decide nothing of what happens to themselves and others, or God does not decide everything that happens. In the former case, does the idea of deciding make sense? (What could we mean by deciding if another power decides all?) In the latter case, how can our rewards and punishments, our joys or sufferings, be dealt out precisely by deity? It seems obvious that it is other creatures that help or harm us.

Wordsworth had a theistic view, but he never discusses the relation of freedom and causality. He felt God in everything but cannot help us much to think out what this means in conceptual terms. He did feel that the agents in nature must have their own feelings. By similar arguments they must have their own freedom. Epicurus was opposite to Wordsworth. He was confident that he had freedom and so did atoms; but his materialism prevented him from making the other parallel inference. We know ourselves and others as individuals in terms of feeling as well as of freedom. Hence whatever is individual in nature must have both aspects. Putting Epicurus and Wordsworth together in their positive views, one has what is needed. If we can (vaguely) imagine freedom different enough from human freedom to apply to atoms, why can we not also imagine feeling different enough from ours to apply to them? Unimaginative persons will hardly accomplish either generalization. A Peirce or Whitehead can do both. I have given the argument for the Wordsworthian procedure in a previous article.[5]

Whatever his limitations, I regard Frost as the greatest Anglo-American poet of this century (almost the very words of T. S. Eliot about him).[6] Frost

5. "In Defense of Wordsworth's View of Nature," *Philosophy and Literature* 4, 1 (Spring 1980): 60–91.

6. Since Frost's character as a person has been severely, and I think excessively, attacked by his most detailed biographer, Lawrence Thompson, I want to go on record as siding emphatically with the view of Frost taken by W. H. Pritchard in *Frost: A Literary Life Reconsidered.* I find Pritchard's quotations from Thompson concerning Frost's supposed motivations meanspirited and presumptuous. They remind me of what the psychiatrist Sullivan said in one of his books: "There are some people whose attitude seems to be, 'If I cannot be great, by God there shall be no greatness!'" Two

does give us some help regarding religious problems. To see this we need to return to the fact that we are the animals that foresee the inevitability of our eventually dying. This means that we either renounce any long-run permanence for our achievements or adopt some metaphysical belief. What is called social immortality will not do; for no empirical observations can establish that our species is immortal, and, if possible, still less that what we do well will always have a good influence on posterity. For this reason alone, though it is far from the only reason, I hold with Bergson that our species, no matter how its science progresses, will always need some metaphysical belief.

There are two principal metaphysical options. We may suppose that death is not the end of a person's career, which goes on forever to additional experiences in some supernatural form, or in reincarnation in a natural form. In the posthumous parts of our careers we may hope to reap permanent results for ourselves from our earthly activities. The other option is to believe in God, not as the means to our own posthumous careers, but as the one who will everlastingly possess whatever beauty of experience we and other creatures have enjoyed or helped others to enjoy. This is Whitehead's "immortality of the past" in "the Consequent Nature of God." God is taken as the ultimate heir of our achievements, the ultimate posterity whose permanence is guaranteed, or whose power of survival is invincible.

Frost does not give us the idea of God just referred to, but he does take a stand against its chief alternative, the idea of posthumous human careers. "Earth's the right place for love / I don't know where it's likely to go better" ("Birches," in *The Mountain Interval*). This is only one of several ways in which he makes clear that he believes in no heaven where we will "go up . . . to live" ("A Steeple on the House," in *A Spire and Belfry*). On the negative side he supports the Whiteheadian solution that in the main is also mine. The positive side he at least leaves open. I hold this to be no mean service. Otherworldliness in my view makes us rivals to God in the infinity of our future careers. It also distracts us from our real problems, which are to live well for self and others and finally for God while we live on earth, or at least in this solar system.

In another way Frost is helpful to a philosopher. He knows that the power of human thinking depends on analogies, or what he calls metaphors. He thinks he knows also that "every metaphor breaks down somewhere." Consider the idea of God. It is an analogy or partial similarity between something primordial, everlasting, cosmically efficacious, and infallibly wise and good and a human or high-level animal individual that is not primordial, not everlasting (at least, not obviously so), only very locally efficacious, and fallible in wisdom and goodness. Thus God is to us as ideal ruler is to ruled,

can play at the game Thompson undertakes of imputing motives. Pritchard sees some limitations in Frost but shows how to deal with them without losing sight of his own limitations and of Frost's genuine humanity as well as superb genius.

leader to led, parent (not, I implore you, merely father) to child. This interpersonal analogy, or metaphor, is the one most writers have had in mind, and this includes most poets. The analogy breaks down in some ways rather badly. Unless we have another one, strong or clear where this one is weak or unclear, we are in trouble.

There is another analogy, going back to Plato, than whom no greater philosopher is known. It is the soul-body analogy. We as conscious subjects are in some sense or degree rulers in our psychophysiological systems. This is a more intimate relation by far than that of child to parent (especially male parent!). When Whitehead refers to God as "the fellow sufferer who understands," he fails to note that this applies to the relation one has to one's bodily cells. We feel their healthy functioning as our good and suffer their injuries as our bad. We even seem to feel their feelings. Consider physical pains and pleasures. Nothing in these experiences seems to conflict with the idea that there is cellular suffering in the pains and cellular pleasure in the pleasures. How else could we derive suffering and enjoyment from cells if they had nothing remotely similar themselves? But we can partly understand cells, which can scarcely understand themselves.

I am quite unconvinced that the significance of the cellular constitution of our bodies, unknown to Plato and Aristotle, has yet dawned on most philosophers or theologians. Alas, even Whitehead scorns Plato's analogy, apparently because of the way it was used in Neo-Platonism. He overlooks here the possibility that Plato is, in important ways, including this one, wiser than most of the Platonists. He also overlooks the fact that as Plato puts the analogy in the *Timaeus* it is not inconsistent with the doctrine of the Consequent Nature of God. It also makes more sense with modern than with ancient physiology. If Whitehead missed the point here, following in this mistake most of his predecessors in philosophical theology, why should not Frost miss it also? And what did Frost think about freedom and causality? Obviously, we do not completely determine our cells' behavior, and it is bad philosophy to suppose that they completely determine ours. Some neurophysiologists reject this assumption.[7]

So far I have mentioned only one writer of fiction as on the right side of a metaphysical issue—Peacock. I wish now to consider two others who at least do not say wrong things on the subject. Jane Austen and Anthony Trollope are among the superb geniuses of the novel. They both, especially Trollope, have a good deal to say about clergymen but rather carefully avoid metaphysical problems about God. They do not quarrel with traditional ideas about heaven or hell, but their work can be taken to support the proposition that these ideas are of little relevance. Neither seems to feel that their charac-

7. See R. W. Sperry in *Brain and Conscious Experience,* ed. J. C. Eccles (Berlin and New York: Springer, 1966), pp. 298–313.

ters are living for the sake of avoiding hell and getting to heaven, or getting their friends there either. They seem to live for the sake of what Austen regards as rational happiness on earth. Trollope seems to me essentially the same in this, even though he is more concerned with the clergy. The notion that people must be threatened with everlasting punishment or attracted by visions of everlasting bliss, a disgusting doctrine at best, as Berdyaev says, gets no impressive support from either of these wonderfully penetrating observers of human affairs. Is it any different with Fielding, Thackeray, Peacock, Dickens?

It remains a serious question whether or not rational happiness can flourish without something like the belief in God or in something more permanent and relevant to the meaning of our lives than empirical science can provide us with. The Japanese, it seems clear, though apparently without an explicitly theistic religion, live with remarkable freedom from the vicious violence that disfigures many Western societies (alas, including our own). Most Japanese lack a definite idea of God. However, Japanese Buddhism is not a merely empirical doctrine, nor is Shinto; in both there are metaphysical overtones. It is seldom entirely clear that Buddha is or was merely a human animal. The scholar Suzuki said that he was not sure that Buddhism was nontheistic.

Wallace Stevens said (in prose) that he had substituted man for God. He seems to have an idealized view of the essence of humanity, something like Feuerbach's virtual deification of our species. This is also the Marxist approach. Is it enough? The problem of mortality is still there. What *eventually* do we accomplish or achieve? This was William James's question. Whitehead, not James or Stevens, has clearly answered it. So far we lack the poet who does justice to this answer, as Dante did to the other religious solution.

I wish to consider three more literary figures, all poets, whatever else they may have been. One of these, Edgar Allan Poe, famous as a poet and writer of fiction, also wrote a long essay called *Eureka*, in which he stated his religious beliefs. He called it "a poem," although it is entirely in prose. It is scarcely philosophical as philosophers go at their work. Nor are philosophers or theologians the writers who are referred to or cited. Rather they are natural scientists, especially astronomers. However, something is said about God, and a solution of the problem of our mortality is implied. Poe insists that we are not unequal to God and suggests that it is inappropriate to worship God as essentially superior to us; indeed, in a sense that is left vague, we seem to be God. So, somehow, we are immortal. Is this a livable philosophy or theology? Poor Poe, he had tragic misfortunes and was unable to control his alcoholism. A genius, yes indeed; but a wise man?

If Poe rejected determinism—unlikely since it was the belief of most scientists at the time—he did not, I think, say so. As the reader knows, my belief is that determinism is mistaken in principle, and that the mistake is not

harmless in its effects on life and literature. Jeffers was wrong to accept it, and Lanier right to repudiate it. In ignoring the problem, Frost, Stevens, and Poe limited their resources.

I have two more poets in mind, both also remarkable in other ways. These are Edward Fitzgerald, translator from the Persian, and Omar Khayyam, the Persian original. In many ways the relationship of these two men of genius is startlingly unique. Omar was not a self-proclaimed poet but a scientist of distinction, in an Islamic country, who circulated his poems among friends. A modern Islamic scholar has shown that the skeptical philosophy for which the poem in Fitzgerald's version (*The Rubáiyát of Omar Khayyám*) is so famous is essentially the philosophy of the original.[8] What is harder to ascertain is how the two writers compare, not as philosophers but as poets. Frost's trenchant dictum, "poetry is what gets lost in translation," here receives its most notable apparent refutation. For, of middle-length poems, what other in English is more haunting, more magical than Fitzgerald's? Perhaps Coleridge's "Rime of the Ancient Mariner," but what else? Perhaps a few more. Are the translated and the original Persian poem two equally good but quite different creations? My guess is that the translation is even more poetical than the original, but certainly different poetically.

Nothing is clearer than that the ground of the skepticism is the baldly proclaimed theological determinism. Omar himself:

> Today is nothing but a make-believe;
> Tomorrow all will be as it was planned.
> It's all arranged . . .
> Tomorrow's plans were settled yesterday.

Fitzgerald:

> With earth's first day they did the last man knead,
> And there of the last harvest sowed the seed:
> And the first morning of creation wrote
> What the last dawn of reckoning shall read.

Other verses in both versions make the same point. Omar's "We are the pawns and Heaven is the player" is far from his only other variation on the theme, and the same can be said about Fitzgerald's "Impotent pieces of the Game He plays." Frost's equation of poetry with the untranslatable fits highly philosophical poetry less well perhaps than it does some other forms of poetry. Still, one at home in medieval Persian and also in modern English would have two quite distinct aesthetic experiences in reading or listening to the two

8. See Ali Dashti, *In Search of Omar Khayyam* (New York: Macmillan, 1971).

poems. However, two classes of things would be common to the two experiences—the images (lion, lizard, wild ass, bubbles that burst, wine, and many others) and certain abstract ideas (death, birth, life, individual, God, sin, responsibility, and freedom, or rather the lack of it). And the same sense of meaninglessness, assuming theological determinism. In my opinion, the medieval type of theism, all too similar in the Islamic and Christian versions, scarcely deserved to survive the ridicule to which Omar and, many centuries later, Fitzgerald subjected it.

What the two poets show is how, from theological catastrophe, art can wring human value, not ethical or positive religious value, but aesthetic value—not goodness or wisdom, but beauty. For life as a whole, however, goodness and wisdom are also needed, even by poets as well as their readers. Fortunately, there are wise and good poets as well as wise and good writers of fiction.

Two American writers, born twenty-six and thirty-three years after Fitzgerald's birth in 1809, reacted to the type of theism made fun of by Omar and his English imitator and reached a similar conclusion. These were Ambrose Bierce and Mark Twain (Samuel L. Clemens). Unlike Omar, the Americans, especially Bierce, almost made careers by exploiting the absurdity to which such a theism seems to reduce life and the universe. They were existentialists before Sartre! Omar had something that these writers of fiction, especially Clemens, largely lacked even secondhand acquaintance with: a disciplined and informed intellectual life of scientific and philosophical inquiry. Omar was highly educated by the world standards of his time. Bierce and Clemens were not, by the standards of theirs. True, many of those for whom they chiefly wrote were not much better- or as well-off. The postwar nineteenth-century life in this country, at least in the Western part of it in which the two spent much of their lives, was only beginning to pass beyond the crudities of the pioneer days.

One difference between Bierce and Clemens, as Hartley Grattan puts it, was that whereas Bierce was crushed (and embittered) by rejection, Clemens was crushed by acceptance. Born to poverty and a grim Calvinist father (who gave him a library to read in and very little else), Bierce—self-educated, witty, intellectually penetrating, courageous, defiant—encountered many difficulties, including a hopelessly flawed marriage (by whose fault seems to be unknown). He may have died by suicide somewhere in Mexico. Clemens, in contrast, had a successful career, including a happy marriage into a respected family in a cultured Eastern society with whose religious foundations he had little sympathy but which he did not wish to offend. Bierce suffered from, but also intensely enjoyed (at least in retrospect), participation, as an imaginative, sensitive young man, in the Civil War, which was one of the early examples of the ever-increasing degradation of warfare into the utterly hopeless, wholesale carnage it now threatens to become.

Bierce's complete acceptance of strict determinism is made plain in his story "Missing in Action." What happened to the hero—and he is depicted as truly heroic—was, the author says, to the last detail settled ages ago by "The divine, eternal plan." A Darwinian, Bierce combined the worst aspect of Darwin's thought (his rejection of genuine chance, which is an essential aspect of creaturely freedom) with the worst in the theological tradition. How close to Omar or Fitzgerald is the following from *The Devil's Dictionary*: "Howe'er your choice may chance to fall / You'll have no hand in it at all"! Note the ironical use of "chance" by a complete mechanistic determinist.

I will try to make very clear what troubled these two heirs of the Middle Ages. Countless theologians had committed themselves, either ambiguously or unambiguously, to the following proposition: "There is a Being who enjoys absolutely free and complete control over all other beings." From this it follows that the other beings have no freedom at all if "free" means able to decide without being completely determined in one's decisions or actions by another being or set of beings. In short, we are offered absolute freedom in one being and zero freedom in all others. The proposition is doubly absurd: absolute freedom is meaningless or contradictory, for it would imply an agent dealing only with itself or mere puppets of itself; and the idea of mere puppet, or agent wholly controlled by another agent and thus with a zero of self-determination, is similarly empty of positive, coherent import. All freedom, and indeed all meaning, is social, involving a plurality of agents influenced, but not wholly determined, by others. Freedom must be shared; it cannot be monopolized.

Plato came close to seeing all this, and we know why he could not quite see it all. Being, he said, is activity or power; soul, or whatever thinks, feels, or desires, and the like, is "self-moved" (not wholly determined in its motions or changes by another); souls move, have power over, other souls and also (Plato thought) over what is soulless—inanimate matter. What Plato did not know (but Epicurus shrewdly guessed) was that the idea of absolutely inert, not self-moving matter is an illusion of our sense perceptions, as modern physics has discovered. Atoms, particles, radiation waves, are not inert, and matter consists of them. They need not be soulless, a zero of freedom or a zero of mind. The zero of activity cannot be distinguished from the zero of actuality.

Plato must have known, but he grossly understressed, what Aristotle noted: that a soul in knowing anything is influenced by what it knows. This means that no being can both unilaterally influence (not to say fully control or determine) another being and also know it. Hence the traditional pair of terms, omnipotence (as often construed) and omniscience, form a contradiction. That is why Aristotle's supreme soul, his God, knows only self, not any other. Absolute freedom, as traditionally conceived, defines no deity worth discussion. The only literal truth of this kind of theology is the historical truth

that many did hold it, or at best failed to distinguish what they believed from it.

William James in his "Dilemma of Determinism" shows admirably clearly that the only way to defend freedom is to admit *chance* as a genuine though negative aspect of reality. That an action is not fully determined by anything prior to itself, either temporally or logically, has, as its positive bearing, that the act is an *addition* to the definiteness of reality as it was without this act. In each free act we add something to the definiteness of the universe and to any deity that knows this universe. Determinism would deny this, for deity, knowing the causal antecedents, would know all about their predetermined effects. This is just what causation cannot be if it allows some self-determination. Chance is not the whole of freedom but is its necessary negative aspect, the absence of any fully determining precondition. The positive aspect is creativity, the form of forms. To be is to create. Each creature is in some degree a creator. No being is zero, and no being is simply absolute or self-sufficient, in freedom. It does not follow that no being can be divine.

Although divine freedom is not in every respect unlimited power, it is power whose only "limitations" are those included in sharing freedom with others. The others have further and radical limitations. In scope they are localized to a fragment of the cosmos, whereas deity is cosmic in scope. In quality the others are both self-surpassable and surpassable-by-others; deity is in one respect surpassable but by self only. These differences define deity; they are great enough to make the idea difficult—so difficult that we have no right to despise those who cannot believe it makes sense, but also so difficult that easy charges of anthropomorphism are misplaced. All our thought is human thought; we have no other basic model of individual reality than ourselves (and other animals).

Plato is relevant in one more respect. As already noted, he thought God was analogously related to us as each of us is to the parts of his or her own body. Deity is the World Soul, the mind of the cosmic body. I follow Cornford's scholarship here. I have argued elsewhere that the weaknesses of the interpersonal analogy (God as parent or ruler), or the artisan or artist analogy (God as carpenter or sculptor), are partly overcome by stressing the mind-body (or mind-nervous system) analogy. All of this becomes nonsense if combined (as in Spinoza and the Stoics) with causal determinism, the denial of creative freedom.

Unlike Peacock, or even Trollope, Bierce was blatantly antifeminist; he also glorified war and disparaged peace. Yet he was cynical about professed war aims and saw hypocrisy in President McKinley's war. He did not, I suspect, foresee what Peacock virtually did foresee: the ultimate doom to which unqualified reliance on military means of settling group disputes seems to condemn us. It is hard to think of any writers of the past who help us much in this new trouble. Kant perhaps, or Royce, but not Hegel or Marx. The rational

animal must, it seems clear, become more rational, or more wise, generous, and strenuous in the pursuit of the common good than most of us seem to be at present, if our species, or perhaps much of the beautiful web of earthly life that Darwin so deeply and rightly admired, is to survive. The species has become not only its own worst enemy but the primary threat to the value of the only inhabited celestial body we individually know of as yet—though I refuse to suppose it is anything like the only one there is. For that dismal conclusion there is no evidence that seems convincing.

Samuel Clemens's success, like that of Frost, was deliberately and sagaciously sought. He became, through pen and lecturing voice, a public entertainer comparable to Bernard Shaw. But he reserved his religious heresies largely for posterity, in the posthumous publications *The Mysterious Stranger* and *Letters from the Earth.* (See also *What Is Man?*, published in 1905, five years before his death.) I agree with Edgar Lee Masters that Clemens was not knowledgeable enough to make a serious contribution to philosophical or religious thought.

I have another instance to add to the one from Sidney Lanier of an American poet expressing what I regard as a theological truth. Richard Hovey clearly anticipated one of the implications of Whitehead's "objective immortality." Having described a desperate military situation,

> There is no escape by the river,
> There is no flight left by the fen,
> We are compassed about by the shiver
> Of the night of their marching men . . .

he comes to his conclusion:

> God has said, "Ye shall fail and perish
> But the thrill ye have felt tonight
> I shall keep in my heart and cherish
> When the worlds have passed in night."
> Give a cheer! For our hearts shall not give way.
> Here's to a dark tomorrow and here's to a bright today.[9]

I also like to remember his tribute to a forest:

> For here there is lilt in the quiet
> And calm in the quiver of things.[10]

9. "End of the Day," in Bliss Carman and Richard Hovey, *More Songs from Vagabondia* (Boston: Small, Maynard, and Co., 1886; 8th printing, 1911), p. 72.
10. "The Faun," in *Songs from Vagabondia,* vol. 1 (1894; 11th printing, 1911), p. 16.

I can understand why Frost did not greatly admire this poet; he was too deeply convinced that "every metaphor breaks down somewhere" to like so positive an approach to life as Hovey's. But there is room for both approaches.

Like Frost, Hovey appreciated the value of fidelity in sexual relations. Like Frost also, he regarded patriotism as an extension of self-regard. Unlike Frost, but like Bierce, he exalted war and depreciated peace. He was an enthusiastic supporter of the war to end the Spanish rule of Cuba and the Philippines. He did not seem to realize how shamefully we treated the Philippine people after the Spanish surrender. Like nearly everyone in his time, he failed to realize how technology was beginning to degrade war, a process the ultimate limit of which was what we now face, the prospect of ending war by ending humanity itself. However, Hovey, very unlike Bierce, was in advance of his time in his appreciation of the rights of women and the obsolescence of the patriarchal family.

The life of Hovey was a tragic one, with a good deal of frustration and an end in early middle age. How far the cause was bad luck and how far it was bad management—lack of sagacity on his part—seems obscure. His goal was to be a great playwright; he did not achieve it. An intensely idealistic individual, he failed to relate sufficiently to the real world. Frost's sagacity and practicality were in clear contrast. But in my view (and also, I have been pleased to find, in Karl Popper's), worldly success is "mostly a matter of luck."

The awful nuclear dilemma referred to above was, so far as I know, not anticipated very long before by any philosopher or any scientist. It was, however, virtually anticipated by the novelist Peacock in 1860, using only facts open to such use by any number of writers. A character in Peacock's *Gryll Grange,* the Reverend Doctor Opimian, replies to another character's praise of the benefits of science by pointing to the way explosives keep getting more and more powerful. Who knows, the doctor suggests, they may get so powerful that their employment could "exterminate the human race." Given ever-increasing power to destroy, *either* the upper limit to this terrible power is low enough, taking human folly into account (as Peacock always did), to make the continuance of human life a reasonable probability for at least a long future, *or* the upper limit (if any) is so high as to make this continuance rather improbable. Peacock really faced the situation eighty years before the first chain reaction. Who else did? In general, philosophers and scientists have failed to see that all freedom involves risk, that science increases the scope of *human* freedom so that scientific and technological progress magnify the dangers. Consequently, only an increase in human wisdom and virtue can offer much hope for the long future.

I explain the failure to think this matter through by the historic fact that philosophers, scientists, and even theologians have scarcely believed in

freedom in the causal sense of decision making by individuals whose behavior is not fully determined by anything other than or prior to their actual deciding. Providence cannot—logically could not—substitute for the decisions of creatures. To be a creature is to be a nondivine form of freedom. As a great inventor, Arthur Young, has said, in spite of Einstein God does "throw dice," by "taking a chance on what free creatures may do." "Free creatures" is tautologous; the idea of a wholly unfree creature is contradictory or meaningless. That disbelief in freedom in the libertarian or causal sense is harmless is unfortunately a momentous falsehood. It distorts everything.

A final tribute to Hovey: he believed in God but not in heaven and hell. I add his testimony to that of Frost on the point.

Another poet, called great by many but difficult for me to assimilate, has expressed a similarly this-worldly standpoint by these six words in "Sunday Morning": "Death is the mother of beauty."[11] As usual with Stevens, there is some enigma as to just how this statement is to be taken, but I think it fair to say that the meaning includes this consideration: by viewing a human life as definitely bounded by birth and death, the definiteness, which is the gift of finitude and is essential to beauty, is enhanced. Vague suppositions of survival, what Stevens calls "chimeras of the grave," tend to rob life of its vividness. Any number of beautiful things are around us; let us attend to them. I heartily agree. But without some cosmic power to preserve our experiences, what in the long run do they amount to? Here I think Hovey, anticipating Whitehead, gives us the other side of the story of life's value. What is needed is not some vague afterlife, but the preservation of this definite, finite life of ours here and now. Without the permanence of that, Stevens gives us nothing much by way of a substitute for religion.

Each of the poets and writers of fiction referred to in this essay gives us truth, but only taken together do they come close to the whole essential truth about life's meaning or value. And only by including and completely generalizing Lanier's point, the reality of liberty, can the various half-truths, some or other of which every great poet sees, be united in a coherent faith by which one can genuinely and wisely live.

11. *The Collected Poems of Wallace Stevens* (New York: Knopf, 1978). See p. 68. I confess that it took me a number of rereadings to see the greatness of this poem. I still find rather little in most of the others by this poet.

4

DEMOCRACY AND RELIGION

DEMOCRACY and religion need each other. They have this need partly because Plato's Philosopher Kings are unobtainable; and so, for many of us, are infallible purveyors of divine revelation. Democracy needs religion because our kind of animal (that is, the speaking, picture-making, writing kind) needs religion. If you doubt it, read Bergson's book *The Two Sources of Religion and Ethics.* He gives three reasons why our vigorously thinking animal, *homo sapiens,* needs to believe in God. If anyone has refuted these reasons, I do not know his or her name. Nor does Bergson mean by God the human species, however idealized. He means the uniquely cosmic or supercosmic Being, unborn and undying, yet not timeless nor in every sense unchangeable—though the changes cannot be by decrease in value. Divine becoming preserves its past achievements and those of its creatures, which it loves. If theism is logically possible, so is mutability without corruption.

The paradoxical, or love-hate, relations of religions to democracy are well known. Less well known is the possibility of making religions in the future more helpful and less troublesome for democracy. The troublesome aspect comes partly from the intensity with which religious beliefs may be held, and the opportunities thus given for human arrogance, or (more or less unconscious) collective selfishness, to do their destructive worst. The helpful aspect comes partly from the way the idea of God, clearly central in the great world religions (with the somewhat ambiguous exception of Buddhism), can support the three values important for the long-term success of democracy. These values are liberty, equality (in some properly qualified sense), and fraternity (or siblinglike good will) of citizens. If we are all children of God, we are brothers and sisters. If God is supremely free and preconditions all of us, should we not, in our humbler way, have some freedom? We have been called "images of God." If good will is infallible in God, should it not be our ideal to display such goodness as our fallible natures make possible? In addition, are

we not all, unless very subnormal, alike in that we are superior to other terres-
trial animals in our capacity to *think* in the way human languages alone make
possible? Today we are all threatened by the same global problems: expand-
ing populations, diminishing nonrenewable energy-supplies, environmental
poisoning, and all-too-possible nuclear war.

Why then did religion not do more for democracy than it has done or is
now doing? The failure stems partly from some definite theological mistakes.
God was often defined as Lord, King (or Queen?), whose subjects we all are.
God decides what we are to do, it is for us to accept and obey. And since this
King of Kings (or Queen of Queens) was by many thought to plan, or at least
eternally know, every detail of our lives, it becomes questionable what room,
if any, is left for our freedom. This difficulty is increased by the obvious fact
that there is an order of nature which obtains, whether we like it or not; night
follows day, winter follows summer, the heavenly bodies move in predictable
ways. The simplest way to view this order is that it consists of all-determin-
ing, necessary conditions of events in the past having necessary consequences
in the future. The Stoic theology, the most prominent form theism took in
ancient Greece, followed this line, and alas it was accepted (or not clearly
corrected) by medieval theologians, by Spinoza, and by most of the German
idealists—with the honorable exception of Schelling in his maturity. He
believed in contingency and freedom. Hegel was at best unclear about God
and freedom, and even less on the side of freedom (except political) were
some of his Anglo-American followers. The Stoic-Spinozistic view makes
God the opposite of supreme creative originality. Divine action, too, was
thought to be by necessity. Freedom, some said, is mere voluntariness, acting
from the necessity of one's creaturely or divine "nature." Divine freedom was
thus in the same box with the freedom of a triangle to have three angles! Or it
was like that of water to consist of drops. These were Spinoza's metaphors. If
it were not so important it would indeed be comic. Contemporary "compati-
bilists" who say being causally determined and morally responsible can go
together are prolonging an ancient blunder.

There was a further mistake. If one admits supreme freedom to create in
God, does one go to zero freedom, or creativity, in us? Or to a lesser type or
form of freedom? Surely the latter is more reasonable. What is God's unsur-
passable freedom without the contrast to worldly, surpassable freedom? And
what about the other animals; have they simply no freedom? Is there only the
one human form of nondivine freedom (or are there three forms, human,
demonic or Satanic, and angelic)? Eighteen centuries of Christianity and
more than a thousand of Islam passed before a few Western writers began
speculating upon the definite possibility that freedom is a *metaphysically uni-
versal* capacity, or what the Scholastics called a "transcendental," applying
both to God and *every one* of God's creatures. Human consciousness, ele-
vated by the retentive capacity of language, has its own uniqueness; it enables

us to transform the earth's surface (for good as well as ill) as has no other earthly species. But, wherever there is life or awareness, must there not be some freedom, in the genuine sense of deciding (usually scarcely consciously) the previously undecided?

In reading many recent biographies, one finds evidence of the importance of the classical theological "problem of evil" as an important cause of agnosticism, atheism, or metaphysical despair. The problem is not solved by merely admitting *human* freedom. Much human and nonhuman suffering comes from "inanimate" nature, some from the behavior of wild animals, or bacteria, and the like. Skeptics argue that God, by making a choice to allow members of our, or other species, to be free, is responsible for the bad effects made possible by this freedom. If, however, freedom is a transcendental, God has faced no option between a world of more or less free creatures and a world consisting partly, or universally, of unfree creatures. Rather, to be a creature is to be an "active singular" (my phrase) with freedom of a humbler sort than divine freedom, but still *not zero*. The zero of freedom is, then, also the zero of concrete actuality. No other view, I am fully persuaded, as are many others (e.g., Peirce and Whitehead), does justice to the importance of freedom.

Obviously the necessity and universality of freedom deprives the classical atheistic argument, or anything at all close to it, of a major premise. This could help to explain the lack of enthusiasm for freedom in some writers! Freedom cannot be monopolized; it must to some degree be shared with *all* others. Divine power, as my father, an Episcopal minister, used to say, is power *over all* others, it is not power to *determine* all, or even (as I, though perhaps not he, would add) not power to determine *fully any* single other. Even optimal power must be power over other powers, not over absolute puppets. Indeed, physics no longer furnishes a basis for the traditional idea of a Newtonian, or mere, puppet. Things in nature lacking freedom as wholes (for instance a ball someone has thrown) consist of molecules or atoms that have some freedom or "self-motion" (Plato's term), and the motions conform to no absolute pattern binding upon individual behaviors.

Clerk Maxwell, as physicist, rejected strict determinism long before Planck's quantum physics. So did still others. Unqualified determinism never was more than a leap in the dark. W. Gibbs, superlative chemist, had no use for it. To have come, as a good many have, to see all this is a momentous intellectual achievement, about which our news media and even some mainstream religions fail to inform us.

Let us return to the question of good will or mutuality among members of human groups. Society works well only so far as there is mutual sympathy, ability and willingness to share the feelings as well as the thoughts of others. For the best or happiest forms of this sympathy we use the word love. There is a Christian saying, "God is love." Was the classical theism of Augustine

and Aquinas compatible with this declaration, or with Wesley's "Love divine, all love excelling?" No—and I stake my reputation on this—the Scholastics grossly equivocated at this point. To love, as the Greeks saw, is to depend somewhat for one's own feelings on the feelings of others. Yet Anselm, for one example of many, tells us that God feels no feelings of ours. "God is not compassionate," he writes. However, the effect upon us is "*as if* God were compassionate." God is, the medieval Aristotelians tried to think, the unmoved mover, which is far from being the supreme friend (or, in Whitehead's words, "the fellow sufferer who understands"). God, according to the Scholastics, is pure motionless intellect or reason, nothing honestly like love at all. Of course Jesus and Mary, his mother, did love, but so did the God in which *they* believed.

A further mistake in the history of religions was the refusal to accept birth and death as what they seem to be, the beginning and ending of an individual's career. On this topic much of ancient Judaism was superior to the entire medieval development. The Jews have the honor of having shown (see especially the Book of Job) that one can worship, and seek to serve, God entirely without hope of rewards, or fear of punishments, in places or states called Heaven and Hell. Personally, of the hundreds of things I could be afraid of, Hell is not to be counted as one. It is an absurdity too glaring to be taken seriously. I could not wish, or be able, to believe in any God capable of deliberately inflicting harm. I find this, in the words of Nietzsche, "human, all too human." To cite Reinhold Niebuhr, theologians, too, can exhibit wickedness in their thinking. The idea of Hell seems to me a wicked idea. Calvin, theological determinist, had disciples who burned Servetus. Was that loving their neighbor? Or serving a loving God?

Belief in heavenly rewards and hellish punishments made the Inquisitions and religious wars possible. Our job is to live our earthly lives first for their own sakes, then as gifts to our fellow creatures, and inclusively and above all, as gifts to God, whose participatory sympathy embraces all. Dante and Milton were great poets but bad theologians. Neither an unmoved mover nor a cosmic judge and police officer is worthy of worship as God.

William Wordsworth, also a great poet, came far closer to being a good theologian than those others. Yet even he did not definitely, in his poetry as I know it, affirm human freedom, though I think he believed in it, influenced by Coleridge. An American poet, Sidney Lanier, did affirm it in his truly philosophical poem called "Individuality." He really believed that if he made a poem praising God, it was he "and no other, man nor God," who "made" the poem. The equivocation in the contrary view is plain enough. We say that God "makes everything," but we also say, in good English, "*we* make decisions," or "make up our minds." *Yes* or *no* are the only pertinent comments here. By saying yes we help to rid religion and philosophy of one of their worst mistakes, the denial of creaturely freedom.

The mainstream Protestant "reformers," the Unitarian Channing being an honorable exception, scarcely improved theology, in some ways they made things worse. They substituted Bibliolatry, worship of a book, for worship of a church organization, while leaving intact the intellectual idolatry of worshiping one-sided abstractions such as the philosophical "absolute." The real reformer was Fausto Sozzini, or Socinus, who was so far ahead of his time that scarcely anyone not a convert paid serious attention to his, and his disciples', careful revision of the relation of God to human freedom. They also took science seriously and moderated claims for the uniqueness of Jesus. Above all they redefined God's eternity, so that it no longer implied a total absence in God of contingency, change, and dependence on others. God's eternity is the "impossibility of the divine non-existence." By no valid logic does it follow that there is nothing contingent in God, and no divine kind of change or dependence. Divine eternity does not exclude divine change. If even we can change but still exist as ourselves, why cannot God, in a uniquely excellent manner, maintain self-identity forever while changing?

One more mistake that I accuse theologians of making is that of *deifying infinity* so that there can be no finitude in God. As though *finitude* must, in principle, be bad or inferior! On the contrary, *mere* infinity is an utterly empty abstraction, as most of the Greeks, and I think the Hebrews, realized. What makes us nondivine is *not our finitude* but our *fragmentariness*. Each of us (and our entire species) is but a fragment (or group of fragments) in the vast cosmos, which also, at least spatially (I am confident) is finite. That it should be left to me to be the first to make the obvious distinction between 'finitude' and 'fragmentariness' is amazing. There have been so many great thinkers. How could they all, or so nearly all, have missed it?

Another thing that amazes me is something that I, and only a few modern predecessors, have seen, but that Plato saw quite clearly (I may have gotten it first from him, helped later by Whitehead and, oddly enough, by Hume). This is that the best analogy, in our common experience, to the relation of God to us and other creatures is that of our (and other animals') experiences to our (or their) own bodily constituents (especially, in modern terms, to processes constituting nerve or brain cells). This is incomparably more helpful in suggesting the intimacy of God's relation to creatures than the analogy of God as parent (worst of all, only as father) to children. To quote an author I haven't a name for (al-Ghazālī?), "Closer God is than breathing and nearer than hands and feet."

Many have said that God is *ubiquitous,* but few have drawn the consequences. Plato did, brilliantly, draw some of them; however, Aristotle ignored all this and theologians followed his guidance until, some time after 1860 in Germany, Pfleiderer, and in this country early in this century, Mcintosh (whom I knew as a saintly elderly gentleman), went back to Plato's suggestion that God is the "Soul" of which the cosmos of nondivine things forms the

body. One of Plato's implied conclusions is that, although God has no external environment (from which harmful or dangerous influences might come, or to which God needs to respond), still God, analogously to us, does have an internal environment from which influences do come and to which God responds. Plato even says that God *cares* about the creatures, values them. Being Greek, he refrains from saying God "loves" the creatures, but this is virtually implied. Moreover, God's influence upon the creatures is termed *"persuasion,"* not coercion.

Plato and Aristotle partly agree in holding that the divine power is not separate from the divine beauty. Indeed the beauty *is* the power. Whitehead agrees; "God's power," he writes, "is the worship he (?) inspires." This view overlaps with Plato's; yet, sadly, Whitehead sharply rejects Plato's soul-body analogy for God. The argument (historical, not systematic) which he gives here is one of his weakest. Thus the neglect of Plato's analysis was given another impetus. One more "cultural lag," of which intellectual history, especially philosophical and religious history, is rather full. Yet, unsteadily, up and down, the peaks of the waves grow higher, and there really is progress in theoretical insight, both in science and in philosophy of religion.

The idea of many nontheistic humanists that science will gradually displace religion is given little support by modern history. The best hope for democracy is rather that religion will outgrow its prescientific and even, philosophically, its pre-Platonic phases, and become philosophically and scientifically enlightened as worship of a Love that excels all other loves in its quality and scope; a freedom that, in humbler forms, is echoed in all the singular creatures; an infinity *and* finitude that are both, in principle, superior to any creaturely infinity or finitude, an eternity and temporality similarly beyond rivalry by any creaturely eternity or temporality. This scheme is more complex than classical theisms and classical pantheisms even dreamt of, but it is still not hopelessly complex. The human mind tends to seek eagerly for simple outlines of an intricate reality, but often has to reintroduce some of the omitted complexity in order to rescue values threatened or nullified by the oversimplifications.

A physicist (was it Bohr? Pauli?) has said, "Nature is stranger than we think; perhaps it is stranger than we can think." Is God natural? Well, nature is God's body. But, and here too Plato was more right than most of his followers, Soul (or that which "moves itself" and has some freedom) includes and surpasses its body. I, for instance, am not my body; I *have* my body, employ its movements, but am more than it is. It does not follow that I could be myself without my body. In this question Aristotle, not Plato, can be our guide. For Aristotle, we are born and after a time we die—period. Plato, by denying this, opened the door to dismal superstitions. Socrates, however, was somewhat more careful at this point. (I follow Vlastos here.)

Democracy needs a theology for which God is *not* a ruler demanding simple obedience, but rather, as Berdyaev says, an ever-creative Love asking of us, not strict obedience to an eternal plan, but loyal response to the divine persuasion. It is for us to obey the imperative: "be creative and foster creativity in others." The quoted words are from Berdyaev; it is significant how little attention has been paid to his book, *Human Destiny,* and its great vision of the God-World relation. The message was apparently too clear, too simple, or too sublime to suit a sophisticated world. Or perhaps a Russian emigré to Paris has been thought too remote from our concerns. Yet the book has been available in excellent English, as was not the case with the Socinian message and some other similarly splendid anticipations of what is now called Process Philosophy. Not the absence of religion is democracy's need, but a religion whose deity is the very supermodel of the will to cooperate with others that democracy requires. The intellectual basis for such a religion is already present, not in perfect form but good enough with which to work.

Science no longer (as for many centuries it did) insists upon unqualified causal determinism. Quite the contrary, it now supports the idea of real, piecemeal contingency wherever we have accurate knowledge of nature's processes. Epicurus anticipated this by more than twenty centuries when he attributed a slight bit of free play, his famous "swerve," to atoms. If atomic actualities have atomic freedom, actualities on the human or higher animal level may have greater freedom, and the cosmic mind's freedom may be beyond rivalry in scope or quality by any other agent. We have new religious opportunities such as no previous century had.

The newspapers sometimes tell us about scientific discoveries, but philosophical or theological ones are scarcely news in this country of ours. As Alexis de Tocqueville said long ago, our population has a philosophy, but it is unaware of the history of philosophy or its outstanding representatives in other countries, or even in this country. This is still too true. But, here and around the world, the means for improvement are known to some. If classical physics has been *permanently* superseded, so for many has classical theology, or philosophy of religion.

The problem is educational. Even John Dewey lacked adequate knowledge here. His great essay, "Time and Individuality," is mostly close to Process Philosophy—blind only to its positive theological implications. These are what democracy needs, not a mere cosmic question mark, or a merely "negative theology," which was always partly contradicted by affirmations with no clear principles for selecting among them. God, nearly all said, is cause. Is God *in no sense* also effect? I call this discrimination *against effects* "etiolatry," worship of cause. God as effect, or (Whitehead) as "Consequent" upon, influenced by, creaturely free acts, is infinitely *more* than God merely as *cause of all but effect of none.* Indeed there is no coherent meaning

for such a one-sided view. Causation just isn't like that in any experiences of it we have or can coherently conceive. Moreover, the only hopeful view of process is that it *increases* value, otherwise we are running hard to stay put. What is so glorious about that? In principle, effects should *surpass* causes. The inclusive effect is in God's appreciation of the creatures.

The history of human thinking shows us how fallible we are, but our hope, without some of which one cannot live, tells us not to settle for mere despair. As Popper and Peirce both tell us, there is progress; some mistakes are really overcome. The demonstrated fallibility of our human power of thinking should make us tolerant, but not cynical. It is reasonably demonstrable that Plato would have been happy to see our present state of science solving some of his worst problems, by getting rid of his (definitely false) notion of utterly *inert* bits of matter, totally devoid of the "self-motion" which he took as a sign of the presence of mind.

I think of Plato, Aristotle, Leibniz, Newton, Hume, Kant, Peirce, Whitehead, as capable of understanding some of our revisions of their world views as valuable truths which they missed. Thomas Kuhn's arguments against this way of thinking I (with Popper) find perverse and unconvincing. We have one indisputable *advantage* over our predecessors: we know (much about) them and their contributions; they did not and could not have known us or ours. How stupid we would have to be for this asymmetry to give us no benefits. We are not *that* stupid! Hope of improvement is the reasonable attitude.

Religion is partly a sociological phenomenon, how human groups cooperate in trying to relate themselves to their highest ideals and most important purposes. As a philosopher, I am not necessarily as well equipped to deal with this aspect as sociologists, anthropologists, or psychologists may be. What is most essentially philosophical about religion is the metaphysical aspect. And what is that? Much confusion exists about the empirical-metaphysical distinction. I hold that the most illuminating definition of 'metaphysical' was first sharply and correctly formulated by Sir Karl Popper, whom some of us term the greatest philosopher of science of his generation: A metaphysical statement is one that, although given coherent *meaning* by experience, is *not falsifiable by any conceivable experience.* For instance (my example), "there are experiences." Another (close to Popper's primary example): "there is more to nature than our (or any animal's) experiences." In other words, *realism* in some broad sense is not experientially refutable.

For metaphysical statements to have meaning, without which the question of truth does not arise, their positive and consistent meaning must be accessible through experience. This requirement cannot, I think, be met by 'fairies', 'demons', 'Satan', 'Zeus', or 'Venus'. Either these are disembodied spirits or they have bodies. If the latter, then experiential scientific evidence is abundant against their existence. If the former, then the analogy by which we impute mind to them is extremely weak. Here again we see the wisdom of

Plato. Think about it: for Plato's theism the whole of science, so far as true, is true of the divine body, and insofar is true of God. This is what many great scientists have virtually believed. It was theism that, with science, rid us of demonology and other fancies about nature. *Habeas corpus,* have the body, helps in such cases. If the interpersonal analogy extends even to deity, so does the mind-body relation.

Plato's doctrine was that one's mind is more than and contains one's body, not vice versa. Here he somewhat oversimplifies. In dreamless sleep, where is one's mind? Buddha said something appropriate on that question. Still, with Whitehead I hold that, *except* in dreamless sleep, we prehend (intuit, respond to) the actualities composing our bodies, especially those in the central nervous system, and they, in their much less adequate manner, prehend us. In both directions there is containment of the prehended, but all prehending other than the divine fails to contain the *full value* of the prehended. However, the human subject's prehensions come much nearer to doing this than those of their minute bodily subjects do, while the contents of divine prehensions are coincident with truth or reality itself. So Plato was mainly right. A mind includes and is more than its body, and this is most true of God.

One of Plato's worst mistakes was to think religious belief can or should be commanded by law. Here Socrates was superior. In Soviet Russia atheism was commanded. Now the collapse of that great political power is threatened. (As I write this sentence it has happened.) The other two large and populous countries, besides the United States—India and China—are in sharp contrast to each other; India with both considerable religious freedom and democracy, China with not much of either, especially not of democracy. In my country theistic religion is fairly pervasive, but some of it is of a kind hostile to the sciences and to philosophy cognizant of the history and present state of that subject. Also the cold war has caused us to become dangerously overreliant on military means of dealing with international disputes. Moreover, our population is scandalously undereducated in geography. Finally, a religion that associates belief in God with belief in posthumous careers for individuals tends to focus too little on the problems of life in this world between birth and death, in which world alone our known responsibilities and opportunities are found. Because of its more this-worldly stance, I see Judaism as a better tradition than the one which Roman Catholics and most Protestant sects inherited from the Middle Ages. Not only religion and democracy, but our species and much else on this planet depends for its future on how well and how fast people can learn to achieve a proscientific rather than an antiscientific form of religion.

An eloquent religion of mere humanism was advocated more than 120 years ago by L. A. Feuerbach and still earlier by Auguste Comte. There is little evidence that humanism can meet the human needs that Bergson so well

expressed. Feuerbach became the chief Marxian authority in philosophy of religion.

Buddhism, in my view, is in some respects superior to any Western form of humanism; however, its belief in reincarnation weakens its concentration on our one-time individual life spans, while its surface appearance of atheism makes it unable to give permanent significance to our lives without the reincarnation myth (it offers nothing like a proof for this belief). A high Japanese authority on Buddhism, named Suzuki (I met him once), said he was not sure that Buddhism is nontheistic. Another authority, Nakamura, says it is polytheistic. If so it is in this respect like Epicureanism. Mahayana Buddhism is ambiguous on freedom and the temporality of Nirvana.

What democracy needs is a religion that has learned, not only from the Judeo-Christian explicitness about God, but also from Plato's partly similar view (in his writings after the *Republic*), also from some post-Reformation theologies, as in Socinus and his disciples, first in Poland and then in Transylvanian Hungary, also from both of the greatest philosophical and scientific geniuses that ever lived, the American mathematician-logician-chemist-astronomer-psychologist, wide-ranging empirical scientist, theistic philosopher Peirce, and, a generation later, the similarly Leibniz-like Anglo-American, Alfred North Whitehead, mathematical logician, physicist, speculative philosopher—the last unrivaled philosopher in this century.

What is also needed is to learn from the Buddhist emphasis, also from Thoreau's and Mahatma Gandhi's, on nonviolent, nonmilitary ways of settling disputes. Neither Christianity (except in the Quaker branch) nor Judaism is comparable to Buddhism, or Gandhi, in this respect. And yet China's (partial) Buddhism did not save it from Marxism, nor did Japan's (partial) Buddhism save it from militarism. Neither did Germany's Protestantism and Roman Catholicism save that country from Hitler. Finally, our American Christianity did not save us from slavery, or other less obvious forms of racism, sexism, or vicious forms of imperialism, in the Philippines, Latin America, and Southeast Asia. There is enough blame to go around, repentance is in order for religious people generally.

In religion our species tries to deal with its best and its worst potentialities, its goodness and its wickedness, its wisdom and its folly. In this century both seem to reach extreme forms: Hitler and Stalin, Mother Teresa and Jimmy Carter's mother going to India to help poor people there. When Khomeini was an exile in Paris, before his rise to power, he gave a televised talk. Two people, of whom I was one, watched and listened; my thought was, "utterly grim, pitiless fanatic," the other's, as I somehow learned, was "pure evil." It seems that we have among us today some of the very best, good, and wise people there have ever been and some of the worst. I wish to end with some encouraging cases of the best and wisest.

Rabbi Abraham Heschel and his wife, when I called on them, seemed to me good, wise, in the best sense pious, people. Reinhold Niebuhr, when I heard him preach or talked to him, seemed a prophet, akin to Isaiah. I learned after the death of both that they and their wives were close friends for many years, neither trying to convert the other. What was this if not religion at its best and wisest? Both men were not just theoretically good, they were activists. Heschel tried hard to stop the Vietnam folly, Niebuhr kept taking stands on public issues.

Karl Barth is often described as a very conservative theologian, but he is also a twentieth-century thinker, who in some ways has reached some of the ground the Socinians first broke open. When I said to him in Basel, "I think there is change in God," he replied eagerly, "I say that too." In his systematic treatise he also says there is contingency in God.

I end with a tribute to one of our most admirable Polish-American citizens, Zbigniew Brzezinski. In a recent interview, I think during a McNeil-Lehrer News-Hour, when asked about the defects that brought about the collapse of the Soviet Empire, he gave the usual list of weaknesses of Leninist-Marxism and then added one more, the rejection, or neglect, of religion. I do not recall his exact words but do recall the kind, wonderful smile with which he said the words. It was, for me, as if the "beauty of holiness" had come upon his face. Ever since, I have thought of this person as one of our national treasures. And yet, in the several *Who's Whos* in my house, all of which refer to me, and in a recent encyclopedia which has my name in four places, I cannot find Brzezinski's. (He is in some reference book, I'm told.) Could this be one more indirect effect of the undereducation of our population, as shown in the inability of individuals of the quality of Adlai Stevenson and Hubert Humphrey to get themselves elected? Were they all three (including Brzezinski) somewhat too good for us Americans? Alas, we partly deserve our troubles. How much and how fast we need to learn to think better in order to act better! The fortunes of our, and many other, animal species are at stake.

5

OF the many forms of theism, one form, held by numerous Christian, Islamic, and to a lesser extent Jewish theologians, has shown a remarkable power to convince thoughtful people. True, it began to lose this power in the Enlightenment, but the Protestant Reformation left it largely intact, or even worsened its faults. I'm thinking of the absurd view of omnipotence as power to make the creatures' decisions for them, as though these could then be *their* decisions. In short, supreme freedom was taken to be the only freedom. I'm also thinking of Luther's cruelty to the rebelling peasants, and of Calvin's disciples' burning of Servetus at the stake. (If there is any wickedness inherent in human nature, is it not shown in the latter hideous action?) The point is not that Luther's or Calvin's beliefs implied (or did not imply) the correctness of such behavior. The point is that Luther's or Calvin's voice was not literally the voice of God, nor are words in the Bible literally words of God. No human individual is entitled to claim infallible knowledge, and surely not of the precise degree of truth in a book set down in words by various human authors (or translators) in various human languages. For the worship of an allegedly (in certain of its functions) infallible church, the mainstream Reformers substituted an allegedly infallible book which they could (infallibly?) understand. They committed the religious sins of idolatry and also of fantastic degrees of "pride," in claiming to *know* that one human group, institution, or document is beyond criticism, just as God is. Apart from the collective conceit or arrogance shown in this, what about the implausibility of any such absolute knowledge by human beings? And to kill or torture to death on the basis of such a claim, if not near insanity, is certainly most wicked.

There is a conceptual, systematic reason why, in spite of the foregoing, there are still classical theists. The *most true* view, one might argue, must be the extreme opposite of the *most false* view. This seems but is not a counterexample to the principle that errors or departures from truth come in opposite extremes—as, according to Aristotle, do departures from virtue. With the help of a deceased lady artist student and a German writer (Dessoir) on aesthetics, I have been able to show that beauty too is a mean between extremes, and with Bosanquet to show that ugliness is not the opposite of beauty. Ugliness is not sheer disorder and beauty is not sheer, unrelieved order. Beauty is rather the mean between these extremes in one dimension and also the mean between two other extremes in another dimension. The sublime, comic, tragic, pretty, and neat or tidy have their places in the scheme (see chap. 12).

It remains correct that the most true view must be the *extreme* opposite of the most false one. By this test, however, classical theism fails, though it takes some care and subtlety to see this. In classical theism God is wholly necessary and the world wholly contingent. Symbolized by *N.c,* the widely accepted doctrine is surely more true than its opposite *C.n,* at least for theisms in the high religions. (Capital letters refer to God, lowercase letters to World, or what is not God. Thus *C,* used apart from *N,* means, God is contingent and only contingent; *n* used apart means, World is necessary and only necessary. *NC.cn* [the permutation in *cn* is neutral to questions at issue in this essay] means, God is both necessary and contingent, world is both contingent and necessary.) Obviously a wholly necessary created world could not depend on a wholly contingent Creator. So the opposite of classical theism is definitely false of the God of the high religions. But is it the extreme or complete opposite, is it the most, or wholly, false? Overlooked for about two millennia was the logical point that, since the most false view must be most opposite to or negative of the most true view, if we know what the former would be, we need only a small step of reasoning to arrive at the most true view: simply negate every negative feature of the false view. This is not done by merely reversing the modal poles as between God and World. Many writers, especially among critics of the Ontological Argument, deny that necessity can apply to being or existing. Kant, preceded by Gassendi, is one of these writers. Descartes defended himself ably against Gassendi, hence in effect against Kant! To assume that *C.n* is the most complete negation of *N.c* is to beg the question against *NC.cn,* which overlaps positively with both *N.c* and *C.n.* Only one of the sixteen options expressible in this symbolism has a complete opposite, or negative, and that is *NC.cn,* which is completely negated by *O.o* (or *Z.z*) the interpretation of which is the same as that for *OO.oo.* (*O* here means neither contingent nor necessary, and *Z* is for zero). And what is that but impossible? The smoking gun, the real enemy, is the *theologia negativa.*

I ask, What classical theist or pantheist ever so much as mentioned *NC.cn,* in any definite symbolism? This neglect is not disposed of by calling

NC a contradiction, since formal logic only requires that incompatible predicates apply to different respects, parts, or aspects of a subject. True enough, classical theism denies the possibility of real respects, aspects, or parts in the divine actuality, but this too is merely a dogma, not an established premise for argument. For partisans of *NC.cn,* God is both the simplest *and* the most complex of all beings, simple in essence but not in accidents, which are vastly, even infinitely, complex. God as both essence and accidents is the divine *actuality* which, as I have shown, is very different from mere *existence* even in ordinary cases, as in an animal or person. Existence (as follows from Whitehead's categories, though he never quite tells us so) is definable in terms of actuality and essence (some specifiable predicate). Actuality is *how,* or *in what* concrete thing or things, an essence is actualized; mere existence is only that the essence is *somehow* or in *something* concretely actualized. Actuality must be pointed to; its full quality is too concrete, even in ordinary cases, to be identified by mere universals or eternal objects. God, who knows or adequately experiences all creatures, must surpass us in perceiving as well as in thinking or knowing. Quality, value, must be perceived, intuited, or felt. It cannot be reduced to mere ideas, or eternal objects, or even non-eternal mere objects. Only subjects and their combinations or nexus are concrete.

The joke about the famous negative theology is that, since to go from most false to most true is an easy step, it cannot be true that there is epistemic security in mere negation. It must be at least as difficult to know what is most false as to know what is most true! To issue negative directives to God (no dependency of any kind, nothing contingent, no change of any sort), as theologians thought themselves modest, secure, and reverent in doing, is merely poor thinking. They were not secure or modest and what they did had little to do with reverence. Negation is parasitic on affirmation. We learn, not by effecting an initial act of wholesale negation, and then perhaps accumulating positive facts. We start with beliefs and supposed positive observations or truths. In all this Popper is the master. There is no other way to begin thinking than with something positive that is taken as known, at least roughly or with some probability. We purify initial affirmations by falsifications (in metaphysics the latter are logical not empirical).

The polarity necessary-contingent is one of a number of similarly abstract contrasts that can be used to distinguish God from what is not God. Other such contrasts are absolute and relative, infinite and finite, independent and dependent, even simple and complex. With each of these contrarieties, using combinatorial mathematics, a table can be constructed of the *sixteen possible conceptual combinations,* as affirmed or denied of God or World. I take this as a striking example of Peirce's (also Whitehead's) belief that all *definite* knowledge is mathematical, whether the mathematics is pure or applied. It may be extremely simple, as we are about to see. The traditions in their essential problems were no simpler, and the implied, but not explicated,

mathematics was the one I have just sketched. Classical theism, Aristotelian theism, and classical pantheism (Stoics, Spinoza), violently oversimplified the issue and only appeared subtle and complicated because of their maze of ambiguities and maneuvers as they tried to hide basic absurdities or contradictions. We are all merely human and none of our capacities are infallible.

There is a possibility of ambiguity in the explication of World or cosmos as "what is not God." This is to be construed as *not* entailing that the divine actuality fails to include the cosmos. Inclusion is not identity. You or I in some sense include our bodies but to identify a person with that person's body is reductive materialism. Hobbes may have been a theist who did this, but who else? I think theists should reject this identification. In addition, *denying* that the divine actuality includes the cosmos and yet saying that in God is something analogous to knowledge or love in us, and that divine knowledge or love is ideally adequate and *all-embracing,* is using words while abandoning any reasonable, even analogical, meanings for them. Knowledge of (love for) *x,* includes *x.* The reason many have not seen this is that our human knowledge (or love) is so mingled with defects and limitations that it may be better to say that it is closer to ignorance or guessing than to the full import of the word *know* (or *love*). One of the reasons for being a theist just is that we have to tame down many words in describing ourselves, since only God could fulfill the values the words tend to connote. We love, but how much of the import of that wonderful word do we actually achieve? With our best words, anthropology needs to be (partially) negative. Here too, however, extremes are wrong. Take "freedom": are we simply unfree and only God makes genuine choices among open alternatives? Is all our love merely self-love or self-interest? Certainly not. Negative absolutes are always suspect.

The polar contrast, necessary-contingent, is far from the only one that can be used to contrast God with what is not God. Others are: absolute-relative, infinite-finite, independent-dependent, simple-complex. God, for *N.c,* was form, pure actuality, pure spirit, *without* body, pure unity *without* plurality. With all such very abstract conceptual polarities, using combinatorial mathematics, there are $4 \times 4 = 16$ combinations of assertions about God, allowing for sheerly negative or zero applications.

In figure 1, column I has the superiority over column II because II makes God something that might not have existed, so that one must then ask, How does it happen that God does exist? The creator of all thus requires a supercreator, or mere groundless lucky chance. And to what does the divine happening happen? (My happening happened to my parents—and to many others.) Happenings, accidents, belong in time, not in pure eternity. I hold with Aristotle (and Plato as well, though less explicitly)—that to exist merely contingently is to have come to be. Aristotle: "With eternal things to be possible and to be are the same." The God of the high religions does not come to be, but always has been and always will be—without possible alternative of

having not existed. Eternal here need not mean immutable, but must mean unborn and undying.

In none of my books, including this one so far, is my most important original metaphysical discovery presented in its best mathematical form, or as what Peirce called a diagram. (In an inelegant form it is in *CS*.) The right formation (figure 1) is as given me by a dear friend, a Colorado College theologian. Note that the logic is a simple case of combinatorial mathematics, and that, of the sixteen combinations of statements no two could be true and they could not all be untrue, for the completely negative case is in the fourth column and fourth row, *Z.z* or *O.o*. Note also that the most positive case is in the intersection of the third column, third row, and the diagonal, *N.n, C.c, NC.cn* (the permutation is neutral to the argument) and *O.o*. These three lines embody three principles each of which has been or would be accepted by a number of philosophers who were or are not committed, and by some who were or would be hostile, to my theism. This furnishes a genuinely new argument for my neoclassical theism, nor is there anything like it for any other theism.

The sixteen options become thirty-two if each is subdivided into those accepting and those not accepting Plato's mind-body analogy for the relations between God and the cosmos.

Figure 1. The Sixteen Positive and Negative Options in Thought About God

NECESSITY AND CONTINGENCY AS APPLIED TO GOD AND THE WORLD

(Hartshorne's Model Somewhat Revised by Joseph Pickle)

	I	II	III	IV
1.	N.n	C.n	NC.n	O.n
2.	N.c	C.c	NC.c	O.c
3.	N.nc	C.nc	NC.nc	O.nc
4.	N.o	C.o	NC.o	O.o

I. = God is in all respects necessary
II. = God is in all respects contingent
III. = God is (in diverse respects) necessary and contingent
IV. = God is impossible (or has no modal status)

1. = World (what is not God) is in all respects necessary
2. = World is in all respects contingent
3. = World is (in diverse respects) necessary and contingent
4. = World is impossible (or has no modal status)

It took more than fifty years to get this table right (with Joseph Pickle's help—he, a theologian, was the neater mathematician).

Here are the principles represented by the dotted lines in some of their aspects.

First, III includes what is positive in I and II so far as deity is concerned. *Second,* 3 includes what is positive in 1 and 2 so far as world is concerned. *Third,* the diagonal from *N.n* to *O.o* includes the four cases in which a variable is used symmetrically as between God and World. This has the advantage that the ideas used to characterize deity can be given a basis in our experiences of the world, so that we need not appeal to mystical insight to give human meaning to our theism. *Fourth,* we can refute Aristotle's and Carneades's implicit objections to classical theism (before it existed) that it involves contradiction between categorial characterizations of deity and analogical ones, such as "living," "good," "beautiful," "happy," "spiritual," "rational or conscious," "loving," and the like. As Hume's Cleanthes said, a God *solely* necessary, self-sufficient, independent, unmoved, infinite, mere cause and in no way effect, can have no positive value-qualities, no awareness or intelligence, however analogical. It is really a kind of atheism from a religious standpoint. This was Wolfson's view also. To model a religious view of God on Aristotle was an unwitting but catastrophic blunder. How it could occur I am trying to partially explain in this essay.

An apparently conclusive objection to any symmetrical application of categories to God and World is that it nullifies, or at least complicates, their function of distinguishing God from God's creation. I say, apparently conclusive because the objection presumes *either* that there is only one way in which something can be contingent or necessary (relative or absolute, finite or infinite), or both of these together, *or else* that no such way could surpass in value, transcend, any conceivable other. This is a nonneutral, question-begging assumption. Take "I am finite," and "God is finite"; does this combination make me equal to God? *How* am I finite? I am only a tiny *fragment* of the finite; God's finitude is vast, indeed there may be a real temporal infinity of finitudes in God. Suppose the present cosmos is spatially finite. What am I in this vastness? Think of the galaxy or the island universes. God is *nonfragmentary* rather than nonfinite, but what CT (classical theist) ever made this manifestly justified distinction? It is as though these people had a phobia toward finitude and wanted to worship mere infinity instead of an all-surpassing and positively good actuality. Indeed what else was the case with Hinduism in the Advaita version? Or take the Thomist definition of God as *actus-purus,* actuality *without* potentiality. The Hindus were more consistently negative when they said, For Brahman we are not there, the supreme reality is free not only from potentiality and change, but also from any knowledge of multiplicity or the temporal world, which is Maya, there "only for ignorance."

To the objection to potentiality in deity, the reply is similar. *Iff* (logicians use this word for if and only if) value in *every* essential dimension admits of an absolute *maximum* of value, worth, or goodness, then indeed the All-surpassing and by-conceivable-others-Unsurpassable must be incapable of increase in value, and certainly incapable of decrease. (This was Plato's argument in the *Republic, not,* I think, later.) We know, since Leibniz, that there are *incompossible* possibilities of positive value; also that greatest possible multiplicity is a dubious notion. We know too that beauty, aesthetic value, has a close relation to variety and hence to multiplicity. Both Whitehead and Berdyaev argue that tragedy is not simply evil instead of good, but rather mutually incompatible goods that could not all be coactualized. Hence, although God is never wicked in the ethical sense, and never chooses the lesser general good instead of the greater, still God could not possibly have a *most* beautiful possible world to enjoy contemplating, and hence can increase in value as new beauties are added to the cosmic treasures already achieved. I distinguish two forms of perfection *A* and *R,* absolute and relative. In whatever sense *A* is logically possible, God has *A;* in the remaining (aesthetic) sense God has *R.* No matter what, God will enjoy incomparably more of the cosmic beauty than anyone else ever could. The very year I came to this view, a visiting Hindu scholar, Mukerji the sociologist (who also called himself a mystic), expressed a similar idea in the University of Chicago chapel.

In many ways, some of them decisive, we are no longer in the thirteenth century philosophically, nor even in the eighteenth.

Let us return to the advantage that the distinction of *N* from *n,* and *C* from *c,* gives us. If there were no illustration in the world for absoluteness, how would the idea of God as absolute acquire human meaning? By sheer negation? Yes, said classical theists. *God* surpasses all possible others (the meaning of the word in the high religions) by being *in no way* relative, dependent, effect, or changeable. In the world, however, every cause is also effect, every dependence is balanced by some form of independence. We depend on our ancestors for our very existence, did they depend on us for theirs? If you say yes, then you are begging answers to the following questions. Is the causal order of the world symmetrically absolute, so that what happens in a given situation is the only possible outcome of what went before, just as what went before was the only way what happens next could have come about? In short, is there any freedom of decision making in the creatures, or is the divine freedom the only genuine freedom? Or, does even God act only by necessity? What is cognitively safe about any of these negations? In ancient Greece, after Democritus, only the Stoics were complete necessitarians, denying freedom of choice even to God. All these ideas conflict with normal common sense just where common sense ought to be considered relevant. They

also conflict with quantum physics, and even, in subtle ways, classical physics, as Maxwell hinted and Peirce and others asserted.

In any case, classical theism, CT, was not *consistently* negative. Is *cause* merely negative, is *dependence* merely negative, is love or knowledge a mere negation? One has only to call their bluff to see how insecure classical theists were in their negativism. At their best these people did not quite believe what they were saying. They did want to think that we influence God, who cares about and cherishes all the creatures. In all the Western religions, mystics spoke for such truly *positivistic* affirmations.

The most negative and also most false view in the table is *ZZ.zz,* or *O.o.* Ergo its complete opposite *NC.cn* is the most true. Q.E.D., assuming the principles the three "lines" represent, also assuming that we are discussing 'God' as a religious term, not a mere visual mark without positive coherent interpretation. Apart from all actual religions, the idea of "all-surpassing excellence" or "eminence" might seem to lack relevance, were it not that, in fact, when people try to dismiss the God of the high religions they tend to substitute deities of low religions, or a virtual deification of humanity, or (Strawson) "The Universe." Were Lenin or Stalin taken realistically as merely human in Soviet Russia? Was Sartre (definitely an atheist) merely human for the disciples of Sartre who helped to ruin Cambodia? The view that "when God departs the half gods (or demons) arrive" seems to have substantial empirical support. Was Buddha merely human? What is Nirvana, entirely beyond suffering but surely not beyond joy or bliss? Suzuki said he did not know the answer here. If we don't worship God, we are for many, if not most, important purposes atheists. Here I disagree with Morton White and various others but agree with Peirce, William James (in some passages), the mature Bergson, Whitehead, and also Plato—than whom, in his mature phase, I know no greater philosopher, by the standards of his time, or of any time until rather recently.

In spite of the counterargument from the opposites, most true and most false, the maxim, avoid extremes, is in general sound; indirectly it supports *NC.cn* and invalidates *N.c.* Modal terms, and other extremely abstract contrasts, including infinite and finite, are only ambiguously evaluative. Simply denying finitude of God does not exalt deity; rather, it makes God less than the world, with the latter's immense, and by us mostly unknown, treasures of beautiful finitudes. Sheer infinity all by itself is nothing recognizable as good or beautiful in any positive sense. "Formless, all lovely forms, thy loveliness declare," taken literally, is mere gibberish. If not taken literally, just how then? Such rhetorical flourishing with words is not using them to express definite thought. And how can the supreme idea we are to live and die by be so indefinite as all that?

The remarkable charm of the words I have called gibberish is partly explicable by the phonetic verbal music they constitute; the rhythm, the many

(seven) repetitions of the soft letter *l,* the many nice vowel contrasts, the rhyming lovely-loveli, and the avoidance of harsh or hard consonants. Consider the following quatrains from one of Shakespeare's wonderful sonnets:

.
Since brass, nor stone, nor earth, nor boundless sea
But sad mortality o'ersways their power,
How with this rage shall beauty hold a plea,
Whose action is no stronger than a flower?
O how shall summer's honey breath hold out
Against the wreckful siege of battering days,
When rocks impregnable are not so stout
Nor gates of steel so strong, but time decays?

In this matchless genius's hands *phonetic* aspects of words reinforce their metaphorical or literal meanings and associated visual imagery. Accented harsh, sharp, or hard sounds (*t* eight times; hard *g* twice; *k* or hard *c* four times). These fourteen accented consonantal sounds express the violence by which the seemingly strongest things are in the long run destroyed. And then consider the soft sounds in *plea, flower,* and *summer's honey breath.* Of course these soft musical things cannot endure either.

Religious music, verbal or instrumental, is fine, but it is not theology, philosophy, or science. And religion, to be fully relevant, must include all of these.

There is a special historical reason why classical theism had its long reign and could with impunity enforce its dicta by fire and sword, or instruments of torture. This was the bad luck that much of the mature thought of Plato was seriously distorted or simply hidden by his disciples and successors. I refer to Aristotle, Carneades, Philo, Plotinus, and various other "Neo-Platonists." People much more scholarly than I am have spelled out this story in recent times. The connotations of the word *Platonism,* as mostly used, are far from Plato's mature thought. Richard McKeon, on his oral examination, was asked, "In what writing was Plato's theory of ideas first expressed?" "In the fifth book of Aristotle's *Metaphysics,*" was his reply. This was not just a joke and I do not take it as such. To approach Plato through Aristotle is the hard and inefficient way to understand Plato. Philo is in some ways better, but in others worse; ditto Plotinus. McKeon himself did not claim to be a Platonist, nor was he.

My approach to Plato, luckily for me, was through the Americans Paul Shorey, Paul Elmer More, Ronald Levinson (Shorey's student and a close friend of mine), also Burnet and Cornford of England. I also read a French admirer of Plato (who was not deceived by and very critical of Aristotle), and a German scholar in Plato; indeed I was exposed to the work of two such

scholars. In addition, I listened to a Chinese specialist in Aristotle (Hung-hwan Chen) who studied nine years in Germany and one year in England before coming to this country. I knew him personally and well. Recently I discovered in the famous 1911 *Britannica* Lewis Campbell's fine and enthusiastic article on Plato. Finally there is Daniel A. Dombrowski, who sees sense in my interpretation of Plato and who has written a fine book on Plato's view of history. In all of my thought about the history of philosophy, from Aristotle and Philo on down to Spinoza, I have learned much from Harry Wolfson, whom also I knew well. He enabled me to see how the classical theists were misled by Aristotle's radically one-sided, and scarcely even mildly plausible, view of the divine life as the mere thinking of thinking (totally *devoid of* any intrinsic relation to, or awareness of, the contingent specificities of the world), and how these negations were, with radical inconsistency, combined in patristic and medieval classical theism with so-called knowledge of and love for created individuals and creation of the world *ex nihilo.*

What was Plato's mature view? First, that in the central and deep questions we cannot hope to capture the full truth in wholly precise and secure language, but second that we should not (with the Sophists) give in to mere skepticism, vagueness, or humanism (man as the measure of things). Third, philosophy is dialogue, requiring long, cooperative effort and maturity (so that we should not expect articulate wisdom from young persons). Women as well as men (here too Plato [and Socrates] surpassed Aristotle) can, in unusual cases, play their part in the process. The way to philosophic truth, to be expressed as definitely and precisely as we can, though never wholly securely so (for we are not God), is through mathematics, geometry in particular. We also need to be aware of our concrete human situation, between the other animals who lack Logos, language and the capacity for rational thought that goes with it, and divinity, which transcends language. Fourth, what we hope for is "something like the truth." We need also to balance rational thought with mythical intuitions. Experience is in essence other than mere intellection and involves feeling, love, friendship, hoping, fearing, desiring, goal seeking. Plato knew too that civilized humanity arose out of previous, uncivilized stages (Dombrowski).

For Plato the key to life and reality (Burnet) is *not* the famous ideas or forms, but the idea of *soul* or mind, with its processes of sensing, feeling, remembering, desiring, planning. However, we must also, Plato thought, admit a nonpsychical factor, for the psychical is where there is "self-motion," and in wholly inanimate nature there is (or then seemed to be) the inert, with no self-moving power at all. If this intrinsically inert "matter" moves then it is moved by push-pull from other bits of matter, and ultimately also by some psychical entities or individuals. Any talk about Platonism that simply omits the idea of *psychical self-motion as source of all motion,* is not about Plato at

all, so far as I am concerned. See the *Phaedrus, Timaeus, Sophist,* and *Laws,* book 10.

Plato was the first great, and an enthusiastic, theologian. Why is God required? Because there are many souls, or individuals endowed with self-motion, and there are also inert things that by themselves would never move or change. How, Plato asks, out of multiple self-motions and inert bits of matter, can one get an ordered cosmos with overall meanings and purposes. Multiple decision making to Plato suggests hopeless conflict, and lack of order of intelligible cooperative goal-seeking. The solution, as he saw it, was in a supreme psyche. Was this an unmoved mover? Of course not. Psyche as such is at least self-changed not unchanged. Indirectly it is clear that Plato knew also that a soul is moved by others as well as by itself, for he says it *cares* about others, and this is why Plato speaks of two Gods (or aspects of God— Cornford), the demiurge or merely timeless God and the "God that was to be," the World Soul, whose body is the cosmos of all that is not the divine psyche, especially all the animals, including us, and the inert things as well. Plato's God "cares" about creatures. In God is being and becoming.

The supreme soul, Plato says, is not only the cosmic orderer; it is the all-inclusive reality, for it is false that body completely includes and is more than soul. On the contrary, soul in principle includes body. This is explicitly affirmed. In this psychical inclusiveness Plato is right, both on his own grounds and (in a partly different way), on mine. The wholly inert cannot (this is a logical cannot) contain movement, and the wholly unfree cannot have any free constituents. In addition, in subject-object relations, subject includes its object so far as the subject's awareness is of that object. To deny that x is a constituent of awareness-of-x is an outright contradiction. Not that Plato ever wrote what I have just written. It is only one of the things he needed to write to complete his picture.

The truth is that Plato, being human, had some blind spots or arbitrary biases. His ambitious theocentric cosmology had a number of loose ends or ambiguities. That it was not adequately understood or at all fully accepted by his contemporaries and successors is easy enough to explain. His cosmology involved the puzzle of the two Gods, one creative of the other; the mysterious cosmic "receptacle," single subject of all the huge number of ever-changing predicates, a strongly monistic aspect of the system, which (Chen) Aristotle pluralized in his multiplicity of quasi-independent substances—a partial improvement and partial regression that left a trail of echoes in a long future; the indigestible mix of inert chunks of matter included in self-moving psyches; also the form of the Good, a principle of value consisting of an "absolute" beauty, of which all concrete goods or beauties were but defective copies or shadows thrown in a cave lighted from outside. Sometimes it seemed that the Good was almost a God beyond God, like the sun radiating

light and warmth to everything else, a Being beyond beings. Finally also there was the rather ungreek ("Barbaric"—Thomas Altizer) notion of a vast plurality of immortal souls capable of successive reincarnations. With such unfinished business in itself, Platonism had to face a threat from the Stoic notion of a completely necessitarian cosmos with purely "rational" causation by a supreme Psyche in which there were no distinct self-moving psyches, each with its own freedom genuinely able to conflict with the self-movements of others. It was a cosmos in which what happened was always the only thing that then and there could have happened—all was, in advance or eternally, determined. Virtue consisted in resignation, not in choices among truly open possibilities.

Is it any wonder, then, that Carneades, leader of the third Academy, became a deeply skeptical opponent of Stoicism, a probabilistic empiricist and nothing more? Remember, too, that in that society simply *no one really knew* anything *specific* about nature's microstructure, which is where, universally, much of the basic action is—nothing of cells, molecules, atoms, and mostly invisible radiation waves!

No aspect of contemporary philosophizing astonishes me more than the apparent failure to realize, and act upon, the *radically new opportunities* for metaphysical problem solving presented by the fact that the said microstructure is now no longer totally hidden or at best only vaguely or arbitrarily guessed at but is, in magnificent abundance, specified for us by the sciences. Of course there are new unsolved problems, but they are on different levels than the old ones. I select one aspect of the change showing how the improvement is not a mere matter of degree. Where in current physics is there an in-itself simply inert matter? Of course, nowhere! Epicurus guessed rightly here but could not convince the Aristotelians or so-called Platonists. Atoms are self-moving and may be psyches! The opaque dualism of Plato, Aristotle, and Descartes is needless from now on! Leibniz was the first to see this sharply. Insofar he was more truly Platonic than Plato (or anyone) could be in ancient Greece. Alas, he spoiled it by contradicting the self-motion of soul with his ultrarationalistic fiction of *sufficient* reason in the extreme sense that contradicts any distinctively individual freedoms. For Leibniz, freedom was only the unwinding of the necessities inherent in the "law of succession of states" which individuates a monad, and the monad itself existed only by God's selection of it as required for the uniquely best possible cosmos. Leibniz's God acts by "moral necessity." Even God has no real freedom. Here I side with Russell: Spinoza and Leibniz are two ultrarationalists; they equally reject genuine contingency. Plato knew far better than this. Indeed Epicurus did.

With Peirce and Maxwell, science and philosophy began to change again to allow for bits of contingency seeping into the world every moment, and on all cosmic levels of individuation. With Planck, Heisenberg, Whitehead, and others we can begin to have a more complete Platonism. The time is at last

ripe for Plato to get a fair hearing! We can now stand on his shoulders and in certain ways also on those of Aristotle, Epicurus, Anselm, Leibniz, Peirce, Bergson, Whitehead, yes and Popper. Kant comes in only if we rid ourselves of the idea that he disposed of Hume and the other pre-Kantians mentioned above. Against every one of these, Kant was partly wrong. We cannot go back to him or reverse the movement from his climate of opinion to ours. We need a New Enlightenment as, according to Whitehead, we need a New Reformation.

As some of my readers will probably know, Whitehead emphatically rejects Plato's doctrine that the cosmos is the divine body. However, the reason he gives for this rejection is a weak historical argument from the use made of the doctrine by the Neo-Platonists and Gnostics. Here Whitehead fell into the trap already occupied by so many others. It was Whitehead "nodding," with Homer. Oddly enough, my earliest clear recollection of encountering the divine-body idea in a modern is of a disciple of Freud, a German psychiatrist with whom I briefly discussed a psychosomatic difficulty of mine. He said, As our brain cells are to our experiences, so (analogically) are we to God (or to divine experiences). I told him this was also my idea. Whitehead should, in his philosophy of religion, have reminded himself of his own statement that his philosophy was a "cell theory" of reality and applied it as the psychiatrist did. The latter, I think, did not refer to Plato, but Whitehead should have, in just this context. To streamline his scheme, cells were what Plato needed—and *did not have.*

We now have that the lack of which wreaked havoc in the philosophico-theological traditions of the Western world for two thousand years. Is that not long enough?

I wish to end more positively. The almost deadly serious poet, Longfellow, reminds me of Wordsworth in his apparent lack of humor, but like Wordsworth, he could be profound. In one of his poems ("The Builders") he writes as follows:

All are architects of fate,
Working in these walls of time:
Some with massive deed and great,
Some with ornaments of rhyme.

.
[omitting a quatrain I consider foolish]

For the structure that we raise,
Time is with materials filled;
Our todays and yesterdays
Are the blocks with which we build.

I consider the poet in these last two lines to come close to sound philosophizing. What the present has from the past is the experiences of the past as

still intuited, experienced in the present. Note that the poet talks of days, not weeks, months, or years. Many philosophers make the mistake of discussing the fallibility of memory after a long time. These are the complex hard cases, exactly the wrong ones with which to begin theorizing. The poet is thinking minutes and hours, todays as well as yesterdays. Philosophers should emphasize seconds and minutes. Information theories tell us that we get new bits of information several times per second. Birds, with higher bodily temperatures and shorter brain pathways, live faster than we do. Each day our conscious awareness forgets vastly more than it remembers. Then there are dreams. Bergson wrote the best essay on dreams since Aristotle and much more factually accurate than Aristotle. I have verified what he says many times with my own dreams. The learned world has paid little attention to this achievement of the great Jewish-French thinker. This is not untypical of that world. The territorial function of highly developed bird song was discovered and cogently argued for several times before much notice was taken of this. Finally an entire book by Eliot Howard with "Territory" the first word in the book title settled that issue for nearly everyone in ornithology and influenced people studying animal singing in general.

The function of the brain (Bergson again) is not primarily to make remembering, that is, experiencing the past, possible, but to prevent excessive and inopportune remembering from interfering with appropriate responses to the very near past and almost present possible. Causality, as David Hume and the overestimated Kant alike failed to realize, in principle just is memory. I learned from the great Anglo-American, Whitehead, that mentality, in its non-human forms, including the human form as an extremely special case, needs no explanation. Mentality is all we know, the rest is mere verbiage. Whitehead's concept of prehension, or that which perception and what we ordinarily call memory have in common, interprets all experience as of the past, not the absolute present. To explain mentality, a positive power, by an in principle mindless matter is upside-down thinking. The old Buddhist phrase mind-only is an early version of this truth. In the West, Plato came the closest to it with his doctrine of mind as self-activity and the cause of all activity or change. Aristotle missed it and the West allowed Aristotle to dominate in theology, precisely where he was at his weakest, with his unmoved, timeless mover.

Another mistake was absolutizing genetic identity, thus starkly contradicting the lack of any sense of community or sympathy and inviting us all to give in to the excessive individualism of our Western societies. Whitehead expressed this when he said, "I sometimes think that all modern immorality comes from the Aristotelian doctrine of substance." In fairness it is Leibniz, not Aristotle, who absolutized personal identity. Aristotle's admission of *accidental* predates the successive stages of the idea that substance qualifies the identity. But Aristotle made far too little of the *interdependence* of persons, and Peirce's extreme continuity-ism or synechism made his theory of succes-

sive actualities, experiences, too indefinite to be of much use. His "infinitesimal" present experiences, with an infinite number of successive ones in a finite time, however short, blurs everything. So often a great discovery is partly spoiled in some such way. (Aristotle also and Bergson had no definite present experiences. On this issue, von Wright and Whitehead, with their temporal finitizing of experiences, seem unusual in the West.)

As I like to say, we all make mistakes. We are neither *A*-perfect nor *R*-perfect. However, we do not all make the *same* mistakes. (Only *some* Hindus accept the saying, "That art thou.") Let us do the best we can with our agreements and disagreements. Posterity may do better still. We should not be intimidated by pronouncements of the demise of metaphysics or the lack of progress in it. I offer this essay as proof to the contrary.

6

WHAT METAPHYSICS IS

METAPHYSICS can be approximately defined in a number of ways, including the following:

(a) The unrestrictive or completely general theory of concreteness

(b) The theory of experience as such

(c) The clarification of strictly universal conceptions

(d) The search for unconditionally necessary or eternal truths about existence

(e) The theory of objective modality

(f) The theory of possible world-states, or the a priori approach to cosmology

(g) The general theory of creativity

(h) The search for the common principle of structure and quality

(i) Ultimate or a priori axiology (theory of value in general)

(j) The inquiry into the conceivability and existential status of infinity, perfection (unsurpassability), eternal and necessary existence

(k) The rational or secular approach to theology

Diverse as these formulae may seem at first glance, I believe that they all imply the same thing and differ only in emphasis and focus of explicitness. "Unrestrictive" says the same as "negates no positive or extralinguistic possibility," and this is the same as "unconditionally necessary" (d). "Completely general" (a) or "strictly universal" (c) imply applicability both to what is and to what could be, and this coincides with what has no alternative and is simply necessary (d). It also coincides with what is eternal (d, j). The strictly,

or unconditionally, necessary must be known, if at all, a priori (*f, i*) and be valid of all possible world states (*f*). What is inherent in experience as such (*b*) cannot be denied except verbally, and must be necessary and knowable a priori (*d, f, i, j*). "Inherent in experience as such" means exactly what it says; "inherent in *human* experience as such" would mean something else, and those who can see no great difference are probably not fitted for metaphysical inquiry. The most general factor in creativity (*g*) will be expressed in any possible creation; as the very principle of alternativeness it will have no objective or ontological alternative, but only a linguistic one, and thus be necessary.

"Theory of concreteness" may be compared to the Aristotelian "being *qua* being." Collingwood bases his rejection of metaphysics, or his reduction of it to the making, and historical study, of "absolute presuppositions," partly upon the argument that "being," purely in general, can have no distinctive characteristics, and hence there is nothing significant to be said about it. But the theory of concreteness is not the bare theory of being, of what an "entity" is just as an entity. Rather it is primarily the theory of what a concrete entity is, as concrete rather than abstract. From this it appears that pure nominalism is metaphysically wrong, or at least antimetaphysical; for it destroys the distinction upon which metaphysics as such rests. Collingwood's argument is cogent enough if "completely general" must mean "applies alike to the concrete and the abstract," or without regard to any such distinction. What it should mean is, "applies in some way to the concrete as such, and in some presumably different way to the abstract." A purely general theory of concreteness will include a theory of abstractness, but there will be a real distinction between the two. (Actually, Aristotle was not without resources for defending himself against Collingwood's argument. Nevertheless, I believe we need a much sharper sense of the meaning of "concrete" than the Greeks or the Schoolmen achieved. The "fallacy of misplaced concreteness" is pervasive in the history of philosophy.)

There is another counterargument to Collingwood: it is idle to speak of being, or concreteness either, unless we can relate such a term to experience and knowledge. To generalize the object of thought or experience is to generalize thought or experience itself. And again, please note that "*human* experience" is restrictive, rather than a harmless redundancy. The unrestrictive notion of being or reality cannot be separated from the unrestrictive notion of experience. Nor—as Plato saw—can this generic notion of experience be separated from the purely general notion of value, the form of the Good. (Note definition *i.*) Thus at least one thing is true of any entity whatever, that it can be thought, experienced, and valued. Or, as Peirce put it, any concept is a potential contributor to the *summum bonum,* and how it can contribute is its meaning. In spite of Collingwood, all this is worth saying, and is true, rather than a mere presupposition.

"Being" suggests a contrast to becoming, yet according to Colling-wood's argument, the generic notion of being would ignore this contrast. Whitehead has shown that it need not be so. His formula is: any entity, abstract or concrete, has this in common with every other, that it constitutes a "potential for every [subsequent] becoming." Here we have, for the first time in intellectual history so far as I know, a definition of "being" in terms of "becoming." Hitherto, apart from Bergson (ambiguously preceded by Hegel), the effort had almost always been to define becoming in terms of being. This could only result in a fallacy of misplaced concreteness. Becoming is the more concrete conception, and includes within itself all needed contrasts with mere being. In each particular instance of becoming, what has previously become does not *then and there* become; yet it does constitute a causal factor in the new, and in all subsequent, instances of becoming. This *cumulativeness* of becoming (first stated sharply by W. P. Montague and Bergson) is caus-ality, the efficacy of the past in the present. And any strictly eternal entity constitutes a factor in every becoming whatsoever. Actual happenings, for instance our acts of thinking now, are what relate themselves (consciously or not) to the eternal, as well as to past, happenings. To try to put all such rela-tions into the eternal is either to eternalize everything, and therefore in no dis-tinctive sense anything, or to dissolve the eternal into the flux, whereupon again the distinctive meaning of both terms is lost. The unique relatedness or relativity of becoming makes it the inclusive or concrete form of reality; all else is abstraction.

If the reader asks, what does "concrete" mean, he has just been given an indication, at least, of the answer. The concrete is the inclusive form of re-ality, from which the abstract is an abstracted aspect or constituent. Again, the concrete is the definite, for to abstract from details or aspects is to conceive the indefinite. The number "two" is abstract because it is indefinite or non-committal, for instance, between two apples, two persons, two ideas, two entities. (Extensional logic seems sometimes to obscure more than clarify such problems.)

Plato rightly regarded the Form of Good as more ultimate than "being" taken in abstraction from value. Any such abstraction would conflict with (*b*), for valuation enters into every possible experience, and hence value enters into every possible object of experience or thought. As theory of concrete-ness, metaphysics can abstract neither from value nor from experience or thought. It abstracts from *this* concrete thing, this value, this thought or expe-rience, also from this structure or quality, but not from concreteness, value, thought, experience, structure, or quality in their pure generality. Materialism either has no theory of concreteness, or it tries to construct one while making some of the abstractions just mentioned. But this is impossible. Materialism is a covert dualism, and dualism is simply the refusal or failure to achieve a general theory of concreteness.

That metaphysics is theory of concreteness is implied by Whitehead's description "the critic of abstractions." The abstractions are criticized, not, as in science, because they are inaccurate to the facts, but because other *equally general* or even more general abstractions are left out of account, and thus the general meaning of "concreteness" is not brought out. In all human knowing there must be abstraction, disregarding of details, but it is one thing to disregard details and another to disregard aspects quite as universal as those taken into account. Physics abstracts from mind, and even more obviously from value and quality as contrasted to structure. Yet any entity, even in merely being mentioned, is in some minimal way being related to experience and assigned a value; also structures, that is relations of relations, presuppose entities distinguished in some other way than merely by their relations. How else if not by their qualities? What current physics abstracts from is therefore no detail, even in the broadest sense of "detail," but a matter of principle.

The point about structure as the concern of science is not just that it is general, but that it is precisely or mathematically expressible (even though not without subtle qualifications which are commonly forgotten, but which Plato long ago [partly] saw). Also structure is intersubjectively observable in a sense or degree in which quality and value are not. Accordingly, to abstract from quality and value in science is reasonable; but not because we thus transcend details. Mere generality is not the goal of science, which is, rather, definite or publicly and accurately manageable generality. Value as such and quality as such, like experience as such, are as far from mere details as any scientist can get; but their intersubjective manageability is difficult or problematic.

"Concreteness" is that abstraction in which *only* details are set aside and even unmanageable generalities are given their due in whatever way possible. (Note especially formulae *b, g,* and *i.*) No study, unless metaphysics, is responsible for *this* abstraction. To deny metaphysics on principle is to guarantee that there will be no careful, disciplined theory of concreteness. The difficulties which cause science to set this notion aside form no absolute obstacle to such a theory, for in metaphysics we are seeking, not prediction or specific definiteness, but only generic understanding. We are looking, not for particular facts, but for the principle of factuality itself, the general status and value of facts as such, any facts.

How the secular approach to theology (*k*) leads in principle to all the metaphysical problems and suggests their solution I have tried to show in my *The Logic of Perfection;* also in *Anselm's Discovery.*

In (*d*) it is assumed that, as Aristotle held, "unconditionally necessary" and "eternal" are equivalent. I hold that the common doctrine of the "timelessness" of factual or contingent truths is metaphysical, and precisely in the bad sense. This is one of the most glaring illustrations of the charge that "posi-

tivists" do not escape metaphysical commitments. Reichenbach and Felix Kaufmann almost alone, among antimetaphysicians, have avoided this trap.

Concerning (*e*): Aristotle suggested, in somewhat uncertain outlines, a theory of objective modality, but failed to see or adhere to some of the implications of this theory. Nothing much was done about this until Peirce proposed his view of time as "a species of objective modality" with explicit reference to Aristotle. And indeed, it was Aristotle's theory to which Peirce returned. That time is the "schema" (Kant) of our basic conceptions was already seen by Aristotle, although neither philosopher realized that time or becoming explains eternity or mere being, not vice versa. Eternity is a function of time, not the other way around. The current view that modal concepts are merely linguistic or logical, rather than ontological, is due to not seeing that the essential structure of time or becoming is inherent in concreteness (and in factual truth) as such, and hence is a priori, and that this structure is modal and cannot be grasped in merely extensional terms. That "only propositions can be necessary" is a mistake, for the creative process (one aspect of which is time) is the concrete from which alone any abstractions can be abstracted, and alternative propositions are contingent only because and insofar as this process as such is free to realize what either alternative asserts. What is objectively necessary absolutely is that the creative process will continue to produce creatures, and thereby itself continue to be creative. There can be no alternative to alternativeness itself. Deterministic philosophies fail to understand this, for they rule out alternativeness, at least as an innerworldly principle, and leave at most a mysterious contingency of the world as a whole, to which conceivable alternatives are perhaps admitted, but no principle by which any such alternative could have been realized. Determinism attempts to abstract from the creative aspect of experience, as materialism attempts to abstract from experience itself. Neither can offer an intelligible theory of concreteness. Here Socinus, Lequier, Bergson, Peirce, Varisco, Montague, Whitehead, Wenzl, and many others before them, including Plato and some Buddhists and a Hindu sect, are not far apart. But this neoclassical tradition is largely unknown to many philosophers today.

The reader will note that, as I use terms, "empirical metaphysics" is an absurdity. "Empirical cosmology," perhaps—but then scientists are probably the best people to attempt this. And without an a priori element it is doubtful if much can be accomplished. Einstein has said that we might empirically show the world to be finite, but we could not thus show it to be infinite. This I suspect is correct. Infinity, whether of the actual past or of actual space, is not an empirical concept. It must then be a metaphysical one. (I also suspect that space is necessarily finite.)

Similarly with the nonquantitative infinity, or perfection—unsurpassability in some value sense—which defines deity. In spite of Leibniz no one

knows what a "best possible" world would look like, nor if he (or she) did could he know that our world had this supposed character. Nor can inference from a perhaps partly botched product yield a flawless cause of that product. By no merely factual argument, therefore, can we prove or disprove divine perfection in any religiously significant sense. But in my view, nothing metaphysical, nothing in any strict sense necessary, infinite, eternal, universal, ultimate, absolute, or all surpassing could be known empirically.

Did Hume and Kant demonstrate the impossibility of significant theistic arguments? Yes, but only if they also demonstrated the impossibility of metaphysics, of a priori evidence about existence. Many take them to have done this. I think otherwise. And I have been studying these writers with care for forty-five (and then some) years.

It might be thought that empirical evidence could at least *disprove* the existence of perfection. On the contrary, Anselm showed that any being whose existence would or could be contingent, that is, with a possible alternative which facts might have shown to obtain, must for that very reason lack perfection in any strict sense, "even if it exists." Thus to try to conceive a factual disproof of theism is already to change the subject. Only an idol, a fetish, as Peirce says, could be subject to factual disproof. Perfection, divinity, is a nonempirical topic, and must be handled as such. Or else mishandled, as so often occurs, both in theistic and nontheistic circles.

The illusion of an empirical test for the existence of perfection arises partly because we are used to looking to observed facts to tell us what exists, and partly because of subtle confusions embodied in the conventional ideas of omnipotence and omniscience, that is, of unsurpassable (or better, all-surpassing) power and wisdom. It has been supposed that a supremely free being could and must create creatures themselves quite without creative freedom— as though "creature" meant anything less than an individual instance of creativity other than supreme, and as though supreme creativity or decision making must or even could be a sheer *monopoly* of decision making. The fallacy of this notion can be seen a priori, and it would cause trouble no matter what facts of good and evil might be experienced. The error is logical; hence appeal to empirical facts is beside the point. A perfectly created and perfectly managed universe—in whatever sense this is conceivable—cannot mean a predestined or an absolutely controlled universe, for this is the same as no universe. Individuals (not alone human individuals) must in some degree be self-managed, agents acting to some extent on their own, or they are not individuals, concrete units of reality. This is inherent in the concept of concreteness. A definition of deity which violates this concept is illicit, regardless of facts. The literal meaning of "fact" involves making, creativity, as ground of the contingency of fact as such. I agree with Kant: empirical procedures to justify or falsify theism are one and all fraudulent—with all due respect to

Mill, James, Brightman, Hick, and many others who have tried and are try-
ing so valiantly to show the contrary.

But surely, you may be saying, concepts derive somehow from experi-
ence. Yes, but there are two classes of concepts, and two modes of derivation
from experience. One set, the ordinary concepts, derive from special kinds of
experience, and get their essential meaning from this specialization. The
other set, the metaphysical concepts, derive from *any* experience in which
sufficient reflection occurs, and they will be illustrated in any experience,
even unreflective (if only *for* a reflective experience which is aware of the
unreflective one). Such universal conceptions used to be called "innate
ideas," by which was meant something rather like what I have just described,
though John Locke was perhaps not entirely to blame for misunderstanding
this.

"No experience means no ideas": who has ever denied that? (At most,
classical theists perhaps denied it of God, who apparently, in their view, did
not experience, but just knew.) The metaphysical ideas, however, are unique
in applying to *any* experience, human, subhuman, superhuman; hence if some
do not have them, it is not because they lack some particular sensory or per-
ceptual experience to reflect upon, but because they do not reflect sufficiently,
or in a sufficiently general way, upon those experiences which they have. As
Leibniz cleverly put it, everything in the intellect comes from the senses—
except the intellect itself! The *intellect's self-understanding* is innate, a priori,
or metaphysical. If Locke is supposed to have refuted innate ideas in this
sense it is because many other accidental and irrelevant factors have been
allowed to confuse the record.

Locke was particularly, and rightly, concerned about the supposed cer-
tainty of the innate ideas. But it was accidental and irrelevant if the rational-
ists identified "a priori" with "certain." That any experience, *to sufficient
reflection,* illustrates the metaphysical conceptions is no guarantee that a
given individual at a given time has so reflected as to be "clear and distinct"
or certain about his formulation of the conceptions. Formulation, verbaliza-
tion, is an art, and a fallible one whose success is a matter of more or less;
most animals and all infants have no such art. Who knows that we are not all
partly infantile in this matter? Whitehead's reference, in this connection, to
our "ape-like consciousness" is perhaps a literary exaggeration, but otherwise
it is seriously intended and appropriate. Mistakes are possible in mathematics
and formal logic; is not metaphysics just that part of a priori knowledge in
which clarity and certainty are least readily attained? Intellectual history sug-
gests that this is so. And there is no reason, apparent to me, why lack of clari-
ty or confusion must always be due to insufficient awareness of relevant facts.
It may be due to insufficient, or biased, reflection. Accordingly, "a priori," or
"innate," is one thing, and "certainly known" is another. If what a person

most wants is certainty he or she might better turn to arithmetic, elementary logic, or even some parts of natural science, than to metaphysics.

It is arguable that there is but *one* metaphysical, innate, or strictly universal and necessary idea or principle, *concreteness* (containing internally its own contrast to abstractness), so that to speak of innate ideas in the plural is really to slur the distinction between our formulations of metaphysical truth and the truth itself, or the necessary nonrestrictive aspect of reality. The former, the ideas in the plural, are our contingent ways of trying to become conscious of the noncontingent ground of all contingency.

To show the equivalence of the various characterizations of metaphysics in greater detail would be to work out an entire system. Here I wish rather to indicate some relationships of metaphysics to other studies. In *logic* one speaks of entities on the first logical level, values of the variables for "individuals," but one may or may not propose a general theory of what it is which assigns an entity to this level. One may say that one has in mind individual things existing in the spatiotemporal world order; or sense data; or sometimes, even individual numbers. But obviously numbers are abstract, compared to persons or physical things; moreover, events (in the most concrete sense, total unit-becomings) may also be taken as individuals, and then persons or physical things are more or less abstract by comparison, unless they are (wrongly, I hold) taken to be mere actual sequences of events. Metaphysics does what logicians would do if they gave serious thought to the a priori or strictly universal traits of their first-level entities. In addition logicians assume but do not adequately investigate the concepts of knowing or experiencing; this, in its purely generic sense, metaphysics does investigate.

That metaphysics deals with quality as well as structure distinguishes it from mathematics, which deals with structure only.[1] Also mathematics, like logic, does not discuss the *experience* of structure, but only the structures experienced; thus it says nothing, except in an informal, semiofficial way, about the value aspect which no mathematical experience, let alone nonmathematical experience, can lack. Nor are mathematicians as such interested in subhuman experience, whose reality nevertheless comes somehow under the general concept of experience. They may perhaps discuss superhuman (divine) experience, but casually or at most semiofficially. Yet the pure concept of experience must either entail the logical impossibility or entail the logical possibility and in principle necessity of divine (in some sense maximal) experience, and until we know what the entailment is we do not have a wholly clear concept of experience as such.

That metaphysics seeks for necessary principles distinguishes it from physics and scientific cosmology. For, if these attempt to claim necessity for their principles, they are simply doing metaphysics. And no mere physical

1. See P. Bernays, German mathematician.

experiment can establish necessity. Whether and how it can be established is exactly the metaphysical question. It is not to be settled casually. But in recent decades that is how it has generally been disposed of.

To the eleven characterizations of metaphysics already given, I should like to add one more:

(1) The attempt to make nonexclusive or purely positive statements.

Consider the sentence "there are people," meaning men and women. It seems purely positive. But in fact it has negative implications which are not merely verbal. Consider the forests which would still be standing had people not cut, burned, or bulldozed them down; the animal species which would still persist had men or women not exterminated them. True, people might have existed in less destructive ways, but this is a matter of degree; some destructiveness was inherent in the very existence of our species. Ordinary existence is perforce partly competitive, and only partly cooperative or symbiotic. It is this competitive "existence" which cannot be necessary, for it cuts off extralinguistic possibilities, and this is the very definition of contingency. No a priori science could tell us which extralinguistic possibilities are cut off, and hence none could tell us what, in the ordinary sense, "exists."

But take such a statement as, There is something concrete. What extralinguistic possibility does it cut off? Surely not that there is something abstract. Indeed, unless extreme "Platonism" or extreme antinominalism is correct, there can be something abstract only as an aspect of something concrete. So the sole possibility which could be said to be annulled by the statement is, There is nothing, whether concrete or abstract. And what is this but mere verbiage? Certainly such a "state" of reality must, at best, be absolutely unknowable. I hold that what the statement "there is something concrete" excludes is purely linguistic, not an objective possibility at all. This is one mark of a metaphysical statement, that its denial is verbal only, not signifying anything beyond language.

Consider unqualified determinism, the doctrine that, in the actual world at least, there is an *absolute* order according to which the successor or outcome of any particular state of things is uniquely specified and alone causally possible, given that state. Is this statement partly exclusive, or is it wholly positive? It seems at first glance to be the pure affirmation of causal order, and so entirely positive. But this is deceptive. For in the absolutizing of the aspect of order, the aspect of creativity is equally absolutely *denied*. And creativity is positive. It does not mean merely that what happens is *not* fully specified by the causal conditions and laws; it means that there is *more definiteness* in reality after a causal situation has produced its effect than before. This increase or *growth in richness of determinations* is not an absence of something, it is a positive presence. True, there was first, if you like, an absence; but subsequently and forever after there will be the succession from absence to presence, and thus the richer conception has the last word. *Growth*

is inherent in the very meaning of becoming. In Plato's world there was (as W. P. Montague said) no Newton or Einstein; to all modern science Plato's having been was a factor. Otherwise history is language idling.

Consider the atheistic denial that there is any unsurpassable or divine being, or the seemingly positive assertion that any being could be surpassed by another. The statement seems either negative or positive according to how it is stated. But the negativity is essential, while the positive character is no more than verbal. For only a surpassable being can *by its mere existence* compete with, or exclude, anything in other beings; the unsurpassable is unsurpassably able to harmonize its own existence with that of others, and consequently denying its existence opens up no positive possibility whatsoever, any more than "there is nothing concrete" does so.

Leibniz was even more right than he knew in saying that philosophers err in what they deny, not in what they assert. But he himself often denied when he thought he asserted. His demand for a "sufficient reason" for particular or concrete things reduced creativity, even in God, to zero; his assertion that an individual always possesses all its adventures reduced becoming to a sheer illusion; his acceptance of classical theism, or the view that all possible value is actualized in God, entailed the implicit renunciation of his own correct doctrine of genuine competition among possibles, for it rendered this doctrine irrelevant or unintelligible from the divine standpoint, that is, the standpoint of truth. But Leibniz's assertion that every individual (as distinct from aggregates of individuals) must have something like experience or perception was truly in accord with his doctrine of positivity. "Every individual (not identical with an aggregate of individuals) experiences" denies nothing but what is itself a mere denial, viz., "some singular individuals are *absolutely insentient and mindless.*" Of course aggregates of individuals need not themselves be sentient individuals, and the possibility of forming such insentient aggregates is an a priori aspect of the idea of sentient individuality. Leibniz saw, as no man had before him, and not many have after him, that an entity can show itself to be singular rather than a mere aggregate only by *acting* as a singular, but this is also the only way it can show that it is sentient, though perhaps not on the level of conscious thought. If we could ask an atom, "do you feel?" having no language, it could only answer—just as it does, in effect, answer—by responding to stimuli (changes in its environment), by withdrawing in some situations, advancing in others, in some cases reorganizing itself internally, dropping constituents or assimilating them, acting in an "excited" or in a "satisfied" fashion. Any evidence there logically could be for very low-level sentience there actually seems to be. And in what possible world could it be otherwise? How in any world could one know *either* that a seemingly inert mass like a rock was inert also in its imperceptible parts or individual constituents, *or* that it had no such constituents? I hold that in any world, one *either* would not know what the individuals were,

or would know them as genuinely active—and so, by the behavioral criterion sentient—agents whose activities collectively produced the sensible effect of an inert mass. Agency, singular concrete reality, are one; until one encounters the former, one does not know the latter. "Insentient," in behavioral terms, taken absolutely, has the same force as "individuals unidentified."

What we need to do is to follow Leibniz's prescription not only where he followed it, but also where he did not. Metaphysical truth is *purely positive* truth; all else is partly negative, or, if absurd and a mere confusion, wholly so.

When another great rationalist, Spinoza, said that *all* things follow from the essence of God which also entails its own existence, he was really saying that "metaphysical" has no distinctive meaning. Leibniz is by implication in the same difficulty. But these men fell into this trap not because they were rationalists, if that means believers in the possibility of a priori or nonexclusive and purely positive knowledge. No logical bridge leads from "there is a priori or necessary truth about reality" to "all truth about reality is a priori or necessary." Quite the contrary, to regard all truth or knowledge as metaphysical is to fail to take the idea of the metaphysical seriously for it deprives this idea of any distinctive meaning. Exaggeration is often in effect denial.

If Hegel was wiser than the previous rationalists in the matter presently being discussed he hid his wisdom under elaborate dazzling systematic ambiguity such as only high genius could have conceived, but which can hardly serve the needs of our day or the future. In spite of George Lucas this is my belief. In some other subjects Hegel is more relevant.

The way to discredit nonexclusive or necessary truth is the very way its sponsors adopted when they unduly extended its scope, so that contradictorily it became exclusive or contingent after all. Nothing is more necessary to the future of "rationalism" in the good sense than the avoidance of this extravagance, which deflates rationalism's claims by overinflating them until they burst. Metaphysical or nonrestrictive truth is very little, rather than very much; but that little is precious nonetheless, provided it be seen in its purity and not adulterated by restrictive elements.

One might say that the seventeenth-century continentals (some of them) were not so much rationalists or metaphysicians as intellectual imperialists. Like other ambitious men they wanted to take over any not too strongly contested territory. And as the excuse for political or military imperialists has been that if one's own country had not been the aggressor against some defenseless area another country would have been, so the excuse for the older rationalists was that empirical science had not yet learned to claim its own. Today the danger is in the opposite direction: now metaphysical territory is too weakly held, and empirical scientists or their admirers want to take over even that extremely colorless or most abstract knowledge, the knowledge of nonrestrictive truth. This is merely the old mistake, but now made by going too far in the opposite direction. Empire is always temporary and insecure.

Just as it did not really exalt metaphysics to offer to let it swallow up science, so it does not exalt the empirical method to offer to let it adjudicate for possible worlds, necessities, or the all-surpassing. Confusion weakens everything, strengthens nothing.

Another classical example of blurring the distinction between the genuinely a priori and the empirical is Kant's attempt to make Euclidean geometry (in an unqualified fashion) a priori, on the ground that human cognitive powers require it. But they require *at most* the *approximate* validity of this geometry, and in this approximate form the requirement is shown by respectable empirical evidence to be met by the contingent structure of the universe. The idea that an absolutely precise requirement (with conceivable alternatives) could be justified by so vague a ground as our self-awareness of the forms of our perceptual intuitions is logically incongruous. Absolute precision requires a more definite ground than that.

I recall these classical cases to remind the reader that the collapse of certain false claims to a priori necessity is no proof that all such claims must be false. Exaggerated reactions to exaggerated pretensions will not get rid of exaggeration itself.

A word about how "God" is intended in definition *k*. I am deeply convinced that classical metaphysics mistranslated the essential religious issue by misdefining "God." It thereby fell into a subtle form of idolatry, worshipping not the divine fullness but an abstraction called "the absolute" or the "infinite," "unmoved mover," or "most real being." None of these, I am persuaded, is genuinely worshipful, though they can be subjects of intellectual amazement, wonder, or awe. I agree with one main conviction of current philosophizing, that people have been so eager to answer questions that they have failed to give proper heed to the way words are being used, and perhaps misused, in formulating these questions. "Is there a greatest or most real being?" Well, first of all does the notion of a "greatest being" make sense, any more than that of "largest possible number"? I myself think the answer should be, No, neither greatness nor "reality" is without qualification logically capable of a maximum. Is there a strictly immutable yet living being? I think the answer is, No, life in any sense, no matter how exalted, implies some form of real change or becoming—indeed some form of real growth. I think the history of natural theology from Aristotle, Philo, and Augustine to Hume and Kant has brought out rather clearly that *if* God must be defined in terms of these traditional paradoxes, then theism has no rational content. But I am equally persuaded that this way of defining God is mistaken anyway, both on purely religious, and also on philosophical, grounds. This mistake is one of the penalties we have had to pay for putting too much trust in the first form of rational metaphysical thought, the Greek. Great as its achievements were, it was at best a one-sided first approximation, and at worst a melange of calamitous errors.

There are several reasons why a metaphysician cannot sensibly proceed very far without considering how he is to handle the theistic question. First, the logic of the idea of God itself shows that the whole content of metaphysics must be contained in the theory of deity. Comte was not mistaken in this: metaphysics is no more and no less than natural theology (supposing the latter is possible at all). For (a) the existence of God cannot be construed as contingent, an accidental exemplification of metaphysical principles, but must be admitted, if at all, as necessary, as inherent in these principles having any truth at all; moreover (b), the metaphysical or necessary features of the reality with which God deals (whether by creating it, knowing it, or what not) can only be the same as the intrinsic or implied correlates of whatever is necessary in God's being. That is, what God *must* have or *must* know is necessary, and that alone; anything God merely *can* have or know is contingent, and so a subject for science or faith, not for rational metaphysics. The metaphysical theory of deity is either nonsense or it is simply metaphysical theory—period. I reject the old distinction between general and special metaphysics; theology, not metaphysics, is more than mere theism. The only concession to make here is that the theistic meaning of metaphysical concepts may be left implicit, unformulated. But to that extent the concepts will be left vague or ambiguous, and the system too indeterminate to give much purchase to rational criticism.

Second, the history of metaphysics is so entangled in various ways of trying to adjudicate contingent, historical religious questions that it is difficult to abstract a religiously neutral residue from this history. This is what one should expect from the logic of the case and it is what we find. (Difficult is not the same as wholly impossible.)

Third, I see in the application of metaphysical categories to religion their chief use and one test of their adequacy. If a metaphysician can make sense out of this topic so much the better, but if not why do we need his system? Science and common sense (almost seem to) take care of factual (contingent) questions; art, or personal or group faith, can handle the rest, if there is any residuum. But only the metaphysician can clarify what it means *intellectually* to ask about God. I hold that much ancient Greek metaphysics, and I include even Kant as a kind of belated and sub-Platonic Greek, has failed this test. It has muddled almost as much as it has clarified the topic it chiefly sought to illuminate. Not that we owe it no thanks for this failure. If we see better on the same topic it is partly because we have these majestic examples of how *not* to define God. And such learning by mistakes seems the destiny of all nondivine consciousness. Moreover, the (allegedly) Greek way of defining God is not so much wrong as one-sided. Terms like absolute, infinite, independent, uncaused, do apply to God—but only on condition that the correlative terms, relative, finite, dependent, caused, also apply. Contradiction of course results if—but only if—no qualification such as "in some respect" is attached to the attributions. The classical error was one of overtrust in

extremely simple ways of characterizing God. It was a kind of learned (extremely stubborn) simple-mindedness.

If the religious issue is as central in metaphysics as it seems to be, to attempt first to settle everything else (as though there were in metaphysics much else to settle) and only then to ask about "God" is to be in danger of begging all chief metaphysical questions. Hume and Kant did just that, in my opinion. Unwittingly assuming antitheistic postulates, they not surprisingly inferred the impossibility of a rational theism. But the reasoning can be reversed: since theism at the least deserves a hearing on its merits, the experiment should be made of provisionally rejecting every postulate which shows itself hostile to theism. And this includes (Hume's) axiom, "the distinguishable is separable" or independent, for though God (and this *is* inherent in the religious idea) exists no matter what other individuals may or may not exist, and thus is indeed separable from them, God is also thought of as the power upon whom all else depends, and thus the "creatures," though distinguishable from God, are certainly not separable from, independent of, (God's) existence. Several other assumptions of Hume, and some of Kant or Bradley, must likewise be "put in brackets" while we consider what metaphysical system if any would harmonize with religious requirements. No other procedure is rational inquiry in this sphere, but rather is dogmatic rejection posing as judicial examination.

Such is my apology for intruding the theistic aspect into the definition of metaphysics. "Neoclassical metaphysics," when its ideas are adequately explicated, is neoclassical natural theology, and vice versa. In several books I have tried to show at least in outline how from the mere idea of God a whole metaphysical system follows; one may also proceed in the opposite direction, and show how from general secular considerations one may arrive at the idea of God and a judgment as to its validity. But the two ways of proceeding differ only relatively and as a matter of emphasis. In thinking metaphysically at all one is already more or less close to an explicit thinking about God, and in thinking at all clearly about God one is already somewhat conscious of metaphysical principles. A priori knowledge, valid "for all possible worlds," must coincide in content with the most abstract aspects of omniscience. It is what is common to all that God *could* create or know, and of course God knows these capabilities. H. Scholz (theologian become logician) has pointed out how the symbolic logician is in a certain (very abstract) sense seeing things as God sees them. *A forteriori* the metaphysician is doing this—*if* he succeeds (in talking coherently about universal necessities).

7

A LOGIC OF ULTIMATE CONTRASTS

THE conceptual structure of the neoclassical philosophy can be partly indicated by a rather simple yet comprehensive table. The aim is less to demonstrate than to explicate, and I shall not conceal certain puzzles that trouble me. The point is to show the interconnections between concepts and thereby to exhibit the philosophy as a system.

In every experience, if it is sufficiently reflective, certain abstract contrasts may be noted as somehow relevant, e.g., complex-simple, effect-cause. These contrasts are the ultimate or metaphysical contrarieties. A basic doctrine of this book is that the two poles of each contrast stand or fall together; neither is simply to be denied or explained away, or called 'unreal'. For if either pole is real the contrast itself, including both poles, is so. The unique contrast, real-unreal, may seem to violate this rule. But in the first place this contrast need not be taken as relevant to every reflective experience. Divine experience would consider the unreal either as the really possible (9a) or as the mistaken but themselves really occurrent fancies of lesser modes of experience. In the second place, even we can see that acts of fancying or mistakenly believing are real occurrences, so that the unreal is also a form of reality.

Though polarities are ultimate, it does not follow that the two poles are in every sense on an equal status. As mere abstract concepts they are indeed correlatives, each requiring the other for its own meaning. But if not the concepts but their examples or instances are considered, on one side are the dependent, inclusive entities, on the other the independent, included ones. One side forms, in the given context, the total reality, the other consists of mere though independent constituents or aspects. Thus the admission of ultimate dualities is one doctrine, dualism is quite another. The concept

expressing the total reality is the entire truth, not because the correlative contrary concept can be dismissed or negated, but because the referents of the latter are included in those of the former, while the converse inclusion does not obtain. Thus a basic asymmetry is involved. Here is the essential difference between my philosophy and that of Weiss.

Taking into account the threefold distinction of concept X, contrary concept Y, and Z, the inclusive member in the given set of examples, we see that our dualities are enclosed in triadicities. Thus we meet Peirce's requirements: think in trichotomies not mere dichotomies, the latter being crude and misleading by themselves. To contrast, say, concreteness and abstractness, the two concepts or universals, is blind unless one bears in mind that concreteness is itself an extreme abstraction (to adapt a precious remark of Russell's) and that an instance of concreteness is by no means the concept over again, but something incomparably richer. As Plato and even Aristotle never quite saw, concrete actualities are the whole of what is (*pace* Weiss). There is also a deep truth in Peirce's contention that triads are incomparably more adequate than dyads and in a sense than tetrads, as intellectual instruments. Weiss's fourfold system, dualistically interpreted with respect to each pair, seems a brilliant illustration, as such a stroke of genius, of how *not* to build a metaphysical system. It is a regression from Aristotle, Bergson, Peirce, James, Dewey, and Whitehead, none of whom is finally or in intention a dualist even with respect to a single pair of basic concepts.

METAPHYSICAL CONTRARIES

r-terms (Peirce's Seconds, Thirds) a-terms (Peirce's Firsts)

1r relative, dependent, internally related	1a absolute, independent, externally related
2r experience, subject	2a things experienced, objects
3r whole, inclusive	3a constituents, included
4r effect, conditioned	4a cause, condition (sine qua non)
5r later, successor	5a earlier, predecessor
6r becoming, nascent, being created	6a in being, already created
7r temporal, succeeding some, preceding others	7a nontemporal as
	i. primordial, preceding every occasion
	ii. everlasting, succeeding every occasion after O^n
8r concrete, definite, particular	8a abstract, indefinite, universal
9r actual	9a potential
10r contingent	10a necessary
11r a portion, P, of process as past	11a earlier futuristic outline of P
12r finite	12a infinite
13r discrete	13a continuous

14r complex, with constituents	14a simple, without (or with fewer) constituents
15r singular, member ('mind')	15a composite, group, mass ('matter')
16r singular event, so and so now, individual state or actuality	16a so and so through change, individual being or existent
17r individual	17a specific character
18r specific character	18a generic character
19r generic character	19a metaphysical category
20r God now, divine state or actuality	20a God as primordial and everlasting, divine essence and existence
21r God now	21a God and the world as they just have been

RULES OF INTERPRETATION:

I. Proportionality: as an r-item in a specified context is to its a-correlate (say, 1r to 1a), so (*mutatis mutandis*) is any other r-item to its a-correlate (say, 2r to 2a). Thus (no. 2) an experience depends upon the things experienced, a subject upon things given to it, but these latter are independent of the subject.

II. Two-way, yet asymmetrical necessity: an r-item necessitates (10a) its particular contextual a-correlates; an a-item necessitates only that a class of suitable r-correlates be nonempty, the particular members of the class being (10r) contingent (others might have existed in their place). (In the case—19a—of metaphysical categories, the class of suitable r-correlates is the widest class of particular actualities; in the case of generic or specific characters, the r-correlate may be merely that the idea of the character is imagined in some actual experience.)

Applications

Rule I tells us that experiences or subjects depend upon their objects (nos. 1, 2), though these objects do not depend upon the subjects; however, by rule II we know that a thing experienced could not have been or remained entirely unexperienced by some suitable subject or other. Thus to be is to be experienced, but if S experiences O, O could have existed without being experienced by S. Berkeley's proposition is either correct, ambiguous, or erroneous, according to how we take it.

Using both rules (and nos. 4, 1, 10) we see that a given effect depends upon conditions that did not depend upon and did not necessitate it; but yet the conditions did necessitate that some effect in the 'suitable class' should become actual (9r). How narrow or wide the suitable class is defines the question at issue in intelligent discussions of 'determinism', discussions that seek to explicate rather than explain away the asymmetry characterizing our intuition of causality, and therefore avoid taking with entire literalness the symmetrical or biconditional necessity implied by 'necessary and sufficient

condition'. If fully concrete or definite effects are in question (8r), there are no such conditions. The phrase is only a first approximation to an explication of the causal principle.

Since an r-item always expresses the total reality being considered (3r), the scope of the a-items is to be determined by the scope assigned their r-correlates. This is especially important in certain cases. For instance, 5a and 9a together say that the possibility of a certain actuality is earlier than that actuality. What is possible for today is determined by what happened yesterday. In this sense possibility precedes actuality. True enough, what is actual today determines the possibilities for tomorrow; in this sense the actual precedes the possible. But the possibility we are talking about must, by the principle of scope mentioned above, be determined by considering a given actuality, say something that happened this morning, and asking about *its* possibility. And this will be found in its antecedent causes, i.e., earlier events (4a, 5a). Similarly, a cause or condition is a sine qua non (4a), necessary (10a) for a given later event, which (in its full actuality or concreteness) is contingent rather than necessary, given the condition (even all the antecedent conditions). Again 'independent' (1a) does not mean independent of everything but only of the dependent factor taken as instance of 1r; nor does 'dependent' entail dependence upon everything, but only upon whatever the r-case in question does depend upon. Thus an event may depend upon antecedent events but be independent of subsequent ones. Indeed this follows from nos. 1, 5, and 10.

Dependence simply means the impossibility of existing without the thing depended upon—i.e., *sine qua non possibile.* From this we see the perversity of using the term 'absolute' to mean the all-inclusive reality. A thing cannot exist lacking any of its constituents (even though something very similar might exist lacking some of these), hence nothing is quite so dependent or relative as the inclusive or total reality. That the all-inclusive cannot depend upon something 'outside itself', something it does not include, is mere tautology; it will still depend upon all there is, and will be the most completely relative of all things.

Although given a definite pair of r- and a-items, the first will be contingent granted the second, and the second necessary granted the first, yet there is always (rule II) a generic necessity running in the other direction. Thus, an independent factor must have been or become constituent in *some* whole or other, things experienced (2a) or objects must have had or have this status for *some* experience or subject, universals (8a) must be embodied, or at least entertained as ideas, in *some* concrete actualities (8r, 9r), causes must produce some suitable effects. The necessity of an a-correlate is particular and definite, given an r-item, but that of the r-correlate, given an a-item, is generic or indefinite. This is a basic asymmetry. From an a-item to its r-correlate is a creative step, one that must come *somehow,* but not in any fully predetermined manner;

while that from an r-item to its a-correlate or correlates is a mere matter of analysis, of finding what is already there. Prospective freedom, which cannot be simply unexercised and is always within limits, and retrospective necessity form the directionality of creativity as at once preservative and enriching of reality, adding to, never diminishing, its determinateness.

Using rule I, we see that wholes (3r), metaphysically regarded, are not 'organic', since their constituents are independent of them. The constituents may be themselves wholes dependent upon *their* constituents. 'Absolute', i.e., nonrelative, of course means 'in the specified context', not necessarily in every context. The context is the particular whole, or class of wholes taken as instance of 3r. The limitation of the rules to a context is a principle of relativity, and thus an example of 1r. Like most metaphysical categories, this one is so general that it even applies in some appropriate fashion to categories themselves.

Since 'absolute' is merely the negative of relative, it is clear that the basic principle of the entire table is relativity. The idolatry of absoluteness which disfigures the history of metaphysics needs to be unmasked and if possible done away with. The real absolute is relativity itself, since its limitations are provided by its own reflexivity, or self-applicability, together with negation. And negation is a subordinate principle in the sense that finally we must affirm the conjunction of true positive and true negative propositions to state the whole truth. (Denying a conjunction leaves the truth of the elementary propositions indeterminate.)

Proportionality and nos. 2, 4, 5 tell us that experiences *follow* (rather than being simultaneous with) their given objects and are their effects; also (no. 3) that they include the objects, which yet (1a) are not dependent upon them. Thus, idealists who hold that objects are 'in' the mind and realists who hold that objects are 'independent of' (particular) subjects are both in that sense entirely right. Both erred grievously, however, in equating 'included in' with 'depends upon', an equation that obtains only if all wholes are taken as strictly organic. Since it is a certain brand of idealism rather than its critics who have held this doctrine, one can only marvel that the realists should have shared the belief (unwittingly, it seems) in this special application.

A curiously similar confusion occurred in the Aristotelian tradition. States of an individual were taken as accidental predicates 'in', and *therefore* dependent upon, the individual for their existence.

But this 'therefore' presupposes that a constituent depends upon its whole. Quite the contrary. Constituents may have to be in *some* whole, but the particular whole is accidental or contingent. It is true that a person's state depends upon the prior existence of the same individual person, but not because the state is in the person; rather, because, as ordinary language with profound justice has it, the person is 'in a state'. A whole depends upon its constituents, and one's

past individuality is a constituent of one's present wholeness. States are *more* than identical individualities and contain them, not vice versa.

From 3r, 3a and 5r, 5a we deduce that process is cumulative, as Bergson said, the later including the earlier. From 1r, 1a and 4r, 4a we see that causal dependence, taken strictly, runs backward only (a cause can be 'necessary', but it cannot be 'sufficient' to guarantee what concretely happens later). This does not mean that nothing can be predicted, but only that prediction is in principle abstract and incomplete and causal determinacy likewise. That details of the future are hidden from us is not solely a result of our being, as animal knowers, limited in perceptual and reasoning capacities, but expresses a metaphysical principle. That we do not fully know the past, on the contrary, is merely our human-animal limitation.

There is, it must be admitted, an element of idealization in the relations symbolized by the second and third rows. Ordinary subjects, at least, do not without qualification include the things they experience; but then they do not without qualification experience them. In memory I experience my past, but how inadequately, with what loss of vivid detail, accessible to introspection! One might argue, in spite of 14r, 14a, that the world we experience is much more complex than our experience of it. But again, we experience, yet do not experience, this world. If there is an ineradicable paradox in this philosophy, here it may be. But the defense is that divine experiences can fulfill the principle in question in that they can adequately experience and hence adequately include their objects, and that even our experiences include objects in proportion as they adequately experience what they experience.

It is to be understood that by experienced objects is not meant intentional objects. Thus, if I think of 'my future', my given object is not any concrete event later than the present. Givenness, in this philosophy, is one thing, intentionality or symbolic reference is another. That we lack *absolute* power to distinguish these introspectively is not surprising. Such power would be divine. But we can with relative success make the distinction. Even in illusions and dreams just prior bodily states are felt, states which must be there and be genuinely given. Intentionality adds more or less correct or incorrect beliefs about the external environment and the future, these additions being more or less at our risk.

The common objection to a 'causal theory' of perception that if experiences are effects then the real objects are unknown causes hidden behind the effects, is a confusion. The given things are not effects upon the experience, as a kind of stuff molded by hidden influences; instead, the given things are the real things, and the effect is simply the experience itself as experience of those very things. To infer that not the things, but the effects which they cause, are the data is to assume that an experience has itself as object, i.e., that the subject-object relation is an identity. The causal theory is not responsible for this blunder. Givenness is a genuine relation, and it requires at least

two terms. So does the causal relation. The experience of O (for object) is conditioned by O as antecedently there. And O itself is thus given. The experience as effect *intuits its own causes,* it does not have, as datum, itself the effect of those causes. How could this confusion ever have arisen? Is Kant free from it? Was Hume? I think not.

Since in memory we have as datum not just one previous experience but (a) an entire sequence of experiences, each experience in the past having its own memories, and since also (b) these past experiences included perceptions, in each of which its own causes were given, then not merely the causes of present experience are now given, but the causes of those causes indefinitely far back. We have a genuine sample of cause-effect relations. What we have to do to know the approximate state of the contemporary world and its probable future is to extrapolate the lines of causality already accessible to us.

By contrast, if the data of experience were simultaneous, we should have a cross section of process but no insight into its derivations and hence into its destiny. Symmetrical relations, such as those of simultaneity, are never the key to directional order, which is what we need to know. The strictly simultaneous with us is the last thing we have to worry about, for by the time we could think about it, it must already have become past. We deal with the future by interpreting the past, the absolutely present being for our knowledge the same as the nearest part of the future.

All theories of the mind-body relation, such as parallelism, which take this relation to be one of simultaneity, are uneconomical of principles, since they cannot use the temporal cause-effect relation we employ in all other explanations of dependence. Thus we get the mysteries of the two-aspect view, or the identity theory, or epiphenomenalism, or what not. Whitehead's proposal here is that we take human experiences causally to 'inherit' directly from some bodily processes, and these to inherit directly from our experiences, inheriting in each case implying temporal 'following', rather than sheer 'accompanying'. Thus, the general principle of causality is all we need. And since individual genetic identity (16a) is explicable as a distinctive special case of the way in which concrete actualities are caused by, follow, and include others, sharing abstract factors in common, the concept of 'substance' is shown to be no absolute addition. Causality, substance, memory, perception, temporal succession, modality are all but modulations of one principle of creative synthetic experiencing, feeding entirely upon its own prior products. This I regard as the most powerful metaphysical generalization ever accomplished. It has many of genius back of it, including Bergson, perhaps Alexander, the Buddhists, and many others. But Whitehead is its greatest single creator.

A striking lesson of the table is the unreliability of certain traditional value judgments. Thus, the following terms have been taken as honorific: absolute, cause, earlier (first cause), nontemporal or eternal, universal,

necessary, infinite, simple. All have been used to designate deity, in contrast with inferior beings. But if the table is not utterly misleading, this value judgment entailed the exaltation of objects rather than subjects, the abstract rather than the concrete, and the possible rather than the actual. It also implied that progress from earlier to later, or causes to effects, is a descent from better to worse, from more to less, which makes pessimism a metaphysical axiom! On the contrary, on my principle the dependent is more and better than the merely independent, effects than mere causes, results than conditions, the complex than the simple. Note that the a-items are more or less plainly negative or privative: not relative, not temporal, not definite, merely possible, not finite, not complex.

It is notorious that negation presupposes something to negate. Hence, unless one is indeed bemused by the 'negative theology', one would not expect absoluteness or infinity to explain relativity or finitude, but the contrary. And certainly the idea of whole gives meaning to that of constituent. Even to say that items taken together constitute a whole is to forget that 'together' is just another way to say 'forming a whole'. Nor is it really true that the idea of number is generated by the notion of unit. On the contrary, only the idea of number in the sense of 'several' gives meaning to 'one' or 'zero' in the numerical senses. Hence, the Greeks did not speak of either one or zero as 'numbers'. And they are indeed very special cases, and derivative ones. To be aware of one thing we must contrast it with at least one other, so that there is always the idea of a whole, however little stressed it may be.

Obviously it is subjectivity that gives meaning to objectivity, not vice versa. Intersubjectivity and the notion of other subjects independent of the subject in question, are the only identifiable positive meanings for objectivity. The object is either merely an object, a constituent in subjects, an abstraction, or it is an antecedently real subject, or set of subjects. The endless controversies over phenomenalism and realism arise from the belief that there is some further meaning for objectivity. All over the world for thousands of years men have seen through this illusion, but have failed to make fully clear the compatibility of its avoidance with the full admission of independently real objects of our experiences. There is no contradiction at all, if one is careful to make the proper distinction between particular and generic necessity as posited by rule II.

That subjects are later (2r, 5r) and objects earlier (2a, 5a) will surprise many. It enshrines the doctrine that, both in memory and in perception, the given entities are antecedent events. As Peirce said, perhaps as the first, "It is the past which is actual," there to be experienced. The present is nascent, it is coming into being, rather than in being, and there is no definite entity to prehend. Whitehead, so far as I know, is the first thinker in all the world to take the position with full explicitness that experiencing is *never* simultaneous with its concrete objects but always subsequent. Perception may then be

called 'impersonal memory', intuition not of our own past experiences, but of past events in and around the body. The scientific facts and the metaphysical requirements fit effortlessly together, if we take this view. That we seem to perceive what is happening absolutely 'now' is a harmless exaggeration of the truth that the time lapse for near events is negligible and that the causal stability of much of the world guarantees that what has just been happening is close to what is still happening.

Moreover, if there is an illusion of simultaneity in perceiving, there is a nicely parallel illusion in remembering. For, as Ryle says, 'introspection' is very short-run memory utilized to tell us what we are *approximately* now thinking and feeling. That we are always a trifle behind ourselves in this is not only harmless but the only way to note our mental processes without interfering with them. We do not inspect our mental processes simultaneously with their occurrence. This is nonsense. But through immediate memory, we can keep noticing what they have just been.

Nos. 3, 6, and 7 tell us that becoming includes being, whether in the form of the uncreated or primordial (7a[i]) or in the form of what has already become. This is the revolution first announced clearly by Bergson. Anything which does not now become is an abstraction (8a) from what does now become. Process, as including its own past and abstract aspects, is the reality itself (*la réalité même*). Or as Whitehead puts it: What an actuality is cannot be abstracted from how it becomes; also, 'to be is to be a potential (9a), for every (subsequent) becoming' or every subsequent actuality (9r). Any subject which follows a temporal actuality will include it as object (not necessarily accessible to introspection) and will also include any nontemporal factor.

Nos. 5–14 tell us that an actuality (or the concrete or definite) becomes, is temporal, contingent, finite, discrete, and complex (or—no. 3—a whole with independent constituents). Recalling 2r, we see that subjects are actual, and objects are 'potentials' (9a) for subsequent experiencing. What actual subjects may ever experience them they are indifferent to; but they must (rule II) be experienced by some suitable subjects, where suitable means 'able to experience them'. The historical idealisms and realisms are almost equally far from meeting the requirements of our table, as I hope is obvious.

The table does not directly say so, but since, as we all know, experiences can temporally follow experiences, they can depend (5r, 7r) upon the prior experiences causally, and have them as objects. Thus, being an experience does not conflict with being an object (for other subjects). Objectivity is not a different kind of stuff from subjectivity, but a relation into which subjectivity, by virtue of further subjectivity, can pass. Subjectivity, which (8r) is the concrete form of relativity, is thus the inclusive principle. Objectivity in all senses, including the scientific sense of intersubjective validity, is a function of multiple subjectivity. It refers to one of the following: (i) subjects prior to and independent of the subject under consideration, (ii) potential or future

subjects, (iii) elements shared among subjects, i.e., common constituents (3a), objects (2a), or abstractions (8a) from subjective actualities. The 'subject which can never become object' haunting some thinkers must, it seems, be either the ever-changing class of 'latest subjects' that have not yet been objectified though they are about to be so, or it is subjectivity in general and as such, which is indeed an object, though a very abstract one. True, 'latest subjects' includes deity as eminent instance, and this is no obvious object, even subsequently. Here is mystery enough, perhaps.

Objectivity as a special kind of stuff is the result of a very natural illusion, the key to the removal of which is no. 15. But we must first deal with a puzzle which this pair presents.

No. 15, with no. 3, seems to say that a member of a group contains the group; but not vice versa. Are not members constituents, as in no. 3? Also, is not the group more complex than any single member (no. 14)? But the question is, what makes a group a whole, a single entity? If members are enduring individuals (nos. 5, 16a, 17r), they interact, unless spatially remote relative to their duration, and therefore groups (insofar as composed of individuals) tend to be organic wholes rather than metaphysical ones (composed of states). This means that each member, in its own way, sums up the group, and so the complexity of the group tends to reappear in its members. However, the group must be considered either as subject or as object, for there is no third possibility in this system. As object, as something given and insofar as it is given to someone, the group possesses the full complexity of the members only when God is the subject. Otherwise there will be partiality, abstraction, failure to fully experience and include the members. As objects for God, the group will, indeed, exceed the members distributively in complexity. But hold—not quite. For God is the supreme member. And the subject in principle exceeds the object in complexity, insofar as the subject adequately experiences the object. Thus, the group, even as including God, taken as object is simpler than God as the not yet objectified singular subject objectifying the group. And the group can only be taken as object, for no mere group is a subject. Groups do not literally experience; saying that they do is mere shorthand for saying that the members do. I hope that this reconciles nos. 3, 14, 15.

The importance of distinguishing singulars and groups is chiefly in two contexts. One is the context of valuation. Groups are real and important only because their members are. All the happiness and intrinsic value in the cosmos is in singulars, for they alone enjoy and suffer and find or fail to find satisfaction. One would be as important as billions, if no one objectified the billions in a single experience. The other context is that in which the duality 'mind-matter' is under consideration. This duality is not, as such, metaphysically ultimate. Subjects must have objects, but these can be other subjects. *Mere* objects, or merely 'physical' things, are unnecessary, save in two senses: abstract aspects of subjects and groups of subjects whose members are

not distinctly given or attended to and which therefore do not appear as groups but as 'masses' of stuff. The fact that one can speak of a mass of wax, say, but also of 'the masses', meaning groups or classes of people taken indiscriminately or 'in the lump', is an ordinary language indication pointing to the greatest of Leibnizian discoveries, the real difference between 'mind' and 'matter'. It is not an absolute difference in kind of singulars, but (a) a relative difference in kind (between high and low forms) of experiencing singulars, this difference falling within mind in the broadest sense, plus (b) a difference in kind, not between singular and singular but between singular and inadequately apprehended group, the latter being irreducibly object rather than subject, and irreducibly abstract, since what makes it a single entity is its being objectified by subjects which in principle are richer in determinations than any of their objects, singular or compound.

Materialism, dualism, and some forms of idealism take as an absolute difference of level (sentient vs. insentient) what is a merely relative difference of level (inferior vs. superior forms of experiencing) with a resulting difficulty of distinguishing singulars from groups. This latter distinction is metaphysical or categorial, the other is empirical and a matter of degree. The social dimension of experience, that it always deals with other experiences, or of mind, that it deals with 'other mind', fulfills the metaphysical requirement that subjects must have objects, with no necessary help from 'matter'.

True enough, human subjects could not deal with one another as they do without something like flesh, sticks, stones, metals, gases, and liquids. But what is required is not that these consist of mere inert, insentient matter: but rather, that any sentience composing them, anything like impulse or will, must be on such a primitive level that human impulse and will can approximately control them (and foresee their behavior) as we, in fact, control and foresee flesh, sticks, stones, and the rest. And the Leibnizian distinction between active singulars and seemingly inactive composites whose active singulars escape our sensory detection, taken in conjunction with modern physics and biology, is showing ever more clearly that the concept of mere insentient matter plays no role in explaining the world. We can indeed abstract from whatever sentience may be there, but the denial that it is there adds nothing to the explanatory power of our science. On the other hand, admitting that some sort of sentience must be there explains a number of things, including the sense in which physics is an abstract science. If there is anything a philosopher should wish to be clear about, it is what scientific abstraction omits.

No future discovery can change the essential situation just discussed. Inertness cannot explain the processes of nature, and it was inertness in the apparent singulars of the macroscopic environment which gave what justification there was for materialism and dualism. The Platonic and Aristotelian definitions of soul imply this.

True, one must explain 'extension', spatiality. But spatial order is the order of coexistence (Leibniz, Merleau-Ponty, not to mention relativity physics), or, in other words, symmetrical existential relations. And existential relations are causal. To exist is to act upon other existing things. If minds can influence minds, they can have causal relations to them and can constitute a spatio-temporal order. And if they can become objects for other minds, they can influence them. If they could not become objects, we should not be talking about them. And in memory, past experience, past subjectivity is given. In a pain, I share the suffering of some bodily members of mine. Leibniz's discovery, made in vain for most people, is that extension and matter are not metaphysical ultimates, save in the sense that subjects may be present in such multitudes of similars, that to vastly higher types of subjects the active singulars in the masses are imperceptible, being too trivial to notice one by one. A 'mere body' is a composite object for a subject unable or unwilling to discriminate its individual members.

There are, in fact, two meanings of 'extension' in its spatial aspect. Given many entities, perceived en masse rather than individually, each entity of course in a slightly different place, the mass of entities will appear as extended and, indeed, will be extended. This is the only way in which we can physically perceive singular entities. (An animal body, it is true, *discloses* an in a sense singular entity, but it is a collective one, a society of cells.) This is one meaning of 'extended'. The other meaning cannot be exhibited to physical perception, but only to self-awareness, analogically applied to other creatures. Even a true singular, e.g., my present self or experience, is extended. It is not confined to a point, it is not ubiquitous, nor is it nowhere. There only remains that it is in a region that is extended but as one, not as many. Since no such unity is datum of sight, hearing, or touch, we can have no sensory image of this mode of extension. But we are aware of our experiences as by no means punctiform, but rather with internal heres and theres and elsewheres, with betweens and next tos, and so forth. How could it be otherwise, since we directly respond to bodily processes whose parts are in different places, and since our experience directly controls or influences these bodily processes? A thing is where it acts and is acted upon!

How is an electron or even an atom extended? Physicists agree that no sensory image will do here. Does it follow that these entities are nowhere, or ubiquitous, or punctiform? Spatial extension has more forms than the obvious ones we see or touch. How is light extended? The mystery of extended singular human minds is merely one high-level, and very special, case of the general mystery of how singulars, none of which is directly perceivable by vision or touch, are extended. But unless they are, aggregates cannot be extended either. (Here I depart somewhat from Leibniz.) Each singular enjoys, suffers, and influences the world in a certain perspective. The 'origin' of this perspective is not a point but a volume.

There is an analogous problem for time. A temporally singular event is not instantaneous, but has a finite time length, yet this does not mean that it has temporal parts succeeding one another, any more than the voluminous origin of my perspective on the world means that I am an aggregate of momentary selves or experiences.

It is meaningless to ask what a singular is 'in itself', if this is taken to mean, 'supposing it were alone in existence'. It would then have no character whatever, extension or any other. To be is to be in relation; to be a subject or experience is to have other subjects as objects, forming a world system of such subjects. This system is the space-time world. The mere term 'matter' adds nothing but six letters to a problem exactly as mysterious or intelligible without that term. Only entities intrinsically relative to other like entities can constitute a spatiotemporal or temporo-spatial system. And experiences are indeed intrinsically relative to other experiences, as we learn in memory, and less obviously in perception, as when we feel a bodily pain or pleasure. Two great geometricians, Peirce and Whitehead, agree that this is all we need to explain spatiality.

The reader may have noted that, although temporal relations of before and after are covered by the table, as well as relations of the temporal to the nontemporal, relations of contemporaries, i.e., spatial relations, are not directly accounted for. It is apparently chiefly these relations which Weiss has in mind in his doctrine of 'Existence' as irreducible to Actuality, Possibility, or Deity. I have some feeling for his problem, though I find his solution merely verbal, except so far as it seems to involve a doctrine of complete interdependence between contemporaries, each influencing and being influenced by all the others. Relativity physics is brushed aside here as in some sense incorrect. I once held this doctrine of absolute simultaneous interaction myself. I cannot now believe it. But there does seem to be a puzzle. Contemporaries apparently form a whole which is actual or concrete, and yet this whole is not a subject, contrary to 2r. True, the whole will eventually be in a subject, but not until a long time has passed, unless one conceives deity as somehow escaping relativity principles. (As ubiquitous, God must somehow be an in principle unique case.) However, I should deny interaction between God, as in a certain state, and any other individual in a strictly simultaneous state. On the most concrete level, that of states, there is action, not interaction. And if there could be mutual interaction of actualities, this would mean that this 'mode of being' took care of the problem, and there would be no need of Existence to solve it. What I am sure of is that the concept of mere matter is no help at this point.

Aristotle appealed to matter partly to account for possibility as well as determinate form. But the notion that the psychical is on one side only of the contrast 'actual-possible' is so arbitrary that it seems a miracle it could ever have been believed. Possibility is experienced as the dimension of futurity. It

is mind that looks to the future, that freely creates ever new values because any sum of actual values could always be increased. The concept—or word—'matter' throws not one scintilla of light on why experience can reach no final maximum of beauty, but always faces a future. It is mind's ideal of beauty which implies this.

Nor does 'matter' help to explain (Plato and Plotinus show this) why even definite or limited ideals cannot be fully realized. What a flood of light is shed on Plato's notion of the hampering 'necessity', or better, 'hindrance', 'constraint', which impedes the demiurge in its effort to conform the world, or the contents of the 'receptacle', to the ideal, if we reflect that 'self-moving soul' is really, if intelligible at all, Whitehead's or Bergson's cosmic 'creativity', which necessarily, for the value of contrast and richness, exists in pluralized form and on various levels. For then the recalcitrance of the 'material' any world architect must be molding (it makes no difference if the material is said to be created or merely found) is just the familiar difficulty of eliciting harmony among a plurality of creatures, each having its own freedom which is never fully determined by anything antecedent, including its own past nature.

Social order cannot but have elements of anarchy in it. And social order is *the* order, the principle of all good as well as of all evil. Such order cannot be entirely imposed by any designer, however exalted. The difficulty is logical. And the concept of matter adds nothing, bares nothing, to the problem. If each atom must at every moment have something like will or free synthesis of its own origination, then, of course, no perfect order can result. Multiple, many-level freedom is all the 'stuff' a demiurge, or any creator you wish to conceive, can use in forming a world.

Plato's handicap was not that he had never heard of *creatio ex nihilo* (which leaves the freedom problem unchanged), but that he lacked a clear idea of what 'self-moving', self-determining implies, and that he did not succeed in imagining how what seems mere matter could consist of multitudinous 'souls' of extremely subhuman kinds. He did have a glimmering that the multiplicity of souls is what made absolute order impossible. But he entirely lacked the insight that no definite order whatever could be the one right everlasting aesthetic pattern for a cosmos. Rather, the basic ideal has a dimension of inexhaustible infinity. The Christians (except for Leibniz) realized that no pattern for the world could be exclusively right, but somehow persuaded themselves that God, in total independence of the world, could actualize a maximum of value. The implication is that the creatures are valueless.

Whereas Aristotle and others thought that later events inherit some sort of stuff from earlier events, Bergson, Peirce, and Whitehead hold that what is inherited is simply the earlier events themselves. As the earnest poet has it, "Our todays and yesterdays are the blocks with which we build."

Strange that Longfellow saw the point so long before the philosophers did! The constraint of the past upon the present is simply that an experience cannot generate its own data, but must find them in what has already occurred. The experience is free to make its own 'decision' as to how to accommodate, utilize, or enjoy the data, the previous happenings, but accommodate them it must. If neural activity is a causal condition of human or vertebrate experience, this simply means that just-antecedent neural happenings are among the indispensable data of this type of experience. That introspection cannot discover much about these happenings is of a piece with the general feebleness of man's introspective and inspective powers. (Much of Wittgenstein consists in exploiting and perhaps overexploiting this very feebleness.) There is vastly more given in our experience than we can discover there by mere inspection. Antecedent bodily activities are one part of this "more." Nos. 3, 5 tell us that the primary wholes (by which all wholes can be explained) are formed out of temporally prior and (therefore) independent (1a) constituents, and nos. 2, 16 imply that these wholes are singular experient-events (note that 'singular' does not contradict 'complex' or imply mere simplicity—14a) whose prior and independent constituents are their objects. Thus, an actuality is a subjective synthesis, a single experiencing, of objective factors (which may consist of other instances of subjective synthesis).

Is there any other equally definite, equally economical theory of concreteness or actuality to compete with this? That 'actual' process is past process (9r, 11r) rather than strictly present process (6r) will trouble or offend some readers, I fear. But I hold with Bergson that actuality is pastness, since presentness is a becoming actual rather than a being actual. Whitehead calls all past events "actual entities," or "actual occasions," and this in spite of his saying that actualities "perish," a metaphor which has sadly misled many (unless something else has sadly misled me). They "perish yet live for evermore" is the final word of *Process and Reality,* and to this I adhere, whether or not Whitehead did. The perishing, taken anything like literally, is an illusion occasioned by the hiddenness of deity from us. But, as Whitehead at least sometimes explicates the term, it has nothing to do with an internal change from vital actuality to a corpse or skeleton, but is merely the fact that the definite actual subject is now *also* object for further subjects. No longer is it the latest verge of actuality, since there is now a richer reality, including the once latest one. This has nothing to do, at least in my theory, with an inner shrinkage or impoverishment. Peirce's "the past is the sum of accomplished facts" is not to be taken to refer to a mere propositional outline of the once concrete. This would imply that some facts, having been accomplished, had been dropped out. For our knowledge, yes, but not for the cosmos or for deity.

Bradley and McTaggart argue against the reality of becoming by subtly assuming their conclusion; they neglect the indeterminacy of the future as

such, or fail to see that a stage of process (no. 11) does not consist of definite events until it is all in the past, so that the survey of definite events definitely related is entirely retrospective. In effect, they are imagining all events as though all were in the past. But, as Peirce insisted, they could not possibly all be in the past. 'Reality' means 'as of now', and the 'now' acquires new reference each moment. Events can be surveyed only from within some event or sequence of events. *Sub specie aeternitatis* only eternal abstractions could be contemplated.

Since r-terms are inclusive and express the overall truth, the entire table tells us that we can find the absolute only in the relative, objects (or anything other than subjects) only in subjects, causes only in effects (any knowledge of a cause is already an effect of it), earlier events only in later, being only in becoming, the eternal only in the temporal, the abstract only in the concrete, the potential only in the actual, the necessary only in the contingent, the future as such only in the past (every past has faced a future), the infinite only in the finite, the simple only in the complex, the individual only in the state, the specific only in the individual, the generic only in the specific, the metaphysical only in the generic, God in the necessary, and eternal essence only in divine contingent, temporal states. (Heidegger once wrote that not timelessness but infinite temporality distinguishes God.) If one wants to understand an a-term, one should locate it in its r-correlate. There are not subjects *and* objects but only objects in subjects, not causes and effects but only causes in effects, not earlier and later but earlier in later, not necessary things and contingent things but necessary constituents of contingent wholes (though the class of such wholes could not be empty), not God and the world but the world in God (no. 21).

The old dictum that the supreme understanding was of cause as implying its effect is erroneous. It was a naïve preformationism. Understanding of the actual or concrete is retrospective, not prospective. (Our business with the future is more than understanding, it is deciding, creating.) He who *adequately* knows an effect thereby knows its causes, but the converse is not true. Similarly, it is false that he who knows the universal, the form, knows all that is worth knowing. The concrete is the richest, the most worth knowing. History is the cognitive paradigm, not mathematics, which is chiefly a tool for investigating historical sequences in humanity and nature. The abstractions of metaphysics are not chiefly ends in themselves, but means to wisdom and goodness in the enjoyment and creation of the concrete.

All through intellectual and religious history there has been a bias towards a-terms and a notion that r-terms are opprobrious. But staring at the essence of 'rational animality', or even at a set of psychological laws, is a poor substitute for knowing actual human beings. Yet, the latter are incomparably more relative, changeable, dependent, finite, conditioned, contingent,

and discontinuous. Abstractions are objects, not subjects; but in comparison to concrete entities, they have most of the characters often supposed to define deity. Such definitions turn God into a mere object or abstraction. Of course God is no mere object, yet, of course, God is object, for anything mentionable is so. But only the dead or the abstract are *mere* objects. And for the same reason, only the dead or the abstract can be (henceforth) absolute, immune to further influence. Like everyone, God is both subject and object, but God alone (through divine states) is universal subject, inheriting everything as object; and God alone is universal object, object for every subject. The divine creator is alone *universal* creative power; the divine lover alone is universal lover, sensitive to influence not by some only but by all; the divine beloved is alone universally beloved.

'Universal' is an a-term, and it is true that the 'defining characteristic' of deity, what makes God God and no one else, must be extremely abstract and thus absolute; but no abstraction whatever is anything except thanks to something concrete. And the concrete is precisely the most completely particularized, the contrary of universal, and the contrary of absolute. It takes the entire table to describe God, not just the absolute column alone. This is what I call the principle of dual transcendence. It is the only logical way to combine a negative with a positive theology.

If there is anything abstract and independent in every comparison, Peirce's "absolute first," it must be 20a, the mere eternal essence of deity. (This includes 19a as 'eternal object' for God.) And if there is anything concrete in every comparison, it must be 20–21r, the concrete divine state. But this, too, will be abstract, less rich in definite determinations, by comparison with subsequent divine states. Relatively, positive and negative, instances of the first including those of the second, is the absolute (i.e., the nonrelative) principle. For twenty-five centuries philosophers seemed to have missed this as if by magic.

The key to the idea of independent constituent is the idea of dependent whole; to the idea of necessity, that of contingency or the concrete; to the infinite, the finite; to the simple, the complex. It is comic to watch Plotinus, say, trying to prove the opposite. Without unity, simplicity, he says we cannot understand the multiple, the complex. Apart from unity, there is no plurality and no beauty, goodness, value, or reality. How true! And apart from plurality, contrast, complexity, there is also no unity, beauty, goodness, value, or reality. Moreover, while it is obvious that although the complex can without the slightest inconsistency contain the simple, the converse inclusion is glaringly impossible. Similarly, 'the contingent truth that p is necessarily and q contingently true' is allowable in anyone's modal logic, but 'the *necessary* truth that p is necessarily and q contingently true' is allowed in no such logic. Contingency is the inclusive category. For all these centuries, metaphysicians have been defying elementary logical truisms. Why? This is quite a question.

There is no need to defy these truisms in order to have a metaphysics, at least as intelligible as any produced in this strange fashion.

Concerning 7a(ii): it may seem impossible that what is successor to every (event) should be included (3a) in what is predecessor to some (7r). However, there is an ambiguity in the definition of "everlasting." An actual event cannot literally succeed every (other) event: for there can be no last event, creativity being inexhaustibly fertile. Only something less concrete than an event, an individual being, can be everlasting and only by endlessly having new states, each of which, of course, inherits from the world antecedent to that state. If one accepts personal immortality, then some beings would be everlasting but not primordial. In Asia the belief has often been held that individual creatures are primordial but not everlasting; for they may be 'absorbed' into the One which is timeless. In this book, the view is favored that only the primordial being can be everlasting. However, every event is everlasting 'by proxy' as it were, in that it is bound to be inherited as antecedent condition or datum by every subsequent event, and hence also any everlasting being that there may be. This is Whitehead's "objective immortality," which seems a significant counter to the negativity of death only if we assume an everlasting being able ever afterwards fully to appreciate our lives.

Things more abstract than events or individuals may be primordial and everlasting by proxy in being always found embodied in inherited events. Whitehead's eternal objects are such; in my view only the most abstract universals, the metaphysical principles themselves, are eternal in this sense. They precede *every* event, but not *all* events, because every event has predecessors and any event must instance the metaphysical universals. This is a sort of version of Plato's doctrine that forms are known by reminiscence. Memory is an ingredient in thought as such. But this is an unplatonic Platonism.

The implication of 9r, 9a, together with 3r, 3a, that actuality includes possibility, has often been denied. Is not the actual world but one among possible worlds? Is not the possible more complex (14r) than the actual? By no means. As process philosophers (in this, including Weiss) agree, the possible is always less definite than the actual. There is no such thing as a possible particular (cf. 8r and 8a). Not even God can fully define a world without creating it. Possibilities are irreducibly nonparticular. Rather, determinate particulars are what have a horizon of futurity and indeterminacy. The definite can include the indefinite as the richer can include the poorer, but not conversely. The definite past in outlines implies its own successors, but when these are definite or actual, there will be in them that which their mere possibility failed to embrace, namely determinates corresponding to the antecedent determinables or universals. The fulfillment of a plan, which is always an outline only, implies the plan, but the latter, being more meager in definiteness,

cannot imply the fulfillment. That Weiss admits all this yet makes possibility coordinate with actuality, I can only view as an almost tragic mistake.

That continuity (12a) belongs with the abstract, indefinite, possible, infinite, not with the concrete, definite, actual, finite, is the truth missed by Bergson, Peirce, and Dewey, but seen by James and Whitehead (anticipated by Buddhists and some Islamic thinkers). It seems to be the real bearing of the Zeno paradoxes. A continuum either has no parts, or indefinite or infinite but merely possible parts; definite multiple actuality must be discrete, and, at least for any finite portion of space-time, finite in its actual constituents. Peirce saw that possibilities form continua, thus, all possible hues, shades, and tints of red. But it seems obvious that an actual array of colors does not present all of these: there are always gaps. Similarly, between any shape and any other there is a continuum of possible intermediate shapes; but in an actual part of nature only discrete, finitely different shapes occur. It could not be otherwise. Actuality as such implies arbitrary breaking of a continuum, as Peirce himself in some contexts pointed out. Quantum mechanics was in principle metaphysically inevitable (apart from special features). Peirce should have anticipated the basic idea. He ardently desired to be prophetic of the future of microphysics, but largely failed in this. His bias towards continuity, which made him blur the distinction between discrete actuality and continuous possibility in favor of a belief in actually continuous becoming and motion, was responsible. It led him to his extraordinary doctrine that a human experience has neither finite nor zero but infinitesimal duration so that in a single second, say, we have an infinite number of successive experiences, each drawing inferences from the previous, and, thus, we are always infinitely far from identifying a definite experience with definite direct unmediated data. Bergson does no better. He replies to Zeno by citing a finite movement as a single not further analyzable unit, but fails to refer to unit experiences, with finite temporal spread, yet without internal actual succession, which is the basic point.

James, with his strange flair for (often) reaching the right conclusion though 'only God knows how he got there' (C. I. Lewis), decided that experience comes in finite "drops." Whether this led Whitehead to his own doctrine of quanta of becoming I do not know. Doubtless quantum mechanics helped. But the Buddhists seem—long ago—to have reached about the same conclusion as James—both independently of physics.

A paradox, though I hope not a contradiction, obtains with respect to 20r, taking relativity physics into account. What can be meant by 'God now'? Is this a cosmic simultaneity? Any process philosopher who is serious about the relations of metaphysics and physics must deal with this question.

Because God is universal or ubiquitous, not exclusively localized, and because according to relativity physics there is no cosmic now, it seems that,

unless—as Howard Stein (in a letter) puts it—physics fails to give us "the deep truth about time," we should express 20r as "God here-now." That is, Stein suggests, God as perceiving us now is a divine state or event; God as perceiving a state of some inhabitant of another planet is another divine event. The two events will be embraced in later divine events in which God perceives remote descendants both of us and of our far-off contemporaries. All terms and relations thus become divinely known, and are immortalized beyond possibility of corruption. But the analogy between divine states and states of localized individuals is by this assumption rendered much more complex and difficult to conceive than if one could dismiss relativity considerations. It is a little like the mysteries of the trinity, only incomparably more complex.

Is the foregoing an empirical issue? I doubt it. For relativity, like the quantum principle, is a categorical question on the highest level of abstractness. And it could not, so far as I can see, be observationally falsified. Einstein's formulae could be falsified; but the degree of relativity is one thing, the question of relativity or no relativity is another. Zero relativity would mean that velocities of messages were infinite or at least had no upper limit. And how could this be known?

There is a teleological fitness in relativity as such. For it means that creatures in one part of space are without responsibility for what happens in other, far-off parts. By the time we can know what is happening light years away, it is too late to send advice as to what should be done there; still more, to try to go there and do something about it ourselves. The velocity of light and radio waves is fast enough; because of it, we have to be concerned about events in China or India. But to have immediate communications with, hence, possible responsibilities in, other galaxies would be too much! I strongly suspect that there should not, and, indeed, could not, be absolute simultaneity, at least not such as would be detectable by localized observers.

If *God here now* is not the same concrete unit of reality as God somewhere else 'now', then the simple analogy with human consciousness as a single linear succession of states collapses. I have mixed feelings about this. It seems, on the one hand, that the idea of God as an individual, though cosmic, being is thus compromised; but, on the other hand, I wonder if this is not rather what we might expect when an analogy is extended to include deity. Maybe divine individuality is not threatened but rather only the assumption that this individuality should be simple and easy for us to grasp. However, there is the haunting question, can physics judging reality from the standpoint of localized observers give us the deep truth about time as it would appear to a nonlocalized observer?

Repeatedly, interpreters of relativity physics (d'Abro, Putnam) have asserted that this theory rules out any contrast between determinate past and indeterminate future. Repeatedly, other interpreters (Stein, Capek) deny this. I

find myself sadly handicapped in trying to think about this question. But the concept of creativity is for me more convincing than any argument which assumes that physics, by one disputed interpretation, can give us the final truth about the relations of being and becoming, or settle the Parmenidean question.

Taking Stein's view of God complicates and perhaps fatally weakens one of the chief merits of a theistic philosophy, that it can explain the outlines of the world order, the laws of nature as divine decrees. "The rule of one is best," but Stein's view seems a kind of oligarchy, since God here now and God there now are not in a single linear or 'personally ordered' sequence. How do these gods make the same decision? It may be absurd, but I wonder if the 'big bang' theory of cosmic development could be relevant here. The relativity problem arises because of the spatial expanse of the world process; but the laws of nature may have been decided at a moment in the cosmic process when there was no such expanse. This is a possibly wild suggestion.

No. 12 is rather puzzling. That actuality is finite in space, I readily believe. It is certainly finite in some respects; for to say otherwise would be to say that everything thinkable was also actual, and this is absurd. But the serious question concerns the past of the creative process. Is there an actually infinite regress of past stages—if nowhere else, then at least in the divine becoming? If not, how can a first stage be either avoided or made intelligible, if every experience must have antecedent objects (nos. 1, 6)? So Kant's first antinomy, his most potent argument, stares us in the face. All I can see to do is to reject his disproof of the possibility of an actual infinity. But then, am I not compromising item 1? This question I cannot at present answer to my own complete satisfaction.

G. E. Moore argued that while there is no need to conceive actuality as spatially infinite, there is need to conceive the past as an actual infinity of realized events.[1] For a first event seems to be unintelligible. Finitists hold that an actual infinity is also unintelligible. Counting to infinity is an incompletable process. Of course, this is true if the process has a beginning. But that is the question at issue. Must it have a beginning? And must it be a question of counting? Suppose God is in every new divine state aware of an infinity of prior states, but that the additional set of items then received from the world is always finite. Such an addition does not change the numerical order of the totality. This is still just infinity. But it does add new qualities, and thus aesthetically enriches the whole. (Russell once told me that he found this logically admissible.) And note that God never has had, and never will have, to make an infinite, worldly addition to the divine life, but always only a finite addition. Moreover, the infinity of prior states is not a mere infinity of mutually independent items; for the just preceding state will have included all

1. G. E. Moore, *Some Main Problems of Philosophy* (New York: Collier, 1962).

earlier ones in its own unity. So in a sense, God is combining finites, not an infinite and a finite. The numerical infinity of the previous multiplicity is entirely embraced in the aesthetic unity of an experience. The numerical aspect is a mere aspect of this unity. At least some of the paradoxes which bother finitists are removed by this view. There is no "hotel with an infinite number of rooms, all occupied, into which new occupants can nevertheless without difficulty be introduced." There is no infinity of coexisting objects, but only of successively realized events. Nor can anything be inserted into a past event that is not already there.

The foregoing depends upon taking spatial plurality as finite. I strongly incline to this form of finitism. I think we should assume that the number of stars is finite. And of course I am rejecting Kant's phenomenalism, for which his first antinomy is, in my opinion, the strongest argument.

It should be apparent that the continuous (13a) is simple and the discontinuous is complex. Continuity is a single idea; but the sum of discrete items in the world is as far from that as possible. Similarly, infinity in the absolute sense is simpler and is less than the finite, not more; for definiteness is required for actuality, or value in a more than minimal sense. The finite or actual includes the infinite as an idea or potentiality.

As we have seen, a-terms are negative or privative by comparison with r-terms. For example, the data of an experience are what is left when one sets aside everything which a particular *experience* of x, y, z, \ldots adds to x, y, z. A person is now what he or she is always *plus* what is peculiar to his or her present reality. Always the r-terms affirm more than their correlates. If traditional philosophies understood this, they failed to express their insight.

It is clear that negative or privative properties of constituents or aspects need not apply in the same sense to wholes containing them. Thus, a house can be large though some part of it is not; it can be very valuable though some part is not. Positive properties accrue from parts to wholes. A whole can be more than its constituents, but it cannot be less. Since, as modal logic shows, the contingent contains the necessary, but not vice versa, it is plain that whatever terms belong with contingency are the inclusive characters of reality, and whatever terms belong with necessity are noninclusive or privative. But then the exaltation of 'the absolute' or 'the infinite' or 'the necessary' is simply a preference for something which in principle is less than the relative or the finite or the contingent. In worshiping the independent, people really worshiped the abstract, and preferred the less to the more valuable. I venture to regard this as a species of idolatry.

That an effect (7, 9) is more concrete, rich in definiteness, than a cause would hardly have occurred to one in the main European tradition, which was afflicted with 'etiolatry' (worship of causes). That causation is creation, enrichment of reality as a whole, was the last thing clearly envisaged. Origins, the philosophy of creativity holds, are inferior to what comes out of

them, and the de facto supreme reality must be the de facto supreme effect, which must include its cause or causes. Nothing, just in itself, is cause of anything fully particular, but effects just in themselves are caused by whatever did cause them. This is the secret of memory and perception. Only from the standpoint of the effect is the causal relation definite at both ends. God merely as cause of all would know indeterminate possibilities for worlds, nothing more. As causes, we never know just what we are causing; as effects, we always at least subconsciously know what caused us.

From no. 20 one sees that God must be successor of every becoming as well as its predecessor; as the former, influenced by and aware of each event; as the latter, its supreme causal condition.

Nothing of this could be seen while etiolatry held minds under its spell. Nor could the greater concreteness of becoming be seen while 'ontolatry' or being-worship prevailed. Alas, Heidegger used 'Being' for the basic principle, thus verbally negating his own insight into the primacy of process!

The philosophies hopelessly incompatible with the table are those which take every whole to be 'organic' so that parts depend upon just the wholes they are in; or take wholly independent terms to be actual and concrete; or take things experienced to depend upon the particular experiences had of them; or take effects and causes mutually to imply each other, or to be equally concrete and rich in actuality (or effects as such to be inferior to causes as such); or take the simple to be in principle superior to the complex; or take becoming to be merely an aspect, or inferior kind, of being.

In Paul Weiss's uniquely complicated system[2] a table of concepts must, I suppose, be in four columns to cover his four modes of being, and there seems no simple formula illuminating their relationships, unless it is that there is interaction between each and every other. But thus symmetry would be enthroned as ultimate. Rather, experiences are inclusive, and divine experiences, all-inclusive. Everything else is abstraction. In this way we avoid any mere dualism of particulars and universals or mind and matter or God and world. We avoid even Whitehead's eternal objects and actual entities. For the 'pure potentials' are not definite entities, they form a continuum (13a) which is without definite parts (8a). Only impure, noneternal, relatively independent potentials can exist in definite plurality. As Peirce put it, possibilities as such "have no identity."

According to Stephen Pepper, a metaphysics is the exploitation of a "root metaphor."[3] Neoclassicism takes a momentary experience as the model or paradigm of concrete reality. But is this just a metaphor? Except in and

2. Paul Weiss, *Modes of Being* (Carbondale: Southern Illinois University Press, 1958).

3. Stephen Pepper, *World Hypotheses: A Study in Evidence* (Berkeley: University of California Press, 1942). Also, *Concept and Quality* (La Salle, Ill.: Open Court, 1969).

through experiences there are no metaphors! What resembles no aspect of experience is "nothing, nothing, bare nothing."

The basic decisions are not as to metaphors, but as to logical structure. What depends upon what, what includes what, what is necessary to or contingent upon what? Is symmetry or asymmetry basic in explanation? These are the crucial questions. That experience must somehow be central seems obvious, since the only possible answer to the question, 'What illustrations of meaning do you have?' seems to be, 'Experience, in this or that aspect or datum'. In this sense, as Bergson said, "every philosophy that understands itself" is, in a broad sense, idealistic, some form of psychicalism (or experientialism).

According to Richard McKeon, metaphysical systems may explain things in terms of the following: (1) the all-inclusive whole, (2) least parts, (3) the problems of our species (which is neither all-inclusive nor a least part), and (4) operations.[4] In terms of diverse methods, and other factors, many subdivisions of these are suggested. It seems to me, however, that one must use ourselves as the model in any case, and work from there towards larger wholes and lesser parts. However, there is at least one ambiguity about 'all-inclusive whole': does it mean all that ever has been or will be in the future (assuming that the future is no less definite than the past), or is every cosmic whole merely the summation of what *has* happened, so that the next moment there will be a new whole, not fully determinate in advance? The first view implies (as the 'absolute idealists' insisted) that all wholes are organic and all relations internal to all their terms. The second view implies that there are both internal and external relations. Again, I think logical issues such as the one just mentioned should not be decided by some vague hunch like 'the whole explains its parts' or the like.

An adequate philosophy should clarify the question of whole and parts, provide a proper setting for human problems, and use operations in some broad sense to help explicate concepts. Both Pepper and McKeon seem to set somewhat artificial boundaries to speculation. One must, they suggest, think either in one of four speculative compartments or in one of four styles (Pepper: organicism, mechanism, formism, contextualism; McKeon: holoscopic, meroscopic, pragmatic, operational) or be a weak eclectic. Moreover, it is implied that the choice cannot be rationally demonstrated, but is personal and rather arbitrary. This is historically plausible, except that the great philosophers have always thought that they had rational arguments against one another. I think one must avoid both extremes of dismissing this as pure illusion and supposing that the refutations were as definitive as they were intended to be. When all hope of reasonable refutation dies, philosophy is not in very good health.

4. McKeon's scheme is not readily learned from his published statements. But see *Thought, Action, and Passion* (Chicago: University of Chicago Press, 1954).

8

MINDS AND BODIES

A. PSYCHICALISM AND THE LEIBNIZIAN PRINCIPLES

Natural science tends to abstract from mind and experience, even though it is derived from experience. Obviously knowledge is not complete until this abstraction is overcome. But how? Apart from details there are only a few possibilities. One may try to treat mind as a highly special case of matter. One may try to treat matter as a special case of mind or experience. One may admit an ultimate dualism. The sole remaining possibility is to try to conceive a third, or "neutral," type of entity of which both mind and matter are special cases. This last move is readily reducible to one of the others. For if mind is defined as what, in some minimal form at least, feels, intuits, enjoys, suffers, experiences, then the neutral entities do or do not feel. If they do they are mind, if not they might as well be called matter. As for dualism, it is also reducible. For the togetherness of mind and matter is mental, material, or neutral. The relations of mind and matter must be characterized, and the concept that effects this must cover both terms and be the real principle of nature. Thus "dualism" labels the problem, not the solution.

Today there is a trend toward materialism. Mind is thought of as a special form of matter which emerges on our planet and very likely many others scattered about the universe. However, the concept of emergence does not necessarily overcome dualism. If, when mind has emerged, it is essentially feeling, remembering, desiring, and the like, rather than merely a special way of moving, behaving, then the emergence doctrine is only a temporalistic form of dualism, with all the usual difficulties and perhaps more besides. For it faces the problem of understanding how from mere behavior (spatiotemporal magnitudes, shapes, and their deformation, combination, or locomotion— all we have in the idea of mere matter) is derived something that also has qualities, these being of a different logical type from the bare structures that alone are expressed in the concepts of physics. That there is a logical type

difference here is the point of Peirce's doctrine of Firstness (Peirce 1931). We must also either accept the paradoxes of epiphenomenalism or explain how mind can influence mere nonpsychical stuff or process. There are other difficulties. Emergence, like dualism, is a label for some problems, a solution of none.

Realizing all, or some, of these difficulties, materialists today seek to get rid of dualism altogether by identifying feeling and other psychical functions with material processes. Our sensations, for example, are simply certain neural events. But note, strict identity is a symmetrical relation. If *X is Y,* then *Y* is *X.* Our neural processes, in some cases, are sensations, cases of mind. And since our direct relation to matter is via sensation, why not take the identity of mind and matter in this case as our only clue to the nature of things, with the implication that matter in general is really mind in general—of course, except in human organisms, not that form of mind which is peculiar to human animals, but mind in enormously varied forms, some of them remote from ours, vastly more primitive in many cases. Some biologists have taken this path. Among these Bernhard Rensch is outstanding (Rensch 1968, 1971). Julian Huxley inclined to this view, as did the physiologist Ralph Gerard. The famous geneticist Sewall Wright, pioneer in population genetics, is another psychicalist—a term I prefer to panpsychist, since the latter term tends to suggest that anything you please, say a chair, is a sentient individual, which is nonsense. Feeling can be everywhere even though many things do not feel, somewhat as vibration can be everywhere even though chairs do not vibrate (only their microconstituents do). The distinction just hinted at is the explanation of the commonsense form of dualism. There is a duality of sentient and insentient things, but it is reducible to a monistic theory when the logical type distinction between singular and composite entities is taken into account.

The first clear-headed Western thinker who identified matter and mind was the great mathematician, logician, physicist, and metaphysician Leibniz. It is worthwhile to try to distinguish what is still valuable in his thought on this topic from those aspects (and they are plentiful) that are bizarre and of merely antiquarian concern. Philosophers in general have, I think, failed dismally to make this distinction properly.

The permanently valuable part of Leibniz's theory of matter can be summed up in what I call the True Leibnizian Principles. There are four of them.

(a) Nature consists of active singulars;

(b) What seem to our perceptions mere masses of inert, continuous stuff are really composites or assemblages of active singulars too insignificant, taken one by one, to register distinctly on our senses;

(c) The only singular activity we can directly *and distinctly* experience as such is our own subjectivity or experiencing;

(d) Consequently, our sole hope of understanding nature is to conceive it as a vast society of active singulars, each of which has some analogy with ourselves as sentient individuals, to the extent at least of possessing some form, however different from our own human form, of feeling or experiencing.

I believe that the above formulation captures what is valid in psychicalism and that Leibniz deserves credit for having been the first in all the world to state, or unmistakably imply, the four principles. Unfortunately, in his "Monadology" Leibniz combined the principles with certain other ideas not only not required by, but actually incompatible with, them. As a result, most philosophers have dismissed the Leibnizian system as a mere curiosity and have failed to deal with the principles on their merits.

Every singular or "monad," said Leibniz, is active and experiences or perceives. But what is activity, and what is perception? Leibniz gave sadly wrong answers to both of these questions. For activity in any significant sense he substituted a preestablished succession of states, and for perception, a preestablished correspondence or harmony among singulars, each of which has as its data not occurrences or states in other singulars but rather merely its own states as forming a private picture gallery repesenting ("mirroring") from its own unique perspective all the other galleries.

I submit that activity is one thing and a preestablished sequence quite another; also that perceiving is one thing and mere correspondence quite another. Leibniz has substituted the static for the dynamic, mere being for genuine becoming, and mere similarity between subjects, each logically an independent or absolute entity, for the real connection implied by the idea of perceiving. To perceive is to receive content from another, not to have that content in advance by some internal "law of succession." Perception entails dependence, relativity, in the perceiver. Moreover, the activity which mere mindless matter (could there be such a thing) must lack is no mere succession, preordained or not, but is a creative becoming, where "creative" means (with Bergson, Peirce, Whitehead, and others) that it determines what is undetermined, and thus *adds to the definiteness* of reality. Whitehead's term for this is "decision," the "cutting off" of previously open possibilities.

I think it is a significant feature of our cultural situation, so different from that of Leibniz and the other great minds of the Newtonian era, that in a recent issue of *Animal Behavior* (Dawkins and Dawkins 1973) the term "decision" is used in the Whiteheadian sense. Where the antecedent conditions determine the act of an animal, there is, the writers suggest, no decision; otherwise, there is. In the same issue another student (Baker 1973) says that ethology is passing from its deterministic phase to a stochastic one. I take this change to mean *not* the abandonment of the causal principle, but its *reformulation*. All events are conditioned; however, conditioning restricts possible

outcomes of situations without completely determining the outcomes. Thus
there is always some room, however slight, for decision in the Whiteheadian
sense. And this is what distinguishes activity from a mere series of predeter-
mined states.

I now, somewhat sadly, feel obliged to point out that Professor Rensch,
from whose contributions to biology many of us have profited, is on the Leib-
nizian or Newtonian side of the issue just discussed. And so is everyone who
accepts causal determinism in its classical or absolutistic form. For this implies
the reduction of activity to preestablished or wholly uncreative succession.
Before an act the exact form and quality of the act is already settled, there are
no really open alternatives for decision to exclude. Nor does the relativity or
dependence implied by perception escape a similar reduction. For classical
determinism, which Einstein tried to retain, the world is a single tightly inter-
locked system in which everything depends upon or causally implies everything
else, backward as well as forward in time, and hence nothing distinctively
implies or fails to imply another thing. Yet awareness, as in perception or mem-
ory, implies selective and one-way or asymmetrical dependence of experience
upon the experienced. In memory the experienced events are temporarily prior,
i.e., they are earlier experiences of one's own. In perception also they are tem-
porarily prior, though this is less obviously so. Thus memory and perception
require for their understanding a less symmetrical view of causal relatedness
between successive situations than the classical view implies.

It is too seldom noticed that the standard formula "necessary and suffi-
cient condition" implies symmetry. (If the truth of p is necessary and suffi-
cient for that of q, then the truth of q is sufficient and necessary for that of p.)
The directionality of becoming, time's arrow, is lost in the classical view.
This is the Achilles heel of the Newtonian doctrine, as many great minds of
the past hundred years have come to realize. (But such deep mental changes
are always long resisted by many.) Causal conditions are only sufficient to
make events possible; what makes the final selection among the residual pos-
sibilities is precisely decision or creativity, which as Whitehead says is the
"ultimate" category.

Those interested will find elaborations of the argument in my writings
(Hartshorne 1970, 1973) or in those of Peirce (1892, 1935). William James's
splendid essay, *The Dilemma of Determinism* (1884, 1956) is also relevant.
Its arguments, like those of Peirce, have been ignored rather than refuted by
determinists.

Professor Rensch has reported upon some experiments which he takes to
strongly suggest, though not quite to prove, that our experiences are simulta-
neous with, not temporally subsequent to, their neural conditions. My view—
on this point coincident with and derived from Whitehead's—concerning the
mind-body relation is that all conditioning, including that of human experi-
ences by physiological processes, involves the temporal priority of the condi-

tions. According to Whitehead and me, the conditions are the data, the most directly experienced factors, and an experience is never identical with its data. If I understand Rensch, he rejects such a duality in favor of an identity. (If I am in error here I do apologize.) As for the experiments, with some diffidence I suggest that no observations could establish an absolute simultaneity—or any other absolute. And I see disaster for psychicalism in collapsing the relation of experience to the experienced into an identity. The identity is not, it seems to me, of experiences with their conditions but of the data of experiences with their conditions. Experiences are directly conditioned only by their most immediate data, which so far from being identical with them temporally precede their occurrence. This is another example of the one-way dependence already spoken of as the key to time's arrow and to causality.

The duality between mind and body is no absolute distinction such as that between mind and mere mindless matter. Rather it is, as Rensch in other contexts holds, a distinction between levels of mind. Perhaps our two views are closer than I seem to imply in the previous discussion.

The future of psychicalism depends upon freeing the Leibnizian Principles from the limitations inherent in the one-sided view of causality (excluding all decision or creative novelty) characterizing the Newtonian period in science and philosophy.

LITERATURE CITED

Baker, M.C. 1973. *Stochastic properties of the foraging behavior of some species of migratory shorebirds. Behavior* 45, 241–70.
Dawkins, R. and M. Dawkins 1973. *Decisions and the uncertainty of behavior. Behavior* 45, 83–103.
Hartshorne, C. 1970. *Creative synthesis and philosophic method.* LaSalle, Ill.: Open Court. Chap. 1 and pp. 51, 61, 64, 89, 102, 137, 146, 166, 174, 204, 214.
Hartshorne, C. 1973. *Creativity and the deductive logic of causality. Review of Metaphysics* 27, 62–74.
James, W. 1884, 1956. *The dilemma of determinism. Unitarian Rev.* 22, 193–224. Republished in James, *The Will to Believe.*
Peirce, C. S. 1892, 1935. *The doctrine of necessity examined. The Monist* 2, 321–37. Republished in *The Collected Papers of Charles S. Peirce,* ed. Charles Hartshorne and Paul Weiss, vol. 6. Cambridge: Harvard University Press.
Peirce, C. S. 1931, 1958. *The Collected Papers.* Vol. 1, bk. 3.
Rensch, B. 1968, 1971. *Biophilosophie auf erkenntnistheoretischer Grundlage.* Stuttgart: G. Fischer. Trans. *Biophilosophy,* by C. A. M. Sym. New York: Columbia University Press.

B. THE SYNTHESIS OF IDEALISM AND REALISM

In discussions of "idealism" and "realism" two very different questions are often confused or, when distinguished, still not correctly and clearly related to

each other. One is the question, how fundamental and universal in reality is "mind," "soul," or "experience," in general and as such? This is the ontological question. The other question is epistemological. When a given subject knows something, its *object,* does the former depend on the latter, the latter on the former, are the two interdependent; or, finally, are they mutually independent? The idealists are accused by realists of the following procedure: from an untenable answer to the epistemological question, they seek to derive the idealistic answer to the ontological question. My contentions are: The realists have been largely right, and the idealists (so-called) often largely wrong, concerning the epistemological question, but *both* realists and idealists have in most cases been largely wrong as to the logical relations between this question and the ontological one. For I hold that the realistic position in epistemology is the very one from which the most cogent argument for an idealistic ontology can be derived.

By *subject,* in this article, is meant anything that can be said to be aware of (know or feel or intuit) anything. The concept is intended in a radically broad and nonanthropomorphic sense. Fish presumably have a sort of awareness; but this awareness is surely not human. There may be inhabitants of some other planet which enjoy awareness, again certainly not human awareness. Finally, deity, if there be any meaningful idea of it, involves some supremely excellent form of awareness or realization, radically other than the essentially defective, fallible, partial, localized-body-bound awareness that alone can reasonably be ascribed to us anthropoi.

Also to be understood is that by subject is not meant ego, soul, personality, or "spiritual substance." The same ego or person may (today) be unaware of object *O* and (tomorrow) be aware of it. Thus it is not the person simpliciter that is aware of *O,* but the person in a certain "state." Now, as we are in this essay using language, subject is something that simpliciter or by definition is aware of something, something determinate or unequivocal. It is the subjective "pole" of an actual subject-object relation. Thus the state, not the substance, the experience (in its aspect of awareness *of* something) not the ego, is the subject. Descartes may not have proved that he existed as substance or permanent ego, but he did prove, if anything can be proved, that there are momentary experiences. These experiences, as being *of* things or as having objects, are the "subjects" of this article—except when the distinction between enduring person and momentary experience is irrelevant to the argument.

Consider then the following four theses:

1. An "object," or that of which a particular subject is aware, in no degree depends upon *that* subject. Principle of *Objective Independence.* "Common sense."

Aristotle, G. E. Moore, R. B. Perry, Whitehead.

2. A "subject," or whatever is aware of anything, always depends upon (derives some of its character from) the entities of which it is aware, its objects. Principle of *Subjective Dependence.* "Common sense."

 Aristotle, Whitehead.
 (1) and (2) constitute "realism."

3. Any entity must be (or at least be destined to become) object *for* some subject or subjects. Principle of *Universal Objectivity.* "Idealism."

 Berkeley, Whitehead.

4. Any *concrete* entity is a subject, or set of subjects; hence any other concrete entity of which a subject, *S1*, is aware, is another subject or subjects (*S2;* or *S2, S3,* etc.). Principle of *Universal Subjectivity.* "Psychicalism." (I avoid "panpsychism," because it has been misused.)

 Leibniz, Peirce, Whitehead, etc.

The doctrine of this article is that these four principles are not in conflict or competition with each other, but are rather complementary or mutually supporting. The theory which asserts all four principles as forming a coherent unity may be called, with Whitehead, "reformed subjectivism"; also "societism," for it amounts to a social theory of reality.

That (1) and (2) are harmonious with each other seems fairly evident. (1) provides the subject with something to know; (2) declares that this knowledge in some degree conforms to the known. Thus truth by correspondence is grounded. Facts exist (or occur); by submitting to their influence upon us we know these facts more or less correctly. We are in that way molded to the things, not the things to us (apart from fictions).

What are the relations of (1) and (3)? Berkeley and others have given the impression that the idealistic argument runs: what we know is our idea, hence dependent on us; hence everything knowable is mind dependent. But even Berkeley himself presumably did not believe that when he knew his friends they became merely his ideas in such fashion as made them ipso facto dependent upon him; or that when he studied Plato (or knew God) this caused Plato (or God) to become dependent for existence upon Bishop Berkeley! And indeed, objective independence (1) is logically compatible with universal objectivity (3). (1) states that relation to a particular subject knowing an entity is extrinsic to that entity; (3) states that relation to subjectivity (as such or) in general is not thus extrinsic. There is no contradiction in combining these assertions; just as no logical difficulty opposes combining "John must wear some garment rather than none" with "there is no necessity for John to wear this coat" (rather than some other garment). That an entity could be precisely itself were it unknown to *S1*, or were it unknown to *S2*, or to any subject you

choose to point out, does not imply it could be itself were it unknown to any-
one, or simply unknown. Consider an ambitious man who feels that he could
not stand existence as a "mere nobody," without fame or prestige. It does not
follow that he could not stand existence if precisely I or you were unaware of
his claims to praise. He wants an audience, but any audience with suitable
characteristics will do. Similarly, idealism holds that entities need to be
known, but that any subject suitable for the function of knowing the given
will suffice. Or consider the relations of fish to water. Some water or other
they must have, but there is no one body of water rather than another which is
required. Perhaps being-known is to entities in general what water is to fish.

An objection to the foregoing might be that it makes at least some differ-
ence to the ambitious man just what his audience is, and some difference to
fish in what body of water they are placed. Let us then take another analogy.
According to the Aristotelian theory of universals or forms, there can be no
forms apart from individual substances. Without humans no humanity, with-
out dogs no caninity, etc. But there could be (and once was) humanity with-
out Socrates, or without any person you choose to mention. And it would be
the *same* universal or generic form. For this is the meaning of universality:
that it is neutral to individual (or still more particular) differences. Why may
we not regard X-is-known-by-someone-or-other as a universal, and X-is-
known-*by-S1* as an individual case of this universal? Then the Aristotelian
principle would be that X-is-known does not in the least depend upon $S1;$ for
any other subject-knowing-X would do. Yet X-is-known does depend upon
there being *some* suitable subject enjoying X as its object. And it follows that
if X depends upon or is inseparable from X-is-known, it still might be
absolutely independent of $S1,$ just as "humanity" is (or was) absolutely inde-
pendent of Socrates, though not of there being some suitable concrete
instances or other.

Return again to the ambitious man. Suppose the fame that he requires is
posthumous fame. He needs, then, to believe that posterity will remember
him. Here no future individuals as such are intrinsic to his state of mind. Only
the generic "some individuals or other (in suitable numbers and of suitable
intelligence or worth) remembering X with praise or gratitude" is involved.
Here we have a universal allowing for innumerable variations of individual
embodiment. Yet the universal calls for some embodiment if the ambition is
to be satisfied. Now, perhaps there is in 'being' a sort of ambition to be
remembered, to be made use of in subsequent occurrences, an ambition
which must be satisfied. We shall see that this is less fantastic than might
appear at first thought.

What has been shown so far is that (3) is compatible with (1) and (2).
The same can be said of (4), the principle of psychicalism. If what I know is
another subject, it may still be true that in this knowing I depend upon that
other subject, while it does not depend upon me. The biographer of Washing-

ton apparently has his mental life to a considerable extent molded by the experiences of Washington which he studies, but there is no evidence that Washington's experiences were molded by any future biographer's. (Naturally, a given man's belief about Washington is determined in part by his own nature; but this belief is merely about Washington, not identical with him.) Psychicalism may thus be a wholly 'realistic' doctrine, if realism is defined through (1) and (2).

It appears, then, that the idealistic interpretation of reality as essentially relative to or consisting of mind, experience, awareness, that is, psychicalistic idealism, is entirely compatible with a realistic view of the independence of the particular object and the dependence of the particular subject, in each subject-object situation. It may also be urged that we need the word "realism" to refer to the mere thesis that every act of knowledge must be derivative from a known which is not derivative from that act. Thus the practice of contrasting "idealism" and "realism" as though they were contradictories, is of doubtful convenience. "Realistic idealism," or "realistic subjectivism," has a reasonable and consistent meaning.

I wish now to contend that not only are the realistic theses compatible with idealism, but they furnish a basis for a cogent idealistic argument. Only certain steps in the argument can here be set forth.

Any actual occurrence, once it occurs, immediately acquires the status of being past. Past always means *past for some new present,* some new occurrence. What is this relation of being-past, or of having-as-past? Such a relation is given whenever an event is remembered. Memory is at least one way of having-as-past. What other ways, if any, can be pointed to? One may say, the cause is past for the effect, or the effect has the cause as its past, its predecessor in time. But then what is this relation of causality? And let us bear in mind that the answer must derive from some given instance. We are at Hume's problem. Is there a convincing nonidealistic answer? Whitehead, James, Bergson, Kant, and others have "answered Hume," but these answers are all in psychological terms, essentially within idealism in the broadest sense of (3) and (4). For the rest, Hume, so far as I see, has not really been answered. Again, suppose one drops "causality," and merely says that 'pastness', or 'before' and 'after', are ultimate data of experience. We hear one note as 'after' another, and that is all there is to it. But still, is it possible to separate, as an experienced datum, *"B comes after A,"* from "when *B* is heard, *A* is remembered"? We are at Kant's problem of distinguishing subjective and objective succession. But Kant did not exhaust the possible solutions. An objective serial order does not require that there be a strictly deterministic causal relation, an invariant 'rule' according to which precisely *B* is bound to follow once *A* has occurred. Suppose there is a relation of *B* to *A*, intrinsic to *B* but extrinsic to *A*. Thus "*A* occurs" would not entail "*B* occurs"; but "*B* occurs" would entail "*A* has occurred" since *B*, according to the

hypothesis, involves a relation requiring A as relatum. But how is such a relation to be conceived concretely? The simplest positive answer furnished by experience is memory. If B remembers A, while A was unaware of B, then the objective order of the two must be: A by itself, not involving B, then B-remembering-A. If all reality is some form of experience, with each unit endowed with some form of memory, then an objective temporal order is explicable. If I observe you to smile and then to frown, this order of events is in my experience as, first, a perception of smiling without reference to frowning, and second, a perception of frowning which refers to smiling as its remembered antecedent. In your experience there may be the same order, since you too in feeling yourself to frown may have a sense of having just smiled. For (these) experiences, following-A is an intrinsic property of B. This property is memory in its basic or "pure" aspect (Bergson). It is not equally true that for an experience A 'preceding B' is an intrinsic property of A. For the creative aspect of experience lies in the fact that it is never literally anticipated. Abstract general features may be anticipated, but not particular experiences as such. On the other hand, psychoanalysis lends some support to the Bergsonian-Whiteheadian thesis that memory refers not to abstract features but to particular events in their particularity. And there are other grounds for the thesis.

The foregoing considerations suggest that one dimension of reality, the temporal, is best conceived as the (creativity-memory) structure of experience as such. The present experience is a subject with past experience as its object; in this subject-object relation, the particularity of the past experience (the object) is intrinsic to the present experience (the subject), while the particularity of the present experience is extrinsic to that of the past. The two realistic theses are thus illustrated. But also, one may hold, the object is bound to be remembered by *some* future experience or other; and indeed, while no experience anticipates particular successors, experiences do, at least normally, involve a sense that they will be looked back upon by some sort of memory.

The logic of the foregoing argument is nearly the reverse of what idealistic logic has generally been supposed to be. Whereas the realist urges the independence of the known and the dependence or relativity of the knower, the idealist is supposed to urge the dependence of the known and the independence or 'absoluteness' of the knower—at least of some one knower, such as God. But it is, rather, the relativity of the subject that should incline us to idealism. Modern logic should by this time have cured us of the absurd prejudice that, to explain everything, the great thing is to find the nonrelative, or absolute. On the contrary, not nonrelation but relation is our main problem. Ours is a world of structural order. And nothing can constitute this but something that can intrinsically *have relation,* be genuinely *relative.* A subject, according to realism, just is such an intrinsically relative entity, in its very nature more or less conformed to something not itself. The subject or experience is rich in relations, the mere object has no relation, at least not to the

particular subjects which have it as object. But, the reader may say, the experience is an effect and causes are what explain things, not effects. However, please observe that every cause, with the problematic exception of God, is also effect; further, that unless we can understand what it is to be an effect we shall certainly not understand what it is to be a cause. Subjects, experiences, are certainly effects, since memory is clearly a result of the thing remembered (perhaps along with other causes). But since the thing remembered is itself, in this case at least, an experience, both cause (or a part of it) and effect are subjects. And here we see the relational structure that so much controversy over idealism seems to have missed. That subject $S1$ is relative to object $O1$ is quite compatible with $O1$'s being itself another subject, $S2$, itself relative to another object, $O2$, this object itself a third subject, $S3$, etc. Effects, in other relations, are also causes; the dependent and relative, in another relation, is independent or absolute;[1] likewise subjects, in other subject-object relations, are also objects, things known. In memory, experiences are both subjects and objects; each is subject for its predecessors and object for its successors. But since the subject is what is intrinsically relative, or really has the subject-object relation, to say of a thing that it is subject is genuinely to describe it, while to say of something that it is object for a certain subject is to describe only the subject, since the asserted relationship belongs exclusively to it. Thus, in the idea of subject, that of object is fully embraced. In principle, *materialism can add nothing to a psychical description of reality.* It cannot add relativity; for the subject is relative to its object. It cannot add nonrelativity or independence; for since subjects can be objects (for other subjects), and since by (1) they must then, in that relation, be independent, it follows that subjects can, so far as certain relations are concerned, be nonrelative. Since subjects can be effects, they can certainly be causes; for every effect is cause of subsequent effects. In the subject-object relation, interpreted psychically, we have precisely the "asymmetrical transitive relations" that modern logic has discovered to be fundamental in reality. The memory of the memory of the memory of A is in principle, and however indistinctly, memory of A; but A is not memory of the memory of the memory of A. The relation runs one way only, but it is transitive. Surely a principle thus illustrated in experience is worth two or a million verbally formulated principles for which a single illustration in the given is lacking. "Matter" is one of the other million, for who ever directly intuited a bit of matter as intrinsically referring to its past? Only experience as such exhibits this intrinsic relativity.

1. It may be asked, must there not be something that, in all relations, is absolute? My answer to this question will be found in my book, *The Divine Relativity* (Yale University Press, 1948). It is there held that there must be something universally nonrelative or absolute; but that this something is not simply identical with the supreme being or with God, and is no actual subject.

I submit that, if we put aside medieval (theological) prejudices which exalt the "absolute," we shall see that the one-sided relativity which realism finds in the subject-object relation is reason for expecting the subject as such to prove explanatory of the nature of things.

To explain in detail how the psychic principle is to be reconciled with the doctrines of physics is an unfinished task. Whitehead—especially in *Science and the Modern World* and in *Process and Reality,* has begun the work on it. I mention only that one must generalize the notion of 'memory' to include not only cases where the remembered experience expresses the same personality or ego, but also those in which this is not the case. For example, we remember feelings which have just been felt by the bodily cells, without for all that being distinctly aware of the individual cells as such. Whitehead (also Peirce) has shown how "extension" as well as temporal succession can be described in psychic terms.

The psychic principle is able to remove the air of paradox that otherwise clings to the Berkeleyan principle. It may seem nothing to a stone that there are (or will be) subjects aware of the stone. But if the stone consists of subjects, the matter is altered. Each of us is most anxious, painfully so at times, to call the attention of other subjects to ourselves, that is to get them to make us their objects. The full exploration of this topic would take us into the philosophy of religion, in which it would be shown that our very being is our sense of presence to the divine awareness.[2] We should also have to meet the objection that the divine subject must be conceived as wholly "absolute," whereas we have held that every subject is, in relation to its objects, relative or derivative. Our answer would be a theory of the divine as both absolute and relative, in diverse aspects. This would not contradict the principle of subjective dependence or relativity; since *qua* actual subject with given objects, the divine would be relative, and its absoluteness would qualify only an abstract "character" within this subject (or rather, series of subjects).

The case for psychic idealism can be summarized as follows.

1. In the subject we have a really connected or genuinely relative, "internally related," term. Human subjects furnish examples; but what principle of relativity can be found in the idea of "concretes that are simply not subjects"? What in a present actuality refers back to the past, what *in* anything is the objective counterpart of what we conceive as its history? The leaf resting on the ground "has fallen" there, but this having-fallen, where is it, as property of the leaf, or of anything else? In our memory (real or imagined), our past experience (real or imagined) of the leaf may inhere as a feature of present experience. But that is no help to the anti-

 2. Ibid. Also see my article, "Ideal Knowledge Defines Reality," *Journal of Philosophy* 43: 573–82.

idealist, who must find another objective meaning for "past" as a real relation of something. It comes down to this. Things either intrinsically refer to, "take account of" other things, for example, past events, or they internally contain no such reference to other things. Or, in other words, there either is reference to other actuality, or there is not. If there is such reference, then it is at least *as if* the thing perceived or remembered or felt the other. For "taking account of" is the external or spectator's indication of what internally to the thing itself can only be imagined as perception or feeling or memory. And if, to take the other horn of the dilemma, there is no reference of one thing to another, then the world has no real connectedness, and is no world, no real succession of cause-effect at all. Thus it is analytic that either everything must be as if idealism were true, or else as if there were no world, no real temporal-causal system. Positivism and psychic(alistic) idealism exhaust the positions that have any semblance of clear meaning. And of the two idealism alone makes sense when considered with reference to the deeper intellectual and other needs of people. There is a world, a temporal-causal process, and we cannot understand this unless through (realistic) idealism.

2. In the subject we have a principle of *unity* or wholeness, of actual *singularity,* which is yet not the unity of an ineffable bare identity, but admits of a variety of qualities and relations and components. An experience has aesthetic coherence which makes it one, not barely one, but a unity-in-variety, a synthetic unity, able to relate itself to a rich diversity. Temporally, the subject is one through the specious present, or the *quantum* of psychic becoming. Spatially, it is one through the voluminous rather than punctiform character of its perspective, or dynamic relationship with other entities (above all, in the human subject, with brain cells). But apart from subjects, what principle of many-in-one is to be found? Points of space and instants of time are surely not the answer. They presuppose units that are actual, not mere geometrical constructs. "Electrons"? But that is only a word for a certain class of units whose principle of unity is not in the least furnished by the physical measurements that indicate some of the relationships in which whatever the unit may be is known to stand. The advantage of idealism seems patent.

3. In the subject we have a contrast of particular and universal, or of actual and potential. For every subject has desires, purposes, which contrast with actual fulfillments as universals to their instances and as possibilities to actualities. "Ideas" are only the more sophisticated development of this contrast. In the alleged 'nonsubject' actualities, what if anything is the principle that furnishes such contrast? It cannot be desire or purpose or thought, contrasted to consummatory feeling and sensation. What is it then? One may speak of "laws" or "principles," but these are

not given in experience in the required nonsubject form. Shall the mere
"matter" which is supposed to constitute at least portions of nature be
regarded, in absolutely nominalistic fashion, as composed solely of par-
ticularities? But not only is such extreme nominalism doubtfully tenable,
but, alas, the anti-idealist is as destitute of a meaning for "particular" as
he is of a meaning for universal or potential. The "chronogeometrical
measurements" which are the most that an entity devoid of subjectivity
can with any show of evidence be supposed to possess by way of charac-
ters, determine not particulars, but classes, geometrical types (as DeWitt
Parker keeps reminding us, thereby meeting what seems to be a real
need). A shape is not a particular entity, but a generic character that such
an entity (or more likely, group of entities) might exhibit. This brings us
to a closely related point.

4. A subject has *quality* of feeling or sensation. What is the principle or
kind of quality in the nonsubjects? The moment we become aware
of any quality, our feeling acquires it as also its own quality. The feeling
or sensing of blue is not the feeling or sensing of red but of blue, and
differs from the feeling-of-red by all the difference (and no doubt
others besides) that distinguishes the blue and red of which we are
thus aware. Thus all *known* qualities are actually qualities of feeling,
whatever else they may be, and all knowable qualities are potentially
qualities of feeling. So the anti-idealist at best duplicates the world of
subjects with a world of mere objects having no distinctive qualities
whatever. Berkeley's contention is still entirely unrefuted, and to many
of us is as nearly self-evident (which may not be very near) as anything
in philosophy: not only are qualities when known "ideas," that is, things
known, or rather felt, enjoyed, but—and this point is overlooked by most
commentators—passing beyond mere verbal tautologies (as Berkeley
did in the dialogue between Hylas and Philonous), it is introspective fact
that qualities of color, smell, taste, thermal sensations, are qualities of
feeling in the same general sense as pleasures and pains. Whitehead and
many others have held the same. At least one entire book by a competent
psychologist, and one by an amateur in the subject, develop the argu-
ment in detail.[3]

True, G. E. Moore might superficially seem to have refuted the
notion that blue is a quality of the awareness of blue. But what Moore
really shows is only that the blue cannot be *merely* a quality of the
subject in the transaction, but must qualify the directly given object,

3. F. Aveling, *The Psychological Approach to Reality* (1929). C. Hartshorne,
The Philosophy and Psychology of Sensation (1934).

whatever else it may or may not qualify. Ducasse in his disputation with Moore shows the complementary thesis, that the blue must qualify the subject, whatever else it may or may not qualify.[4] Both overlook the limitation in their evidence which calls for the addendum "whatever else it may qualify." With the addendum, the two positions become compatible, and the total evidence can be accounted for. Of course the awareness-of-blue-something must feel the blue quality, and of course there is no conceivable way to feel what a quality would be like if it were simply unfelt. Anyway, awareness-of-blue is a unitary actuality of which blue is a constituent quality. But equally of course, the subject aware-of-blue is not aware merely of itself and its own quality, but rather, or also, of something not itself or *merely* a quality of itself. And it will not do to suppose that the direct object is intuited as shaped yet not as colored; for the directly intuited shape *is* the outline of a color, and only as such is it intuited. It is not intuited as the outline of *X,* but of blue-against-red, or black-against-white. However, none of this prevents the blue or black, as quality of the subject's feeling, from being also quality of feeling of the immediate object—nothing except the prejudice, as strong as it is little reasoned, against psychicalism, together with inattention to the fact that the direct conditions of color sense are living cells, entirely, by all established principles of comparative psychology, capable of feeling on their own. Nor is this reply cogent: if the blue-something intuited *is* cells why do we not all know the truth of the cell theory intuitively? This assumes that direct intuition is bound to be clear and distinct, and this is opposed to many facts of psychology, not to mention philosophical principles (for our intuition is not divine). We know something or somethings as blue and red; but that these somethings have the further characters of cellular individuals, our visual intuitions, for all their air of simplicity and clarity, conceal from us by their lack of definiteness. Neither the table we see nor the bodily cells we thereby intuit have actually the simplicity of character which vision seems to ascribe to them, or to whatever is directly intuited. If we directly intuit tables but (apart from science) "know nothing" of molecules, this is at least as paradoxical as that we directly intuit bodily process, but know nothing of cells. Let us play fair here. And the cells, at least, always exist, while the table might in some cases be merely a dream object.

5. In the subject there is an act of decision with regard to alternative potentialities; in the nonsubjective there must be something corresponding, since the concrete is *always* logically arbitrary, involving something

4. See *The Philosophy of G. E. Moore,* ed. P. A. Schilpp (1942).

emergent with respect to antecedent conditions (this emergence being the very meaning of time or process). However mysterious "self-determination" or choice or creative fiat may be in the subject, it seems totally unintelligible in the mere nonsubject.[5]

6. In the subject there is intrinsic value, with the implication that to be interested in a subject is to participate in its value, share in its life, and thus enrich's one's own. What then is there in the nonsubject to reward interest? Its sheer nonlife cannot enrich any life. And if there is nothing in the nonsubject to reward interest, then the anti-idealist only pretends to think about the nonsubjective; he cannot really focus his attention on it if nothing is gained thereby. Nor can the interest of the nonsubjective be merely instrumental or extrinsic. For to focus on the 'means' itself, as an entity in its own right, is to find a reward of attention in the entity itself as presented. One may take up study of something for extrinsic purposes; but the study itself must have its immanent values, and these must derive something from the object itself, or the lure of values will distract attention elsewhere and spoil the study. The only intelligible conception of direct derivation of value from an object is that the object has value to give, and this means, has its own values, its own life and feeling, and thus is some sort of subject, or collection of subjects. A subject's value will not, of course, wholly derive from the subjects which are its objects. There will be an emergent plus of value; but the object must contribute some value, or it will not determine the subject at all. For the subject as a whole is its value, and a part of the subject is a part of the value, and an independent part is an independent value. Introspection confirms all this. The more vivid is the immediate givenness of anything the more obviously does it present itself as living, and with a content of feeling in which we participate but do not create. A good example is the way sounds are given in musical experience. As Croce says, there is here no duality of mere sensations and feelings, but the whole experience is feeling through and through. Croce is mistaken only in thinking that the feeling is all merely ours. He misses the derivation of human from subhuman (cellular? molecular?) feeling. He misses, as do so many, the *social structure* of reality.[6]

5. Alois Wenzl's *Philosophie der Freiheit* (München, 1947) contains a careful, comprehensive study of the scientific and philosophical aspects of this *decision* factor.

6. Besides Whitehead, Charles Peirce (*Collected Papers,* vol. 6, bk. 1, esp. chaps. 5, 11) and Paul Häberlin (*Logik,* Kapitel 3, 6, 7; *Naturphilosophische Betrachtungen,* especially part 1, 206–9, part 2, 110–18) seem to have most adequately dealt with this social structure. Häberlin's contributions here do not seem to depend upon his theory of "eternal perfection," which appears to me to misconceive the relations of the eternal and necessary to the temporal and contingent. (His books are published by Schweizer Spiegel Verlag, Zürich, the most recent one, the *Logik,* in 1947. The Peirce Papers are from Harvard University Press.)

Readers of Professor Nyman's subtle and searching article "Problèmes et solutions en philosophie"[7] may ask if it is the 'method of zero degree' which is here applied to the contraries "mind-matter." My suggestion would be that we must distinguish between such purely logical contraries as unity and variety, novelty and permanence, and less formal ones like mind and matter. The formal or logical contraries require each other, and neither can be reduced to zero. Both are 'positive.' There is no reality without some diversity to unify. Also, there is no subject without object, no awareness without something of which there is awareness. But since one awareness can have another as its object (as in memory) the genuine formal contrary here has nothing to do with "matter." Matter as not-mind would indeed be the zero of mind, a mere negation—except so far as *nonconcrete* objects are taken into account. These indeed are no minds or subjects; yet they are something. They are abstract aspects of subjectivity. Subjectivity itself is not a subject. (Yet, as we saw, the contrast, abstract-concrete, falls within subjects.) Thus the method of degree zero applies only to contraries which are not logically necessary, but "artificial." For other types of contrast one must avail oneself of one or more of the other solutions which Professor Nyman expounds.

Psychic or realistic idealism bases itself, not upon an 'egocentric predicament', "there is no theoretical escape from the self," but upon the principle (which is no predicament), "the escape from the self, theoretical as well as practical, is into that larger community of selves or subjects the ultimate reaches of which coincide with reality." The remedy for the narrowness of experience is the sense for the vast "ocean of feelings" (Whitehead) of which it is a part. The illusion to be overcome is not, "all reality is experience, feeling, subjectivity, value," for this is no illusion, but the veritable *egocentric illusion,* "experience, feeling, subjectivity, values, are solely or chiefly found in my self, or my kind of self." The notion of *mere objects* as entities which, though concrete and singular, are not in themselves subjects is the subjectivist illusion par excellence, for it is the arbitrary supposition that subjectivity, that is to say, inner life, spontaneity, satisfaction, and suffering, are vividly real only where vividly presented in one's own experience, and pale, negligible, or nonexistent where they fail thus to come into one's own possession. The limits of our sympathetic participation in "the life of things" (Wordsworth) is thus made the measure of reality. This might be justified in the modest form:[8] "*Perhaps* there is no subjectivity where no specific form of it is accessible to us (say, in molecules)"—were it not for this, that subjectivity is not simply *a* form of concrete reality, with conceivable alternatives among which, or between which and it, we might be unauthorized to choose. Our analysis has

7. *Theoria*, part 1, 1940.
8. For a good example, see C. I. Lewis, *Mind and the World Order* (New York, 1929), p. 411.

shown rather that we know nothing of a *positive* form of concreteness other than that of subjects. To say, there are individuals whose subjectivity we cannot know, and to say, there are individuals whose concrete mode of actuality we cannot know, are by all available criteria coincident assertions. Hence the alternative to psychic idealism is not materialism or dualism, but agnosticism or positivism. The alternative is epistemological or methodological, not ontological. Ontology, I conclude, is idealistic (in the psychic or realistic form) or nothing.

C. THE TRUE PHYSICALISM: THIS CHAPTER IN A NUTSHELL

If physical means spatial then mentalism or psychicalism is physicalism, for space is how sentient beings have neighbors (Peirce) with whom they react, and their basic operations (Whitehead) are prehensions, feelings of (others') feelings. Even God could not want to or be alone, nor (by the implicit Platonic definition of deity) could God fail to have a body inclusive of all actual lesser bodies, and a mentality inclusive of all actual lesser mentalities. Supreme freedom is responsive to all actual lesser freedoms and supremely able without possible failure to have a world of lesser freedoms. "There is nothing but freedom" (Sewall Wright), "mind only" is what there is (Buddhists, also Fechner, Peirce, Bergson, Wright, Whitehead, Hartshorne, Griffin, Cobb, et al.). What limits freedom is simply previous acts of freedom, both divine and nondivine.

Generalizing the idea of mentality completely is the same as generalizing the idea of actuality completely. (See chapters 4, 7.) Mind (Peirce) is "the sole self-intelligible thing." Nothing can be simply other than mind, but there are innumerable ways and degrees in which *this* mind or experience can be other than *that* mind or experience. Language in no sense about mind is language idling, doing no useful work. After three thousand years of trying to find something simply *other-than-mind to talk about* why not try to *talk adequately about mind* in its inexhaustibly various possible forms?

9

PERCEPTION AND THE CONCRETE ABSTRACTNESS OF SCIENCE

IT is a truism that science gives us an abstract description of reality. Ryle has compared this description to the financial accounting of a college in contrast to its actual life. It is easy to see why this analogy should have occurred to him. A chemical formula for sugar omits the sweet taste which we enjoy when we eat sugar; a physical formula for redness, whether of a light-reflecting object, or of light itself, omits the sensory quality which we enjoy (or suffer) when we see red things. Science uses the sensory ("secondary") qualities as mere indices of abstract structures such as vibration rates. The colorful rich world of daily experience (the *Lebenswelt*) makes the scientific picture seem rather empty, a result of wholesale omission. And so there is naturally resistance to the pronouncement often made that the scientific objects are the realities and the sensory appearances of these objects are subjective, real only so far as human or animal experiences are real. However, I think we should equally resist the converse statement that the lifeworld is the concrete reality, and the scientific picture but an abstract catalogue of the things manifest in that world. Nor is it enough to say that both worlds are real. The correct view is more complex and more subtle than any of these three propositions even begins to express.

First, science does not simply abstract from, omit, certain of the *positive* features of the perceived world; it also adds enormously to those features. To the obvious macroscopic organisms in nature it adds microorganisms, a whole subworld to itself, including the cells of which all visible plants and animals are composed. To the obvious stars in the sky it adds galaxies and island universes. To the obvious stones, bodies of water, and diaphanous air it adds molecules, atoms, and particles. To water waves it adds air and light waves and a vast system of kinds of waves. To the obvious cases of motion it adds many forms of movement of which mere common sense knows nothing,

e.g., the Brownian movement, or that motion which is one aspect of what heat is, apart from the sensations of animals. To the obvious contrasts between parents and offspring it adds very unobvious and far greater contrasts between living species and their extinct ancestors and predecessors.

Second, and in part as a corollary of the foregoing, it is not only science that abstracts; our very sense perceptions do this for us. Sense experience is an enormous *simplification* of the perceived world. Where there are billions of individuals (cells, molecules), direct experience gives us only gross outlines of quasi-individual groups of these individuals. Where there are complicated rapid motions, perception gives us only a statistical averaging out or neutralization of these motions, as in the sensation of heat. Where every cell in the retina has its own unique processes and each of the still more numerous molecules in the seen object its more primitive processes, we may experience but a small number of shapes and colors. What is this if not an extreme form of abstraction, though one performed not by but for us as conscious beings— partly by our bodies, and partly by mental functions that escape conscious introspection?

Of course we all know the ways in which the implications of the foregoing paragraphs can be evaded. 'Molecule', we may be told, is but a conceptual device useful in predicting or controlling experience. Or in Dewey's terms it is our recognition of certain possibilities of interaction between organism and environment. I wonder where we are to stop in explaining away the discoveries of science about the individual constituents of nature. Are cells only conceptual devices? I admit that what Dewey says is close to what some quantum physicists say. This raises questions I have not succeeded in judging with any approach to competency, because of my limited mathematical abilities. Still, I venture to say, in the words of Whitehead, "Science is not a fairy tale." Nor is it mere adaptation to an unknown reality. When physicists speak of atoms, they do not normally mean a concept, or concepts, but particular items in nature as nature might be (and once was) without any animals similar to man. But no such items are directly and definitely encountered, one by one, in the lifeworld.

Leibniz, not Hume or Kant, first gave the clue to the double character of science just considered—that it enriches as well as impoverishes our world picture and is at once more and less abstract than common sense. The Leibnizian clue is that all our perceptions are "indistinct." (Leibniz also used the word "confused.") Kant was right in objecting to one feature of this doctrine as Leibniz intended it, namely the contention that the perceived world is merely represented or "mirrored," rather than actually given. As Kant said, the given is the concrete or individual in contrast to the abstract or universal. It does not follow, however, that the individual is *distinctly* given. Individual constituents of inorganic nature are all imperceptibly small, as the great Greek materialists correctly surmised. And not even other macroscopic ani-

mals, nor oneself, as individuals can be perceived more than relatively distinctly by any of us. Our memories of our own past are mostly very indistinct, with a few patches standing out less unclearly than the others. *All* human or animal intuitions, whether perceptual or mnemonic, must fail to exhibit concrete individuals in their full concreteness or definiteness.

Science and perception are both abstract; but there are two forms of abstractness. In one form details, special cases of some general property, are left out of account; in the other form one or more general properties are omitted. Science is abstract in the latter sense, for it sets aside the entire class of what are often called secondary and tertiary qualities and substitutes the so-called primary qualities, which are really structures rather than qualities in the distinctive sense. Perception yields both structure and quality, but neither one with distinctness and sharply individual detail.

What is the conclusion? I think it is this: Where direct perception yields positive qualities, there (or somewhere in the situation) these qualities exist; but where (as everywhere in [so-called] inorganic nature) perception fails to exhibit individuals as possessors of the qualities, while science has valid evidence that the individuals exist, there and to this extent it is science that reveals the reality. It is tautological that no one can visually perceive the "nonexistence of invisibly small individuals"; all one can do if they exist (and why not?) is to fail to perceive their existence. Consequently, it is mere logic that direct perception cannot be the criterion for the existence or nonexistence of individuals other than those above the threshold of the resolving power of our vision and touch. What is left if not scientific inference from perception? Accordingly, to condescend to science as essentially and exclusively abstract, as Ryle and many others have done, is a blunder. Only science can decide what very large (but less than [cosmic or] divine) or what very small entities there are. Mere perception has to be limited by the capacities of the sense organs and the degree of distinctness of the human modes of intuition. On the other hand, it is perception, not scientific inference, at least as science is now constituted, that reveals qualitative aspects of reality.

It may seem question-begging to term perception indistinct simply because it misses individuals whose reality is established only by science, taken realistically. However, the indistinctness is apparent, even apart from the theories of science. Consider *transitive* relations such as qualitative sameness for perception, as when we perceive no difference between color samples A and B, or between B and C, or C and D, but do perceive a difference between A and D. Consider the speckled hen the number of whose specks cannot be counted. Consider, as the level-headed Greek atomists did, the many indications in ordinary experience that the visible qualities of things tell us next to nothing directly about the things' possible or probable behavior. One white powder will explode if ignited or pounded, another white powder will do nothing of the kind. Color seems beautifully irrelevant to the dynamic

natures of things. Vision gives no direct clues as to weight, hardness, magnetic features, and many other behavioral properties. Again, why do smells come of themselves to the sense organ, while colors require light? Neither sense gives any direct answer, nor do the two together do so. The world of sense appearances is obviously hiding much of what matters to civilized humanity about the things appearing. Therefore, I cannot be persuaded that Aristotle was being very bright, or Leucippus, Democritus, and Epicurus anything but *very* bright, in their thinking about this matter. What a feeble attempt it was when Aristotle tried to derive from touch qualities (warm, cold, wet, and dry) the explanation of physical transformations!

If sensory appearances are hiding so much, what is the means of this hiding? Is there some film of stuff, or largely opaque veil, between us and nature? Rather, "appearance," as contrasted to "reality," is essentially negative. It is not something experienced but a partial failure to experience. The stuff between us and things is, with one *qualification* to be noted in the next paragraph, simply the indistinctness of our sense intuitions themselves. Not that we are merely intuiting our own intuitions. No, we intuit independent realities, but in some only of their real qualities, and we intuit these qualities abstractly with individual outlines drastically blurred. In short, there is no veil; but direct experiencing is limited in its capacity to appreciate details. This limitation is to be taken as an ultimate principle. Moreover, the idea of an unlimited or perfect capacity to apprehend details and individual qualities is remarkably like one of the many ways of defining deity. That our direct experience is only more or less distinct may be a way of putting the point that we are not God.

One other distinction is required. Granted that in perception we directly experience independent reality, it is a further question whether this reality is (at least chiefly) inside our own skins or around us in the environment. I hold, with Spinoza and Whitehead, that the primary physical data are inside our skins. To this extent there is indeed a stuff, a veil, between us and the "external world." But this veil is physiological. By perception we normally acquire much reliable knowledge of that external world, but we have been learning how to do this since infancy, or even since fetal stages. So of course we form perceptual judgments about the environment extremely rapidly, easily, and in many respects accurately. The realism that forgets the generic development encapsulated in this fact is indeed "naive." Appearance as veil consists of physiological processes translating (of course not perfectly or without "noise") some external events. What we most directly possess in sensory experience is essentially the physiological surrogates or analogues of external structures. Science is finding out how these analogues are produced, and why, for normal purposes, they are quite reliable. But all physical process, whether inside or outside the skin, involves vast complexities that we cannot distinctly intuit. Hence the physiological account cannot of itself explain the basic fail-

ure of perception to directly reveal the fine structures of the world. The explanation must be found in experiencing itself, or mind as such (apart from any eminent or divine form).

If we now return to the other side of science, its genuine abstractness, its impoverishment of the world picture, we can, I think, see possibilities for a synthesis of science and ordinary life as each in its way revelatory of the natures of things. We know our own experience not merely as having certain spatiotemporal structures but also as having certain qualities, sensory or emotional—a rich treasure that is not described in books on physics, chemistry, or even physiology, so far as they stick austerely to their subjects. A blind or deaf man can understand these sciences, but he misses a part of the ordinary *Lebenswelt*. Whether or not the sensory and emotional qualities are confined to animals more or less similar to ourselves, they are certainly *in nature,* unless nature is arbitrarily limited to what is outside the skins of such animals. The qualities are at least in us, and we are in the spatiotemporal scheme of things. "Idealistic" arguments to the contrary seem to me weak.

Three questions remain. (1) Are the qualities merely in our minds, or are they also in our bodies? (2) Do the qualities, or qualities more *or less* similar, occur elsewhere in nature than in high-grade animals? (3) How far down the scale of individuals, from man to atom or particle, is there something at least remotely like such qualities (in the sense in which a vibration rate is not even remotely like blue or sweet—indeed there is a logical-type difference)? Leibniz was the first to put this third query sharply; since his time Peirce and Whitehead have considered and somewhat revised his answers; most philosophers, so far as I can see, are pre-Leibnizian in not clearly seeing even what the problem is. For they never reckon carefully with the evidence, apparent long ago to Democritus, far stronger now, that conscious sense experience omits and abstracts as genuinely as science does, though in a different way. Only a combination of thought and sense can give us such awareness of the concreteness of things as falls within our capacity.

Whatever may lack sensory qualities, experiences do not lack them. To deny that red is in the experience of red is to talk nonsense, as G. E. Moore did in his famous "refutation" (later, on this point, rightly repudiated).[1] But it does not follow, in spite of Ducasse, that the redness is *only* in our experience.[2] If we are aware of a red something or process, then there is, in our experience, not simply red but a red something. And this something is not merely our experience of it. Experience, awareness, is never simply of itself, but is always a more or less transparent response to a given.

1. See *The Philosophy of G. E. Moore,* ed. P. A. Schilpp (Evanston and Chicago: Northwestern University Press, 1942), pp. 660–63.
2. Ibid., pp. 223–51.

Husserl's disciples in general unluckily missed and obscured this truism by their ambiguous or question-begging term "intentionality." One can mean or intend a mere possibility, but experiencing is never merely intending. It is always a having of a given, and this given cannot be a mere "claim" that something is actual; it is always an actuality. Nor can it be a mere quality, a "hyletic datum." Rather, to intend is to use a *given* qualified actuality as sign of something not effectively given. Nor can the given depend upon the experience. It is always independent. The reflective experience for which an experience is itself given is, as Husserl almost says but seems not to grasp clearly, an immediately *subsequent* experience, and is thus a special form or use of memory, what Husserl first called "primary memory" and then later "retention." His first usage was best, since the contrasting term is not mere memory but recollection (*Wiedererinnerung*), remembering after forgetting. Simple memory, not complicated by intervening forgetting, is just memory. Thus it can be held that every experience has something other than itself as simply possessed, rather than merely intended, claimed, posited, inferred, or what have you.

What is this given something? It has two main forms: (1) previous experience by the same person, and (2) other types of events which are not obviously, but are perhaps really, also experiences, though not experiences by the same person. The first form occurs in what we normally call memory; the other in what we call perception, the data of which *always* include events in the members of one's own body. In being aware of these members one is not a self aware of that very self. One is, at least at a given moment, a *single* individual; one's bodily members are a vast *multitude* of other (though only relatively independent) individuals. The longer philosophers neglect this elementary distinction between self as knower and the self's body, the longer will confusion about the structure of perception persist. In sensory experience vast numbers of individuals are (indistinctly) given. These individuals are not the experience; there is a subject-object distinction, and while the subject (the momentary experience) is one, the objects are numerous.

Consider a pain. One experiences the pain; however, the pain is not the experience, but the datum of the experience. (It is an element in the experience, but inclusion is not identity.) Nor can the given be produced by the experience, for what an experience produces is precisely what is not given to it. Experience is a partly free, self-creative response, not to that very experience but to something else which must be there to make the experience possible. This is why we cannot avoid pain simply by refusing to produce it, and cannot turn it into physical pleasure simply by producing that.

An old controversy about pain derives partly from a failure to recognize the duality in all experience, its subject-object structure. In experience of red (or of pain) the red (or pain) quality belongs *both* to the experience and to the experienced. It belongs to the former, for otherwise what is the difference

between experience of red (or pain) and that of green (or pleasure)? The contrast in object qualities becomes derivatively also a contrast in experience (or subject) qualities. Now the controversy referred to is this: some say pain is a sensation, some say it is a feeling, others say it is a sensation to which normally a certain feeling is attached. Normally pains are disturbing, that is the feeling; but indifferent or masochistic experiences are possible in which pains seem either neutral or even enjoyable.

I think the truth is more subtle than any of these descriptions. The pain as independent datum is not *my* feeling, for that would be dependent. The pain as *my* disturbance is of course my feeling, and dependent on me as subject, but this is the pain quality as an attribute not of the datum but of the experience. There is a to-me-painful awareness of a painful datum. What is this datum? We have sufficient evidence to locate it somewhere in the bodily processes. Just where in these processes is a secondary question; the point is that the processes are somatic, belonging initially to human cells, not to human experiences or minds. Put simply and roughly, certain of my cells suffer; as aware of their suffering I, too, suffer, normally speaking. For sympathy with somatic processes just is one main aspect of the mind-body relation. Hurt my cells and you probably hurt me. However, I can to some extent neutralize this somatic sympathy, or give it a perverse turn. After all there is usually much more than pain in my experience; unless the pain is massive and intense, the rest of the experience may give such satisfaction as to cause me to say that I do not mind or even enjoy the experience. What in some cells may be overwhelming misery may in my vastly more complex and capacious experience be but a trifling speck of suffering, which may have a certain value, perhaps of contrast with other elements in that experience.

If pain is taken as intrinsically neutral, then the fact that it is normally disturbing is a mystery. On the contrary, if it is intrinsically negative, a suffering but—as given, as object—a suffering by what, for all we know, may be certain cells, then—though there may well be a range of possibilities as to how one appropriates this cellular suffering into one's own momentary suffering-enjoyment, one's happiness-unhappiness—still, the normal way must be to suffer with the cells, to accept their naive verdict of negativity as valid for me. For plainly an animal had better, normally, take the side of its own members, favor their weal not their woe. I submit that this view fits the facts, as no other can.

One obvious consequence is the falsity of the alleged axiom that one can be immediately aware of no feelings but one's own, or that "other mind" cannot be a direct datum of sense perception. On the contrary, sensation in a multicellular animal just is its feeling (some of the) cellular feelings, the latter feelings having their own independent reality. Here we have Whitehead's "feeling of feeling" instantiated in a crucial case. This is but the beginning of a long story, which future science and philosophy should be able to elaborate, correct, and complete in a fashion of which many have not the faintest suspicion.

In this way we may finally recover the concreteness of the lifeworld as integral to our overall picture of reality as a coherent whole whose vague outlines are given to direct experience, but whose specific and particular details are largely hidden from that experience and from mere common sense.

One clarification is needed. If the datum is independent, and the datum in sensation is chiefly somatic, it follows that the given somatic processes are independent of our awareness of them, while the awareness itself is dependent upon the processes. In Spinoza's two-aspect view, neither aspect, mind or matter, is independent of the other, since they are but two ways of conceiving the same substance. According to interactionism, mind and body mutually influence each other. But we are looking for a one-way influence of bodily upon mental processes.

To speak of influence or action is to speak causally; causes precede effects, according to physics, and I believe according to any clear-headed philosophy. So the bodily conditions of givenness must precede the experiences in or to which they are given. Whitehead asserts just this. He, unlike almost every other Western philosopher (some Buddhists appear to have preceded him), has drawn the correct conclusion from the one-way influence essential to a realistic conception of experience: experiences must follow, not be simultaneous with, their data.

At once three basic problems are illuminated. (1) We see how experiences can depend upon independently occurring actualities; (2) we see that the standard puzzle, "How can past events be experienced since they are past, gone out of existence?" is wrong-headed; (3) we see the answer to Hume's query about causal connections. (1) If events depend only upon preceding conditions and not upon subsequent ones, and if the data of perception are precedent, then of course they are independent. (2) So far from its being a paradox that the past is given, anything else is indeed paradoxical. Only that whose becoming is finished can be given, i.e., only past events. Also simultaneity is a mutual relation; therefore, it is unfitted to explicate the relation of givenness. And it is paradoxical to suppose that future events, those which have not yet happened, can be given. (3) If givenness can itself be given, and personal memory is just that, the givenness of past cases of givenness, then we can furnish Hume with an impression of causality. It is memory as *impression of previous impressions,* the givenness of previous cases of givenness.

But is there not interaction between the mental and the bodily? I believe that there is, but the action of the humanly mental on the bodily is not the relation of human experience to its data. When I feel an occurrence of feeling in some of my cells, the cellular exhilaration or disturbance has already happened by the time my exhilaration or disturbance, my sympathetic participation, occurs. It is then too late for the participatory feeling to influence the feeling participated in. Only a later stage of bodily feeling can be open to influence by the present state of my human feeling. A bodily response to the

humanly mental must follow it temporally; and this will be (retrospective) cellular sympathy for the human, not human sympathy for the cellular. This reverse influence of mental upon bodily may well be slight (epiphenomenalism says nil), since the capacity of cells to sympathize must be very inferior to that of human beings.

Nothing is easier than to understand the skepticism which many feel toward any such view. What I call the "prosaic" or "apathetic" fallacy is almost as naturally human as the poetic or pathetic fallacy. The world is neither the fairyland of primitive cultures nor the great machine of early modern science. Nor is it merely a vast but mindless organism. It is rather a vast many-leveled "society of societies." Enormous imagination and courage, combined with careful weighing of rather complicated chains of evidence, are required if we are to arrive at much idea of this cosmic society. There is no easy path, whether sentimental or cynical. But we are not even fairly started on the right path if we overlook or deny the *pervasive indistinctness of human experience or the evidence in direct awareness of two levels of feeling,* the second derivative, logically and temporally, from the first.

I return once more to the abstractness of science. Structures can be traced from experience to bodily process, from that to the environmental process, far out into the universe; but qualities can reach us only across bridges of feeling which at each stage lose most of the individual distinctnesses of the previous stage. Hence it is that science must focus upon *group structures* rather than individual qualities. Most of the universe is and must remain qualitatively mysterious to us. What does it feel like to be a fish, a paramecium? We can know much of the spatiotemporal patterns of what goes on in these organisms, but their feeling qualities, how shall we know them?

The view I have defended is a "causal view of perception," but it is the last type of view that seems to be meant by most of those using this phrase. I hold that close to the most important and original contribution of Whitehead is his discovery that, instead of using an otherwise explicated doctrine (what doctrine?) of causality to characterize givenness ("prehension"), we can use the natural realistic conception of givenness to explicate causality. Then we have both an answer to Hume and a truly realistic conception of experience. And, by taking to heart the indistinctness of experience, we can understand that the concreteness of the lifeworld is somewhat illusory and in need of help from science; also, why science, to transcend common sense, is compelled to set aside (not deny but subordinate) the qualitative side of the lifeworld, and why our knowledge of qualities is incapable of definite, intersubjectively valid extensions to keep pace with the structural extensions that science can effect, so that our wish to know things as they are is only to a limited degree realizable.

Our comfort is that what we cannot know we do not need to know in order to plan our lives and find our role in the creative advance which is

reality. Moreover, we know what, in principle, it is that we are missing, and why, no matter how our knowledge increases, we are bound to miss it. The fish and the paramecia enjoy, though they do not objectively know, their to us inaccessible feelings. As for the question, "Can these feelings, along with the rest of the concreteness of reality, be adequately and distinctly known?"; that question is purely theological, so far as it makes sense at all. It is God "to whom all hearts are open"—God, or no one!

The position taken in this essay can be summed up by expanding its title so that it runs: "the abstract *concreteness* of perception and the concrete *abstractness* of science." Perception is essentially concrete in that it exhibits all the general categories of reality, but it is in detail abstract by failing to exhibit distinctly most of the individual instances of the categories; science is essentially abstract in that it systematically sets aside some categories (because they are not interindividually measurable) but in detail it is concrete by its power to detect otherwise hidden individual cases of the categories it employs. To use science to remedy the defects of perception it is necessary to expand the catalogue of *individuals* far beyond the deliverances of direct perception. To use perception (or what perception and memory have in common) to remedy the defects of science, it is necessary to expand the list of cosmically applicable categories to include generalized versions of the basic dimensions of experience as such, e.g., qualities of feeling, and personal and impersonal memory (i.e., perception). In carrying through this program one discovers that the distinction between "appearance" and "reality" is ambiguous: it may mean the contrast between the physiological and the extrabodily processes generative of perception; it may mean the contrast between the indistinctness or indefiniteness of all perceptions (other than divine) and the definiteness of independent reality, or reality as omniscience would experience it.

The inclusive function is experience of (past) experience, or feeling of (past) feeling, in its two forms, personal and impersonal. This inclusive function Whitehead calls prehension. The structure of the lifeworld is in principle the basic structure, but it must be seen as more intimately, subtly, and variously social (and temporal) than is obvious to common sense, yet in fair agreement with those philosophers, prophets, and poets down through the centuries who have held that love, or social relatedness, is the key to the great problems.

10

THE ZERO FALLACY IN
PHILOSOPHY:
ACCENTUATE THE POSITIVE

Philosophers have erred in their denials, not in their assertions.

Leibniz

OFTEN philosophers err in exaggerating the truth and importance their sentences. Give a philosopher an inch, wrote Charles Peirce, and he will take a million light years. However, it also happens now and then that a philosopher speaks more truly than he knows. Before showing how Leibniz illustrates the second mistake I will present something that he did know and knew that he knew. He did know, but failed to communicate his knowledge effectively, that the dualism of mind *and matter* is a mistake. Mind is a positive something, it involves, in all cases, at least feeling, more or less pleasant or unpleasant but primarily the former; in addition to mind, taking all its kinds and abstractive aspects into account, there is not anything. According to dualism, however, matter is also real and only in some cases involves mind in any form. Cartesian dualism is the classic case, and was known to Leibniz.

What is matter, the physical, positively? It has extension, spatial character. And what is spatiality? Leibniz gave the answer: space is how the psychical, the only, actualities *coexist*. It is how one has neighbors as well as ancestors. In mere time, some realities succeed others, and this is an asymmetrical relation, whereas coexistence is symmetrical. We succeeded or followed our ancestors, not they us.

Given mind, in its vast variety of forms, do we need matter and if so why? If cases of mind can coexist, or better co-occur, then the question is, can they do so in all the ways science shows that such co-occurrences take place? If the answer is yes, then matter is entirely superfluous. Leibniz gave

this answer. Was he refuted? His total position, his monadology, was refuted surely—who believes it now—but this was not because he dismissed mere matter as having no positive content which mind cannot supply. It was because his concept of mind was itself too negative, and this in several ways.

The famous Principle of Sufficient Reason sounds positive but is really ambiguously or contradictorily positive-negative. Causal explanation has two logically distinct aspects that are often fused but are genuinely distinct. A cause is, by definition, a necessary precondition, meaning something without which an event cannot occur; it may, it was often assumed, be also a sufficient condition, given which the event definitely will occur. To deny this distinction is simply to make unqualified determinism true by definition and this is sheer dogmatism. Without all the necessary preconditions the event cannot occur; with them it can. But can and will are irreducibly distinct, by any tolerable modal logic. All one has is, it may or may not occur. Like many of his time Leibniz did not believe in genuine libertarian freedom. In our century even physicists can do that. Descartes did believe in and brilliantly defended human freedom, but simply no one who counted in science then, so far as I know, saw the genuine duality of necessary and sufficient conditions, or the possibility that, for all we could ever know, in their full concreteness events in general have no sufficient conditions for their actual occurrence.

To pretend to express this logical truth, in its relevance to science, ethics, and philosophy of religion, by saying that some events may be *uncaused,* is remarkably careless. To be caused is to have necessary preconditions. My birth was conditioned, made possible, by my parents and their world, but many possibilities are never actualized, for all any human knowledge could ever tell us. Strict determinism is essentially negative. It denies the creativity involved in all genuine activity when its constituents, including the invisibly and intangibly minute ones, are taken into account. Physics now agrees with, or at least is compatible with, the view of Epicurus that even atoms have bits of freedom. The bits are trifling, taken one by one, but the multiplicity of cases is so great that the collective results are by no means trifling. The question is no longer, determinacy or not determinacy, it is only how much and where and when. Leibniz's requirement of sufficient reason was a classic case of having inches and taking light years. He knew nothing of the kind.

Another unconsciously negative statement of Leibniz was his "no windows" description of his monads. What this meant was he carried a moderate negativism of Aristotle to a vicious extreme, and in two ways. Aristotle did (wisely) distinguish between essential and accidental qualities of individuals; Leibniz denied the latter, making all their qualities essential to the individu-

als. Before I (C. H.) was born, Leibniz would say, I was the one who was already destined to die in just a certain way more than ninety years later. This would have seemed crazy to Aristotle, but still the modern thinker's error came partly from the ancient Greek. For, in two ways, Aristotle also was negative. He admitted freedom, and the chance that goes with it, only grudgingly and inadequately. In addition he strongly pointed toward a no-windows doctrine by trying to avoid what I call relative predicates. He wrote (or is quoted) as though subjects of predicates could be described one by one, $S1$ with predicates a, b, etc.; $S2$ with predicates x, y, etc. In other words he seems to deny internal relations. No description of you or me would amount to much if it omitted our parents, nurses, spouses, friends, enemies, the authors we have read, etc.

The ironical fact, however, is that Aristotle also explicitly asserts just what "no windows" denies. He denies that X experiences or knows Y independently of Y. He says, if an animal goes round a pillar, this is a relation for the animal but not for the pillar. Two of the greatest logicians in history were trying to make do almost or entirely without a logic of relatives, as Peirce calls them. Being related to X is positive, the presence, in some genuine sense, of X in S, at least if S is in the least aware of X; it is not the sheer absence of X in S.

Aristotle, and Leibniz after him, conceived God as not intrinsically related to any nondivine thing. Here Aristotle was more consistent then Leibniz who, under overwhelming pressure from the medieval legacy, and the Reformation that left so much unreformed, did not challenge the dogma that God is not genuinely related to or influenced by the creatures and, in knowing these, by the same act, which is the divine essence itself, creates them, being only "morally not metaphysically" necessitated to choose them among possible individuals or worlds. Who can believe that Leibniz knew the validity of all this? And what freedom does it leave the creatures? I think we can know about that—read his *Theodicy*. We also can guess why he felt he had to take such a position. He was, and there is a certain nobility in this, trying to reconcile Protestants and Catholics; but alas, they were negativists themselves! It almost seems that all Leibniz accomplished for his purpose was to make the bankruptcy of both traditions only too glaring.

The Socinians really reformed theism, but who paid much attention to them or learned from them? The only decent book on their admirable thinking I know of is in German, and there seems no translation. We human animals stumble and stagger toward the truth. We do what we can and there is real progress, in spite of the regressions. Like Kierkegaard much later, the Socinians really believed in human freedom and altered their theism to take this into account. Did Kierkegaard do that? He continued to identify deity with eternity, and to that extent he had Aristotle's and Aquinas's problems

about how God can know, and hence be in some way dependent upon and
changed by the contingent things in the world. I would like to be shown
wrong about Kierkegaard; I read a book of his in German translation before
most English writers, perhaps, had heard of him, and I have since read much
in English.

Since science no longer excludes freedom, even of atoms, and this
not solely because of quantum theory—Maxwell, Peirce, and others took
a similar stance before that theory—we have now a new opportunity to think
positively about almost everything. One of my articles early in my career was
about this new opportunity, and what I said then is more easily defended now.

Obviously mind is a very positive idea, connoting joy, hope, love, pur-
pose. Even pain and hate are not mere absences. What is matter *positively* if it
is without mind? And what is the evidence of this total negation of feeling,
thought, memory (in the psychological sense)? Long ago Plato answered this
question, but alas, out of a hundred references to Plato, taken at random, will
more than one or two, if even that many, include this item? Surely there is
bias in this neglect! Philosophers have, as Leibniz said, overaccentuated the
negative. Plato's criterion for the presence of mind was positive, "self-
motion," which I take to mean self-activity. So positive is he about this that
when he talks about God in the *Timaeus* and the *Laws* he makes it clear that
even divine mind is self-active, and involves change, *becoming,* as well as
permanence or being. He also says that God cares about the creatures. This
caring is not an absence but a presence. So positivistic, in a more reasonable
sense than Comte's, was Plato.

Further, Plato's God has a body (again an assertion) which is the entire
cosmos, and this not as a totality of things and events fixed once for all but as
a totality with ever-new additions. I feel safe in denying that Plato in his full
maturity held the standard medieval view of a timeless omniscience. Time*less*
is one of those pseudosacred negations by which we have been bewildered for
too long. Plato, in his post-*Republic* maturity, transcended this knee-jerk eter-
nalism, which was already in Parmenides and Zeno. Time is what we know;
we had better be modest about our ability to absolutely negate it and have
even a vestige of meaning left.

Not only did Plato affirm a divine body, it is not clear he thought there
could be such a thing as a bodiless spirit. What a mass of superstition van-
ishes if one goes with this: fairies, demons, Jupiter, Venus, Satan—where are
the bodies and what are they made of? We now know a lot about bodies and
what they can be made of, and this includes the cosmic or divine body. What
we don't know is still vaster, but the knowledge we have rids us of many
beliefs we can do well without.

Does Plato's view of a divine body blur the distinction between divine
and not divine? No, he says that souls are superior to and include their bodies.

Indeed he overstates the independence of human souls from their bodies, by positing prenatal and posthumous careers for the souls. On this question I am Aristotelian or Epicurean, and no Platonist. Plato did make mistakes, but not some of the ones often attributed to him, or he made them early but not late in his career. Just where A. E. Taylor, whom I visited early in my career, found Plato congenial to his own religion, I did not. Whitehead states his dependence on Taylor and this helps me to understand his remarkably unjustified dismissal of Plato's theological use of the soul-body analogy. My scholars on Plato include many I trust more than I would Taylor, including Burnet, Cornford, Lewis Campbell, Paul Shorey, R. Levinson (a disciple of Shorey and close friend of mine), and several others, including two German and a French writer. One of the Germans, named Cohn, I heard lecture a number of times. Of him it was said, Cohn *weiss Alles*. He taught me a lot in 1924, especially the importance of the *Seventh Epistle*.

Plato was a mind-matter dualist, but largely because, like the other ancients, he had no secure knowledge of the microactivities of which so-called inanimate matter consists, and unlike Epicurus he did not make the brilliant guess, and rather more than a guess, that inert things, such as grains of sand, are actually made up of highly active, indeed self-active, singulars as I call the noninert entities of nature which, with Plato, I also call souls or minds. My own complete psychicalism was not derived from microphysics, but, like Whitehead's, as he told me, from phenomenological observations of sensations as a special class of feelings. Mindless matter is not a given but a logical construction, and a negative one. No such thing is, or so far as I can see, *could* be experienced. Later I found the same argument against materialism or dualism in Croce. It is also in Berkeley's argument against those two positions. But Berkeley's kind of idealism does not follow, by any logic I know, from this dual rejection; Leibniz was neither a dualist nor a materialist, but his mentalism was radically different from Berkeley's. At the time I reached my antimaterialist and antidualist conviction I knew almost nothing of Berkeley and nothing of Leibniz.

From whom did I, or Whitehead, derive this conviction? Independently Whitehead and I read the same two great poets who most eloquently expressed the phenomenological basis of the view: Wordsworth and Shelley. We both reasoned, if sensations are feelings, as these poets and we found they were, then, since nature is given only through sensations and these are feelings and obviously mental, what other materials do we have with which to conceive nature than forms of mentality?

The foregoing is only one of the ways in which I can almost claim to have had a preestablished harmony with Whitehead. He incomparably surpassed me in mathematics and physics, but I knew more biology than he did; also more of the history of philosophy, though much less of general history,

or history of science. So it was fortunate that we came to know each other well. I recall his saying, one of the last times, perhaps the last, "We are always glad to see you." Once, when I criticized something he had said, he replied, "That's a very good objection." Another time, when I explained my partial rejection of his eternal objects, he said, "That's a very subtle argument; perhaps I've missed something." This recalls Husserl's answer to my claim to have an intuition of essence, *Wesenschau,* of sensations as a class of feelings, *"Vielleicht haben Sie Etwas."* With all his faults, and he had some, he was a serious and honest inquirer. So was Whitehead, and with lesser faults.

It is time to state the zero fallacy, which should be formulated in logic texts, but is not: with properties of which there can be varying degrees, the zero degree, or total absence, is knowable empirically only if there is a *known least quantum,* or finite minimum, of the property. Planck's constant is an example; it excludes complete continuity in changes by setting an absolute finite minimum. Thus light intensity may be reduced to *one photon;* less than that is simply no light. I hold that metaphysicians should have anticipated this. Absolute continuity of change, nature "making no leaps," never was or could be an observed fact, for to observe it one would have to be God, with absolutely clear and distinct perceptions. There are also reasons why God should not be supposed to observe continuous change. A zero of elephants is observable because there is a finite minimum of what can properly be called an elephant.

The truth, first proclaimed by Whitehead, but implied by both Hebrew and Greek thought in general, is that actuality and finitude belong together. Only abstractions, possibilities, can be absolutely infinite. Infinity is a negative word and a negative idea, and it entails inactuality, another negative word. Identifying deity with *pure infinity is no praise of God* and reduces the all-worshipful to an empty abstraction. Neither the book of Job nor the mature dialogues of Plato imply any such identification. Nor do the metaphysical writings of Whitehead imply it. Peirce hesitated here and his synechism not only failed to achieve what he hoped, which was to guide physics; it predicted the opposite of what actually happened. His tychism, or chance-ism, was born out, but precisely *not his synechism or continuity-ism.* On Peirce's own principles I argue he should have predicted something like quantum theory. There he missed an opportunity, leaving it to me, immensely less gifted in mathematics and logic, to post-do it for him. As Mortimer Snerd used to say, That's the way it goes. We all, even the best of us, make mistakes. In time even the least of us can see the point.

Applying the foregoing to the question of mind and matter, we find the physicists searching for the minimum of the physical or spatial, but the psy-

chologists scarcely daring to raise the question of the minimum of mind. Is it in the lowest animals, or the single-celled organisms, plant and animal, or where? And what physicists seriously defend the notion of mind*less* matter? Dirac, Wigner, Dyson, Wheeler, Sudarshan, Prigogine? Leibniz thought there was an infinite regress of lesser and lesser little minds. But this was his infinity worship in which he was too close to classical, that is medieval, theism. Without some finitude there is no concrete definiteness. Sheer continuity is not beautiful, just one vast blur. A merely infinite God is an intellectual form of idolatry; is a *merely finite* God any better? Certainly not, *merely* is another negation that belittles deity. The only single word that is permissible for God is in the New Testament, and it is love, as in the Wesleyan hymn title, "Love Divine, All Love Excelling." Even the word good must be qualified before divineness is identified with its import. If *God is good* means that the concept of Hell is blasphemous, then yes, no such thing could be divinely decreed. But if *evil* includes suffering vicariously, out of sympathy for sufferers, then yes it is more godlike to have such sympathy than not to have it. Whitehead's "God is the fellow sufferer who understands" follows from his technical doctrine of prehension, which is a transcendental, applicable supremely to God.

After Leibniz, Kant (of the moderns) most nearly dominated philosophical theism. How positive were his doctrines? Recall the following: he condemned God to be timeless, devoid of becoming, and our human freedom also to be timeless—hence unintelligible; he said we do not know what either mind or body really are, and he asserted our human immortality, not in the Peirce-Bergson-Whitehead sense of the immortality of past actuality in God as the ultimate posterity, but in who knows what noumenal sense. The good side is in Kant's saying that our categories (or ultimate contrasts, as I call them) are positively applicable only in temporal terms; the bad side is that his determinism destroys, rather than, as he claims protects, the structure of time by making causes both necessary *and sufficient,* thus negating the arrow, the asymmetry of becoming, or as Bergson would say, spatializing time.

Kant was noble in saying that our moral obligations and the starry heavens awakened his reverence; he was right in holding that we must view ourselves as in some sense everlastingly (not eternally, timelessly) real, also in some genuine sense free; that we should believe in a superintelligent being worthy of worship; should value ourselves and other people according to the same principles and live entirely for the summum bonum as made possible by God but also partly dependent on our use of our freedom. However, none of these things requires Kant's utterly negative or infinitely indefinite doctrine of reality in contrast to appearance, the former of which we know absolutely nothing save that it is something. According to a sentence in the *Nachlass,* not even "whether it is one or many."

Concerning the great skeptics, Carneades, Hume, and Nietzsche, I offer some remarks. Hume and Nietzsche denied freedom (asserted absolute determinism) and thereby begged the question of theism, for, as Carneades saw, the Stoic (or Spinozistic) use of the word freedom is self-contradictory or meaningless. Carneades himself was negativistic in denying that we experience anything more than our experience itself as "impressed" by a not-further-known something, Hume repeated this doctrine, combining it with the modern scientific doctrine of determinism, and so opened wide the door for Kant's deterministic doctrine of appearances and hopelessly vague doctrine of reality knowable only as timeless and spaceless, that is, nowhere and nowhen. Appearance and reality are words whose meaning vanishes when so treated. Mirror images are precisely not totally different from what causes them, but quite intelligibly related to the latter. There is no way for Kant to know what he is talking about in much of what he says. Most of his contemporaries rejected it and I have never seen any reason to take it seriously. Only a great intellectual architect could construct such an imaginary castle, but what more is it?

Our experiences neither give us clearly and distinctly what we experience—as though we were God, the cosmic Psyche—nor do they wholly hide it; they indistinctly or confusedly (Leibniz uses both words, and Whitehead talks of [partly] "negative" prehensions) exhibit what and where and when it is. Let us be more specific. If one feels a physical pain, one then has not just one's own suffering, but rather a feeling of the sufferings of some constituents of one's body. This is not refuted by talking about pain 'in' an amputated limb. The cells involved may be at the cut-off point of the amputation, or/and in the brain. Locating the suffering cells is an ability that requires cooperation of several sense organs and the brain, and like all abilities has its limitations. Another mistake is to suppose that we experience either just our own subjective states or else some physical realities *outside our bodies.*

I'll never understand how people can talk like this. There are billions of physical realities inside our bodies, have we forgotten that? I got over this forgetting more than sixty years ago and no Husserl could ever persuade me to *bracket* it all in order to discover some transcendental something or other. With Whitehead I find life too short to suppose science is only a fairy tale and explore what is left. The ancients bracketed the cell theory more effectively than we ever can; it was just not in their minds, and if that helped them to understand the human condition we can find the results in their writings. My interest is in them too, but that experiment has already been done! What we can add is achieved by *not* putting out of our minds what *we* know and they did not. Whitehead and Merleau-Ponty both tell us that we experience the world through the flesh, that is, the cells and other active singulars in the body. Physical pleasures come in as even more fundamental than physical

pains and both have the same social duality. I once wrote an essay arguing that there are no purely private pleasures. There is no feeling that is merely mine.

Nietzsche's "death of God" I find unthreatening, since the God he seems to know about never was alive for me (as Carneades said of the Stoic God); worse still, when it was thought of as alive it was cruel or had a bizarre or "human all too human" notion of justice in punishing by eternal torment. Good riddance, I dare to say. On the other hand I salute Nietzsche for seeing that being is only an abstraction from becoming. Hegel can be taken to say this but I prefer the later German's simpler formulation. Yet, by introducing the meaningless or self-contradictory eternal recurrence, also by his explicit determinism, the famous God-destroyer falls into the traditional blind alley of denying the asymmetry of causality or time, and the primacy of creativity. Cosmic mind makes much better sense; the integrity of the cosmos is relied upon by every scientist and every creature in the galaxies. If atheists need the Recurrence belief, good luck to them. The rest of us do not. I began reading Nietzsche in 1916 and have read him enough to see his limitations. A lady psychiatrist, I forget the name, said that between love and hate he chose the latter. Another lady, Philippa Foot, reaches a similar, more gently expressed conclusion. A third lady, Nietzsche's secretary, said: "What he wanted from me was secretarial use and sexual abuse."

For me there is no war of the sexes, though occasionally I find something partly right on the side of my sex. In general if sexism or racism are intelligent, then don't ask me what isn't. If they go anything goes.

Four skeptics are left: Heidegger, whom I knew as his postdoctoral student, Wittgenstein, Derrida, and B. Russell, whom I also knew rather well in Chicago, and also once at Harvard.

Heidegger distrusted the metaphysics he knew, and rightly enough, but much has happened in the subject that he seems not to have known. (Even his distinguished disciple, Gadamer, called the master's view of Plato "eccentric.") He was also right if he thought Aristotle's view of God fantastically wrong, and he did say that God should be thought in terms of infinite temporality, not as merely eternal. But Montague and Brightman had already taken this turn, as Whitehead soon did, with some hesitation and less than his usual clarity. Peirce and Bergson had hinted at it, and I as student of W. E. Hocking had accepted it.

With Wittgenstein, whom I have long read and thought about, it is hard to know what he did or did not know about the history of ideas. He saw some of the mistakes of metaphysicians but seems to have been blind to their discoveries. So he virtually defines the subject as misuse of words. This is a good description of bad metaphysics. To define so negatively a subject so

important in the entire history of ideas seems to me to beg too many questions. I call it a viciously "persuasive" definition. It completely fails to persuade me.

By definition, metaphysics is (Aristotle, Kant) the search for strictly universal and necessary truths about existence. Denials of necessary truths cannot be mere contingent falsehoods, they must be impossibilities or nonsense, "language idling." Popper first said it correctly, metaphysical truths are those which not only no actual observations falsify, they are truths no genuinely conceivable observation could falsify. One is, there are experiences. Another is, there are nonhuman experiences. Another is, God, as defined in some of the high religions, either exists necessarily or could not possibly exist. The only kind of God that could contingently exist or fail to exist is a merely finite deity which science should be able to show does not exist or could only exist in some remote solar system and has no religious significance for us.

Derrida is indeed a negativist. I gather that some at least of his group admit that deconstructionism itself needs to be deconstructed. More important, a good deal of what I and my favorite philosophers have done is a kind of deconstructing, for instance of medieval theism. So of course I do not say these people are just wrong. But I can't imagine how they could be just right. They are certainly remarkably vague, ambiguous, or inarticulate.

Is language very different from much of what language is about? Yes, but so what? Language, visual or auditory, is far from *absolutely* different from other visual or auditory phenomena. Insofar as it is similar to them there can be *iconic* meaning. This goes quite far in some ways. Having been a poet in my early years, I know how verbal music can actually simulate what it is about. Even in mathematical notation the order among symbols can partly instantiate the order of ideas they stand for. One can count symbols for numbers as easily as anything else. Icons of relations among things as well as for single things are very possible. Then there are *indexical* meanings. My daughter's first word was *doggie,* uttered by her when seeing a dog. So it is not mere language we are inside of and can't get out of, it is sensory-emotive experiences, with experiences of language one class of such experiences, plus thinking, remembering processes—and what is all this but the standard epistemological problem of mind as mirror of nature. I totally fail to see that Rorty, once my student, has shown the complete falsity or uselessness of this comparison. Of course no mirror is perfect. We have always known that. But again, so what? As often the new is not so new, or so true, as it appears to its discoverers.

Russell was the last on our list of skeptics. He was a gifted mathematician, in this a pupil of Whitehead, whom he called a "perfect teacher." Russell

may be called a great writer because of the lucidity and readability of his lan-
guage and the accuracy of his knowledge of science. I once gave a course on
his book of knowledge and found the readability and accuracy very helpful. I
read many of his books and heard him give one lecture. It all contributed to
my education. Whitehead labeled him "The most gifted Englishman alive."
Russell repaid his teacher by the help and stimulus he gave him for ten years
as they collaborated on their *Principia*. But I do not call him one of the great-
est philosophers. His skepticism was too essentially that of Hume, as Pass-
more, who does not have my prejudices, said of it. Santayana, who also did
not have my prejudices, called Russell's mind "conventional." His clarity
was achieved partly by using words exclusively in their accepted meanings.
Creative novelty is not achieved in this way. Some meanings have not yet
been put in words. As Whitehead liked to point out, the "perfect dictionary"
does not exist. Russell never made any useful criticism of Whitehead's
metaphysics (or mine, or Peirce's). He merely said Whitehead was "muddle-
headed," which elicited in return "he is simple-minded." He did once help me
on a problem in applied mathematics.

Russell's attempts to poke fun at theologies are on the level not much
above some "village atheist," and scarcely need refuting. Thus he pretended
that if the most perfect being necessarily exists, then the most perfect devil
must also exist. Obviously devilish and perfect contradict each other or make
no sense together. Language here is idling, doing no real work.

The chief function, I suggest, of skeptics, is to search for flaws in con-
structive or speculative thinking so that its mistakes or exaggerations can be
corrected. In this role Hume seems to me more efficient than Kant, who
added more mistakes of his own and not only that but was much vaguer or
more ambiguous than Hume and takes much more study to even begin to be
sure what he means. Even in his ethics Hume is helpful, and his dialogues on
religion show more awareness of the conceptual possibilities for theism than
Kant does.

With our vastly profounder physics and biology than anyone could have
in the time of either Hume or Kant, we have our own problems. In our cen-
tury we begin to see what *can* be believed with a comprehensiveness never
before approached. Even the Russian totalitarianism has broken down; Marx-
ism no longer has the force of law in the northern hemisphere, nor is much
left of the Christian inquisitions that disgraced medieval Europe and some
parts of the so-called New World. Colonialism is about finished. From now
on what we believe may perhaps be determined by truth-seeking more and
brute power-seeking less than ever before. This is the good side of our situa-
tion. The bad sides are too obvious to need naming. Kant at his greatest pre-
dicted one of them, our desperate need for peace. One of my favorite English

novelists predicted the most terrible new aspect of that problem, as a few
years later did an American Civil War general, I forget on which side. They
did not need to know physics to make the prediction. Everybody knew the
evidence they had, one only needed to just think carefully a bit to see the
point. Trouble is, most people think about the near future or about their own
personal or family problems. These two thought about the long future and
mankind's problems—indeed, life-on-this-planet's problems.

11

DREAMING ABOUT DREAMS: AN EPISTEMOLOGICAL INQUIRY

Dreaming is the life of the mind in sleep.
S. Freud

A WELL-KNOWN philosopher of our time has attacked, as a grievous error, the ordinary conviction that dreams are experiences which accompany sleep. I agree with Professor Malcolm that many philosophers have seriously misinterpreted dreams, with unfortunate consequences for their philosophy. However, the mistake does not lie in taking dreams to be mental events occurring in sleep.

Malcolm's contention (upon which his argument repeatedly depends) is that genuine dreams, by definition, belong only to deep or "full" sleep.[1] So far as there is any resemblance to waking, he holds, one is not really sleeping and hence not really dreaming: "really" to dream means to be unqualifiedly asleep. Whatever the merits of this view, it surely does not follow from our having the two words, "asleep" and "awake," plus the definition of dreams as aspects of the former condition! For we could define dreams as accompaniments of light or disturbed sleep. Also "paradoxical deep sleep." Or, we could define them as psychical aspects of being partially, but not fully, awake. This would no more beg the question than Malcolm's definition. The only neutral formula would be "accompaniments of sleep, perhaps light, perhaps deep, perhaps not quite either."

The Cornell philosopher's decidedly original doctrine is that dreams, though not identical with the "impression," upon awaking, of "having dreamt," are yet "not logically independent" of this impression, and hence are not mental events or experiences, or any kind of happenings in physical time, occurring in sleep. Also, since dreams are logically dependent upon the waking impression of having had them, there can be no merely forgotten dreams,

1. Norman Malcolm, *Dreaming* (London, New York: Routledge & Paul; Humanities Press, 1962), pp. 39–40, 46, 63.

nor can the memory or impression be mistaken as to the contents of the dreams. The author, doubtless partly to soften the paradoxical nature of this conclusion, speaks not of "memory" but of the "impression of having dreamt." Still, what else if not memory is an impression of having experienced (or of having had or done) something? Besides, "infallible impression" is as dubious as infallible memory.

To be sure, as Malcolm points out, if I have the impression I am in pain, then I am in pain. But do we always notice the fact when we feel pain, especially slight pain, and supposing we are at the time keenly interested in something else? Moreover, "in pain" is a very crude description of any experience. The phrase covers endless nuances and degrees, diverse locations in phenomenal space, and so forth. Since our actual impressions of dreams indicate something much more specific than merely having been dreaming, it seems impossible that they should infallibly exhaust the contents of the dreams.

Part of Malcolm's argument is that the impression is the only evidence we can have for the dream. Hence the impression is incorrigible, infallible. Yet I dare to affirm that an infallible human impression, translatable into detailed descriptive words without loss or addition, is an absurdity. And if there is loss or addition in the verbal report of the dream impression, then is not this impression in the same case as the dream? Will it not be what, afterwards, we say or think that it was? For how much independent evidence is there for it, more than for dreams? Even supposing there is somewhat better evidence, this is a relative difference, and Malcolm is talking in absolutes, not in terms of more and less.

Of course our author cannot deny that the language we use for describing dreaming constantly suggests a succession of past mental events. As he says, a report upon a dream typically has the form of telling a story, narrating a sequence of acts and occurrences. However, he tries to explain this by saying that ordinary language, normally concerned with events and actions, is all we have to use in referring to dreams. This is also why we talk of feeling, thinking, and so forth, while dreaming. But why does the language seem so very appropriate that small children, primitive people, and probably all of us at times may have to go to some trouble to be sure that the dream occurrences were not actual ones in the public world? We have no sense, I think, that we are forcing language when we speak of succession with reference to dreams. "First" the leopard (large catlike animal) was (or seemed to be) at some distance. "Then" he came closer and leapt toward me—"whereupon" I woke up. This describes a sequence in a dream of my own as a boy. And if the dream sequence is, as we all feel, in the past, but yet "not in physical time," in what time is it? Merely private, psychological time? But this seems to be correlated with physical time, for the dream is past to the physical act of relating it.

In quite a few of my own dreams I argue with a philosophical opponent, or explain my doctrines to a listener. Upon waking, I sometimes find that I have used essentially the same sort of reasoning as I would when awake (not much worse, and, alas, no better). Am I to concede to Malcolm that so far from having, as I seem to remember, introduced words, one after another, in argumentative, and by my standards, mostly logical order, in short, having gone through thinking processes, I was really not "doing" anything which occupied time, or involved succession?

In dreams, we are told, one neither judges nor believes, one does not think, feel, or sense. Well, some of us at least do. Thus I have repeatedly dreamt that I was having trouble going to sleep, and upon awaking, realized that I had actually been asleep and that the "insomnia" was merely a state of light and troubled sleep infected with somewhat anxious and unpleasant dreams of insomnia. If this was not a case of falsely *believing* that I was awake but trying to go to sleep, I cannot imagine what it was. And when Malcolm says that one who is really frightened or feeling fear cannot be fully asleep, and so cannot be dreaming, he is putting his conclusion into his own peculiar or extreme definition. One must admire the daring of this author as he tries to convince mankind that it suffers, not at all in its night-mares, but only in its "impressions" of having had them. (That these impressions may cause much additional suffering, especially in children, must be granted.)

Let us consider behavioristically the twilight zone between deep sleep and waking life. When fully awake, we respond constantly to stimuli, especially external stimuli; we adjust our eyes, turn our heads to see or hear better, balance ourselves, take up more appropriate positions to fit changes around us, and so forth. In deep sleep, on the contrary, it is as though there were no external environment, or at least no changes in it; also, there is apparently no response to internal conditions. If there is pain, or the physical basis of pain, it causes no groans; if we are exposed to the cold, we simply lie exposed without effort to remedy the situation. Only the movements of the heart and lungs, and perhaps a few other muscular functions, proceed somewhat as usual. As for sleepwalking, I have not in any way experienced or studied it and neither, if I recall correctly, has Malcolm.

The intermediate zone is of course characterized neither by sheer nonre-sponse, nor by normally alert and energetic response, to stimuli, but by mini-mal, mild, inadequate response, or perhaps violent response channeled more narrowly than when awake, such as shouting with eyes closed. An asthmatic patient gasps for lack of breath, the poorly covered person shrinks farther down under his blankets or pulls them up, or if too warm pushes them away, there are probably slight eye movements, perhaps turning over in bed, and so on. How does this intermediate physical state correspond with dreams as we recall them? Far better than most philosophers seem to realize. (Bergson is an

exception to this state of innocence.)[2] Pervasive in dreams is the more or less obvious presence of material traceable to sensory stimulation, external or internal, playing upon the subject at the time of dreaming. The asthmatic patient has the sensations of suffocation in the dream which he relates shortly after the physical state is observed from without; the sleeper with light flashed upon his eyelids says just afterward he dreamt of light; the sound of the alarm clock, more or less fancifully interpreted, appears in the dream of the one it awakens; distended bladders produce dreams of looking for a toilet (and usually not finding it); sexual excitation is woven into the pattern, the insufficiently covered sleeper dreams of cold, the physically real sound of thunder has its dream version, and so on and so on. The list, I venture to assert, is as long as that of possible sensations. Itching is definitely included. I once dreamt of an itchy swelling on a leg which I wanted to scratch, or thought I did scratch, I forget which. On awaking I looked at the leg and there was a bite or pimple, plainly swollen and itchy. I have also dreamt of an electric fan (I "saw" it) making a loud humming; the dream stopped just there, and I was awake listening to an airplane overhead. The noise was the same, according to my memory.

We should bear in mind, too, that always we are lying or sitting, so that tactual and pressure sensations must be physically present, especially considering that we constantly change position slightly through breathing. Bergson beautifully shows how the sense of the reclining position upon a soft bed can produce the illusion of levitation. We are not actually floating on air, but the sensations are much as they would be were we doing so. As Bergson also notes, having eyes closed does not end experiences of light and color. And how seldom is there total absence of sounds of audible magnitude when we sleep? At least, there is the noise of our breathing. Nor does absence of air waves mean total lapse of auditory stimuli. Faint "ringings" may persist, internally induced.

I suspect there is in sleep one more source of sensory stimulation, that when little energy is going into most of the normal channels, there may be a sort of cortically initiated innervation of the sensory areas. I know for sheer fact that one can (I did when young) experience intense, organized, often beautiful, rapidly changing colors and color patterns with eyes closed while awake. Either these are mere "sense data," mere mental facts or "contents of awareness," or they have also physical reality, and this reality is identifiable only if it be neural activity somewhere, in the brain or outside it. If this can happen when awake, why not in sleep? The waking experiences in question are somewhat influenced by one's thoughts, wishes, or fears, and hence simi-

2. See Henri Bergson, *L'Energie spirituelle,* essay 4, "Le reve;" English version, *Dreams,* trans. E. E. Slosson (London, 1914).

lar ones may in sleep be more or less controlled by the emotional or ideational content of the dream.

The conclusion emerges: We have every reason to regard dreams as, like all other experiences, responses to sensory stimuli occurring at the time (or immediately before it). The bland assumption of so many philosophers that this is not the case is baseless, when looked at coldly in the light of evidence. Dreams, whatever else they may be, are interpretable as *elaborations of sensory materials supplied by the de facto bodily processes;* they are not mere mental inventions or mere memory echoes. The difference between waking and dreaming experiences must consist in something subtler or more complex than the absolute gulf between response to stimuli and total nonresponse. This is what the presumptively intermediate status of dreaming should have led us to suspect all along.

Malcolm is aware that stimuli may intrude into experiences associated with sleep—he instances thunder—but he declares that when and insofar as this happens one is not really asleep and so is not really dreaming! He fails to note that on this basis there can be no proof that "dreaming" ever occurs at all, so that, for all he knows, he has defined "dreams" as a null class! Why not argue that there can be no experiences associated with sickness, because insofar as the supposed experiences, including their sensory and behavioristic aspects, had any resemblance to those of the well state one would not be "really" or "fully" sick. Hence "experience" as in (absolute) sickness and as in perfect health can have nothing in common! And of course, if one is completely sick one is presumably dead, and then too there is no experience. Just so, I suspect, does one's own, not one's cells', awareness lapse in deep sleep.

If all experiences, including dreams, are in part sensorially stimulated, equally all are in part mnemonic. (Cf., once more, Bergson's essay.) Over and over one can trace a connection between the subject matter of a dream and something which was experienced the evening before, a play seen, book read, conversation engaged in, task worked at, or thought entertained. But these elements of memory supply the meaning of the sensory material, and not, I think, unless indirectly (through the cortical innervation spoken of), the material itself. For instance, they enable the material to mean a certain person, or a tiger, or what not. We know from waking perception how much besides mere sensory qualities is involved in the recognition of objects. Experience is more than sensation, and dreams exhibit this almost as plainly as waking experience.

If dreams are experiences accompanying light or somewhat disturbed sleep, it follows from the definition of sleep that the expressions of such experiences in overt behavior are usually minimal. Accordingly, the publicly observable evidences for the occurrence of dreams, and for their particular characters in each case, will be severely restricted. This is part of what

"dreaming" means, a "withdrawn" experience, a transaction between the individual and his or her bodily state and past experience, not between him or her and other individuals localized outside him- or herself. Is it reasonable to try to turn this withdrawnness and consequent poverty of external positive evidence into evidence *against* the occurrence of dreams as experiences, as mental events?

The argument seems to be: where we have only the testimony by the subject himself, there we have no testimony at all. But must memory by itself, in the isolated case, be either worthless or infallible as evidence of past events? And if a single memory establishes no probability, I fail to see how any number of memories, in no matter how many individuals agreeing among themselves, can establish any higher probability. Multiplying zeros gives no positive product. The proper axiom ought to be, "a conviction of remembering always establishes something," just what it establishes depending upon many factors. The burden of proof is not in principle upon the one who says he remembers, but upon him who denies that at least something like the remembered event took place. On any other assumption life could not go on, so far as I can see.

However, is it correct that we have only the subject's memory of the dream experience? There are physiological signs of dreaming. Malcolm asks, how do we know them to be signs of dreaming, unless we know that the dreaming, as a sequence of experiences, does occur? How indeed? But if, as I maintain, conscious memory is already a degree of knowledge, then we do know that dream experiences occur, for we remember them. Furthermore, this claim to knowledge accords beautifully with what behavioristic and public evidence there is. That the evidence is restricted follows from the definition of dreaming as belonging to a withdrawn, inactive sort of response to the internal-external situation. Nevertheless, whatever evidence the hypothesis calls for seems to be abundantly available. There are characteristic brain waves, slight movements (at least of the eyes), there are publicly observable stimuli recognizably identical with features of the dream. Everything is in order, except that a withdrawn experience is withdrawn, i.e., manifested much less plainly than other experiences through overt signs. In short, everything is in order. Nothing conflicts with the hypothesis.

Does the hypothesis "do any work," explain anything? Certainly. It explains, at least, the occurrence of the memories of the dream experience, the "impressions" of having undergone them. Malcolm forbids us to inquire into the causes or reasons for these impressions, invoking Wittgenstein's saying that we must "know where to stop" (asking for explanations). True enough. But is this particular place a good one at which to stop? On the contrary, by the very meaning of the word, "impressions" occur only if some-

thing impresses us; and we have every right to ask *what* impresses us. Memories, and that is what *these* "impressions" seem to be, occur if there is something to remember, and those who deny this can never tell us why we should trust memory at all. Events are caused by previous events, and the most likely events to explain the events of remembering dream experiences are the previous occurrences of these experiences.

The greatly overrated "mistakes of memory" mostly concern mistakes of verbalized recollection, and usually recollection after long intervals, at that. In such cases we are dealing with memories of memories of memories, with elements of verbalization and fantasy added each time the memory is reactivated, some of these elements being later misidentified as belonging to the original event. But memory of dreams may be virtually direct and immediate, the most reliable kind of memory. If I begin the word "tintinnabulation," am I likely to forget, when halfway through, what word I started to say? Yet it is provable that time enough will have elapsed for memory to be involved. Challenge the approximate validity of such short-run memories, and I at least see nothing but sheer skepticism as the logical outcome. By the time one can use the testimony of others, or the records of instruments, these too will be memories for oneself—or nothing. In short I think Malcolm is in this essay by implication a nihilist, and since I suspect Wittgenstein of being dangerously close to nihilism, I take a somewhat malicious interest in the former's evident conviction that he is working in the latter's spirit.

The admission of dream experiences also explains, among many other facts, the great emotional effect which they have, especially upon small children who are not able to dismiss them easily as mere dreams. An impression of having been terrified, which shows its reality by powerful continued effects to terror, is most readily explained by the simple assumption that one has in fact been terrified, not solely in the moment of impression but a short time previously.

It is contended that one can never reasonably say, "I am asleep," hence there can be no evidence of experience in sleep. However, the verbalized judgment, within a dream, that one "is asleep," must at most be an extreme limiting case. For in dreaming we are floating with experience, not criticizing or classifying it. Besides, the withdrawnness of sleeping, its self-sufficiency, implies that it would be unlikely to compare itself to the contrasting state. (Awake we often compare this state with dreaming, in spite of Malcolm's contention, paradoxical even for him, that we do not. "Thank goodness I am awake, and out of that nasty dream!" is only one example.) "Judging," in the explicit verbal sense, that one is asleep is not the most probable type of "mental act" to be expected in dreams. Yet something close to it can occur. Occasionally one has a feeling in dreams which one expresses afterward by saying

"I knew I was asleep," or "was not awake," or "was dreaming," or in subtler ways. Thus once recently I seemed to be looking down at a large map of the Mexican west coast. As I "looked," the map "became" the ocean, far below me, with tiny waves visible, as one sometimes sees them from mountains or airplanes. And it seemed that I was moving over this ocean. However, I felt that this was *not* the real situation, and that I could banish the whole scene by making an effort to rouse myself. But since the experience was pleasant, and there was no great motive to terminate it, I failed to make the effort. The dream soon ended by itself. I should say that there was here something like a "judgment," or at least a suspicion, that I was asleep. If it be asked, "what is the evidence that the judgment did occur in sleep, and that it was true?" I reply, about all the evidence there needs to be. My memory was clear upon awaking; the experience I remembered could not have been, as it seemed to me to be, that of an ocean far beneath me; hence it was a dream. And the feeling of unreality was part of the dream as remembered.

Malcolm tries to support his view that dreams are not in physical time by showing the wide differences in estimates of dream length. Dreams probably differ greatly in actual length; and in all measuring errors can easily be made, especially in early stages of the investigation of a problem. However, our author subtly argues, it is meaningless to say that there is a proportional relation between the eye-movement period and the real length of the dream, for either the real length simply is the eye-movement period, and then there is no proportional relation, or there is no criterion for the dream length. But there is—the subject's memory which, as Dement and Kleitman found, agrees remarkably with the other test. An agreement of this sort certainly proves something, or the probability of something, and Malcolm leaves it "in the air" what this something might be. Science does not flourish by ignoring such signs of relatedness. If one can predict the subjective estimate from the physical observations and vice versa, then the estimate is genuine knowledge, or will become so when we understand it properly. Nor is it sound to say that either the objective or the subjective criterion must simply determine the length, and so neither can correct the other. All verbalized judgments are more or less open to criticism, and no criterion as humanly applied is foolproof. If the subjective report is memory, it is only a relative criterion; there is no psychological clock whose strict accuracy is established. Yet there is a psychological clock of sorts, as is easily proved. Also, very complex dream sequences must take longer than simple ones, for there is a limit to the number of successive items we can deal with per second. Finally, eye movements are only the most manifest of physical accompaniments of dreaming, which must be supplemented by more subtle ones if the exact length of the dream on its physiological side is to be estimated. At least, there are also brain waves to consider.

There is one more argument, to me a most important one, against our author's view. For a theist, such as (if I am not mistaken) Malcolm is, it will not do, I submit, to say that the "logical independence" of the dream from the impression of having dreamt it, is meaningless (since we know the one only through the other). For, obviously, if *d* is independent of *id,* at least God can know both and how *id* differs from *d* and can know that many dreams are not consciously recalled at all. Malcolm might say that this is irrelevant, since we human beings must be able to know what we are talking about in referring to both the dream and the impression of it as objects of God's awareness. True enough, and we can know this. For part of the human meaning of "impression" or "memory" is that its object is logically distinct from, and in some sense independent, as cause is from effect, or earlier from later, and part of the human meaning of "God" is that its referent can discern many differences and similarities imperceptible to us.

Putting these two considerations together, I fail to see any legitimate demand for meaning which, at least on a theistic view of the status of dreaming, is not met by our theory. And why should a theist accede to Wittgenstein's dogmatic veto upon the introduction of the idea of deity into this, or various other, philosophical contexts? It follows from any definition of God worthy to be taken seriously that the topic is relevant to any context whatever. Indeed, it already defines God to say that the deity, alone of all beings, is always and everywhere relevant. To suppose that this or that must make complete sense in abstraction from deity, or that only some special "religious" form of experience, or some one special type of problem, points to God for its full intelligibility, is a gratuitous gift to nonbelievers. It would furnish the premise for a very strong disproof of theism. I, for one, repudiate such a premise. I hold that nothing quite makes sense when combined with the denial of God's existence. Show me such a thing, and I will abandon theism.

I conclude that Malcolm has proved *nothing* against the view that dreams are special types of experiences, or mental events, occurring during (some stages of) sleep, though he has exhibited admirable ingenuity in playing the role of devil's advocate. Posterity may well thank him for doing this so well that the task will probably not need to be undertaken again.

What is the philosophical moral? I think there is a moral concerning method. The genius of Wittgenstein consisted, in part at least, in proposing a somewhat novel intellectual experiment, that of placing very severe requirements of public meaning upon all words. As compared to the opposite extreme, to the notion of merely private meanings with no public import, his experiment may well have yielded impressive positive results. In some sense probably all language must be public. But it remains to show that Wittgenstein has succeeded in finding the right balance between the most

public and the at least *relatively* private aspects of experience (relatively private, except to God) which are nevertheless to some extent expressible through language.

It is also to be borne in mind that a great experiment may turn out negatively, by establishing something rather different from what its designer has hoped to show. The awe which surrounds this particular genius ought not to inhibit us from considering the possibility that what Wittgenstein's inquiries really indicate was, to some extent, not what he had in mind. Perhaps in some aspects they constitute a *reductio ad absurdum* of the ultrasevere criterion of publicity he employed. And perhaps, too, they show that there are functions of the divine intuition that we would be almost megalomaniacal to try either to usurp or to do without supposing. Dreams cannot be any secret to God, and He/She surely need not wait for the subject's waking report. I take Wittgenstein as, among other things, one of a number of great men who should help us to see just how high the price of renouncing the theistic explanation of the world may really be. Or rather, they may help us to see part of the price. For I am convinced the full price is beyond measure, and could not really and literally be paid. (We only imagine we deny God.) For a theist, all meaning and all fact is completely public in the sense of completely transparent to One "to whom all hearts are open." Deny this, and paradox lies ready for us in every direction. The greatest skeptics are those who, like Hume, come closest to admitting this.

I cannot refrain from commenting on the lamentable fact that the treatment of dreams by the man of genius among philosophers who has most carefully considered the phenomena themselves, the essay by Bergson, is left unmentioned in Malcolm's book. He told me he had not read it. I do not share the implicit view of some current writers that all relevant recent philosophizing has been done in England—or New England.

A mistaken view of dreams has misled philosophy over and over again. Descartes and many another has argued that since in dreams there are mental events without any real objects other than the events themselves, even waking experiences might also lack objects, be merely more orderly forms of dreaming. Malcolm would short-circuit this skeptical argument by denying the mental events, and inferring that waking experiences, which are such events, cannot have any analogy to dreams. I sympathize entirely with the motive of cutting short the skeptical inference. But there is another and less paradoxical mode of attack, and this is to deny the premise that the mental events in sleep are without real objects. They have such objects, consisting first of certain physical (but not mindless) processes in the sensory nervous system, and second of remembered mental events in the personal past.

Dreams are then no different from waking experiences in having the two poles: a real physical basis in sensory stimulation and a real psychical basis in

past experience. Thus the problem of getting from supposed mere (or solip-sistic) mental states in the present to something else is a pseudoproblem. There *are no mere mental states*—the real difficulty is to understand how the fragmentary physical and past psychical realities, some or other of which are always *given,* can be correctly interpreted by waking (though not by sleeping) experience as fragments of the total environment, which as a whole is never given (at least with effective distinctness). In sleep, the means of arriving at such an organized and correct picture of the situation are lacking. Indeed, in sleeping experiences, accuracy or truth is scarcely even an aim. The interest is rather in the intrinsic sensory and emotional values of the experiences them-selves, plus, as Freud says, the maintenance of the state of sleep against some disturbing factor. While dreaming we live through combinations of physical and mnemonic material for the sake of the interesting or comforting experi-ences which result. Awake we may do this, too, and "daydreaming" is an appropriate phrase; but the aspect of critical adjustment to the material, with the aim of meeting the environmental challenge is less completely sub-merged. As Bergson says, while awake we "concentrate" our memories, focusing them upon the messages from without in order to elicit those which are most relevant to the problems of adaptive behavior. Even in hallucinations we are experiencing actual physical events within the body. Only the interpre-tive elaboration goes astray. In dreams, the contact with reality is enjoyed or suffered, in conjunction with whatever interpretation makes an interesting or reassuring experience; it is not used, and for good reasons cannot successfully be used, to disclose to us our external situations as a whole. Natural selection sees to it that waking experiences can and generally do for ordinary purposes disclose this; but sleeping experiences have no such biological obligations. They only need to promote our rest, or disclose our least conscious wishes, in preparation for more effective action when we awake.

It is high time that philosophers realized the groundlessness of the famous argument for radical skepticism, that for all we can know waking experiences may, "like dreams," have no data other than themselves. Dreams are experiences of the actual world; but distorted, loosely organized, fleeting, uncritical, or vague experiences, not energetically seeking, nor advantageous-ly placed to arrive at, a realistic account of that world. Waking life also is experience of the actual world, while one is more or less energetically seek-ing, and more or less well placed to arrive at, such an account.

The skeptic will say, "how do you know all this?" The answer is, "by comparing it with alternative accounts of waking and sleeping experiences, and noting which account yields harmony of ideas and ideals, besides surviv-ing confrontation with all aspects of experience, compared to accounts which, on the contrary, fail to accomplish these ends of thinking." Does either the Cartesian theory of possibly objectless mental events during sleep, or the

Malcolm-Wittgenstein theory of no mental events during sleep, exhibit such harmony and survival? Or are these advantages found in the Bergsonian theory that all dream experience has materials from prior mental and bodily reality, relaxed from critical concentration and adaptive control during sleep, and more or less tensed for such control in waking experience? For me the answer is not difficult.

12

BEYOND ENLIGHTENED SELF-INTEREST: THE ILLUSIONS OF EGOISM

THE world, according to common sense, consists of a great many individual things and persons, each individual (in some sense) identical through change but losing some qualities from time to time and acquiring others. This view has obvious truth, but it easily misleads in serious ways. Consider the human species. At a given time it consists of a number of persons, each the same person from birth to death. At every moment I am Charles Hartshorne, and John Smith is John Smith. Never since my baptism have I been anyone other than Charles Hartshorne, and never since his christening has John Smith been anyone other than John Smith. That each of us is always the same human individual is true; but that each of us is always simply the same thing, the same *reality,* is false. We are identical through life as human individuals, but we are not identical as concrete actualities. The identity is somewhat abstract, the nonidentity is concrete. Without this distinction the language of self-identity is a conceptual trap. Into this trap have fallen most philosophers. Of all the great traditions, only Buddhism has almost entirely escaped the error. However, Buddhists have tended to be intuitionistic or anti-intellectual and so have failed to develop conceptual devices altogether adequate to their insight. (In addition they have assumed reincarnation.)

Personal identity is a partial, not complete identity; it is an abstract aspect of life, not life in its concreteness. Concretely each of us is a numerically new reality a number of times per second. Think of the difference between a newborn infant and an adult person; also, of that between an adult and a senile octogenarian. These differences are not slight. The infant is only potentially a "rational animal"; actually it has no rational thoughts. A senile person may also have scarcely any.

Another difference is that between a person in dreamless sleep and the person dreaming; also between the dreamer and the person awake. In addition there may be aphasia, loss of any clear sense of one's past history, delirium, insanity, intoxication, weird drugged states, multiple personality. Personal "identity" must span all these differences. We say that at some moments a person is "not himself." The New Testament speaks of being "born anew." Personal identity as many philosophers construe it leaves out all that these expressions report. To abstract from such vast contrasts and say that from birth to death the person is one and the same entity is to emphasize the abstract or the potential at the expense of the concreteness or actuality of life. This one-sided emphasis has momentous consequences.

Let us be clear on one point. I am not disputing that there is a definite sense in which each human individual is distinguishable from any other. A person's bodily career is (fairly) continuous in space-time. People could have been observing me from birth on and would have seen no (notable) gap in my physical development and persistence from infant to adult; from middle age to elderliness. Also there have been scarcely any abrupt changes in my habits, my personal style. But this physical continuity is an abstract feature of one's existence. It allows very radical changes in quality from a nearly mindless infant with incomplete brain cells to full maturity, thousands of transitions from dreamless and apparently *mindless* sleep to being wide awake, from irritated or furiously angry states to happy or benevolent ones, and so on.

Consider, too, that many minute portions of one's body were once parts of the environment, and vice versa. So far as these portions are concerned, spatiotemporal continuity connects one not with oneself in the past or future so much as with the environment, that is, other individual beings, in the past or future.

Forget about the bodily continuity, and think instead about the mental one. Of my thoughts or bits of knowledge, many go back to thought or knowledge not my own, and some will in the future become part of the thought or knowledge of others. If I am influenced now by what I have been in the past, I am as genuinely influenced by what others have been in the past. If I can plan now to bring about results in my future bodily and spiritual career, so can I plan to bring them about in the future bodily and spiritual careers of others. Where, in all this, is there any absolute distinction between relation to self through time and relation to others—apart from the abstract physical distinction already granted?

If we forget how relative, partial, or abstract, as well as *primarily bodily,* personal identity is, we pay serious penalties in our interpretation of fundamental issues. For instance, it then seems natural to adopt a self-interest theory of motivation. I am I, you are you, neither of us is the other. If I care about my future, it is because it is mine; so runs the thought: but if I care

about your future this must be because that future, or what I do for it, will benefit my own. *My* future advantage is then the end, while contributing to your advantage is but a means. For over seventy years I have rejected this view, and my original reasons still seem valid, though they have become enlarged and fortified. I think the view is bad psychology, bad biology, and bad ethics and metaphysics. It also contradicts the imperative of all the higher religions that one should love the other *as oneself.* If loving the self is a sheer identity relation and loving the other a sheer nonidentity relation, then one can never do anything like loving the other "as oneself"; for on the hypothesis this is a metaphysical or logical impossibility.

My position, since 1918, but rendered much clearer by exposure, first to Hume, James, Peirce, and Whitehead, and then to the Buddhists, has been that self-love and love of others are alike, both being relations of *partial, not complete,* identity or nonidentity. This view is to some extent recognized in common speech but usually denied in philosophical and theological doctrines in the West, with of course some notable exceptions. The exceptions include post-Kantian idealism, Marxism, and the doctrine of Saint Paul in his saying, "We are members one of another"—an epigram closer to the truth of this matter, in my opinion, than anything to be found in Aquinas or Kant, not to speak of Hobbes or Bishop Paley. But none of the writers mentioned does full justice to the degree of nonidentity abstracted from by the commonsense notion of the "same" individual. Only in Whitehead (most nearly anticipated by Peirce) does the West, after more than two millennia, come to meet the Buddhists on the question of selfhood and motivation.[1]

In common speech occur such remarks as that we "identify ourselves with" a friend, or with offspring, or fellow advocates of a common cause. We have the expression "alter ego" for such cases, or "better half" for a spouse. But where are the absolute limits of these qualifications of self-interest? I take the qualifications to show that the really basic principle of motivation is not regard for the future of one's own bodily and mental career. This regard is merely a principal derivative of the truly basic principle, of which regard for the future of other organisms or careers is another derivative.

The basic principle is the appeal of life for life, of feeling for feeling, experience for experience, consciousness for consciousness—and potential enjoyment for actual enjoyment. One's own future is interesting, appealing, motivating. Why? Because it is the future of a sentient and conscious

1. A. N. Whitehead, *Adventures of Ideas* (New York: Macmillan Co., 1929), chap. 20, secs. 1–8; *Process and Reality* (New York: Macmillian Co., 1929), chap. 2, sec. 2; also Charles Hartshorne, Paul Weiss, and Arthur W. Burks, eds., *The Collected Papers of Charles Sanders Peirce* (Cambridge, Mass.: Harvard University Press, 1931, 1958), 1:673, 8:82.

career—and present experience more or less vividly and sympathetically anticipates this future. If we find means to be as aware of the prospects of others as of our own, then we may take a similar interest in their prospects. The interest may or may not be very sympathetic, it may even be more or less sadistic. But this is because of some lack of harmony between the career of the other, as we envisage it, and our own present currents of thought or feeling. It is not because the abstract thread of individual identity leads only to one's own past or future rather than to the others' past or future. The grounds of antipathy, as of sympathy, are much more concrete. And parallel to sadism is masochism. The difference is relative.

1. The first illusion of egoism, then, is the notion that motivation depends basically upon the mere spatiotemporal continuity of organic careers. True enough, it is normally the case that we are more vividly and steadily aware of and sympathetic to our own future prospects than to those of others. But this difference of degree provides no reason to make an absolute of self-interest as compared with interest in others.

To value oneself *rationally* is to value oneself for the same reasons, and by the same criteria, as are used in valuing others. In short, "love others as oneself" is a command of reason, not just a requirement or gift of grace. We should not give the prestige of reason to the fact that every animal tends to feel its own weal and woe more vividly and steadily than the weal or woe of any other animal. To use reason (and it requires reason) to extend self-interest to include one's own entire future, but not to use it to extend interest in others so as to include in principle their entire futures, seems misuse of the power to generalize, to seek truth and value wherever they may be, and as "there" for any impartial spectator. Reason should universalize our ends as well as our means. The value of one's own life is more in one's power than is that of other lives; one can understand it more easily, and so it is normally one's greatest *single* responsibility. But there are times, as when one is close to death, when one may be able to do much more for another or many others than for oneself.

Mortimer Adler eloquently urges that we should have as our concern the goodness of our own lives as entire careers and, only as derivative from this concern, care about the future of others. But why should I now care infinitely for my life or career as a whole? Adler admits that this whole will never be experienced, possessed, or enjoyed by me. I have glimpses of it, and so do my acquaintances. But none of us will ever really possess it.[2] Why then is it so important? I agree that it is important, but for the same reason that makes anyone else's life important, not just to him or her but to any rational specta-

2. M. J. Adler, *The Time of Our Lives: The Ethics of Common Sense* (New York: Holt, Rinehart and Winston, 1970).

tor. It is not my entire life's goodness that I have to have right now, but only the satisfaction of having a rational aim right now. The reward of virtue, which, as Spinoza said, is in virtuous action itself, is not the whole of happiness, but it is the only reward that one needs to take as absolutely essential. For a rational being it is the pearl of great price. The rest is additional good fortune to be utilized by practical wisdom.

Like Adler, though in an interestingly different way, Michael Scriven derives the motive for good conduct from rational concern for one's own career. Both writers show some realization of the limitations of the Project, but neither seems to see clearly that ethics has a deeper and more rational ground elsewhere.[3]

There is of course partial agreement between the aim at future well-being for oneself and the aim at the good of others. But the value of knowing this is to weaken the force of man's natural though relative self-centeredness, not to enthrone this animal limitation as the voice of reason. A great deal of self-interested action is self-defeating, and there are often great rewards for bringing genuine good to others. I do not envy anyone the benefits he or she gets from selfishness. On the other hand, I cannot see any need to make the future rewards to self for now acting upon a rational aim *the* reason for having this aim or acting upon it. Nor can I see that giving self-interest an absolute priority is in any good sense rational.

The lower animals, which I have been studying most of my life in one way or another, are not merely selfish but selfish and altruistic, both of course in the same largely instinctive or genetically determined fashion. (What they cannot do is to generalize either self-interest or altruism; for they cannot symbolize abstract ideas, they cannot deal with the absent or potential as definitely as with the given situation.) The basic instincts are to keep the species going; the individual's preservation is subordinate. A male spider may risk his life in courting the female, but in running this risk he serves the species.

2. The primary egoistic illusion about motivation tends to associate itself with another, which is the unexpressed but felt anticipation of living virtually forever. That one is mortal is known, but not genuinely realized and acted upon. What matters is thought to be one's own future. But which future? One's life prior to death? Or one's future altogether? Our ultimate destiny, so far as we know it, is to be—or rather for our bodies to be—heaps of dust. What then will it matter *to us* that we have, perhaps, been happy—or unhappy? *For us* there will then be no such truth. But we put this out of our minds almost completely, and face things as though we would always be

3. Michael Scriven, *Primary Philosophy* (New York: McGraw-Hill Book Co., 1966), pp. 229–301, esp. 250–72. For Adler's qualifications to the self-interest thesis see *The Time of Our Lives,* pp. 4, 6, 13, 15, 173–74.

there to reap any harvest we may sow. This, I hold, is an illusion, and one of the commonest. St. Exupéry wrote that, of the many persons he had seen facing their own imminent death, not one thought primarily of him (or her?) self. If we lived in the full light of the truth, this would be our attitude all along.

The future that matters is not our own future as such, but rather any future we can influence, sympathize with, and in some degree understand as good or bad *for someone*. To serve this future can be our present aim, whether or not the good we do to the other will also be our own future good. It is our good, right now, to promote what we care about for the future, whether it be a child's welfare, even a pet animal's, or our country's, or mankind's—and one could go further still. Other things being equal, one prefers that persons, even animals, should be happy, not only while one can share in their happiness but afterward as well. Anyone of whom this is not true is to that extent a subnormal or irrational human being, and may be a sick one as well.

So, far from our valuing others only for their usefulness to ourselves it is in no small part for our usefulness to others that we value ourselves. Convince yourself that you are no good to anyone, and how much will you love, rather than hate and despise, yourself?

There is a great Buddhist passage that goes something like this. "You say, 'He injured me, he insulted me, how terrible!' " "But," the writer goes on, "this is writhing in delusion." Why so? It is writhing because it is unhappy. It is delusion, first, because the self that insulted you has been partly superseded by a new concrete actuality, the other person-now, which may be indefinitely different from the insulting self. It is delusion, second, because the insulted self has also been superseded. There is incomplete identity on both sides. But third, there is only incomplete nonidentity between the two persons. The other's past has entered into your present being, your past into his or hers, and both share a partly overlapping causal future. Each helps to create a new self in the other and will influence some of the same future selves. Finally, fourth, both you and the other, as individual animals, are passing phenomena, the continuation of whose careers is not strictly guaranteed much beyond the present moment.

The angry person may react like a badly treated animal, using reason only to articulate the animal's lack of perspective rather than to overcome it. This is a misuse of reason. The human power of abstraction and generalization is ill employed if it merely generalizes the means and leaves the end the same, or if it merely generalizes the self-protective aspect of instinct and not the species-serving aspect. The rational aim is the future good that we can help to bring about and take an interest in now, whether or not it will do us good in the future and whether or not we shall be there to share in the good. We share in it now, and that is all that present motivation

requires. It is a luxury, not a necessity, if we can hope to have a future share in the good we make possible for others. Moses did not need to enter into the promised land.

3. A third illusion generated by overemphasis upon self-identity is the misconception of the meaning of death and the real problem of immortality. Thinking in terms of self-identity we seem to face the stark alternative; eventually "I" become nothing at all, or—what seems virtually the same in value terms—a heap of dust, or I survive death in some heaven or hell, or in some new animal body in which I have further experiences of a scarcely imaginable kind and for even the bare possibility of which I have no clear understanding or evidence. Thinking in terms of concrete momentary states of experience, the alternative is quite different. Concretely I am not a mere self, the same through change, but (as Whitehead says) a "society" or sequence of experiences, each inheriting its predecessors, so far as memory obtains. But our human memory is very selective and for the most part highly indistinct or faint. Thus, shortly before death, even though we are fully conscious, the wealth of experiences we have already enjoyed is almost entirely lost to US. Death is merely the definitive form of a lack of permanence which pervades our entire lives.

The basic question of "transience," as Whitehead profoundly and perspicaciously insists, is not what happens to our identity at death but what happens at every moment to what we were the previous moment. Or as atheist Santayana put it, every moment "celebrates the obsequies of its predecessors." Santayana saw also, though not so clearly as the Buddhists or Whitehead, that the concept of substance, at least in the form of individual identity, is not the illuminating one at this point.[4] The concrete permanence, if there be one, must be something very different from self-identity as we human beings have it. For that is, at best, an extremely partial preservation of the actual quality of life.

If death means that the careers we have had become nothing, or a heap of dust, what is history about, or biography? And what is autobiography, if the past experiences and actions are now reduced to mere faint and partial recollections and a few records, photographs, and the like? On this hypothesis, the very idea of truth grows problematic. Thus the great doctrine of the "immortality of the past," found in Bergson, Peirce, Montague, Whitehead, and some others, is an answer not simply to the frustration we tend to feel in thinking about death and the mutability of all individuals, but to the puzzle of historical truth, the most concrete and inclusive form of truth.

4. George Santayana, *The Life of Reason,* one-volume edition (New York: Charles Scribner's Sons, 1953), 5, chap. 8. pp. 462–63.

My personal view is that the complete rational aim is the service of God, whose future alone is endless and who alone fully appropriates and adequately appreciates our ephemeral good. What some term "social immortality" is literal immortality only so far as God is the social being who is neighbor to us all, is exempt from death, and able to love all equally adequately. Deity is the definitive "posterity."

The egoist, I have been arguing, subordinates the concrete to the abstract, the whole to the part, the really inclusive future to a limited stretch of the future, and is in a poor position to see the meaning of life and death. This meaning is that the passing moment is, first, self-enjoyed, valuable in itself, and beyond that, so far as it is rational, an intended contribution to the future of sentient life, or whatever part of that life it can best hope to enrich with itself or its consequences. The future career of the same individual is normally a prominent part of future life as proximate receptacle for the present contribution. But the ultimate receptacle of values must lie beyond any one human career, and even, I hold, beyond human life as such. Of course the self, and its future, is interesting. But how much else is interesting!

Long ago I made my decision: No one will ever compel me to shut myself up in a prison of self-interest; compel me to admit that others are for me mere means and myself the final and absolute end. In that case how ghastly an affair my death should appear! And how seriously I should have to take every misfortune to myself, and unseriously every misfortune to others. "Writhing in delusion"—what else is it? But many a philosopher and many a theologian, tragic though this be, has in effect told us that such is the rational way. How grateful we may be to the Buddhists, and to Whitehead, and to the Judeo-Christian insight (indeed the insight of every great religion), when taken at its best and not explained away, for showing us another possibility!

True enough, saying that one rejects the primacy of self-interest does not prove that one is living unselfishly. But it might help at least a little to strengthen our generosity, and weaken our self-serving, self-pitying tendencies, if we gave up the theoretical adherence to self which disfigures so much of our philosophical tradition and opened our minds to the really inclusive cause we can all serve, the future of life in all its forms, human, subhuman, and (if we can conceive this) superhuman.

4. The radical abstractness of mere self-identity is obscured if one takes the view that by a certain individual, say John Smith, one means the John Smith career, a certain sequence of bodily and mental states from birth to death (or perhaps beyond), as forming in some fashion a unitary whole. Actual bodily or mental states are concrete; but until an individual is dead his career is, to common sense—and, process philosophers hold, in truth—only partly concrete or actual. What has occurred in a person's life constitutes an actual or definite career, but the future is a matter of more or less abstract or indefinite potentialities and probabilities. Only a doctrine of the absolute pre-

determination of the future can equate what makes a man himself with what actually happens to him. Shall I not be myself tomorrow whether I do just this or that, and whether just this or that is done to me? To deny this (and Leibniz for one denied it) is to burden one's thought with a radical paradox. For then, the moment John Smith exists at all his entire future history is already real fact. A man's notion that he, and not someone else, could have done otherwise than he has done and that he faces real options for the future, not foreclosed by his character as already formed plus circumstances, must then be taken as illusion. Process philosophers think it more sensible to take the Leibnizian view as the illusion. But then self-identity is indeed incurably abstract; for (like every abstraction) it is neutral as between concrete alternatives.

5. Another illusory basis of egoism is found in a certain view about the relations of God to the temporal process. One of the commonest ways of conceptualizing the difference between deity and other forms of being is to say that, while nondivine beings undergo change and are affected by what has happened around them, God is immutable and immune to influence of any kind. It then follows that the good we can hope to contribute to the future cannot be a value we would thereby confer upon God. For, on the hypothesis, deity can receive nothing, being timelessly complete or self-sufficient. And so the harvest we sow must be reaped, its benefits collected, either by ourselves or by others than deity or the supreme reality. But what reason is there to think that these others will in the end escape final destruction? Also, what reason to think that posterity, so far as there is one, will always continue to benefit from our lives in their concrete actuality? Finally, what does it mean to say that our achievement will have contributed something to the happiness of many lives benefiting from our having lived as we have if these many happinesses are scattered about in innumerable consciousnesses? The sum of many pleasures, many happinesses, each in a different state of consciousness, is not itself a greater pleasure or happiness, for it is not a happiness at all. Many apples are not one very large apple—though they are a large quantum of apple flesh and much more useful than just one apple for several people wanting to eat apples. But *of what use is happiness,* after it has occurred, except to contribute to further happiness? Our achievements "add up" to something only if there is an inclusive consciousness which enjoys them, which values their having taken place. A merely timeless and wholly self-sufficient deity cannot meet this requirement. In many writings I, and other authors, have defended a different conception of deity.

Orthodox Hinduism (if there is such a thing) meets the problem of motivation by denying that it exists. It holds that, finally, there are no human selves or careers, but only the one infinitely blissful immutable Brahman. The rest is, to the seer, in some sense mere appearance, or like a forgotten dream. This solves the problem by dynamite, as it were. And why is the problem

worth solving if there never was such a problem? What does it really matter whether we accept or reject Hinduism, since in either case nothing has really happened? Verbally one can talk in this way, but the mere fact of continuing to talk contradicts what is said, or at least fails to express it. I hold, with James and Peirce, that a doctrine is merely verbal unless our living can show that we believe it. But how can there be a way to show by living that we believe we are not living, that is, not changing, not reacting to influences from the past in partly determining the future?

Buddhism has never quite committed itself to the doctrine of Maya; or, at least, Buddhism in what I regard as its best forms has not done so. We are to find the permanent and the all-inclusive in the midst of change. Reality is not merely impermanent and localized; but still it is really so. There are these two aspects in a mysterious unity. But the distinction real-unreal is not the key to this unity. The key is rather this: that the actual, concrete self is much less permanent and self-sufficient than Hinduism took it to be, so that all regard for the future transcends self as concrete actuality. The Bodhisattva works for the salvation "of all beings."

Charles Peirce spoke of the "buddhisto-Christian religion." I believe that the "meeting of East and West" must be chiefly on the Buddhist side of the heritage of India, together with those forms of Hinduism which are not ortho-dox, taking Sankara as the classic of Orthodoxy. The Gita, fortunately, is somewhat ambiguous and can be taken either way.

Egoism is an illusory doctrine, although the real plurality of careers is an ultimate truth. It is, however, an incomplete truth, the other side of which is that, as the identity of a career is abstract, so is the nonentity of the diverse careers. Concretely, the momentary states or selves are the realities; but, to have a rational aim beyond the present, they must regard themselves as con-tributory to future selves generally, no matter to what careers these may belong, in the faith that all lives whatever are embraced in or contribute to a mysterious but real and abiding unity. This unity some Buddhists perhaps, and more easily Christians, Jews, or Mohammedans, may wish to character-ize as the life of God. Others prefer a vaguer description. The essential is that the aim of the individual should in principle transcend its own future advan-tage and take the whole of life into account.

ETHICS AND FREEDOM

Many writers have argued that the only freedom needed for ethics is lack of constraint in making and executing choices. If an act is fully voluntary, not done under duress or threat and not while the agent is hopelessly intoxicated or impassioned, it can in the ethical sense be considered free, even though the

choice was entirely determined by and in principle predictable from antecedent conditions. Nay, more, it is held that such determination is required for ethical responsibility, since acts not determined by character and conditions would be irrelevant to the judgment of persons as good or bad. It is said, too, that since all events must be caused, and since also we have to consider man as ethically obligated, we must believe that moral freedom and determinism are *compatible*.

With James and many others I reject the foregoing reasoning as it stands. But the issues are somewhat subtle. I agree heartily that voluntary action demonstrates freedom and that any determinism which could possibly hold of a being making conscious choices is compatible with that freedom. But I deny that unqualified determinism could possibly hold of conscious beings. Indeed, with Peirce and others, I deny that it could hold even of inanimate nature. The proper meaning of "all events are caused" is not "all events are fully determined by causes." The proper meaning of cause is necessary condition, a *sine qua non* of a phenomenon. But, granted that all necessary conditions for an event have been fulfilled, it follows, not that the event will, but only that it *may,* take place—unless by "event" one means not what actually happens in all its concreteness but only some more or less abstract *kind* of event to which the happening belongs. "Effects" as strictly implied by the sum of necessary conditions are less concrete than actual happenings. Conditions set limits within which the abstractness, that is, the indeterminacy, of the implied effect is resolved into the concreteness of what in fact happens. With this understanding I agree that there are no "uncaused" happenings; yet I reject the notion that there are any antecedently determined yet concrete happenings. The statistical character of most natural laws as now known is relevant here. But I hold, with Wigner and some other physicists, that the quantum uncertainty in inorganic systems is not the only limitation upon determinacy; rather, in organisms, especially the highest ones, there are further limitations to causal predictability or orderliness, though even there the limitations are presumably sufficiently slight to give science plenty of scope in searching for order in phenomena.

Of course character is expressed in acts; but each new act creates a partly new character, and character as already formed implies only a certain range of probabilities and possibilities for action. Each moment we shift, for good or ill, this range. This view does all the real work of the deterministic absolutization of the relation of settled character and other conditions to conduct. Absolutes are needless and worse than needless in most problems, including this one. Often the very people who profess to be skeptical of absolutes also defend absolute determinism.

Freedom in the full sense means more than just voluntariness, and no voluntary animal is free in that sense only. Freedom in the full sense

means creativity, resolving antecedent, though mostly slight, indeterminacies. Creativity is not, taken generically, unique to us, or indeed to animals. As Peirce, the mature Bergson, and Whitehead believed, it applies even to atoms and particles. But the animals have higher degrees and vastly more significant forms of creativity. Yet even in them the causal limitations are always real and important. We can, apart perhaps from rare climactic moments, shift the probabilities of future action only a little each fraction of a second. That is why life is "real and earnest." We are forever influencing our probable futures. But we are never simply determining them. The future will determine itself.

One consequence of the doctrine of universal creativity is that no conditioning, whatever Skinner may believe, will put an end to conflict and frustration. Where free beings interact, there must always be real risks of more or less painful disagreement and opposition. Except for God, every free agent is fallible, both in understanding and in ethical goodness. Hence neither destructive folly nor destructive wickedness can be ruled out by any institutional arrangements. True, the degree of freedom can be diminished and hence the scope of risks reduced. But the limit in this direction is to make human beings almost as lacking in intensity of consciousness as the lower animals. Intense consciousness means, as Bergson and Dewey saw, a higher than usual degree of freedom, a greater scope of options for action. To trivialize risks by reducing freedom means trivializing opportunities also.

Obviously Skinner would think of the foregoing paragraph as a good illustration of the bad effects of the belief in creativity. I see his point. But I think he is missing the very meaning of concrete existence. Here the existentialists are indeed right.

However, while the search for a risk-free utopia seems vain, I heartily support the search for a better system of risk-opportunity, more appropriate to our technology than we have now. For instance, the freedom for each national group to be judge in its own cause, with no group really judging for mankind, is clearly obsolescent and needs to be combated with every educational and political device we can find or invent for this purpose. The 100 percent American, or Russian, or what-have-you, is an enemy to all of us. We need an element of world citizenship in each person. There is no other way effectively to counterbalance the major evils and dangers of our day, whether atomic war, pollution, unjust extremes of rich and poor, or the coercion of one group by another. Moreover, I think Skinner has helpful suggestions as to how needed social changes can be made. Positive reinforcement is indeed far better than negative. My chief quarrel with Skinner is that he takes reinforcement to be an unqualifiedly deterministic concept, whereas all it requires are causal probabilities, not necessities. What he is really asking us to do, and we need to try to do it, is to optimize the probabilities for the future. Conditioning is a

fundamental reality. We all agree on that, even though it is very true that some underestimate its importance. Skinner is merely overstating a good case. In this he has innumerable precedents.

MAN, THE OBLIGATED ANIMAL

We are thinking, speaking animals. "Thinking animal" is scarcely sufficient, because it is arguable that some other animals can also think, in their humble fashion. But a speaking animal, in a normal use of the word "speaking," can think to a degree not closely approached by the other terrestrial creatures. We may not, in any very high degree, be rational animals, but think we do throughout our waking and dreaming life after infancy. We have now to show that a thinking, speaking animal is either ethical or unethical—it cannot justifiably be neutral, or simply nonethical.

All higher animals, arguably all animals, are in some sense and degree social. An animal is more or less interested in other animals. No one who has kept pets can be in doubt about this. Moreover, the instinctive patterns of behavior divide into those that tend to preserve the health and safety of the individual and those that, though they may somewhat endanger the individual, tend to secure the persistence of the species after the individual is dead. Under special circumstances instinct may even produce actions directed to the benefit of individuals of other species. But the extent of such extraspecific service is narrowly limited. And of course the instinctive provision for future results beneficial to the species is largely outside the animal's awareness. Birds building nests, at least for the first time, perhaps do not know the reason for this activity. (Or do they remember the nest they were hatched in?) In sum, though subhuman animals act not simply for their own benefit but also for that of other animals, yet, so far at least as their own awareness is concerned, they may do this only within very narrow limits of space, time, and kinds of animals benefited.

Thinking on the scale that goes with language produces a change so drastic that it is only quibbling to argue whether it is a difference of kind or of degree. For some purposes at least it is a difference of kind, or if you prefer, a "difference that makes all the difference." If thinking does not extend the scope of other-regarding actions infinitely, it does extend them indefinitely. The moment we decide on a limit, we shall have come in sight of passing beyond that limit. We can, in some sense and degree, care about other human beings, wherever and whenever they may be; we can sympathize with the trodden insect, with characters in fiction, with "all sentient beings." We can also inhibit, or not strongly feel, sympathy for anything but ourselves and perhaps a few others. Indeed, we can largely confine our sympathy to our

present self and its immediate or near future, neglecting the months and years to come. Thus we stand before the option: shall we or shall we not generalize self-regard to take the entire personal future into account, *and* generalize regard for others to include the futures of the entire circle of creatures whose welfare depends upon our actions? To use thinking to effect only a little extension beyond instinctive limitations of interest in the future of self and others is an arbitrary restriction of the thinking process. To speak is to be at home with universals. Not just tomorrow concerns me but my life as a whole, and not just that one human being which I am, or my little circle, but human beings generally so far as I have dealings with them or can influence them. Indeed, not human life only but life as such is the final referent of thought. Here the Asiatics were right against the Western tendency to limit value to humanity.

In the foregoing, apart from the last remark, I am agreeing with Kant: The ethical will is the rational will, the only form of will appropriate to a thinking animal. Conscience is practical reason. It is sometimes held that ethical obligations are only to other individuals, not to oneself. I hold this to be a mistake (and here too I go beyond Kant). One's present self has duties to one's future self as truly as it has duties to other human beings. To be enlightened, thoughtful, in one's self-interest is an ethical requirement. Mere impulse will repeatedly pull one in directions contrary to this requirement, just as impulse will pull one in directions contrary to the requirement to give heed to the needs of others. To be (allow present desires to make us) careless of our own future needs is unethical for the same reason as carelessness about the needs of others; for such behavior springs from failure to generalize the instinctive sympathy of present experience for potential future experience, whether of self or other.

Ethics is the *generalization of instinctive concern,* which in principle transcends the immediate state of the self and even the long-run career of the self, and embraces the ongoing communal process of life as such. The privilege of thought carries with it the sense of a goal that is universal and everlasting, not merely individual and temporary. It makes the individual trustee for living things in its part of the cosmos. Anything short of this is not quite ethics in the clearheaded sense but mere expediency, or failure to think the ethical business through.

Of course we cannot design the lives of others in the sense and to the degree possible in determining our own actions and careers. This is especially true when we are young, with the largest portion of our careers still to be decided. It is much less true in the prime of life and thereafter, for then our own destinies are more fully determined, and our power over others is increased. But at all times it is irrational to set a higher value upon oneself than upon others collectively, for the others are many and we are but one. Adler may possibly be right in saying that most "do gooders" do

less good than harm to others. Even so this is relevant only to questions of strategy or tactics, of *how* to promote the cause we serve, not of what cause nor why we should serve it. The ultimate principle remains: we care about life, above all life on the conscious personal level, and especially, for the reasons and to the extent just indicated, our own lives. There is also truth in Maeterlinck's saying, "It is necessary to live naively." Too pedantic an insistence upon altruistic considerations may, by destroying spontaneity and zest, make one a less valuable person, both to oneself and to others. Nevertheless the aim is one's total contribution, taking what one is and what one does into account.

THE AESTHETIC BASIS OF ETHICS

Granted that the ethical or rational motivation is toward the inclusive good, the question remains, how, by what rules of action, can the inclusive good be promoted? What indeed is "good," whether mine or someone else's? Here ethics must lean upon aesthetics. For the only good that is intrinsically good, good in itself, is good experience, and the criteria for this are aesthetic. Harmony and intensity come close to summing it up. Being bored, finding life insipid, lacking in zest or intensity, is not good; however, discord, conflict between intense but mutually frustrating elements in experience, also is not good. Intensity and beauty of experience, arising not only from visual or auditory stimuli as in painting or music, but in experience of whatever sort, are what give life its value. *To be ethical is to seek aesthetic optimization of experience for the community.*

Emerson was wont to speak of "moral beauty," or the majesty of goodness, and he could follow eloquent praise of the beauty of nature by saying that it paled before the beauty of a right act. An ethically good act is good in two senses: it contributes to harmony and intensity of experience both in agent and in spectators. A good will enjoys a sense of harmony between self and others (in that way, virtue is indeed its own reward); and its consequences, if it is wise and fortunate as well as good, will be to enhance the possibilities in the community for intense and harmonious experiences. Obviously cruelty produces ugliness in the experiences of many; genuine kindness produces beauty, directly in itself, and indirectly in many ways. Parents who fail to inspire in children a sense of the direct and indirect contributions of good actions to beautiful, satisfying experiences, fail indeed. Moral exhortations and disciplines which make life seem ugly or boring for self and others are counterproductive.

The insane are those who unwittingly invent an unreal world that gives them more intense and harmonious—or less inharmonious—experiences than the real one as they are able to see it. All basic problems are aesthetic. The

"beauty of holiness" is one of the finest of biblical phrases. And one has only
to read Emerson's *Journals* to see that moral beauty was for him a reality. His
attitude toward slavery, toward the emancipation of women, and in many
other matters earned him the right to emphasize the phrase. He saw the ugli-
ness of male chauvinism when not so many did, and no one saw more vividly
the ugliness of slavery. He saw, too, the ugliness of war and aggressive
nationalism, though perhaps not the necessity of something like world gov-
ernment as the only feasible eventual alternative. He saw, though inade-
quately, the beauty of the scientific vision of nature. Here Thoreau definitely
surpassed him.

It is an aesthetic principle that intensity of experience depends upon con-
trast. Since memory is central in high-level experiences, an important mode
of contrast is between the new elements and the remembered old ones in
experience. Put otherwise, for experience to have much aesthetic value there
must be significant aspects of creativity. Now that science and technology
have so greatly increased the pace of change in the conditions of living, there
is bound to be a good deal of novelty in life. But the problem is to achieve
intense harmony, beauty, in this novelty, rather than intense ugliness. Here the
young [in the 1970's] are more or less in the right. We cannot simply go on as
we are politically and socially. Somehow we have to make ourselves, our
whole citizenry, more courageously aware of the possibilities of altering the
really hideous disproportion between rich and poor, both within our nation
and between nations. We cannot much longer effectively pretend to practice
democracy while elections can be bought by oligarchically controlled wealth,
and while millions, especially blacks and Latin Americans, are given little
chance of participating in social and political life in a self-respecting way. We
cannot much longer effectively work for peace while failing to take any steps
toward international cooperation without which there cannot be anything but
cold or hot war. We have to inculcate the sense of world citizenship and of
membership in all humanity, not just in some part of humanity. Pollution
problems have similar implications.

ETHICS AND REFORM

Berdyaev's ethical imperative was, "Be creative, and foster creativity in
others." Today, social and political creativity have a new degree of impor-
tance. I agree, too, with Marxists and some contemporary theologians
that the driving force for needed reforms must come in substantial measure
from the less fortunate. As has been said, the ones to change the system
are "those who dislike it." But the fortunate, those who are lucky and success-
ful in providing for themselves and their families, need to learn to dislike
the present arrangements vicariously, because of their injustice. History

shows that this is difficult and uncommon. Nevertheless, it is an ethical imperative. For those with bitter personal grievances are dangerous reformers if given no help or guidance by those who are more disinterested. This is a central ethical problem. The successful middle class needs to consider carefully how far, if at all, it ought to side with the rich rather than the poor. And the rich, including the richer nations, need to realize their ethically perilous position. The New Testament judgment on wealth has, I believe, more validity than we Americans have ever been willing to grant. Emerson observed that the wealthy systematically voted for the wrong things and against every needed reform. We have to resist the natural tendency of those who have "succeeded" to attribute their success to ethical superiority alone or essentially (as though anyone ever achieved anything without a liberal portion of good luck) or to view those who, by the crude standard of wealth, have succeeded as most worthy, and the economic failures as least worthy, of respect or trust. Complex as these matters are, and granted various qualifications, the basic principle holds that the fortunate tend to overrate the rules of the game (including the tolerated violations) and resist their revision to meet new conditions, while the unfortunate are more willing to attempt this.

Technology has finally destroyed the possibility of an easy conservatism such as worked well enough among primitive tribes and fairly well even in early modern times. Now we must change our ways, and it seems foolish to expect those (including myself) whose personal position pleases them to furnish the chief impetus for change. Yet even they are under obligation, I suggest, to try to understand that their own needs are not the measure of the common good and that some discontent of a vicarious sort would become them. So long as no real end to "cold" warfare—or to localized hot wars—and no end to race conflict or to bitter poverty, even in this nation, is in sight (and no end is in sight), we have no right to be content with our procedures. We have to look for better ways.

One further point. I agree both with some of the young and with many Asiatics that we Americans need to revise our shamefully materialistic concept of the "standard of living" so that it is no longer so nearly neutral or worse than neutral ethically (and indeed aesthetically), consisting in large part of preferring conspicuous waste and minor comforts to essential values of health (of which the automobile has in some ways been the enemy), natural beauty, friendship, good feeling among citizens, creative activity, and intellectual and spiritual progress—all of which beyond reasonable argument are more important to achieving that beauty in life which is genuine success.

A Frenchman has coined the phrase "voluntary austerity" to express the idea that there is now a new ethical value upon not demanding for oneself and family all the luxuries at once, a demand which intensifies all our dangers and

evils, including the evils of inflation and pollution and the danger of war. The old ascetic and monastic ideals are not necessarily irrelevant, nor is the notion that the really good person is modest in his or her claims to share in the products of human labor and the creativity of nature. In this regard Americans in general are far indeed from the model the world needs to copy. It is in some ways our very selves that we need to recreate.

13

THE KINDS AND LEVELS OF AESTHETIC VALUE

AESTHETIC quality, aesthetic value are somewhat ambiguous terms. As intrinsic they are values, qualities of certain experiences—or really, certain aspects of any and every experience, for (and this is a second ambiguity) no experience is simply without aesthetic quality or value. As instrumental, aesthetic qualities or values belong to certain objects—and again no objects are absolutely without such values. An aesthetic object is one that actually or potentially enables persons (or sentient creatures) to have aesthetic experiences. The object may or may not be a work of art—unless there is a sense in which nature itself is the work of a supreme artist (called by both Peirce and Whitehead the poet of the cosmic poem).

It would be difficult to improve, in as few words, on Whitehead's definition of intrinsic aesthetic quality: "the mutual conformation of the elements of an experience." One may also take as the key word *harmony.* The word beauty is also used, but like the others it has various nuances of meaning. I believe that in the effort to systematize these nuances, no merely verbal formula is as good as a diagram which has been the result of the work of three persons: a German writer on aesthetics, Max Dessoir; a lady artist named Kay Davis, who was my student at Emory University; and myself.[1] In this threesome I was the one who as teacher enabled the lady (no longer living) to produce the final element of the diagram. Consider a large circle, in the middle of which is a small circle. The small circle represents beauty in the most specific or distinctive sense. The large circle stands for beauty in

1. Versions of the Aesthetic Circle are given in my *Creative Synthesis and Philosophic Method* (Lanham, Md.: University Press of America, 1983), p. 305; *Wisdom as Moderation* (Albany, N.Y.: State University of New York Press, 1987), p. 3; and *Born to Sing: an Interpretation and World Survey of Bird Song* (Bloomington: Indiana University Press, 1973, 1992), p. 280.

the comprehensive sense in which it is equivalent to aesthetic value, some degree or form of experienced harmony or mutual conformation. This conformation cannot be zero, for an experience as one simply is that mutual agreement. And any object experienced as one will have at least a minimal degree of experienced unity. As Croce said, the difference between 'experience' and 'aesthetic experience' is "intensive," a matter of degree. If the degree is low we may call the experience "unaesthetic," but this negation is not to be taken absolutely. I view Peirce, Dewey, Whitehead, and many others as rejecting the notion of an absolutely unbeautiful object or unaesthetic experience. Perhaps Heidegger also implied this, as did Heinrich Rickert the Neo-Kantian. Goethe, Wordsworth, Bradley, and Bosanquet, idealists in general, have tended to take this position. My book on sensation gives various arguments for such a view.

A circle is a two-dimensional figure. Beauty as not the only aesthetic value (the central small circle) is (like virtue) between extremes, and in at least two dimensions. Let the vertical dimension have at the bottom (but inside the large circle) ugliness; at the top (but inside) what may be called neatness or tidiness. The ugly is a mixture, as Bosanquet showed long ago, of harmony and discord. It is not purely discordant, for this could not be experienced and the order of nature makes it impossible. *Mere* chaos is a verbal entity, nowhere to be found, and arguments for its possibility are sophistries. Any state of affairs that can be definitely conceived without contradiction has some degree of order. A hopelessly discordant entity is not *an* entity, nor can an experience be without some minimal degree of concord among its aspects. There is always some "satisfaction," to use Whitehead's term. This is what makes masochism as well as sadism possible.

The other, the horizontal dimension, is that of depth, profundity, and its contrary, superficiality or triviality. Superficial harmony is termed pretty (German *hübsch*). Ultraprofound harmony is the sublime. If in the upper third of the circle, near the neat or tidy, it may be called magnificent, if in the lower third (near the ugly), it is tragic, grim, macabre. I follow Dessoir in putting the superficial side on the right and the profound side on the left.

Before the lady artist had her insight, beauty was put at the top of the vertical dimension (by Dessoir and by me). The artist saw that this was a mistake. The extreme yet still aesthetic opposite of aesthetic disorder is not absolute order, any more than aesthetic disorder is absolute. All experiencing has some degree and kind of order. But, unless there is also some aspect of freedom, disorder, conflict, uncertainty, unpredictability, there is no intensity of experience. (The zero of intensity means no experience.) We do not want the future to be simply predictable. And good musicians take pains to avoid a too absolute order in their combinations of notes. Surprise is an indispensable

element of experience. Arguments that have been used against this are fallacious, overlooking certain distinctions between what we "know" and what we actually have conscious awareness of at the moment, also between certain abstract and more concrete aspects of experiences.

DIAGRAM OF AESTHETIC VALUES
Undiversified unity, absolute order

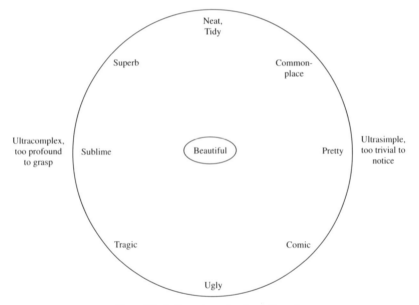

Ununified diversity, absolute disorder

In addition to the introduction of the second or deep-shallow dimension, the most valuable point made by Dessoir was the recognition of the humorous or comic as an aesthetic value in the same basic sense as beauty, prettiness, sublimity. This is very clear in art. Charlie Chaplin was an artist in the silent cinema and the value that he specially gave us was comedy. The comic belongs on the lower right side of the circle, the side of nonprofound (partial) discord. (As humor, perhaps it was profound, but scarcely enough so to be termed tragic.) Shakespeare was a supreme artist, pouring out something like all the aesthetic values not only in the totality of his plays and poems, but almost in each play. Mozart, the "Shakespeare of Composers," in his short career created a similar range of values. Edgar Allan Poe specialized in the beautiful, tending toward the pretty, his poem "Bells,"

and the macabre or gruesome, his stories. Milton excelled in the beautiful and the sublime.

In the art of conversation, the art in which ideally no one should be radically deficient, all the values should appear. The supreme art is life itself. At the conference at which I first read a paper making this point, another speaker (Morris Grossman) also made the same point in his paper.[2] (I regard this as an illustration of how cultural change tends to bring about situations favorable to a certain idea so that more than one person hits upon it independently.) The special point the two of us stressed was that, as in other works of art, in a life there should ideally be a beginning, a middle, and an end. In other words we offered an aesthetic theory of death. In a life that is not prematurely terminated there are the thrills and vague anticipations of childhood, the mature plans of youth, the fulfillment of middle and (with care and good luck) old age. A personality is a theme and like nearly all themes, only a finite number of its variations can avoid triviality, unbearable monotony. This also is the objection to most dreams of heaven. Death together with birth, forms the solution of life as an aesthetic problem: new personality themes.

I have been writing about aesthetic values, what about ethical values? Ethical values also have two aspects. A good will, a noble soul, is beautiful in itself. It is experienced as a form of harmony, both by oneself and also as discerned in others. Horatio's "Thus cracks a noble heart. Good night sweet prince / and flights of angels sing thee to thy rest" is a wonderful example. Another is, "So shines a good deed in a naughty world." But ethical values are also utilitarian. Without considerable good will, what values would be left in human life? A sad, at times grim aspect of our existence is when some who believe themselves to be acting righteously, discharging some duty, make life miserable for those around them. Religious fanaticism, as history amply shows, can do this. The irony is striking when the religion is thought to be one of love, human and divine.

Religious values are finally aesthetic. God is not discharging duties, but lovingly enjoying the creation. The creatures in the preethical stages, the ones without sufficient conscious thought to have consciences, are enjoying themselves and what they sense of the life around them. They do what is needful for the general symbiotic scheme of things, but do it because they feel like doing it. Without language, in the sense in which no other species on this

2. For the idea of individual lives as works of art see *Philosophical Aspects of Thanatology,* ed. F. F. Hezler and A. H. Kutscher, vol. 1 (New York: Arno Press, 1978), pp. 77–81, and 83–87. See also vol. 2, pp. 81–90. In my essay in vol. 2, I refer to God by *he.* I had not, sixteen years ago, given up this practice, as I did soon after-

planet appears to have language (unless, as with some apes, taught something of a [visual] language by human beings), an animal can hardly have ethical notions. Ethical values distinguish humanity; only above a certain level do aesthetic values do so. There is, as I have written a book to prove, all the evidence there could be that some birds have a simple primitive feeling for musical values. Not art (simply as such) but science, philosophy, politics, religion, distinguish us.

For this distinction, we pay a price. If we (too many of us) stifle the sense of obligation, do not consciously love others as valuable by the same principles as make ourselves valuable, then we can in the not very long run destroy our species and much else. Our science and technology make us the only radically dangerous earthly species. Philosophers, scientists, and theologians have not adequately grasped this truth. All freedom involves risk and danger; science indefinitely magnifies the scope of the risks and dangers. Who, well before atomic energy, told us that this might mean we could as a species commit suicide? I know of one person who did tell us, and he was not a scientist, philosopher, or theologian. He was Thomas Love Peacock, the successful satirical novelist, music critic, and unsuccessful playwright. Explosives, he said (about 1860), keep getting more and more powerful; will the end of this tendency not be a power to destroy our species itself? The evidence he had for this, others had; *he* saw the implication. He was not a theologian, but the person in the novel who made the observation was a clergyman.[3]

Theology and philosophy have tended to be excessively, or one-sidedly, moralistic, neglecting the universal aesthetic principles that apply to all creatures and any possible creator. I have said that a personality is a theme, and that themes in general, to avoid monotony, can tolerate only a limited number of variations. Another way of putting this is that there must be a superpersonal theme, of which ordinary personalities are variations. Otherwise the many persons, indeed the many individual creatures, making up reality cannot express any overall meaning or add up to any significant whole. What then can this superpersonal theme be? Some say it is the human species. This simply will not do. For one thing, it dismisses the nonhuman creatures to merely instrumental value, which is deeply counterintuitive and irrational, although Kant was (somewhat inconsistently) committed to it. I hold, and this

3. T. L. Peacock's last novel, *Gryll Grange,* was published in book form in 1861, serially in Fraser's 1860. See *The Pleasures of Peacock,* ed. B. R. Redman (New York: Farrar Straus and Company, 1947). The passage suggesting that (applied) science "might exterminate the human race" occurs almost exactly in the middle of the brief novel, in the Redman edition, on p. 421.

is one of six reasons why I am a theist, that the idea of an ultimate aesthetic theme is irreducibly theological. I wish to sketch the reasoning.[4]

As already pointed out, aesthetic value has an intrinsic and an instrumental aspect. The former may be called the subjective aesthetic value and the latter the objective. Here 'subjective' does not mean relative or a mere matter of opinion. An actual satisfaction in any subject anywhere is in fact a positive value in reality, whatever anyone opines about it. Those who deny this value are *simply in error.* C. I. Lewis, in his great book, *Knowledge and Valuation,* makes this point admirably. It is objective value that may indeed be partly a matter of opinion. If an art object gives me satisfaction my satisfaction adds to the value of the universe. But how far others can derive similar or as intense satisfaction from the object is a further question, and here we can all be more or less radically mistaken.

Even the objective aesthetic values are less arbitrarily judged than some theorists suppose. In studying bird songs in many parts of the world I have found that in every major area some species' songs have been admired for generations or centuries. One indication of this is that certain species (in civilized countries) have been caged because of their songs. In Mexico the slate-colored solitaire (said by Frank Chapman, who had heard songs in various countries, to be the finest singer of all) is to be heard in bird shops more easily than in its mountain habitats. I would be astonished if any musician who heard it had trouble understanding why this song should be admired. "How could it not be?" I think he would say. I could give many similar examples. Again, consider folksongs. Through recordings I have heard these from a good many parts of the world, including Africa. I have yet to hear any that do not seem to me enjoyably musical. And the first time, and still now, on hearing Balinese religious percussion music I found and still find it profoundly expressive and beautiful.

4. See *Creative Synthesis,* p. 247. The context for theistic arguments is given by chapters 10–14 of this book. What is formally valid is the exhaustiveness of the set of options among which only one can be true but which cannot all be false. In the end a more than formal judgment must be made. Both theism and atheism are finally matters of faith, but the faith is most rational if the options are all definitely considered. Until I wrote this book this had not been done, except by me. I delayed publication for about twenty years while I sought to improve the formulation I gave to the departmental collegium at the University of Chicago. I now call the "proofs" *arguments* to emphasize that strict formal logic cannot make the selection among the options because the idea of God involves more than "logical constants." It is however definable by metaphysical constants as I understand these. Note that defining the *idea* of God is not defining God, for no concrete actuality is identifiable by merely conceptual or linguistic means, not you or me as actual and not God as actual. In all cases direct and more than verbal experience is required. That the idea of God (or of you or me) is *somehow actualized* is God's (or your or my) 'existence'. In the divine case the somehow actualized is necessary (or impossible) but not the how. In your or my case even the somehow actualized is contingent; in *all* cases divine or nondivine, the how, or in just what actual state or states, is contingent. I believe I am the first person to achieve full explicitness on these points.

When people disparage exotic music they give information about themselves far more than about the music. They are telling us about the rigidity of their emotional life, how they do not want to grow emotionally. Music is incomparably closer to a "universal language" (of the emotions) than any language in the literal sense. The emotional expressiveness of sounds is not only intercultural, it is to some extent interspecific. What animal needs to learn the meaning of a snarl or growl? It could make a newborn infant cry. The basis of musical expression is deep in the evolutionary past. Psychologists have mostly been too little biological to appreciate this. They want individual learning to explain much that is partly prehuman in its causation.

The superpersonal, or perhaps better, superindividual theme to which persons or individuals in general add valuable variations, must be cosmic or supercosmic. As objective it must be the whole of nondivine realities, as subjective what can it be other than deity? I have yet to encounter a credible nontheistic answer. True, we have some feeling of the beauty of the cosmos as a whole. Indeed we could not have the idea of this whole without deriving some satisfaction from it. Experiencing is not done for no value, or less than no value. But how radically inadequate is your or my appreciation of the value of the cosmic whole? Moreover, your satisfaction and my satisfaction do not together form a supersatisfaction double the value of yours or mine, at least they do not do this if only scientific or commonsensical considerations are all that are involved.

Satisfactions are feelings, they must have a feeler. I have only *very* partial glimpses of your feelings and you have only partial glimpses of mine. According to Whitehead, whose view in this I heartily accept, it is God who prehends, that is, feels all creaturely feelings with ideal adequacy. As the Anglican prayerbook has it, "to God all hearts are open." Before Whitehead few indeed were the theologians who said in a technically definite way that God feels our feelings. In my before-Whitehead period I certainly came close to saying it and meant it, and so did a few others. Anyway, now it has been said. It is typical of metaphysics that so few realize the change this makes if one takes it seriously. For now the superindividual theme is divine-feeling-of-creaturely-feelings. This Whitehead calls the Consequent Nature of God. He does not sufficiently clearly say, but it is true, that this must include the primordial nature of God. For the consequent nature is God as concrete, and the concrete includes the abstract. The primordial nature is said to be an abstraction, "deficient in actuality." It is extremely abstract, the purely eternal and necessary aspect of deity. The consequent nature is God as concrete, contingent, and "in a sense temporal." Whitehead never quite tells us how the two natures form one actuality. His pupil Russell gives us a useful clue here, "*concrete*ness is itself an abstraction." To speak of a consequent divine *nature* is to refer to the divine concreteness. As a mere nature this too is an abstraction that primordially applies to God. What does not primordially apply are the particular instantiations of this abstraction. As so often, *triadic* not merely dyadic analysis is what illuminates. Peirce liked to

stress this point. Here I make what I venture to think an important proposal, that we define 'existence' as the being somehow instantiated of an abstraction. Humanity exists if there are human beings, I exist if my "defining characteristics" (not wholly concrete) are instantiated. God exists if the primordial and consequent natures (both abstractions) are somehow instantiated, and God exists necessarily and eternally if there is and always has been no possibility of God's defining characteristics being uninstantiated.

Without theism the many satisfactions have no intelligible way to add up to an overall meaning. Happinesses, beautiful experiences, come and go, after they are over what does it matter that they occurred? And why are many happy persons better than just one? Better for whom? Answer: for God. It is easy to see that traditional theism did not meet the aesthetic requirements for life's meaning. It said we should serve God, but it defined God as incapable of being served, incapable of being genuinely benefited by what we do or caused to suffer by it either. Berdyaev and Whitehead, apparently entirely independently, attribute vicarious suffering to deity. This is twentieth-century theism, and it implies a wholesale shift from the merely one-sided to what I call the *dual transcendency* view of deity, according to which the divine relativity (on which, forty years ago, I wrote a book still in print) is as unique and all-surpassing as the divine absoluteness, the divine finitude as uniquely excellent as the divine infinity.

No argument for God can start from premises that are for all trained minds self-evident. But the arguments can be formally valid, as I believe I have shown. And the theistic question is far from the only irreducibly controversial issue in philosophy! So I say there are reasonable arguments for theism, of which the aesthetic is one. For me it is close to convincing, except that, since it uses as a starting point one of a number of universal conceptions or categories, it would be suspicious if other comparably universal ones did not also furnish theistic arguments. But they do. Kant himself implies two of these other arguments, though he has assumptions that tend to nullify their utility, assumptions that are not as credible to some of us as they were to Kant. They are also less plausible in view of the present state of science than they were in Kant's day.

The old idea that art reveals the eternal is not, I think, wholly mistaken, but more to the point is the belief that art reveals the everlasting. Once a satisfaction has been achieved by anyone, it is added once and for all to the divine satisfaction. I wish also to say here, as I have in many other places, that the bearer of the inclusive objective beauty, the cosmos of creatures, may be regarded as the divine body, and I once more salute Plato for having been the first, and among the best, to use this analogy. I deplore Whitehead's rejection of it—in my judgment a bad mistake. Our bodies are what we always and directly feel—if we are conscious—whatever else we feel. Our cells' enjoyments and sufferings contribute to ours. Gustav Mahler, the composer, believed this; I was thrilled recently to be told so by a philosophical music-loving friend named M. Smith. Since learning this I have really listened to

and acquired a taste for Mahler's majestic music. I have also met two psychiatrists with similar beliefs.

Although I taught aesthetics for a good many years and did much reading in the subject, I have published little on it. However, in *The Philosophy and Psychology of Sensation* (no longer in print) in the chapter "Dualism in Aesthetics," I presented a theory of sensory qualities (often called "secondary" because, in a sense, they are ignored in science) as explanatory of the power of art, especially music, to express feeling or emotion. The theory was that sensations are themselves feelings of a special kind. This is most nearly obvious in physical pains and pleasures.

Sensations *are* feelings closely associated with the functioning of sense organs; also they are localized in phenomenal space. Being feelings of a special kind they can provide iconic signs and enrichments of feelings of another kind, not so directly sense-organ dependent and not so localized. I still believe that there is no other way to explain the power of music, and I hold that Beethoven implied such a view when he said that tones produced by physical instruments are the *Urgefuhle der Natur* (the primordial feelings of nature). The painter, Kandinsky, expressed a similar idea about color. A recent writer on cognitive psychology remarked that psychology has thrown no helpful light on the problem of quality. It would follow that it has thrown no very helpful light on value. Apart from value what does anything matter? Something like my affective theory of sensation has been held by some psychologists, partly on experimental grounds, as I showed in my book.

A deficiency of our discussion so far is that we have not really answered the question, What measures degrees of aesthetic value? Is the sublime better than the humorous, and if so should we not try to avoid humor and spend our time contemplating sublime objects or thinking sublime thoughts? Only a few hints can here be given in answer. Experiences differ in intensity, and the zero of intensity means no experience and no value. Intensity is one measure of value. Intensity of experience depends somehow upon contrast and variety. Another value measure is inclusiveness. If God adequately feels all creaturely feelings, then God has all the value that the creatures have and radically more besides. And each of us, so far as feeling the feelings of our cells, exceeds them in value.

I wish to close by trying to explain why for twenty centuries and more philosophers and theologians have been as insistent as many of them have been upon the idea that God (or Allah, or Brahman) must be conceived as absolutely perfect, self-sufficient, and complete, so that the idea of divine change is impious, blasphemous. There is indeed, I agree, an absolute perfection, a beauty that is real no matter what, that nothing brought into being and nothing could improve, tarnish, or destroy. Its reality is strictly eternal and noncontingent. Whitehead's explication of the primordial or abstract nature of deity coincides largely (as he pointed out himself) with Aristotle's idea of God. But—I repeat, BUT—as Aristotle saw, it follows logically that God, so

far as defined by this idea, cannot know the world as contingent or changing. Whitehead saw this too and therefore concluded that the God of worship, believed to know and cherish the creatures, cannot be simply identical with the eternal perfection in question. God, insofar as eternal and noncontingent, is indeed absolute, a beauty without a flaw. But God is infinitely *more* than anything merely eternal, absolute, and noncontingent could be. The contingent, as is easily proved by the logic of modality in one of its least controversial axioms, is *more* than the necessary. Proof: a necessary truth conjoined with a contingent truth is itself, the conjunction, contingent. The inclusive truth, and the inclusive reality, must be contingent. So what can the necessary be but an abstraction? C. I. Lewis's strict implication, in systems 4 or 5, and some other similar systems, by the theorem that the necessary is entailed by any and every truth, makes the necessary a universal common denominator of all truths and all entities. How can this be anything but an abstraction?

Note also that Plato's World Soul has unmistakable analogy to Whitehead's Consequent Nature, and Plato's Demiurge to the Primordial Nature. But Aristotle dropped the former and the Middle Ages followed him in this. Why? The main clue I see is the lure of simplicity. "Seek simplicity and distrust it" wrote Whitehead. There is an analogous passage in Popper. We must seek simplicity, but we need also to guard against oversimplification. History has shown over and over that the second part of the injunction is often neglected. We fall in love with our simplifications. In theology this means a kind of idolatry, substituting some favorite one-sided concept for the One Worshipped. Even now one meets with it in some of the latest books. But now that Plato and Aristotle are easily accessible, neither of whom (for good reasons) was a classical theist of the medieval type (which is also essentially that of Luther and Calvin), now too that we know about F. Socinus (and his followers) who, about 1600, rejected the merely eternal notion of God for the same reason that I, for one, reject it, also Fechner's *Zendavesta* (1851), the old simplicity can scarcely satisfy. Its golden time is over.

Besides the oversimplicity of the medieval idea of God, there was the oversimple notion of causality as complete determination of the present by the past (or by the eternal, which if anything is worse, the idea of a beneficent immutable tyrant as deity). Both were unaesthetic ideas. The Greeks and their medieval admirers never quite saw that beauty and order, or beauty and unity, are not identical. If beauty is variety in unity, or unity in variety, the variety is as necessary as the unity; also freedom is as necessary as order, and freedom and absolute order are *not* compatible.

Classical theism implied a defective aesthetics and a defective ethics. I do not find it in the parables of Jesus or, on the whole, in the Old or New Testaments. It tended toward the worship of power much more clearly than the worship of love or respect for the freedom of others. I had pious parents who really practiced a religion of love, and their theology was definitely not classical. There was no dogma excluding every form of divine change or depen-

dence upon and responsiveness to others. In my father's case, at least, the rejection of the medieval doctrine, though not overemphasized, was conscious and explicit. The late nineteenth and early twentieth centuries have opened up religious, aesthetic, and ethical possibilities scarcely available between Plato and Whitehead. The Socinians, who in the seventeenth century anticipated Whitehead in some respects, had little chance against the steamroller of a tradition too enamored of power (and too given to looking to human life after death for solutions to make sense out of life before death). I admire Robert Frost's, "Earth's the right place for love / I don't know where it's likely to go better." Divine love survives, as it preceded, life on this earth, and in it all earthly values, once attained, are imperishable treasures. As Whitehead put it, "They perish, yet live forevermore." Some have said that this is insufficient to reconcile us to our mortality because it means that the final value of our having lived will not be for us but for God, since as having lived we will not still be alive. Only God will still live enjoying our having done so. One difficulty in appreciating this objection is that the same people accept, or do not clearly reject, the imperative that "God," the One Worshiped, is to be "loved with all one's being," or the object of unstinted devotion. How can they reconcile worship in this full sense with an attitude of making bargains with God? There is a book, written by Martin Gardner, which to my reading amounts to this: God must be taken to exist because we must have unending further careers after death, and only divine power could provide such careers. In other words we live not essentially to contribute to the divine life but to have God furnish us with the temporal endurance we feel appropriate. God becomes primarily a means to our prospective infinity!

True, Gardner might say that this is what I (with Whitehead) am doing, in assuming objective immortality in God. Yet consider the differences. Objective immortality applies to all experience and all creatures, not just to human beings. It asserts no special claims for our species, beyond the fact that we are able to conceive, and thereby *enjoy in advance,* our having made an imperishable contribution to the divine life. Further, in solving the problem of the permanence of value it also solves that of the permanence of truth. In addition, the neoclassical theism answers the question, how can there be contingent laws of nature, and yet universal creaturely freedom? One might go on. Gardner's thesis, for me, solves no problem other than that produced by the wish to appropriate the divine attribute of infinite capacity to assimilate novelty. And it introduces problems that otherwise would not arise, concerning disembodied minds or minds endowed with supernatural bodies, and either in or not in the space-time whole.

Admittedly many think there is a problem that objective immortality does not solve, that of cosmic justice, conceived as distribution of rewards and punishments appropriate to desert. My difficulty with this is threefold. Freedom as universal attribute of creatures as well as of God makes any exact correspondence between desert and reward unattainable not only on earth but in any

heaven you please to postulate. Moreover, all experience is social, partly dependent on others; any heaven either wholly without social interdependence or wholly without freedom is, according to my neoclassical metaphysics, a confused or contradictory notion. In addition, since the ideal of goodness is loving one's neighbor in principle "as one loves oneself," it is inconsistent to ask that in the end treating others well should be wholly justifiable as enlight ened self-interest, so that there is no need to do good out of love for others.

One should indeed love oneself, but because one is a creature valuable to others and to God who loves all; one is not to love oneself as the only reason for loving others any more than one is to love others as the only reason for loving self. One should love both in principle for the same reason, that both are divinely lovable and loved. To demand posthumous rewards and punishments can only be justified theistically if it can be shown that God needs heaven and hell in order to have divinely satisfying creatures. God enjoying or suffering the spectacle of hell has never been a very inspiring notion, I rather think. If this is not a masterpiece of understatement what would be?

Would having Hitler endlessly punished for his terrible misdeeds do anyone any good? Or would it merely add to the already vast spectacle of creaturely suffering, endured vicariously by deity? How competent are we in the art of playing God imaginatively?

Dante's and Milton's poetry constitute considerable aesthetic treasure that we owe to classical theism. But we can enjoy their beauty without shutting ourselves up in their metaphysical prison of an all-too-human cosmic magistrate, policeman, or supersoldier, who, nevertheless, is also referred to as the "love that moves the sun and the other stars." We can and I think should believe in that love without believing in the cosmic magistrate. I see no good reason to assign to deity the functions that human judges, police, and jailors are saddled with. Deity as punisher makes no sense to me. God is not Jupiter. The thunder is not divine threatening. It means danger, but not danger aimed at anyone. There is danger because there is creaturely freedom. There is such freedom because without it there would be bare nothing, and bare nothing cannot be. Bergson proves that, to my satisfaction.

What many see as evidence of divine wrath, indifference, or lack of concern for creaturely welfare, may also be seen as sign of infinite respect for creaturely freedom. God sends rain (and lightning) on the just and the unjust, and on human and subhuman alike. Is it really clear that without some such aspects of impartial order a world would be better than ours, or would even be a viable world at all? To have freedom without order, or order without freedom, would for all I can see, be no conceivable state of affairs. The holocaust and other recent genocides (some still going on) show the extent of human freedom and responsibility. But the billions of other solar systems are, God be praised, out of our reach. Could that be a providential arrangement, grounded in the divinely inspired laws and initial conditions of our cosmic epoch?

14

INDIVIDUAL DIFFERENCES AND
THE IDEAL OF EQUALITY

I and my readers are all members of the same animal species, *Homo sapiens;* from which it does not follow that we are equally *sapient,* if that means wise or capable. Rather the contrary. Of all the humanly known species ours is the one whose members are *most unequal* in individual abilities; indeed this is among the greatest differences between us and the rest of the animal world. Granted my readers, for example, are able to read English, how does their command of that (or any) language compare with Shakespeare's, Wordsworth's, or R. Waldo Emerson's? Also there are outright idiots in human form; so far as I know they may be of any racial type, and either sex.

An animal species is defined as a group of individuals able, under natural conditions, to interbreed effectively. Human beings seem definitely to meet these requirements. Consider how, among so-called blacks, there are many whose ancestors included whites (so-called—I wish we had adopted the more literally appropriate "pale-faced" used by some American Indians). In a species every individual, even in identical twins, is noticeably different from every other. However, this is much more true of the higher animals than of the lower. And in us this differentiation or individuation is at its climax. I have encountered, in a family of one of my favorite philosophical friends, a male creature seemingly adult in form who spoke no word in any language and seemed infantile in mentality. The father was downright brilliant, and his wife did get a higher degree.

Yet the founders of our country declared, in their declaration of independence from England, that we are all born equal. They did not say this applied to those of African descent, or to women—as Abigail Adams correctly and appropriately pointed out. Alas too there is the difficulty that individual differences are of two kinds: the obvious physical contrasts, such as sex or race,

and differences which, so far as physical, are subtle and invisible (in the central nervous system), or which are obvious physically only in behavior, and even then may be overlooked or misjudged. Nor, apart from a few extreme cases of deficiency, can they be known at birth.

Clearly the value of a person depends upon mental or psychical and behavioral characteristics. The single most important differentium of our species is in capacity for speech and other forms of symbolization; this, and the closely related capacity for elaborate making and employing of tools, is what sets us apart from the rest of the animal kingdom on this planet. Beavers make dams and shelters accessible only under water, the depth of which they have brought about; birds make nests. Even so human tool-making is vastly more extensive and various; in metaphors such as the "language of bees" one has cases of extreme exaggeration compared to any language in the normal meaning of that word. One must include smiles and gestures as falling on the symbolic or human side, though, as Darwin knew, there are some analogies overlapping behaviors of a few other species.

A great but sadly, tragically common error is to evaluate persons chiefly for their obvious physical characteristics, rather than for their skills, above all, symbolic skills. Women have been disgracefully undervalued, as Virginia Wolff noted in a long speech, which was recently done better by an actress than Virginia herself had done it. The speech tells how almost unbelievably badly women were treated in English history, this treatment supported by the laws of the land. With my love of English literature I was deeply shocked as I listened to this damning indictment. I think in my country women have done a bit better, at least until recently. In pioneer times women formed groups to review books, or to argue for the better treatment of other animals. The English, however, did have their queens, whereas we have yet to have a woman even as vice-president.

Born-equal can hardly apply to a congenital idiot. Is the mere human shape a proof of value? Once we make the idiot an exception, we cannot stop there; the nearly idiotic morons are only somewhat better. First, apart from the so-called Mongolian type of born idiot and perhaps some other extreme cases, only subsequent behavior can show what capacities are made possible by the infant state of the offspring. Genius and excessive stupidity occur in all large groups of people, as do many degrees between these extremes. It is gross materialism to judge capacities by color or sex. Few women have composed very great music or made very great mathematical discoveries (however, three female physicists, I seem to recall recently reading, have been Nobel prize winners); but nothing is plainer than that women have been compelled to put substantial parts of their lives and energies into bearing and rearing children, also that until very recently their educational opportunities have been less and they have been rewarded for cultural achievements and penalized for nonachievements less than men. A man who only cooked, sewed,

swept, and looked after children might be looked upon askance, but in all high civilizations this has been almost the expected thing of many or most women. So we just do not know how much of the superiority of men in cultural activities has been due to their greater opportunities and inducements for such things.

Another difficulty is that human abilities are enormously various in kinds. A poetic genius may be stupid in mathematics and a poet or a mathematician may have no talent for statesmanship. So any person not extremely subnormal in ability to speak or otherwise symbolize thought, is entitled to be respected as one of us. Then too all animals are entitled to some respect. I admire dolphins and whales, also elephants, the latter especially for their matriarchal society.

A further consideration is that some of the most important individual differences are not in skills but in emotional and moral qualities. We have evidence that these are largely learned rather than gene determined. Very bad early treatment, especially by the mother or whoever handles an infant or child, or a brutal father (whose father may have been no better), may more or less ruin any offspring, as psychiatrists have told us. It is harder perhaps to know, but is credible, that very good early treatment tends to make a decent human being out of any nonidiotic infant.

Summing up, the born equality of persons seems to amount to this: their essential human capacities will usually not be apparent at first and will develop well only given suitable opportunities, and they will to some extent be beyond the reach of definitive human judgment, considering the selfishness of many of us, the irrational biases, hatreds, or hostilities daily newspapers reveal to us day after day. However, reasonably normal human beings are exalted above the nonhuman creatures which lack the capacity to symbolize any but the simplest thoughts.

Does the foregoing amount to the current doctrine of the infinite worth or dignity of each human being? A brilliant, eccentric friend recently said to me, Everything is infinite. I see why he could say this, but I also accept what is called the *principle of contrast,* which is that the function of concepts is to distinguish some things from some other things. To say, Everything (or even everyone) is infinite destroys the meaning of the term finite in both its positive and its negative uses. I would rather say that each of us is indefinitely valuable. One should at least hesitate to say what the net worth of this or that not extremely infantile or deficient individuality may be, compared for instance to his or her own.

One attempt to prove the infinite value of human beings is to take as premise their being assured of unending posthumous careers. But not only does this transcend any possible human knowledge, it will suffice to establish the conclusion only if we also assume that while the idiot or near idiot is immortal, a donkey, or horse, is not. It is hard to see any good reason for this,

since in behavior, and any knowable psychical traits, the horse is superior to the idiot. And, if our political principles are to depend upon the unprovable doctrine of immortality, taken as confined to our species, how shall we ever agree upon these principles? We do not, and should not, make political rights depend upon belief in God, although in my opinion this belief is not to the same extent unjustifiable.

It is often argued that each of us is a child of God, and hence of infinite importance. We face once more the overwhelming evidence that being human, in any but the crudely physical sense, is a matter of degree. And if by each being a child or image of deity we mean that he or she can worship God, as the horse cannot, then there is in this respect no equality among all human individuals to recognize their creaturely relation to God, for some cannot do so.

I am persuaded that there is no literal, positive, unqualified sense in which all creatures of human shape are of equal worth. They are all helpless to avoid eventual death, at birth dependent for survival upon the care of others, and each, as individual organism, when awake, under the necessity of determining, several times a second, their next step. Even a slave can decide to try to run away, or rebel, or refrain from doing either of these, or in more subtle ways, determine just how to take his or her situation. By contrast, our brain or muscle cells cannot normally, to a comparable degree, face alternative options as to how far to be subservient to our feelings or purposes. Our cells have a built-in subservience to our thoughts and desires to which there is in person-to-person relations no close analogy (though there is a remote one). Here indeed is an inborn and radical *inequality*. No single brain or muscle cell can have much influence upon you or me, but each moment each of us exerts influence upon billions of cells; and neither we nor the cells can do much to radically alter this relationship. No king has ever been in such a position. Human rule over persons is by convention, custom, conscious decision; it is not established by blind instinct. The (male) idiot I encountered seemed rather hostile toward everyone, not automatically subservient at all.

A practical argument for some sort of political equality is this: if people are to cooperate willingly, each must feel that he, or she, is *end* and not mere means to the ends of others. No such radical inequality as that between end and mere means will express the mutuality of human relationships. I go further: to deal with pet animals, or train dogs, cattle, or other creatures, they must feel that their needs are also being met. The ideal social relationships are friendly, and in friendship superiority or inferiority is not the main consideration. I think of Hamlet and Horatio in Shakespeare. We symbolizing animals, capable of quite conscious decisions, will not willingly permit others to make all but the most trivial decisions for us. Where we have capacity to weigh ends and means and compare values we will want to take part, or to have friends we trust take part, in collective decisions by which our lives are

largely determined. Paternalism, in the form of colonialism, is collapsing partly for this reason.

Paternalism is collapsing not only in its colonial form. In church life, for instance, lay persons are more and more expecting to be treated as persons whose religious thoughts just possibly might be superior to the minister's. Not that all are equal in religious insight, surely they are not, but the inequality must not be assumed on some casual ground, or on official status. There is still far too much colonialism or paternalism in my country trying to respond to results of its miserably wicked—what else was it—century-long indulgence in slavery; nor are we managing, even now, to find a humane and even mildly intelligent relationship with the victims of this mistreatment. The semislavery of women is a part of the problem. No other high animal species treats its own members so badly. Those who have studied the family behavior of wolves, for instance, will know what I mean.

We must, it seems, disbelieve in literal, universal equality. One may also disbelieve in crude materialistic grounds for imputing inequality. And I think this is what Jefferson chiefly had in mind. The American colonists were not as such inferior to citizens of the British Isles; mere geographical location can be no proof of inferiority. Only behavior is such proof, and even that has to be weighed taking into account how the allegedly inferior have been treated by those who had power over them. Thus Emerson said that Jews and African Americans had been subjected to mistreatments that were part causes of their allegedly faulty behavior. He thought the same about women, and at least in his diary said so. Only given ideal treatment can one expect ideal behavior. In this I am talking probabilistically. Because every psyche, as Plato said, is self-moving, partly self-creating, no determination by others can be the whole story. But causal conditioning, though not absolute, is powerful. Only with the best conditioning can one expect the best behavior. We should never forget the importance of the influences upon infants and small children of those who take care of them from birth on. Sullivan and other American psychiatrists have shown how these early influences put their mark upon all that occurs thereafter. For this reason opportunity is not a definitive test of potential ability until the opportunity has run through many generations. My people, on both sides, were cultured and high minded through many generations. Some less fortunate may have done as well as or better than I and my five siblings. But this only means the less fortunate could have done better still with more helpful early role models or helpers.

Since we know little about an infant's inborn capacities, since the uniting of genes from two individuals is radically unpredictable; since there are no signs of ability obvious to anything like everyone (and sometimes I am baffled by the extent to which, to me, obvious indications of high qualities seem invisible to some); since people cooperate better if they find themselves treated as ends and as the reflective, decision-making creatures they are, the

only principles upon which one can expect communities to heartily agree are those of universal participation (especially in adulthood and except for radically deficient incompetents) in collective decisions. Any scheme like the apartheid of South Africa cannot work forever and either (as seems now happening) ends relatively peacefully or in miserable slaughter or poverty for both sides.

It is strange how confused many seem to be concerning the real greatness of our species. Are men *linguistically* superior to women? Is there any tool women, or negroes, cannot learn to use, or make? Is there any large group outside an asylum which is inarticulate, unable to express thousands of distinct ideas, learn to use maps, or draw them, at least in sand, any people without songs, dances, poems, pantomime, or other theatrical devices? Unable, given time and motivation, to be taught mathematics, logic, or physics? Any people in which industry, generosity, heroism, or humor are not found? Both sexes and all races have them, but some individuals in both sexes and all races (I presume) lack them. *Individuals* and their real capacities are what we need to evaluate. To prevent an individual from developing his or her unique abilities is to deprive the universe or God of some possible value.

From a long-run point of view it is perhaps the sex difference which will be hardest to deal with in accordance with the ideal of universal opportunity. Women must, on the average, give more of their lives than men to the continuation of the species, not because of any power men have and women lack. Masculine conceit, or if you prefer, masculine ignorance of what they *had no valid ground* for *denying,* has misled our culture for who knows how many millennia. It is the *inborn inability* of men to bear and even ideally to nourish offspring that has been women's handicap. If one cannot see that what can one see? In general women must grant to men greater opportunities for cultural expression, except so far as dealing with small children is itself a cultural process, and indeed the bridge over which the transmission of traditional wisdom first passes. But it is only fair to women to give consideration to the following: men *can* help to care for children, they can wash dishes (as most of my adult life I have done); as the troubles arising from our dangerously increasing populations are better understood in their effects on environments, women should be less and less expected to spend more than a minor fraction of their lives bearing and taking care of infants and children. Women are people, and though they must on the average leave some of their cultural capacities less fully developed than men yet each woman is a distinct case, her life is no mere average, and may be by right extremely far from it.

Today women, or mating couples, are presenting the world with more babies than seem to be called for. The one thing, the world over, that is not in short supply is childbearing. On the contrary, the flood of infants is causing agonizing stresses, and in some countries outright starvation. If abortions are sad affairs, unwanted and badly treated offspring are likely to help fill prisons

with criminals. Pearl Buck objected to abortions that the aborted might be a potential genius; she neglected to mention that it might be a potential Hitler. The definition of person as "human being" involves, even though perhaps unconsciously, a lack of intellectual honesty. Similarly fraudulent is the vague term "pro-life"—mosquitoes are alive, as are bacteria. Persons in the full sense who make our species important are not just biologically human and alive animals but are individuals who can speak, think, make pictures, sing and dance, or . . . , as only members of our species *beyond infancy and early childhood* can do.

It is curious that although we make far too much of some physical differences among individuals we make far too little of some other equally definite and knowable physical differences. Thus we serve meals in standard sizes, although the amounts of food needed for individuals vary as much and as definitely as peoples' sizes in hats or shoes. Similarly with expected safe consumption of and tolerance for alcohol. Again furniture is made in many shapes but not in many sizes, and are usually too large for most women and some men, including me. Little besides automobile seats are made adjustable to leg lengths. From these stupid practices I have suffered some, hence I say "stupid" deliberately and with malice aforethought. I weary of society dominated by large males, and in my white world minority at that.

It is time we made it a part of our culture to see individual differences in a reasonable and appropriate way. What the *individual* white man, African American, or woman needs is not to be seen as simply equal to somebody else but as a unique human individual, perhaps in some way the best there is, as so and so's spouse or parent, or as expert in some specialty, a creature endowed with the power of speech and symbol which raises our species above the remainder of terrestrial life. I agree with Plato in his saying that "no two things in the world are exactly equal." Equality is a negative thing, the zero of value difference. Only God could know it were there such a zero and I know of no valid argument for believing there is.

Those who say we are all equal in the sight of God claim more knowledge about how God looks upon us than my eighty years of thinking about such things has shown me any reason to suppose could be ours. The Biblical texts they may have in mind are reasonably interpretable quite otherwise than as assertions of any such zero. Our human judgments about individual superiorities can claim no such precision as the word zero suggests. Kings and dictators, Stalins say, are not superhuman for God, that we can safely say; we can also safely say that an embryo or fetus is not actually but only potentially comparable in value to you or me. It is almost mindless, compared to either of us. If potentiality is as good as actuality why should we keep trying to actualize our potentialities? On the pro-life principle, fetuses are already as good as they ever can be? How people can think themselves justified in so defying logic in these matters baffles me. What kind of education, or lack of

it, makes such behavior possible? I've looked at the faces of some of them on TV; not one would I care to have as a friend. Some look childish, those that look mature are still not appealingly so.

Religious fanaticism is impure religion, for it promotes hate rather than love. I deeply believe in God and so did a majority of the philosophers I most admire, but my religion inspires respect for the cosmos which is the totality of the creatures conditioned by the divine cause, and forming what Plato called the divine body. Not for some of us is the idolatrous worship of a book written and translated by human hands and brains. Sometimes I almost regret being a so-called human being. The wolves and elephants lack some of our worst faults, how good that they also are there—though for how long who can say? We are the ones who threaten them—our kind, the not very scrupulous bullies of this planet. So speaks in me my Society of Friends paternal ancestry.

SOURCE ACKNOWLEDGMENTS

Chapter 2. "Do Birds Enjoy Singing?" in *Bulletin of Texas Ornithological Society* 8, December 1975, pp. 2–5.

Chapter 3. "Some Theological Mistakes and Their Effects on Modern Literature," in *Journal of Speculative Philosophy, New Series,* 1, 1987, pp. 55–72.

Chapter 6. "What Metaphysics Is," in *Journal of Karnatak University,* Social Sciences, III, 1967, pp. 1–15.

Chapter 7. "A Logic of Ultimate Contrasts," in Charles Hartshorne, *Creative Synthesis and Philosophic Method* (La Salle, Ill.: Open Court. 1970), pp. 99–130.

Chapter 8. Section A: "Psychicalism and the Leibnizian Principle," in *Studia Leibnitiana 8* (2), 1976, pp. 154–59.

Chapter 8. Section B: "The Synthesis of Idealism and Realism," in *Theoria* (Sweden) 15, 1949, pp. 90–107.

Chapter 9. "Perception and the Abstract Concreteness of Science," in *Philosophy and Phenomenological Research* 34 (4), 1974, pp. 465–76.

Chapter 12. "Beyond Enlightened Self-Interest: A Metaphysics of Ethics," in *Ethics* 3, 1934, pp. 201–16.

Chapter 14. "Individual Differences and the Ideal of Equality," in *The New South* 18 (2), 1963, pp. 3–8.

INDEX

abortion, 38, 220–21
abstract contrasts. *See* metaphysics: contraries in activity, as creative, 135
Adams, Abigail, 215
Adler, Mortimer, xxix, xxx, 188–89, 198
aesthetic principles, significance of, 47, 48, 49
aesthetic quality and value
 and beauty, 203–4
 and ethics, 199, 206
 and harmony, 203–4
 as instrumental, 203–8
 as intrinsic, 203–8
 and music, 208–9
 as objective, 208
 and religious values, 206
 and satisfaction, 209–10
 as subjective, 208
 and theism, 210, 212, 214
 and unity, 204
Alexander, Samuel, 46, 115
Allah, 211
Altizer, Thomas, 90
animal, characteristics of, 52
Anselm, xxiii n. 24, 70, 91, 100
"Anselmian Principle," 41
anti-idealism, 145, 146, 148
Aquinas, Thomas, xxiv, 32, 70, 163
Aristotelian tradition, 113
Aristotle, 49, 58, 74, 82, 91, 93, 98–99, 122, 212
 on chance, 7
 and Collingwood, 96
 on the concrete, 110
 on determinism, 8
 on divine life, 88
 dualism of, 90
 on freedom, 163
 on God, 2, 32, 62, 71–72, 89, 106, 163, 169, 211
 on identity, 92

 and Leibniz, 92, 162–63
 on matter, 121
 and metaphysics, 170
 Metaphysics, 87
 negativism of, 162–63
 on the perfect, 2
 and Plato, relation between, 34, 39, 71–72, 87, 89, 92
 science in, 33, 35
 and sense perception, 154
 on the soul, 62, 119
 and subject-object relations, 138–39
 and theism, 84
 and theology, effect on, 2, 88, 92
 and universalism, 140
 Unmoved Mover of, 6
 on virtue, 80
 See also Hartshorne: on Aristotle
Arnold, Matthew, 41
atomism, ancient, 37. *See also* Democritus: Epicurus
Augustine, 69, 106
Austen, Jane, 58–59

Balinese music, 208
Barth, Karl, 77
beauty, 85
 and ethical value, 49
 and goodness, 49
 and matter, 122
 as mean between extremes, 80, 204
Beethoven, Ludwig van, 211
being and becoming, relation between, 96–97, 99, 117, 129, 131, 135
Bemporad, Rabbi, 39
Berdyaev, Nicholas, xxi, 24, 59, 73, 85, 200, 210
 Human Destiny, 73
Bergson, Henri, 75, 91, 93, 99, 132, 167, 183
 on being and becoming, 97, 117

and ontology, 137–38, 150
psychicalistic, 141, 144–45, 149–50
and realism
 compatibility of, 141, 149
 contrast between, 142
 and the subject, 142, 144–45
identity, personal, 185–86
 abstractness of, 192–93
 and continuity, 186, 188
 and immortality, 191
 and motivation, 188–90
 and nonidentity, 185, 187, 190
 and rational aims, 188–89, 190, 192
 and self-interest, 186–87, 188, 192
 and selfishness, 189
 and universal ends, 188, 194
innate ideas, 101
Isaiah (biblical), 77

Jainism, 40
James, William, 59, 101, 110, 187, 194
 and continuity, 127
 The Dilemma of Determinism, 136
 and freedom, 56, 63, 195
 and Hume, 141
 See also Hartshorne: on James
Jeffers, Robinson, 54, 60
Jefferson, Thomas, 219
Jesus, 2, 212
Job (biblical), 2, 32, 70, 166
Jones, Rufus, 29, 36
Judaism, 70, 75, 76
Judeo-Christian thought, 192

Kandinsky, Wassily, 211
Kant, Immanuel, xxviii, 3, 74, 80, 90,
 115, 187, 207
 a priori and empirical, blurring of, 106
 and causality, 92
 and determinism, 52, 167–68
 on ethics, 198
 first antinomy, 129, 130
 and God, 107, 108
 and Hume, 4, 91, 92, 141, 171
 and metaphysics, 170
 Perpetual Peace, 25
 and science, 152

and theism, 100, 106, 107
and war, 21, 22, 63
Kepler, Johannes, 49
Khayyám, Omar, 60–61, 62
Khomeini, Ayatollah Ruhollah, 76
Kierkegaard, Søren, 11, 163–64
Kingsley, Charles, 7
Kleitman, Nathaniel, 180
Knightman, Frank, 19
Kuhn, Thomas, 74

language
 and ethics, 197–98
 and thinking, 197–98
 and universals, 198
Lanier, Sidney, 55, 60, 64, 66, 70
 "Individuality," 55, 70
Leibniz, G. W., 11, 30, 38, 74, 76, 85,
 90–92, 99, 101, 104, 122
 and Aristotle, connection between,
 162–63
 doctrine of positivity, 104
 on freedom, 90, 162, 163
 and God, 104, 163
 on identity, 193
 and metaphysics, 105
 on mind and matter, 9, 119, 120, 134,
 161, 165, 167
 on monads, 5, 90, 135, 162
 on negativity, 164
 and Peirce, 10
 principles of, 134–35, 137
 on science, 152
 on sense experience, 155, 167
 on singulars, 104, 119, 135
 on sufficient reason, 162
 and theism, 167
 See also Hartshorne: on Leibniz
Lenin, V. I., 27, 86
Lequier, Jules, 34, 54, 99
Leucippus, 154
Levinas, Emmanuel, 13, 23
Levinson, Ronald, 87, 165
Lewis, C. I., 13, 34, 127, 208, 212
lifeworld (*Lebenswelt*). *See* science: and
 the lifeworld
literature